CONCERTS OF THE ARTS

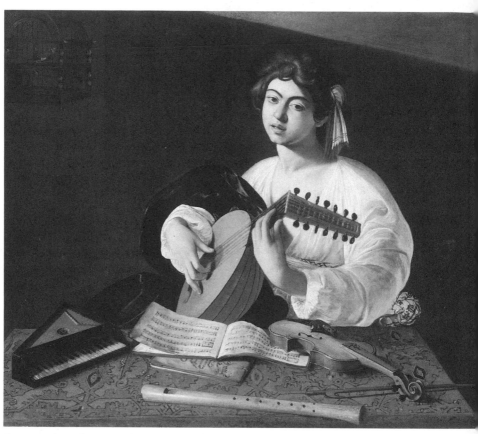

Caravaggio. *The Lute Player,* 1596–97. Oil on canvas, 39⅜″ × 49¼″ (100 × 126.5 cm).
Private Collection. Photograph courtesy of The Metropolitan Museum of Art, New York

Concerts of the Arts

Their Interplay
and Modes of Relationship

William Fleming
Syracuse University

University of West Florida Press / Pensacola

Library of Congress Cataloging-in-Publication Data

Fleming, William, 1909–
Concerts of the arts / William Fleming.
 p. cm.
Includes bibliographical references and index.
ISBN 0-8130-1014-4.—ISBN 0-8130-1026-8 (pbk.)
1. Arts—Psychological aspects. I. Title.
NX165.F54 1990
700'.1'9—dc20 90-12405

The University of West Florida Press is a member of University Presses of Florida, the scholarly publishing agency of the State University System of Florida. Books are selected for publication by faculty editorial committees at each of Florida's nine public universities: Florida A & M University (Tallahassee), Florida Atlantic University (Boca Raton), Florida International University (Miami), Florida State University (Tallahassee), University of Central Florida (Orlando), University of Florida (Gainesville), University of North Florida (Jacksonville), University of South Florida (Tampa), and University of West Florida (Pensacola).

Orders for books published by all member presses should be addressed to

University Presses of Florida
15 Northwest 15th Street
Gainesville, Florida 32611

CONTENTS

ILLUSTRATIONS

Figures

Illustrations

Illustrations

Illustrations

Illustrations

xi

Acknowledgments

WHEN WRITING A BOOK no person is an island, and one must reach out in many different directions. My heartfelt gratitude goes to the many scholars and associates who have contributed so much to this enterprise—most especially to my distinguished colleague Sidney Thomas for sharing his erudition, reading the entire manuscript, and making many helpful suggestions; to Frank Macomber for reading the galleys; to George Nugent for checking the notes; to Abraham Veinus, that man of many ideas; to the staff at Bird Library, Syracuse University, for their resourcefulness in gathering and locating esoteric materials; to the staff at the University Presses of Florida, especially to Walda Metcalf for her unflagging support and editorial expertise, to Angela Goodner-Piazza for her administrative oversight, to Alexandra Leader for her meticulous work on the illustrations and notes, and to Larry Leshan for his designing eye and visual acumen; and to the University of West Florida for making this publication possible.

CONCERTS OF THE ARTS

O N E

Thoughts on Cultural

Historiography

THIS BOOK IS BASED ON the principle that works of art are born not in isolation but rather in a familial relationship with the other arts. The arts tend to grow from soloistic solitude toward orchestral companionship, from artificial separation into natural combinations. This interplay underlies the concept of concerts of the arts.

What was the Egyptian temple but an architectonic framework for myth and ritual, a shrine for the carved images of the gods? The walls were emblazoned with painted murals. A forest of inscribed columns spoke out in hieroglyphic tongues. It also was the scene of the all-embracing spectacle of the liturgy, which moved in stylized steps and musical measures.

The Athenian acropolis was another complex with its gleaming temples, cult statues of Olympian gods and human heroes, sculptured friezes and pediments, and stately processions accompanied by choral and instrumental music (Figure 1). On the hillside below were carved the theaters where dithyrambic choral dances were performed around the altar of Dionysus in the orchestra section, as preludes and postludes to the mythic revelations of Apollonian dialogue pronounced above on the *skene*, the

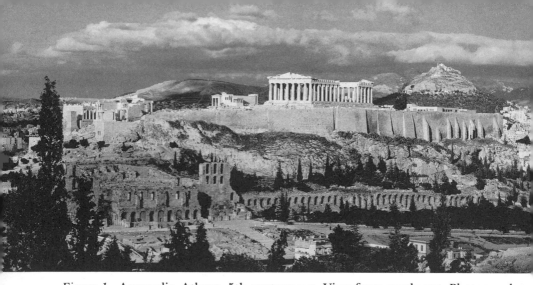

Figure 1. Acropolis, Athens, 5th century B.C. View from southwest. Photograph courtesy of N. Stovpnapas.

stagelike raised platform. One of these theaters, dating from early Roman times, still serves as an outdoor amphitheater. A modern symphony orchestra now plays where the ancient Dionysian chorus once performed (Figure 2).

Other architectonic complexes that reflect the composite art-oriented dreams of a time and its people are the Roman forums, Romanesque monasteries, Gothic cathedrals, and Renaissance and baroque palaces. Today such artistic aspirations are expressed in cultural centers, such as the Southbank festival halls and theaters in London; the Beaubourg complex in Paris; and Lincoln Center in New York, with its two opera houses, symphony and recital halls, repertory theater, the New York Music Library, and the Juilliard School of Music and the Performing Arts. All of these, ancient and modern, can be described as concerts of the arts, where each of the arts performs its appointed role in the orchestration of the civilized life of its time.

The ancient Greeks located the source of creativity in the individual's natural desire for greater completeness and continuity, which was sought in the union of the male and female principle. They personified the arts mythologically as a family of Muses, who represented forms of history, poetry, drama, music, and the dance.

Conceived in the union of the Olympian Zeus and the mortal Mnemosyne, the Muses were interpreted metaphorically as the blend of divine fire and memory. Thus the arts became remembered inspiration. Friedrich Nietzsche saw the Attic tragedy as the microcosm of human destiny and the supreme ancient work of art. For him it was the coupling of awesome titanic Dionysian sublimities with the formal lucidities and grandeur of Apollonian beauty—the joining of darkness and light, dream and stylized reality. As the primordial *Gesamtkunstwerke,* or complete works of art,[1] these dramas brought all the arts together in their architectonic settings. They became the voices of the people and the gods as heard in Dionysian choruses and Apollonian poetry and music.[2]

It is possible, however, to reach beyond the interplay of these *Gesamtkunstwerke* in which each of the arts plays its appointed role in the overall design. The concept of concerts of the arts can be expanded to include the more subtle relationships that emerge when several artists working in different media share a common

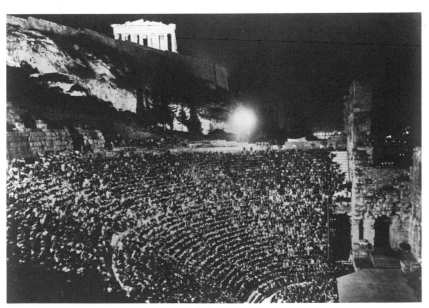

Figure 2. Theater of Herodes Atticus, Athens, c. A.D. 161. Above, Acropolis with Parthenon. Courtesy of the Greek Tourist Office, New York.

heritage of ideas. As will be discovered in Chapter 2, artists start with the vanishing point of the void, select their materials, place them together, and build them up. The movement is from the singular to the plural, from unrelatedness to relatedness. Artists working in one cultural center at a certain time surely share a common aesthetic and intellectual climate. As contemporaries in the latter half of the 5th century B.C., the statesman Pericles, the philosopher Socrates, the architects Ictinus and Callicrates, the sculptors Phidias, Myron, and Polyclitus, and the dramatists Sophocles and Euripides, surely shaped as well as shared the thoughts current in the Athens of their day. They also participated in many aspects of the public, social, and political life of their times.

Viewing contemporaneous architectural, sculptural, and literary works in their broader humanistic context reveals a stylistic interrelationship. In the symbolic language of the arts, a synthesis emerges in which the ideas of order and the meaning of life are expressed in perceptual rather than conceptual terms. In this perspective it is the artist who expresses the logic of reality in the world of events and who breathes life and human warmth into abstract principles. A productive approach to the interrelationship of the arts can then be based on the threefold coincidence of time, place, and idea. This principle will be developed in subsequent chapters.

Specialization versus Generalization

Within the ranks of historians there has long been a debate between some who confine themselves mainly to political, military, and economic matters and others who would broaden the picture to include the entire spectrum of social, scientific, religious, philosophical, cultural, artistic, and linguistic developments of a given time and place. The debate also exists among the specialized historians of painting, literature, and music, who write all too often as if each of the arts evolved entirely out of its own inner technical and causal necessities, and as if their disciplines had no relation to the cultural developments and stylistic currents outside their particular fields. They are so busy peering through analytical micro-

scopes at the minutiae of their fields that they fail to grasp the significance of the social circumstances that surround the birth of a work of art.

Historical writing must, of course, assemble all the pertinent facts and documents. But if the process were to stop there, historians would be little more than the hod carriers and bricklayers of specialized knowledge. Eventually the historical process calls for the building of a structure in which the parts fit into a whole. This is where the sense of perspective and critical judgment come into play, and where the cultural historian fits the various parts into a broader stylistic synthesis. As the distinguished art historian Heinrich Wölfflin pointed out: "To *explain* a style cannot mean anything but to fit its expressive character into the general history of the period, to prove that its forms do not say anything in their language that is not also said by the other organs of the age."[3]

The terms *culture* and *civilization* first came into historical currency in the 18th century to fortify the notion of progress in human affairs and to contrast the intellectual fruits of the Enlightenment with the benighted periods of savagery and barbarism that were then thought to have preceded it. In his influential essay, *Sketch for a Historical Picture of the Progress of the Human Mind,*[4] Condorcet cites ten stages, from primitivism to the threshold of perfectibility. First came the hordes of hunters and fishers, followed by the pastoral and agricultural societies. Then came the religiously oriented Middle Ages and the period of mysticism, feudalism, and theological speculation. The beginnings of the modern age dawned with the rational approach of Newton, Descartes, Locke, and Rousseau. The Enlightenment found its social expressions in the American and French revolutions of 1776 and 1789, which were then believed to have brought humanity to the threshold of social, moral, and political perfection. The empire of reason was at hand. This view, of course, did not preclude the notion of past golden ages. Edward Gibbon found his golden age in the period of the five good Roman emperors[5] and Johann Joachim Winckelmann saw another expressed in the arts of ancient Greece.[6] Together with other factors, their work set the stage for the neoclassical style and the Greek and Roman revivals.

Enlightenment versus Romantic Viewpoints

The search for the aesthetic of the complete work of art in which all the expressive media function together as parts of a whole seems to go hand in hand with the development of cultural historiography. During the 18th-century Enlightenment, the seeds of cultural history were planted. Their early growth took place during the romantic movement. At first emphasis was placed on purely logical principles, but the romanticists broadened the inquiry to include irrational, imaginative, and emotional aspects. In the 17th-century age of reason critical appraisal of the arts received little mention in philosophical writings. René Descartes' uncompromising rationalism, for instance, had defined feelings and sensations as "confused thoughts." Literature, he believed, was an idle use of the imagination and quite unproductive in the search for truth.[7] His disciple Bernard de Fontenelle was a shade more positive, since he believed the successes of science could improve the quality of life and the arts. "A work of politics, of morality, of criticism, perhaps even of literature," he declared, "will be finer, all things considered, if made by the hands of a geometer. The order, clarity, the precision which have reigned for some time in good books may indeed have their primary source in the geometric spirit."[8]

This was certainly barren soil for the critical approach to the emanations of the human imagination. Reactions to this rigid rationalism soon set in from many sides. In England, for instance, John Locke in his *Essay on Human Understanding* (1689) pointed out that all knowledge has its roots in sense experience. In Italy Giovanni Vico criticized the purely rational approach in his influential *Scienza Nuova* (1725). He attacked the wanton disregard of the historical past and its exclusion of sensation, sensory experience, and imagination from the realm of knowledge. In his view no age was in the wrong; each had its particular strengths and beauty. In Germany another by-product was the basic foundation of philosophical aesthetics as the science of feeling. Alexander Gottlieb Baumgarten's two-volume *Aesthetica* (1750 and 1758) paved the way for the scientific investigation of sensations, sensi-

bilities, and intuitions as a basis for the critical judgment and understanding of the arts. Still other reactions arose with the emergence of secular historical writing out of the dark clouds of theological speculations and disputations. Eventually Emmanuel Kant's ingenious synthesis broke the impasse between the processes of reason and imagination, the rational and emotional. As he summarized it, every concept without intuition is empty, and every intuition without a concept is blind.

It was Voltaire who first allowed the arts to grow in the fertile field of human events. As a novelist and playwright, he approached history from a far more liberal point of view. His *Age of Louis XIV* (1751), for instance, chronicled not only political, military, and economic events but also expressions in literature and the visual arts. Thus Voltaire became the earliest modern historian to bring the arts into the orbit of general history.

The German philosopher Johann Gottfried von Herder expanded Voltaire's early perceptions of cultural history. But unlike Voltaire, who had seen the medieval past as a period of barbarism and superstition, Herder saw folk tales, epics, and sagas as voices of the people. He believed that human history reveals itself more vividly in images and pictures, poetry and tales, than in grand principles and broad generalizations.[9] Herder also viewed the course of historical growth as analogous to that of a living organism—"the purely natural history of human forces, actions and instincts, according to their time and place." And he carried the analogy one step further when he wrote: "As the scientist can only fully observe a plant when he knows it from its seed and germination to its blossoming and fading, so the history of Greece should be such a plant for us."[10] Herder's interests ranged over the entire field of creativity, from literature and languages to philosophy and science. Above all, he perceived a broad synthesis of common bonds and trends among the separate disciplines.

Building on Herder's thought and Kant's critiques of reason and judgment, Georg Wilhelm Hegel erected his monumental metaphysical structure, which houses the entire scope of human history.[11] From his theological background, Hegel viewed history as continuous cultural evolution unfolding in a trinitarian process

of successive theses, antitheses, and syntheses. He saw all evolution as a progress from matter to spirit, from rocks to plant life, from beasts to man, from the hieratic animal deities of ancient Egypt to the monotheism of Judaism and Christianity, and in the arts from the early dominance of architecture, through the progressive dematerialization of sculpture and painting, to the more ethereal forms of music and poetry. In his emphasis on the role of the arts in cultural evolution, and in his synthesis of the many facets of human development in their relation to each other, Hegel made an enormous contribution to the concept of cultural history.

Hegel's system, however, was too closely tied to his theological interpretation of the continuous process of God revealing himself through the progress of creative evolution from material bondage to higher states of being. As E. H. Gombrich has pointed out, Hegel was at first a positive stimulus to the development of cultural history. However, the rigidity and overt neatness of his divine plan and the deterministic turn of the later Hegelians can no longer be accepted.[12] Yet his influence persists in Marx's theory of economic determinism, which has been applied to the arts by certain historians, notably Arnold Hauser in his influential *Social History of Art*.[13]

In France the romanticist Jules Michelet, in his *Introduction to Universal History* (1831), broadened historical writing to include the inarticulate aspirations of the masses as they gradually began to throw off the shackles of religious superstition and political exploitation on their way to achieving national self-consciousness and identity. He stressed the role that climate, geography, and local color played in the life of a people. His insight extended to the way that medieval cathedrals expressed the mystic spirit of their time (Figure 3). He wrote:

> Try to imagine the effect of lights in these prodigious monuments, when the clergy, circulating by aerial ramps, animated the dark masses with fantastic processions, passing and repassing along balustrades, on bridges of lacework, in rich costumes, with candles and chants; when lights and voices turned in circle after circle, while from below, in the shadow, the ocean of people responded. That was for this era the true drama, the true mystery play.[14]

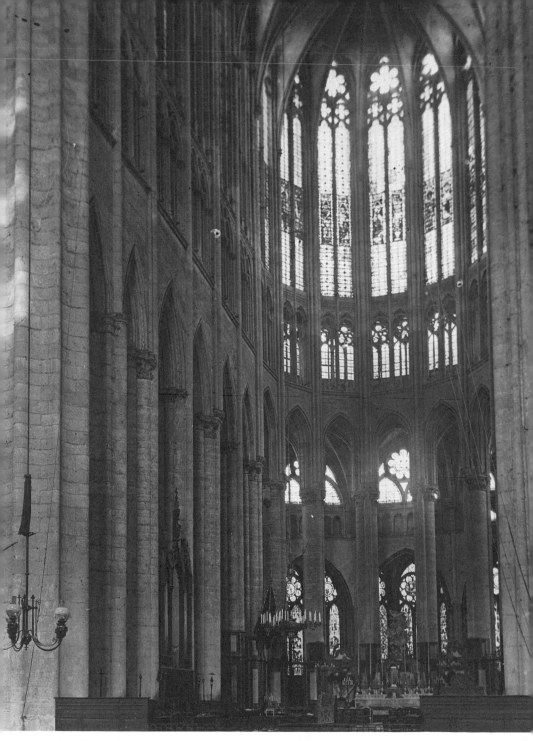

Figure 3. Choir, Beauvais Cathedral, begun 1225, reconstructed 1337–47. Height 157′ (47.85 m). Courtesy of the Archive Photographique, Paris.

Ernest Renan, in spite of his more realistic and positivistic approach, also emphasized the importance of the arts in his historical thinking. "Each branch in the development of humanity," he observed, "art, poetry, religion, meets, in traversing the ages, a privileged epoch, in which it attains perfection without effort by virtue of a sort of spontaneous instinct." [15]

Renan's fellow positivist Hippolyte Taine, in his *History of English Literature* (1864), emphasized the importance of environmental factors on literary expression. "There is," he wrote, "a system in human ideas and sentiments, the prime motor of which consists in general traits, certain characteristics of thought and feeling common to men belonging to a particular race, epoch or country." [16] For Taine: "True history begins when the historian has discerned beyond the mists of ages the living, active man, endowed with passions, furnished with habits, special in voice, feature, and costume, distinctive and complete, like anybody that you have just encountered in the street." [17] The most significant thing about Taine's approach is that in spite of his positivistic assumptions, he felt that literature was material for history and that through literature one is able to approach the figures of the past as "living, active men." [18] Taine points out that just as one studies the shell as a dead fragment in order to form the idea of the living animals, so one examines historical documents in order to reconstruct the feelings of real people. And through the study of living literature, it is possible to "make the past present." [19]

Romanticism versus Positivism

The importance of both romantic historiography and positivism can hardly be overestimated. Romanticism emphasized ideal values, while positivism insisted that facts are facts and as such have the most important place in human history. The romantics recognized the irrational forces and imaginative fantasies in the lives of individuals and societies as well as the interconnection of thought, emotion, and events. This recognition plus the discovery of new methods of approach to the study of the arts were the keystone of romantic historiography. The cornerstone of positivism is its emphasis on social factors and a certain mechanistic evolutionary

point of view. Because of the positivistic influence, history became less philosophical and more empirical as the positivists investigated deeply into social and economic influences. Their methodological system, however, proved less successful when applied to situations involving a broader scope and the investigation of many different related fields.

The first flowering of the cultural-historical approach came with Jacob Burckhardt's *Die Kultur der Renaissance in Italien* (1860).[20] His projection of the state as a work of art was greatly indebted to three Renaissance figures—Machiavelli of *The Prince*, Guicciardini of *History of Florence*, and especially Castiglione of *The Courtier*. Noting the obligation of a ruler to surround himself with men of letters, artists, and musicians, Burckhardt places state support for the arts in the foreground of the courtly life of the time. As he points out, the social life of those times became in itself a work of art. Individual members of the court were encouraged to express themselves in poetry, song, and even in their costumes. In Burckhardt's analyses of various Italian regional governments, all the main literary figures play their parts. He mentions many major visual artists, though he omits Botticelli, Michelangelo, and Raphael, because they did not work at the particular centers he highlights. Individual composers and musicians do not figure anywhere. The paucity of Burckhardt's treatment of art and artists in the *Civilization of the Renaissance in Italy*, however, is perhaps accounted for by his earlier work, the *Cicerone* (1855), a guidebook that describes each of the regional schools in detail. When the two works are taken together they make a more satisfactory whole. Burckhardt managed to spread a glowing panorama before the eyes of his 19th-century readers, and generations of travelers saw Italy through his eyes. The concept of the state as a center of the arts had a certain validity from the Renaissance through Napoleonic times. As this father figure of cultural history wrote: "Every cultural epoch which presents itself as a complete and articulate whole expresses itself not only in the life of the state, in religion, art and science, but also imparts its individual character to social life as such."[21]

In the late 19th century Wilhelm Dilthey, Burckhardt's younger colleague, probed the philosophical roots of cultural history and

divided the methods applicable to the humanities from those of the natural sciences. The sciences, he felt, had gradually and painfully emancipated themselves from their bondage to theology and metaphysics as they traversed the road to their triumph in the age of reason. The humanistic studies—history, social studies, psychology, literature, music, and the visual arts—he pointed out, had also made some progress of their own, but only to fall under a new yoke, that of the scientific method. Dilthey believed the humanities needed their own declaration of independence and their own separate methods in order to achieve significant meaning and understanding. To him the difference was between *Naturwissenschaft* (the natural sciences) and *Geisteswissenschaft,* which can best be rendered as humanistic studies, intellectual history, or the history of ideas. His distinction, however, should not be considered as absolute but more as a complementary relationship in the search for total knowledge. In the humanistic studies, Dilthey reasoned, no single method can suffice. All, however, can be grouped around the concepts of connectedness, interrelationship, and synthesis. Dilthey felt there were three stages in humanistic studies: (1) the search for unifying factors; (2) a harmonious grouping of events; and (3) the formulation of a comprehensive totality.[22] As he wrote: "Philosophy is the effort to make us conscious of the unity and connectedness [*Zusammenhang*] of all the expressions of being."[23] Reality then becomes not a sum total of isolated phenomena, facts, or events, but a whole of interrelated parts. In this architectonic approach, one moves from the whole to its interrelated parts instead of vice versa. Some specialization in the search for knowledge, Dilthey felt, is both necessary and desirable. But he believed that in the process, it is vital to keep in mind how each factor fits into the overall picture.

In his late years Dilthey wrote a series of studies on the relationship among religion, poetry, and music in the light of the history of ideas.[24] While he was concerned with problems of methodology all his life, he did not formulate a comprehensive system of his critical thought. However, several aspects of his approach stand out. The essence of knowledge, as the novelist E. M. Forster was later to put it, is "to connect." Perceiving relationships and making

connections among separate sensations, sensory data, and events is the way one builds up a view of the world and an understanding of it. Reality then becomes a composite picture of interrelated events rather than a chaotic sequence of one thing after another. It is the artificial compartmentalization of experience that leads one astray. Dilthey was also convinced that humanistic studies cannot be compartmentalized, because they are all interdependent and interrelated. Hence interdisciplinary cooperation is vital.

In his cultural-historical writing, Dilthey focused on the work of one particular artist as typifying an age, and he saw history as the ever-changing "image of man" as he traverses the centuries. Here he differed from his colleague Burckhardt, whose *Civilization of the Renaissance in Italy* he criticized as supplying only background without a foreground. The foreground, of course, was the individual artist and works of art. Dilthey also believed in what he called the "structural unity of a culture". This unity could best be comprehended when the culture is "at its greatest height," when the "configurations of poetry, religion, and philosophy" come into sharpest focus.[25]

Well aware of the contributions of both Burckhardt and Dilthey, Heinrich Wölfflin took the historiography of art into uncharted territory with his *Principles of Art History*.[26] In it he was more concerned with the internal dynamics of art history than with cultural-historical considerations as such. He viewed the history of art as a "doctrine of the modes of vision" and set up a system of five categories—linear and painterly, plane and recession, closed and open form, multiplicity and unity, clearness and unclearness. He emphasized the problems of style definition, most particularly the differentiation of the Renaissance and baroque. His approach, however, has proved to be more effective in the analyses of the high points in each of these styles—as, for instance, when he compares Raphael with Rubens and Bramante with Bernini. It is less felicitous with the earlier, later, and transitional phases of the styles. His categories have also been more successful in respect to the pictorial arts, especially painting, than they have been with sculpture and architecture. Wölfflin anticipated that his five pairs of concepts would be universally applicable to all histor-

ical periods. This, however, has not proved to be the case, especially in the more complex fields of medieval and contemporary art where they have relatively little validity.

While Hegel had felt that unity in a historical period could be perceived in a metaphysical *Zeitgeist,* or spirit of a time, Wölfflin found his idea of unity in a *Stilgeist,* or style spirit that could be discerned in all the arts of a given period. His method became a way of demonstrating scientifically how all the components and characteristics of a particular time came together. He succeeded in combining the romantic concept of intuitive expression with the positivistic objective analysis of form.

Modern Developments

The division between the positivistic specialists and cultural historians still persists. Followers of Leopold von Ranke continue to insist that facts are facts and that the purpose of historians is to recreate events exactly as they happened. Yet Benedetto Croce declared that "so far as I know there are no 'universal' or permanent 'facts.'"[27] He also believed that "to understand a work of art is to understand the whole in the parts and the parts in the whole" and that a work of art "taken away from the historical complex to which it belongs . . . would lose its true significance."[28]

Taking off from Herder and the broad sociocultural-psychological methods of Karl Lamprecht,[29] Oswald Spengler brought cultural history to the popular level with his *Decline of the West.*[30] In it he upheld the view that the experience of history is to gain insight into how peoples of the past felt, reacted, and created in a particular set of historical circumstances. As he expressed it, a culture can be "intuitively seen, inwardly experienced, grasped as a form and symbol and finally rendered into poetical and artistic conceptions." As Emery Neff points out:

> One of Spengler's signal achievements was to give refinement and precision to the conception of the *Zeitgeist* by disclosing family resemblances between apparently unrelated, disparate portions of a single culture: between the Greek

city-state and Euclid's geometry, between the space-perspective of Western oil painting and Western mechanical conquest of space.[31]

Another of Karl Lamprecht's followers at the University of Hamburg was Aby Warburg, whose pioneering cultural-historical studies in the Florentine Renaissance continued those of Jacob Burckhardt. He steadfastly resisted the compartmentalization of knowledge in university curricula, and he specifically rejected the formalists' narrow interpretations by recognizing the whole host of complex forces that give shape to a period and style. It was central to his thinking that the interpretation of any social fact, no matter how minute, depends on calling forth every available department of human activity. As he wrote to a friend: "Not until art history can show ... that it sees the work of art in a few more dimensions than it has done so far will our activity again attract the interest of scholars and of the general public."[32] Above all, however, Warburg's most lasting contribution was his important library, which eventually found its way to the University of London's Warburg Institute. Warburg also had a genius for gathering around himself a luminous circle of distinguished scholars—Erwin Panofsky, Ernst Cassirer, Edgar Wind, Max Friedländer, and E. H. Gombrich, to mention only a few who have set the course of modern art-historical scholarship.

On the American scene, Arthur O. Lovejoy's thematic approach has also made a significant contribution to cultural history. His method was to isolate one major idea or complex of ideas as a unit, then to trace its progress and mutations through all "the provinces of history in which it figures in any important degree, whether these provinces are called philosophy, science, literature, art, religion, or politics."[33] In his essays Lovejoy was primarily concerned with the phenomenon that "man does not live by bread alone, but chiefly by catchwords."[34] These catchwords—nature, art, primitivism, evolution, classicism, romanticism, being, becoming—are the constants. The variables are the different assumptions, presuppositions, definitions, connotations, meanings, semantic situations, modes of thought, climates of opinion, diverse

contexts, and historical periods. Lovejoy's ingenious connections of deism and classicism in 18th-century thought and his revealing analysis of the many faces of romanticism in the arts have proved to be landmarks in the field.

Literary criticism is currently polarized between the textualists as advocates of formalism and the historicists as proponents of what is called the "new historicism." The textualists believe in examining a literary work in isolation, divorced from social, cultural, and humanistic considerations. The historicists insist that full interpretative understanding can come only when the work is placed within a larger sociocultural context. For one side the text is the only consideration, for the other the text is shaped by such institutions as the family, religion, state, the economy, and a host of other environmental factors. The textualists have been accused of indulging in pure subjectivity and ivory-tower isolationism, and the new historicists have been castigated as Marxian materialists who see history only in terms of the social and class struggle. The textualists are convinced "that words can only connect with other words," while the historicists publish books with such titles as *Political Shakespeare; Radical Tragedy: Religion, Ideology, and Power in the Drama of Shakespeare and His Contemporaries;* and *James I and the Politics of Literature.* One side sees Shakespeare's *The Tempest,* as an allegory of art, the other holds that colonial expansion and domination is one of the central issues.[35]

This battle of verbal thunderbolts between Kantian purism and Marxian economic determinism cries for a rational neo-Hegelian synthesis. Any viable work of art cannot survive and communicate unless it is a self-contained whole with an internal integrity of its parts. All great works of art, however, have external resonances and reverberations that lead to new areas of experience. Separating the text from all other discursive associations ultimately leads to a solipsistic cul-de-sac, while putting the text into the mainstream of history can open up challenging new interpretive insights without violating the work's intrinsic worth. The rise of the new historicism in 20th-century and postmodern arts is examined in detail in Chapter 9.

My own approach, as shown in *Arts and Ideas,*[36] owes a debt to both Dilthey and Lovejoy. In each chapter I have chosen the span

of years in which the culture has achieved a notable climax, then painted a broad backdrop that depicts the social, intellectual, and artistic climate of the time. This sets the stage for the drama that follows. As with the unfolding acts of a play, particular works of art drawn from architecture, sculpture, painting, music, and literature in turn occupy stage center. In any milieu where artists are active, the taking-off point must always be the intellectual and cultural climate of the time and place in which they are working. Individual artists may accept or reject, endorse or protest, conform or reform, construct or destroy, dream of the past or prophesy the future. But their point of departure is always their current scene. The accents with which they speak, the vocabularies they use, the symbols they choose, the passion with which they champion ideas—all eventually add up to the synthesis of a style. The denouement and resolution come with extracting the nexus of ideas that have manifested themselves in several arts. These concepts then become focal points that reveal the common undercurrents that tie the various media together so that critical judgments and stylistic syntheses can be made.

With Dilthey I hold that no one method is ever sufficient or final. When asked how he climbed a mountain, an experienced Alpinist said "First show me the mountain." So it is with the arts. Works in various media need a variety of methods, and the method chosen is the one best adapted to the special situation at hand. In my own thinking the work of art itself should always come first and foremost. With a painting, one can experience and feel all the fine points of its design, form, linear organization, color harmonies or dissonances, the handling of light and shade, and all the other aesthetic considerations of formal analysis. On another level, however, the work of art is also the distillation of a moment in time, the mirror of history in which the changing visage of humanity is reflected. Finally, as Gombrich has trenchantly remarked: "If cultural history did not exist, it would have to be invented now."[37] But he adds the caveat that "the cacophonic label of an interdisciplinary discipline" should be avoided at all costs.[38]

Each of the following chapters will explore the interplay of the arts and their various modes of relationship in order to reveal new levels of meaning. In the psychological mode, an attempt will be

made to fathom some of the mysteries of the creative act, the key common to all artistic productivity. The discussion of harmonic and visual proportions over the centuries will be examined by relating music with architecture in the analogous mode. The iconographical mode comes into play when literary and philosophical sources underlie the intent and meaning of a painting, statue, musical composition, or the decorative embellishments of a building. The personal mode occurs when a single artist finds expression in more than one medium. When authors, artists, and composers of a period exhibit common characteristics, attitudes, intentions, and techniques, their work can be grouped together under one stylistic designation such as baroque, rococo, neoclassical, or romantic as the stylistic mode comes into play. Artists' letters, journals, and autobiographical writings can also cast much light on their works, as in the autobiographical mode. Finally when a common philosophical concept inspires a period and is reflected in the sciences as well as in the verbal, visual, and musical arts—as with the ideas of relativity and the new historicism in the 20th century—still another mode of relationship can be revealed.

The Creative Mind:

The Psychological Mode

WHAT IS ART? is an age-old question. The most plausible answer seems to be that art is what an artist creates, and the accent is on the verb *creates*. When considering the psychological mode of interrelationship between the arts, two more challenging queries arise: How do the minds of creative artists work? And how do we as observers, readers, and listeners get involved in the creative act?

The Creative Act

No matter how deeply psychologists have probed into the human psyche or how broadly philosophers have speculated on human nature, no one has yet arrived at a definitive explanation of just what takes place in the creative mind. Perhaps comic strips come closest when they depict an idea as the sudden illumination of an electric bulb over a character's head. Whenever we encounter some puzzling problem, when we try to explain something in the world about us, or when we search for solutions in artistic expression, suddenly an idea—in the platonic sense of an image, a form, a picture—comes to mind.

In the creative act the whole world can be changed in an instant. One has only to cite the moment when the apple fell and Isaac Newton perceived the attraction of the larger sphere of the earth for the smaller one of the apple. In a chain reaction there followed the formulation of the laws of gravity, celestial mechanics, the development of the integral calculus, and all the other mathematics needed to come to terms with the new world view. Similarly, while searching in the marble quarries of Carrara, Michelangelo would come upon a particularly promising vein of marble or block of stone and instantly in his mind a Madonna or a Moses would be born. As he wrote in one of his sonnets:

> The greatest artist has no single concept
> Which a rough marble block does not contain
> Already in its core . . .

Then referring to the creative process in sculpture, he said:

> . . . just as one already sees,
> Concealed in the hard marble of the North,
> The living figure one has to bring forth
> (The less of stone remains, the more that grows.)[1]

Michelangelo thus saw himself as a kind of midwife helping the figure in the marble block (Figure 4) to emerge from its stony womb.

When Beethoven suddenly perceived the relationship and potentialities of four tones, ♪♪♪↓, his Fifth Symphony took shape in his mind, and he created a whole universe of sound. As the English novelist E. M. Forster has aptly remarked: "It will generally be admitted that Beethoven's Fifth Symphony is the most sublime noise that has ever penetrated into the ear of man."[2] And Albert Einstein had a similar sudden inspiration when he was going to work on the trolley car in Zurich. He saw that when a tram passed in the opposite direction, there was a feeling of considerable speed. But when a car drew up going in the same direction, there was very little sense of speed. If two cars were going parallel at the same rate of speed, there seemed to be no motion at all. Thus the

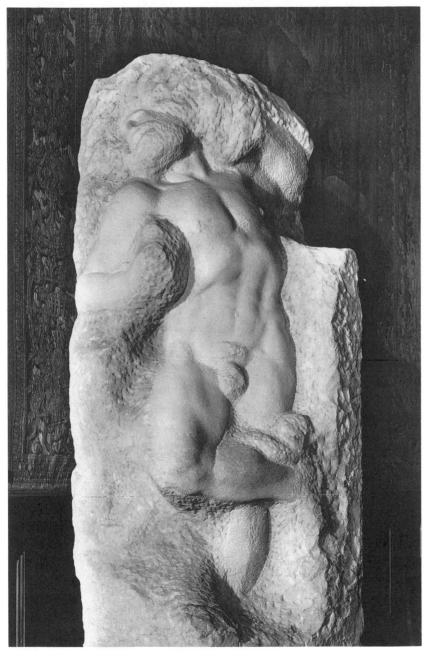

Figure 4. Michelangelo. *Prisoner,* c. 1530–34. Marble, height 7'6" (2.3 m). Galleria dell'Accademia, Florence. Courtesy of Gabinetto Fotografico Nazionale, Florence.

theory of relativity came into being, and the modern world was born.

As they are rooted in such simple, everyday experiences as looking at a falling object, a block of stone, traffic moving, or listening to a few tones, it would seem that anyone could have made these same observations. Yet it took the creative minds of Newton, Michelangelo, Beethoven, and Einstein to make the creative insights that changed the world. Of course, these incidental events were simply the catalytic agents that crystallized their thinking after years of study, preparation, and reflection.

To understand creativity as a psychological phenomenon, we will first look at certain theories about the creative act and then consider how the basic raw materials of sensory data rise through the imagination to become perceptions and ideated sensations. This transition from sensory to ideational experience will then lead to questions of how the products of artists' minds found a place in the life of their times and in ours. No creative work by an artist is complete unless it reaches the eyes and ears of potential readers, viewers, and listeners. Here the re-creative act comes into play. History serves to bridge the gap between past and present, the there and then and the here and now. We will then consider images as they rise to become symbolic forms and metaphors that clue us in to the meanings the artists had in mind, and how we can interpret works of art on many different levels.

Creativity certainly starts with some initial hunch—intuition, insight, inception, inspiration, a sense of wonder, or just plain curiosity. After that comes the long, laborious working-out process. Here technical skills, knowledge, and craftsmanship come into play to shape the end result. For the rest of their lives Newton, Michelangelo, Beethoven, and Einstein worked out the consequences of their creative breakthroughs by technically refining them in laboratories, studios, and libraries. It has often been said that genius in the arts and sciences is 1 percent inspiration and 99 percent perspiration. But no matter how much sweat there is on your brow, it is that 1 percent of inspiration that really counts.

The theory of cosmic creativity that once dominated Western thought derives from the Book of Genesis (1:2–3) ". . . the earth was without form and void; and darkness was upon the face of the

deep. . . . And God said, Let there be light; and there was light."
Two influential modern philosophers have translated this theory
into human terms. William James once described the beginning of
the creative process as a "big, blooming, buzzing confusion"—
something like the state of matter that preceded the big bang, al-
though he was thinking of it as a psychological event.[3]

Friedrich Nietzsche also caught this spirit of creativity when he
wrote in his book of aphorisms, *Also Sprach Zarathustra:* "You must
have chaos in you to give birth to a dancing star . . . I say unto you,
you still have chaos in yourselves." Today it is still possible to fore-
see a shining creative future and a whole galaxy of dancing stars.
When we look at the world around us, the supply of chaos seems
truly inexhaustible. Just as darkness precedes light and chaos gives
rise to the resolutions of art, it is to the inner tensions, the oppo-
sitions, the discordant diversities, the conflicting motivations at
work in an artist's mind that we must look in our search for under-
standing. In a philosophical vein, the poet William Blake ex-
pressed his concept of the creative life in both visual (Figure 5)
and verbal terms:

> I must Create a System or be enslav'd by another Man's.
> I will not Reason and Compare: my business is to Create.[4]

The source and fountainhead of creativity seems to lie in the
human imagination, which manifests itself in the projection of im-
ages. This idea can be traced back to antiquity where the act of
creation itself is described in the Book of Genesis (1:26–27): "And
God said, Let us make man in our own image, after our likeness:
. . . in the image of God created he him; male and female created
he them." Here the key words are *image* and *created.* The divine
principle, then, is creativity. And if God is conceived as the creative
force—whether God be Jehovah or Jupiter, Zeus or Jesus, or some
modern existentialist equivalent—if God is conceived as the crea-
tive force and the human being is created in his image, it follows
that men and women also possess creative powers in their own
right. In turn they create their own gods, ideas, ideals, arts, and
sciences in their own human image. The secret lies in the creative
imagination.

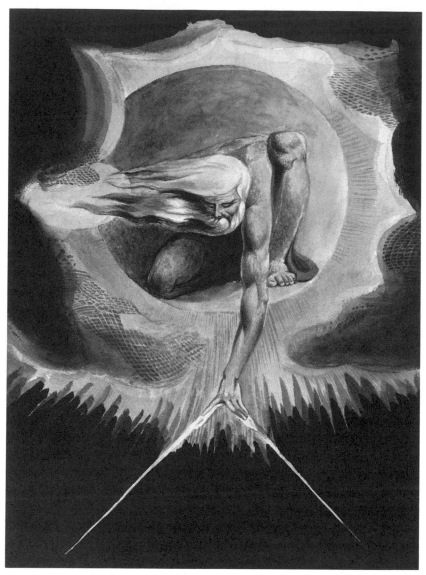

Figure 5. William Blake. *The Ancient of Days,* frontispiece of *Europe, a Prophecy* (1794). Etching, hand-colored. Courtesy of the Pierpont Morgan Library, New York. PML 77268.

Artists have always been intrigued by the creative process itself as a subject for painting. Barnett Newman, one of the old masters of American abstract expressionism, tried to capture the essence of the creative act in his picture entitled *Genesis—The Break* (Figure 6). Its stark blacks and whites suggest God separating light from darkness; the bringing of order out of chaos, form from the void, the essential from the trivial; the image of a celestial body taking shape out of nothingness; the reconstruction of the primal creative force. And in Renaissance times Michelangelo, in one of his Sistine Chapel ceiling murals, reveals similar cosmic concerns in his visualization of the creative act. Here the creator is seen moving in an astronomical orbit as the sun, moon, and stars take shape (Figure 7).

From the void artists conceive images, from nothingness they give birth to being, out of chaos they bring order, by selection they create relationships. Art, then, becomes the language by which artists communicate their ideas, their conceptions of themselves, their society, and their universe. The artist begins the process with the vanishing point of the void—empty space and undefined time—then composes in the literal sense by selecting materials, putting them together, building them up. The procedure is from the singular to the plural, from unrelatedness to relatedness, as artists reach out toward expression and communication.

In my own thinking the creative process also means the making of connections and relationships. As E. M. Forster wrote: "Only connect the prose and the passion, and both will be exalted, and human love will be seen at its height."[5] To put the process on a more basic level, all learning, knowledge, and understanding comes from putting one and one together to make two, or even better, to make three; and putting two and two together to make four, or, one hopes, five or perhaps twenty-two, because the whole is always greater than the sum of its parts.

The Re-Creative Act

Now we may well ask: How do we as viewers, listeners, readers, become involved in the creative act? We must start with the assumption that all human knowledge is sifted through the basic

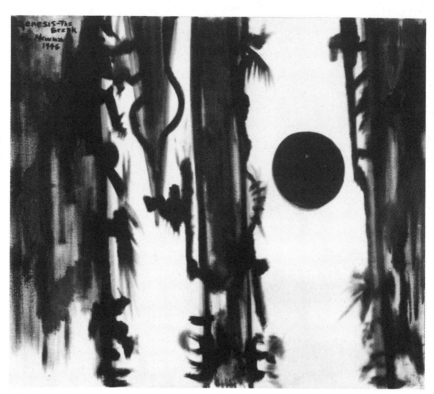

Figure 6. Barnett Newman. *Genesis—The Break,* (1946). Oil on canvas, 24 × 27⅛″ (60.96 × 68.90 cm). Copyright by the Dia Art Foundation, 1987. Courtesy of the Menil Collection, Houston.

sensory experiences of sight, sound, touch, smell, and taste. Mental images, aroused as they are by sensations, assume certain perceptive and symbolic forms associated with visual, auditory, tactile, olfactory, and gustatory imagery. Art expression is based principally on the so-called higher sense of sight and sound. While no fine art is based exclusively on taste and smell, gustatory and olfactory data nonetheless are often used in the visual arts and literature to a corresponding sensations and to intensify description in the minds of viewers and readers. Tactile imagery is used to suggest textures, such as hard or soft, rough or smooth, wet or dry, warm or cool. Perceptions and intuitions, reason and imagination, then, are all composed of these basic sense data by putting one and one, two and two, together.

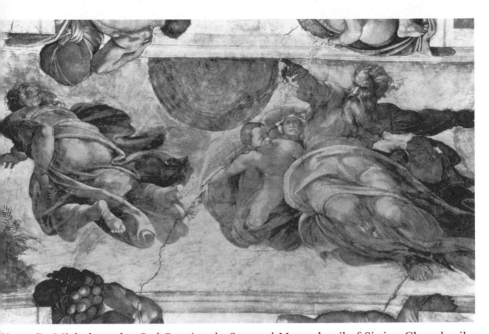

Figure 7. Michelangelo. *God Creating the Sun and Moon*, detail of Sistine Chapel ceiling, 1511. Fresco, the Vatican, Rome. Courtesy of the Vatican Photographic Archive.

Then there are two more sources—kinesthesia and synesthesia. Just as kinesiology is the science of motion, so kinesthesia is the inner feeling or art of motion. Synesthesia is the combination of two or more different sense impressions, as when one sensation conjures up that of another. Kinesthetic imagery is that which we feel in our muscles, so that even when sitting in the audience we can feel movement when watching games or dancing and can imagine the steps and movements of a march or dance while we listen to an orchestra playing. With synesthesia, sounds may evoke the sensation of color, while a scent may awaken an image of touch.

A still-life painting will show how these various sense experiences are brought into play. In a 17th-century French example by Baugin, we can see how an artist stimulates our senses and draws us into the orbit of his picture (Figure 8). Various objects are grouped on a table to create the unity of a quiet, harmonious arrangement. At the same time variety is provided by the various

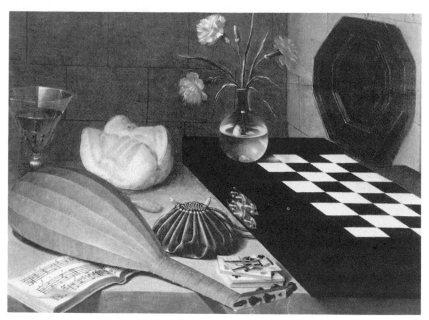

Figure 8. Baugin. *Still Life: Allegory of the Five Senses,* c. 1630. Oil on canvas, 21⅝ × 28¾" (54.93 × 73.03 cm). The Louvre, Paris.

heterogeneous artifacts. A painting, by its very nature, must be primarily a visual experience. But the artist may choose his objects, as Baugin does here, to bring into play other senses and associations. The lute and musical score suggest music to the ear, the carnations fragrance to the nose. The bread and wine bring flavors of the palate to mind, the velvet coin purse and playing cards recall the soft and smooth textures that we feel with our fingers, while the chessboard and mirror pertain to sight.

After we look at this picture, one by one our other senses—hearing, smell, taste, and touch—are awakened in a kind of chain reaction. Furthermore, the placement of the objects on a marble table in a corner against a stone wall defines and limits the expanse of space, while the inclusion of the musical score and the lute suggests the flow of time. Beyond their literal forms and shapes, however, the objects become symbols: the mirror stands for sight, the lute for sound, the carnations for smell, the bread for taste, and the playing cards for touch. These symbols extend the meaning so

that the picture becomes an allegory of the five senses as it enlists both thoughts and feelings.

The painting rises to still another metaphorical or metaphysical level. The bread and wine as the staff of life have a religious dimension, as a reference to the communion service. The chessboard, besides its visual reference, suggests a play of the intellect. The lute, besides its purely musical associations in 17th-century imagery, also denotes lyric poetry and the flow of time while the mirror, purse, and playing cards refer to worldly vanities.

Such a painting concerns the quieter, more contemplative side of human nature. But artists are also concerned with the more active aspects. In architecture kinesthesis, that sense of bodily motion, is ever-present in building design. Far from being mere assemblages of bricks and mortar, steel and glass, every building comes to life with the human activities it was designed to house. I like to think of architects as choreographers who plan their structures so that all who enter must perform a ballet dance as they enter and exit, move along corridors, gather together in meeting rooms, and ascend and descend staircases. Such interrelationships can be seen in Balthasar Neumann's design for the bishop's palace in Würzburg, West Germany (Figure 9). Its illusionistic ceiling mural by Tiepolo depicts the apotheosis of the bishop among the Olympian deities and personifications of the four corners of the world. As they ascend the stairs, visitors feel that they are rising heavenward. And from the reception and ballroom below, their princely hosts would seem to be descending from empyrean heights as they came down to greet their guests.

The work of Gianlorenzo Bernini also well illustrates kinesthesis. Sculpture is usually considered a static medium suitable for quiet, dignified monuments. Bernini, however, brought vibrant life and dynamic action into the designs of his Roman fountains where the splash and flow of the water as well as the fluid postures of the river gods become an essential part of the design. In his *Apollo and Daphne* (Figure 10), the material medium is, of course, a carved block of stone. Yet the artist compels us to feel a sense of rushing motion in the heat of the chase as Apollo, the patron of the arts, is pursuing beauty as personified by the nymph Daphne.

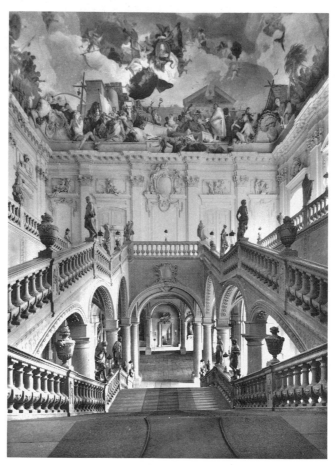

Figure 9. Balthasar Neumann. Staircase. Bishop's Residence, Würzburg, West Germany, 1765–86. Ceiling mural by G. B. Tiepolo, 1752–53. Courtesy of Deutscher Kuntsverlag, Munich.

In this transformation scene, just as Apollo is about to grasp this unattainable ideal, Daphne cries out for help and the gods turn her into a laurel tree. The laurel ever after was sacred to Apollo, and a crown of its leaves always symbolized the highest achievement in the arts. The laurel also reminds us that beauty is an ideal to be sought after and striven for, but not to be grasped and possessed. The contrasting textures of Daphne's soft, smooth flesh as it hardens into a tree, her toes taking root, the legs growing bark,

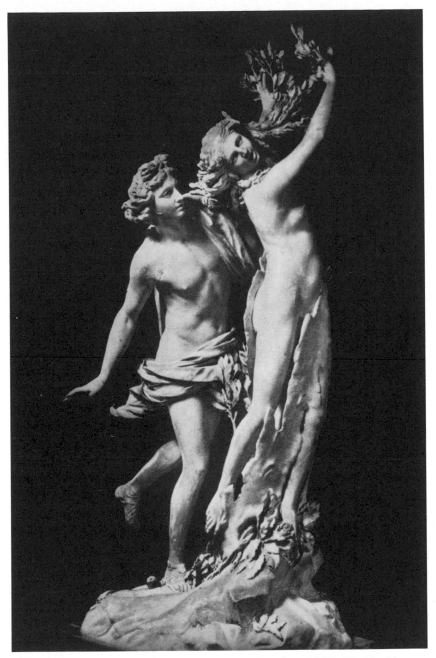

Figure 10. Gianlorenzo Bernini. *Apollo and Daphne*, 1622–25. Marble, lifesize. Galleria Borghese, Rome. By permission of Alinari/Art Resource, New York.

the delicate fingers turning into twigs and sprouting leaves, all make the conception and composition a tactile delight.

With synesthesia, one sense impression can conjure up that of another. Such synesthetic perception is quite common in the arts. Musicians, for instance, distinguish the timbres of various instruments according to their tone "colors," while painters describe their colors by differences in "tone." In paintings the tactile analogy of "warm" and "cool" colors is also frequently used. The American painter Whistler used synesthetic analogies in the titles for such pictures as *Harmony in Blue and Silver,* and *Nocturne in Blue and Gold* (see Plate I). In music, Franz Liszt wrote "symphonic poems," for works that contained some programmatic, poetic, narrative, or pictorial content. Debussy called one of his piano pieces *Sounds and Perfumes on the Evening Air.* Sounds, of course, are heard, but perfume suggests scent and the evening breeze refers to a tactile sensation denoting warmth or coolness. The symbolist poets of the late 19th century thoroughly explored synesthesia in which perfumes, colors, tones, and textures echoed each other. A masterpiece of interwoven sense data is found in a sonnet by Baudelaire called "Correspondences," which goes in part:

> Like those deep echoes that meet from afar
> In a dark and profound harmony,
> As vast as night and clarity,
> So perfumes, colors, tones answer each other.
>
> There are perfumes fresh as children's flesh,
> Soft as oboes, green as meadows,
> And others, tainted, rich, triumphant,
> Possessing the diffusion of infinite things,
> Like amber, musk, incense and aromatic balsam,
> Chanting the ecstasies of spirit and senses.[6]

And even more succinctly, Shakespeare said in one of his sonnets:

> O learn to read what silent love hath writ
> To hear with eyes belongs to love's fine wit.

In this delightful fusion or confusion of sensations, you can feel perfumes, smell oboes, hear colors, see sounds, read love, see with your ears, and hear with your eyes.

Sensory experience, then, is sifted through the imagination and transformed through recollection and memory to become the basis for art. So, as sensations move toward ideas, the mind takes over, demanding that things be put into perspective; fixed in time and place; have a beginning, a middle, and an end—all in the never-ending quest for clarity of expression.

Imagination, then, is the prime source of creative expression. The capacity to discipline the imagination and give form and substance to its products is one of the distinguishing characteristics of a successful creative artist or an intelligent and sensitive observer or listener. A writer's experience is depicted in figures of speech; a visual artist's, in pictures; a composer's, in musical forms; an engineer's, in inventions. Free imagination is fanciful and undirected; constructive imagination represents the artists' conscious efforts to create an imaginary product in order to let others see, hear, or feel the sensations and images the artists themselves experience.

The artistic imagination is thus concerned with the creation of fictitious characters, events, scenes, situations, and moods in such a way as to re-create artists' experiences in the minds and imaginations of viewers. In order to bridge the gap between minds, artists must fashion some vehicle—a poem, building, statue, mural, symphony—that will convey their ideas to their audience. In this way artists make their intuitions and emotions discernible to others.

Historical and Iconographic Dimensions

The arts always involve relationships with each other and with the civilizations from which they spring. A sculptured relief slab, for instance, is not an isolated work but part of a larger frieze. The frieze in turn is part of a temple or public building. The building is located in some relation to other buildings, and all are part of a city and larger cultural center.

Religious monuments in particular result from the collaboration of artists from many fields. Medieval cathedrals, for example, are collective outbursts of creative energy that involve the work of architects, stonemasons, sculptors, and glass painters. The breathtaking vaults, sculptured forms, and mysterious color harmonies of stained glass merge with choral chant and the sacred liturgy to form one grand architectonic design. These concerts of the arts apparently had their origin in primordial religious rites. Eventually these rituals developed into more stylized sacred liturgies and such art forms as the Greek drama and other sacred and secular pageants and ceremonies.

When viewing works of art divorced from their original settings in the neutral surroundings of a museum, it is important to recognize that many of these "art objects" were originally not thought of as works of art at all. A Greek temple or a Christian church was first conceived as the house of God, not as an architectural monument, as we see it now. Statues, altarpieces, and crucifixes were icons—images revealing the divine presence. In impersonal, unsanctified museum settings, viewers must through a creative act of the imagination supply the proper frame of reference.

The same is true of music. Knowledge of the architectural setting and particular occasion for which a piece of music was intended provides an important part of its meaning. Music designed to be performed in an opera house must necessarily be distinguished from that intended for a recital hall. Handel's oratorios, for instance, were written for large London theaters; Bach's preludes and fugues in the *Well-Tempered Clavier* and his solo violin and cello sonatas were intended for home performance with an audience of one (the performer) or at the most the family circle or a few friends. His orchestral suites and *concerti grossi* were written for gatherings in palatial surroundings, while his cantatas and oratorios were to be performed in Protestant churches. None involved a concert hall as we know it today.

Collecting art both for personal enjoyment and public display goes back to remote antiquity. The first collectors were generally ambitious rulers who wanted to decorate their cities, temples, and palaces to add to their own glory and to impress friends and enemies with their might, wealth, and grandeur.

Making art accessible to people in general is also of ancient origin. The entranceway to the Acropolis in ancient Athens, for instance, was flanked by a gallery of fresco paintings on the left and an open sculpture court on the right, thus forming one of the earliest public museums, a temple of the Muses. Similarly, the Roman forums and bath complexes also functioned as museums where freestanding statuary, carved friezes, and battle trophies were exhibited. Christian churches and cathedrals were also museumlike structures where biblical stories, the lives of the saints, and the life and activities of the cities were depicted in brilliantly colored carvings and luminous glass paintings. Over the centuries, great private collections have gradually found their way into public museums. Museums today are the people's palaces that house our humanistic heritage and where the legacy of the centuries is now accessible to all. Art, theater, and music have become a new religious experience. The great cultural centers that are springing up in major cities all over the world are the temples and cathedrals of today.

The arts are always associated with the people and events that help bring them into being. Professional painters, for instance, produce their works for particular purposes and address them to social groups that presumably will understand at least a part of what they are trying to express and how they express it. Ready-made paintings that are bought "off the rack" in commercial art galleries are a fairly recent phenomenon. Up through the early 19th century, works of art were commissioned with a great deal of give and take between the artist and patron. And the status of the patron—king, churchman, aristocrat, city council, corporate board, member of the middle class—plays an important part in explaining the meaning of the work and the purpose it was designed to fulfill.

Social and political events often preside at the birth of great works of art. Unlike the goddess Athena to whom it was dedicated, the Parthenon did not spring fully clothed and armed from the creative mind of Zeus. The temple and its incomparable marble carvings could not have come into being without the wave of creative energy released in the wake of the Athenian victory over the Persian enemy, without Pericles' political decision to move the trea-

sury of the Delian League to Athens, and without the will to bury the old and build the new.

Medieval churches and cathedrals, with their magnificent mosaics, frescoes, statuary, and stained glass, could not have come into being without the support of abbots, bishops, and flocks of the faithful who had the vision to raise the funds for the materials, and the labor of the stonemasons and craftsmen who built and decorated these miracles of soaring stone. And more recently, the newly elected democratic government of Spain commissioned Pablo Picasso to create a large-scale mural for the Paris World Fair of 1937. During the Spanish Civil War the fascist powers had staged the first saturation air raid, which completely destroyed the historic city of Guernica. Picasso's masterpiece *Guernica* rose out of the ashes and horror, then shaped up as a dramatic protest against such wanton destruction. It has since become a symbolic document exposing the cruelties of war and man's inhumanity to man.

In approaching works of art, as with other human events, one always encounters the ubiquitous questions of who, when, where, how, what, and why. The *who* concerns the authorship, the patrons and other personalities involved in bringing the work of art into being. The *when* refers to dating problems and the circumstances of the time in which the work was produced. The *where* points to geography—the country, city, and social setting of the work. The *how* looks to technical considerations—the medium, materials, and the vehicle artists choose to convey their intentions. The *what* leads into the study of images, the subject matter, the story being told, the cast of characters who play their part in the verbal or visual drama in progress, all of which are grouped under the umbrella of *iconography*. The *why* has to do with the mysteries of motivation and meaning, myth, and metaphor, the reasons a particular subject or story is chosen, and the various philosophical questions of interpretation.

Spanning the centuries, what did the picture, statue, or building mean to the people who produced it? And what does it mean to us today? Whether it is ten years or a thousand years old, the temporal, geographical, and social circumstances of its original creation must be considered in order to gain a deeper understanding of the work itself. This brings us to still another dimension of

creativity in the experience of history. The quest is to discover the past and relate it to the present by looking back to what happened there and then and re-creating it in the here and now. In this two-way process, the here and now expands to embrace and include the there and then. There is also the challenge to discover what the images in a picture meant in the symbolic and metaphorical sense to the people at the time the work was created, and how to interpret them for present-day audiences.

Such a challenge and historical situation can be found in the Venetian painter Veronese's great and festive picture, *The Marriage at Cana* (Figure 11). It is a colossal canvas, with dozens of life-sized figures depicting a sumptuous 16th-century wedding banquet with all the pageantry and merriment of a society noted for its hedonistic enjoyment of life. Originally it was commissioned for the refectory wall of the monastery of San Giorgio Maggiore in Venice. The worldliness and luxury shown may seem out of place in monastic surroundings, and indeed Veronese was called before the church authorities and subsequently tried before the dreaded Inquisition because of a similar painting. Venetian monasteries, however, were a special situation where striving for wealth and prosperity permeated every aspect of city life.

The very dimensions of Veronese's painting command attention. It now occupies one wall of the great Italian Room of the Louvre in Paris, having been captured as a trophy of war in Napoleonic days. It spreads some 22 feet in height and over 32 feet in width. Since it was finished in 1562, more than 400 years have elapsed. Today, as we look at it with 20th-century eyes, an act of the imagination is required to bridge the historical gap.

It is a complete picture in that it compounds all the major categories of painting—history, portraiture, still life, landscape, and genre subjects. From the title and subject, we know it is in the grand tradition of history painting. Jesus and Mary occupy the central position, and the moment is that of Christ's first miracle, where he changes the water into wine. The large gathering of guests at the wedding party makes the picture into a group portrait, consisting of figures from the European aristocratic world and notables of the Venetian republic. Seated at the left as groom and bride are Alphonso d'Avilos, a Spanish grandee and a repre-

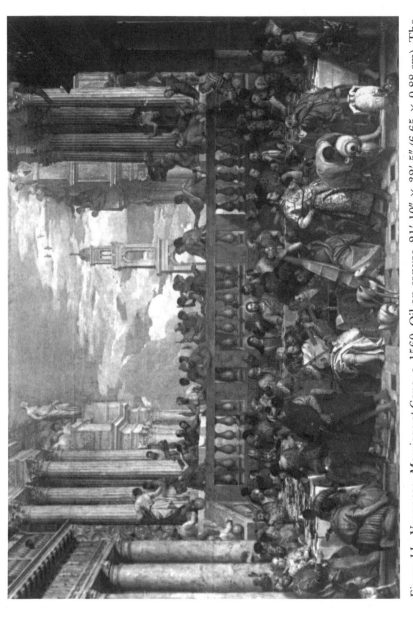

Figure 11. Veronese. *Marriage at Cana,* c. 1560. Oil on canvas, 21' 10" × 32' 5" (6.65 × 9.88 cm). The Louvre, Paris. By permission of Scala/Art Resource, New York.

sentative in Italy of the Spanish crown, and Eleanor of Toledo, sister to Philip II of Spain and Grand Duchess of Tuscany. Farther along one can discern Queen Mary Tudor of England and turbaned Suleiman the Great, Sultan of Turkey. On the right side are various highly placed Venetian citizens. As for still life, an abundance of details fulfill Veronese's express intent of making his pictures a feast for the eye. You can see the elegant Venetian glassware, the polished metal plates and brass jars, the rich food and elegantly set table. All lend an air of sumptuousness. Instead of a landscape setting, there is a fine cityscape in the background with opulent buildings in the Palladian style and a spacious skyscape. The informal everyday atmosphere of genre painting prevails with butchers carving meat, waiters bustling to and fro, and people conversing. So *Marriage at Cana* is a complete picture with something to appeal to all tastes.

High art, however, can go far beyond this surface play of the visual and tactile and engage the mind with what Bernard Berenson called "ideated sensations" while probing for deeper meanings. As Veronese's picture demonstrates, it is possible to rise from the level of sensory experience to the world of ideas, from the descriptive to the metaphysical, from the literal to the allegorical, from the concrete to the abstract, and from the earthly to the spiritual realm. On this plane, as my interpretation will demonstrate, the *Marriage at Cana* becomes an allegory of time with philosophical and religious overtones.[7] The key lies in the group of musicians who occupy the prominent position around the table in the foreground center (Figure 12). All the figures represent outstanding Venetian painters of the mid-16th century. Highlighted in the center, occupying the most prominent place in the picture, is the artist himself in a gleaming cream-colored damask robe. His brother Benedetto, who worked in Veronese's studio and did the architectural and sky details here, is portrayed on the right as the wine steward. At the table again, in the rich red robe, is Titian, Veronese's older and revered colleague, playing the bass viol. The boy beside him playing the violin was one of his painter-assistants. Veronese and his colleague Tintoretto are shown with the violas. In addition to this quartet of strings is a flute player who is thought

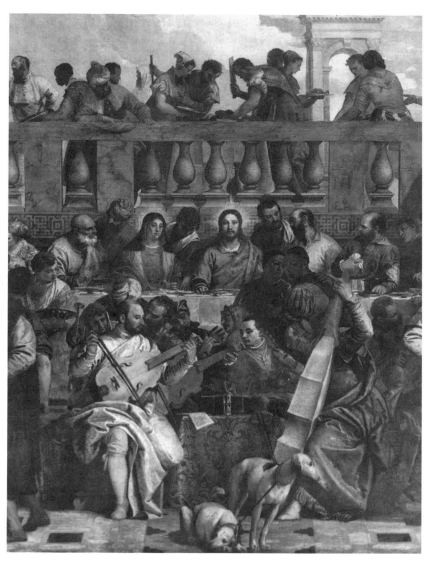

Figure 12. Veronese. *Marriage at Cana,* detail, center figures.

to be Jacopo Bassano, still another member of the painterly con-
fraternity.

Since artists occupied a comparatively high social position in
late Renaissance times, this musical *tableau vivant* can hardly be
taken literally. In Rome Michelangelo was known as Il Divo, the
divine. Leonardo da Vinci was the favorite courtier of the French

King Francis I, who gave him a castle with its revenues in return for the prestige of his presence at court. Titian was a suave and sought-after courtier who enjoyed titles and pensions from Emperor Charles V and King Philip II of Spain. Emperors, popes, and kings vied with each other for his pictures. Not likely then that Veronese would represent himself and his fellow artists as mere public entertainers.

To understand the more profound aspects of the picture, one must turn to the intellectual movement known as neoplatonism, a Renaissance interpretation of Plato's philosophy and his doctrine of forms. One of Plato's theories was that of the tripartite human soul—the appetitive, the emotional, and the rational—located in the abdomen, chest, and head respectively. Plato also divided human understanding into three stages—ignorance, opinion, and knowledge—and human life into youth, maturity, and old age. This neoplatonic theme of the three ages of man became the subject of many pictures of the time, among them two works by the earlier Venetian painter Giorgione.

Giorgione's *Concert* (Figure 13), a painting in which Titian is also thought to have had a hand, depicts three figures, each with a different attitude. At the left appears an elaborately costumed youth, possibly a singer, who seems to be unaware of the situation and concerned only with the vanities of life, thus personifying ignorance. Clothed in clerical garb, the philosophically minded older figure on the right seems to be pondering the eternal verities. He holds a cellolike instrument that corresponds to the bass viol Titian is playing in Veronese's picture. Meanwhile the more emotionally involved middle-aged figure is seated at the cembalo. His fingers play the mystic chord consisting of the three perfect intervals, the octave, fifth, and fourth. The allusion is to Plato's *Timaeus* where the deity creates the world on harmonic principles. By the study of philosophy and the sciences, Plato believed, the human soul could be attuned to the infinite and could aspire to hearing the music of the spheres. The implication is that the chord will fade out and die away, but the harmonic basis on which the Creator founded the universe will remain to hold human beings together, since humanity itself is a reflection of the world soul.

Figure 13. Giorgione (Titian?). *Concert,* c. 1506–1507. Oil on canvas, 42 × 48″ (109 × 123 cm). Courtsey of the Galleria Palatina, Florence.

Giorgione's *Three Philosophers* (Figure 14) is a variant on the same theme. The older figure on the right is pointing to a parchment with astronomical calculations, the younger seated figure on the left holds the tools of geometry and is measuring the earth, while the philosopher in the middle holds the knot of his belt in his hand to indicate his concern with tying together and harmonizing of these opposites—the earthly and divine.

In the *Marriage to Cana,* one can note the presence of a musical score on the table as well as an hourglass. Both refer to music as measured time. Still another one of the preoccupations of Renaissance thought was to make concordances of the Greek philosophical writings with the Scriptures. We turn to John, chapter 2:

And the third day there was a marriage in Cana of Galilee;
and the mother of Jesus was there:

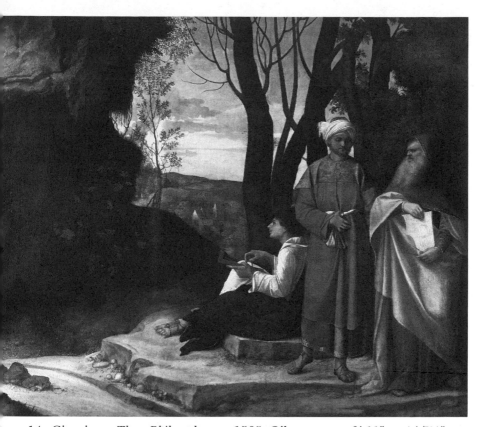

Figure 14. Giorgione. *Three Philosophers,* c. 1505. Oil on canvas, 3′ 11″ × 4′ 7½″ (1.19 × 1.41 m). By permission of the Kunsthistorisches Museum, Vienna.

> And both Jesus was called, and his disciples to the mar-
> riage.
> And when they wanted wine, the mother of Jesus saith
> unto him,
> They have no wine.
> Jesus saith unto her, Woman, what have I to do with thee?
> mine hour is not yet come.

Jesus, however, relents and complies. Thereupon the bridegroom is complimented on his wine: "Every man at the beginning doth set forth good wine; and when men have drunk well, then that which is worse: but thou hast kept the good wine until now." In

neoplatonic terms, this progress follows that of the soul from the lesser to the higher state. And this is the first of Christ's miracles, that of changing water into wine. The *Marriage at Cana* becomes the prophecy of that greater feast, the Last Supper, when he consecrates the wine as his blood, which is sacrificed for the salvation of the world. In this sense the picture becomes an allegory of time, which in turn alludes to Plato's conception of time as the moving image of eternity.

All these levels of meaning can coexist in a great work of art together with their reverberations and echoes down the corridors of time. And together they show how art, history, literature, theology, philosophy, and music interlock to complete ever-expanding meanings in the interpretation of art works.

A work of art, be it a picture, statue, poem, or play, reaches out to arrest the endless flow of time and experience so as to capture a particular moment, make a permanent record amid ceaseless change, and give form to a fragment of infinity. The artist thus does something to give permanence to the present, to make a link between past and future, to build a bridge between individual and universal experience. The broader and wider artists build their bridges into the infinity of the objective world, the more universal will be the values they express and the greater and more lasting the work of art.

So whatever means or methods are used in studying a work of art, there are two main directions to keep in mind. For scholarly purposes and formal analysis, it is always necessary to isolate, break down into component parts, examine in detail, and analyze. But for understanding, it is even more important to synthesize by assembling all the facts, putting two and two together, bringing data together, seeking relationships between one type of experience and another, interpreting and looking for meaning on as many levels as possible.

The humanistic adventure should aim to steer a steady course between the Scylla of specialization and the Charybdis of dilettantism, between the depths of knowing everything about nothing and the shallows of knowing nothing about everything. As Michelangelo remarked about sculpture: "The less of stone remains, the

more that grows."[8] And modern architects have echoed his words with the slogan: "The less is the greater." So, as with William Blake, the goal is to seek eternity in the single moment and the universe in a grain of sand.

Returning to the theme of creativity and the psychological mode of investigation, it is clear that the life of the mind includes much more than mere intellectual activity and the accumulation of factual data. The mind delves deeper into those regions where intuitions, emotions, passions, reveries, dreams, and creative drives hold sway. Facts, concepts, and ideas can be learned in classrooms and libraries, by group discussion and argumentation. But there is another world of percepts, feelings, and personal reactions where you are on your own. This is where creativity, imagination, and emotional involvement are to be found.

The searching eye and ear are the keys to vision. And vision implies not only the capacity to see, hear, and feel the world around us, but the sharpening of our sensitivities so as to envision the invisible, comprehend the incomprehensible, and understand the unintelligible. The adventurous creative life is lived in that no-man's land between instinct and thought, between feelings and concepts, between emotions and ideas, between shadow and light, between reverie and reason. The poet Carl Sandburg once posed the question: "What is this borderland of dream and logic, of fantasy and reason, where the roots and tentacles of mind and personality float and drift into the sudden shaping of a flash resulting in a scheme, a form, a design, an invention, a machine, an image, a song, a symphony, a drama, a poem?"[9]

Imagery and imagination, then, are the prime sources of creative expression. And the capacity to sensitize the perceptions and learn the subtle vocabularies of symbols and metaphors distinguishes the successful creative artist and the receptive observer, reader, and listener. Only through the processes of such creative thought and activity can the eyes, ears, and minds of artists and audiences become aware of the subtle visual, auditory, and verbal languages that make communication through the arts possible and meaningful.

There are whole worlds out there and inside yourself waiting to be explored and experienced. All you have to do is to reflect, reach out, and stop, look, and listen. It is all there in books and buildings, cities and museums. The pursuit of the essential human experience is the search for self-knowledge—yourself, myself, and ourselves. As the Delphic oracle once said to Socrates, "*Sophrosyne*"—know thyself.[10]

Music and Architecture:

The Analogous Mode

"ARCHITECTURE IS FROZEN MUSIC," as Friedrich von Schelling once observed. If so, then music becomes fluid architecture. Theoretically, both arts rest securely on the science of numbers—architecture as measured space, music as measured time. Throughout history there has always been an intimate and harmonious relationship between the two arts. Music's more flowing forms unfold in the time dimension, while architecture defines and articulates space. The picture, however, is not that simple. Music also has a spatial dimension because a performance always implies some architectural setting—a marketplace, temple, church, or hall. So social and acoustical factors must be taken into account. Likewise, architecture concerns itself with temporal considerations, because it provides the framework for human movement and accommodates the ongoing social activities of a given time and place. In the analogous mode, the two arts find a close relationship in their common mathematical and philosophical origins as well as in their practice over the centuries.

The art of drawing analogies between one phenomenon and another is one of probing for correspondences and relationships such as those that exist between the metrical patterns of poetry

and the rhythms of music, or the structural and compositional problems of painting and sculpture. This chapter will concentrate on the analogies between music and architecture, between visual and harmonic proportions. Such perceived relationships extend from ancient Greek times to the present. We shall also look at how composers took the architectural settings of their music into account in producing their works.

Analogies, Correspondences, Correlations

Medieval and Renaissance philosophers thought in terms of analogies, correspondences, and correlations, such as discovering parallels between the Old and New Testaments, between Judaism and Christianity, between Greco-Roman and European architecture, between art and music. In the High Renaissance, it was a case of reconciling the renewed interest in Plato with the older church-approved thought of Aristotle. This is the subject of Raphael's *School of Athens* (Figure 15, see also Plate II). It was painted for a room now called the Stanza della Segnatura. Originally it was to have been Pope Julius II's library. Accordingly, Raphael's commission called for each of the four walls to be decorated in accordance with the quadrapartite division of 16th-century knowledge into the faculties of Theology, Philosophy, Poetry, and Jurisprudence. Raphael's visual summas of each branch are the inspired result.

The magnificent and spacious temple Raphael raises to Philosophy in the *School of Athens* becomes the setting for a meeting of the greatest minds of all the ages from the most ancient to the then-modern. Raphael was familiar with a group of thinkers who believed that every proposition of Aristotle had its counterpart in one by Plato. Hence he divides his picture into two equal halves and places the presiding geniuses above on either side of the central axis. The cosmologists are on the left side under the patronage of Plato, who points skyward with one hand while holding the *Timaeus* in the other. On the right, the natural and social scientists appear under the aegis of Aristotle, who points symbolically earthward while grasping his *Nichomachean Ethics*. The philosophical discourse, then, is how to bring universal divine theories into harmony with particular earthly matters, how to relate the mansions

Figure 15. Raphael. *School of Athens*, 1501–11. Fresco, 18 × 26' (5.49 × 7.92 m). Stanza della Segnatura, Vatican Palace, Rome. By permission of Scala/Art Resource, New York.

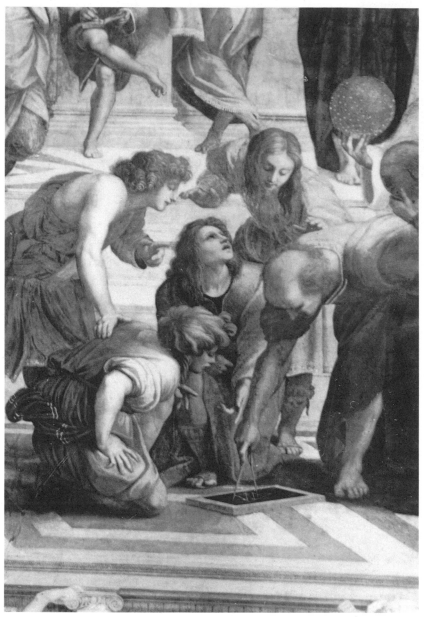

Figure 16. Raphael. *School of Athens,* detail, right foreground. Courtesy of the Vatican Photographic Archive.

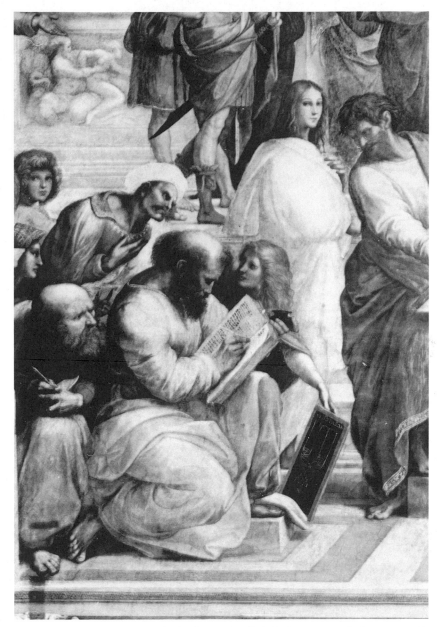

Figure 17. Raphael. *School of Athens*, detail, left foreground. Courtesy of the Vatican Photographic Archive.

of God and the architecture of man. The clue to the meaning of the picture is found on two slate tablets, one on either side.

Raphael depicts himself in the right foreground group, standing behind the crouching, bald figure of his kinsman and mentor, the Renaissance architect Bramante (Figure 16), who plays the role of the ancient geometer Euclid as he describes a theorem on a slate tablet. According to Vasari's biography, Bramante had a hand in the overall layout of Raphael's picture, and the two interlocking triangles drawn on the tablet have recently been shown to be the key to the schematic plan of the fresco's architectural framework.[1]

In the balancing group on the left, 6th-century B.C. philosopher Pythagoras is portrayed seated in a teaching attitude (Figure 17). Beside him is a young student holding up another slate tablet, this one containing a diagram demonstrating Pythagoras' momentous discovery of the mathematical ratios of musical sounds.[2] The drawing depicts the four strings of the lyre. The strings are divided into the ratios of 1:2 for the octave, 2:3 for the fifth, 3:4 for the fourth, plus the perfect number 10, which is the sum of the numbers that make up these close musical consonances. Peering over Pythagoras' shoulder is a figure who may be Terpander, the legendary founder of the Greek scale system. The pair of tablets, as well as the similar postures and concerns of the two balancing groups, invite the viewer to make a correspondence with one diagram referring to the earthly geometry of the picture itself, the other to the divine principle on which the universe is founded.

Still another parallel between music and architecture is seen in the use of the dignified Doric order of the architectural setting. Both Plato and Aristotle had expressed a preference for the Dorian mode in music by ruling out all other modes.[3] Bramante and Raphael then translated this preference into visual terms by endorsing the Doric order in architecture for its strong and stately qualities. The point is fortified by the statue of Apollo in the left niche. The kithara, or lyre, was the instrument associated with Dorian music, while the ruder wind instruments, such as the aulos, were equated with the wilder, more enthusiastic, and even orgiastic expressions of the Phrygian mode. Only stringed instruments

and the rustic panpipes were allowed in Plato's perfect state, the latter only to keep the shepherds happy.

Cosmic and Terrestrial Concerns

The resolution of heavenly and earthly concerns, then, is to be found in the mathematical ratios that underlie the construction of the universe, as well as in the architectural environment that orders and organizes human affairs. So for further elucidation we turn to the *Timaeus*, Plato's "Book of Genesis." Plato was a member of the Pythagorean brotherhood, and Pythagoras' staggering discovery that such a seemingly inanimate thing as a vibrating string or a column of air could respond to exact mathematical ratios literally revolutionized Greco-Roman thought and continued as a central idea right through the medieval and Renaissance periods. The Greeks held that it was the very key to understanding the universe. It was, in fact, as world shaking to the ancients as the theory of relativity and quantum physics has been to the 20th century. The bond between mathematical and musical thought even carries over into the present time. The mathematician Henri Poincaré, for instance, speaks of "the feeling of mathematical beauty, of the harmony of numbers, of forms, of geometrical elegance."[4]

God, according to Plato, found the whole visible sphere moving in irregular and disorderly fashion, so out of this chaos he brought order and endowed it with soul and intelligence. Then the Creator took the whole universe and divided it into parts: first, he took away one part of the whole and separated a second part, which was double the first in the ratio of one to two; then he separated a third part, which was half as much again as the second, according to the ratio of two to three; then he took a fourth part, which was twice as much as the second, or three to four. Further smaller divisions corresponded to the whole and half tones that make up the seven notes of the diatonic scale. All was according to the Pythagorean proportions of the octave, fifth, fourth, and the intervals of the diatonic scale. Next, around the universal sphere, the Creator placed the planets in their circular orbits. Three—Sun, Mercury, and Venus—"he made to move with equal swiftness, and the

remaining four (Moon, Saturn, Mars, Jupiter) to move with un-equal swiftness to the three and to one another, but in due pro-portion." And as the planets described their orbits, they were thought to create cosmic music.[5]

This doctrine was current throughout the Middle Ages and into the Renaissance, right through to the researches of Galileo[6] and Kepler,[7] who held that the planets literally created a music of the spheres in a kind of sonic counterpoint to the laws of planetary motion. The theory persisted as long as the planets were consid-ered to revolve in perfect circular orbits. But when later astrono-mers confirmed the Copernican theory of the sun-centered uni-verse with the planets describing elliptical orbits, the Pythagorean theory of the music of the spheres was scientifically disproved. Ra-dio telescopes of the 20th century, however, have revealed that the planets and stars do indeed emit sounds of varying frequencies; but alas, the cosmic music is only static. The idea, however, has echoed down the corridors of time in poetry. As Shakespeare has so movingly written:

> . . . look, how the floor of heaven
> Is thick inlaid with patines of bright gold:
> There's not the smallest orb which thou behold'st
> But in his motion like an angel sings,
> Still quiring to the young-eyed cherubins:
> Such harmony is in immortal souls;
> But whilst this muddy vesture of decay
> Doth grossly close it in, we cannot hear it.[8]

Next in Plato's conception, God created the human soul as the mirror image of the universal soul. The soul, Plato theorizes, is three part in nature—the vegetative-appetitive, the willful-emo-tional, and the rational-intellective. Of these, only the intellective is capable of discerning and discovering the eternal verities—truth, goodness, and beauty. And only this part of the soul can aspire to immortality "by learning the harmonies and revolutions of the universe."

Greco-Roman Temples

With God as the master builder composing the universe according to musical and geometric laws, it followed that architecture, as the framework of man's activities and aspirations, must also mirror the cosmic order. The problem of building temples and churches was just how this was to be realized. Several ancient buildings will illustrate some of the solutions. In the temple precinct at ancient Agrigentum in Sicily, there are structures predating those in Athens. The Temple of the Olympian Zeus, once the largest and grandest of all Doric structures, dates from 480 B.C. It is now in ruins, but from its foundations and fragments archeologists have made reconstruction drawings.

The Greek temple, just like its Christian counterpart, was thought to be the deity's dwelling place. And since God built the universe on harmonic principles, it followed that human architecture should also mirror the cosmic order. The usual pattern for a Greek temple was a rectangular floor plan enclosing two squares with four, six, or eight columns for the front and rear porticos and double that number for the sides. These proportions yield the ration of 1:2, or the octave. The Temple of the Olympian Zeus (Figure 18), with a neat bit of symbolism, departed from the customary even-numbered porches by having seven front and rear columns as a tribute to the Lord of the Skies who presided over the seven celestial bodies and the seven notes of the diatonic scale. The design is completed with the double square of the interior cella, while the seven frontal and fourteen side pillars complete the octave of the universe.

The climax of the Doric building tradition took place in Athens in the 5th century B.C. There architects treated the strict mathematical ratios as a convenient point of departure so as to transform rigid geometrical proportions into more flexible, lifelike forms. The Parthenon and Theseum, for instance, have the usual even number of columns frontally, but they were lengthened longitudinally so that the proportions became 8:17 and 6:13 respectively. With the Parthenon the underlying decorative scheme is dominated by the ratio of 9:4. Many other subtleties are found in the

variations of the intercolumnar spacing, the entasis (gentle swelling or narrowing of the columns as they rise), and the avoidance everywhere of straight lines in favor of subtle curves. The whole structure then becomes resilient and elastic rather than merely mechanically and mathematically correct. In this way the Parthenon became an incomparable work of art instead of a cold geometrical abstraction.

The Roman Pantheon (Figure 19) was commissioned by the Emperor Hadrian about A.D. 120 to replace an earlier building on the same site. Hadrian, who was educated in Greece, is thought to have taken part in its proportions and design. The building is dedicated only to the planetary deities, not to all the gods as its name might imply, and their statues occupied the seven niches in its resplendent interior, thus mirroring the cosmic order. Appropriately, its geometry is based on the conjunction of the circle, cylinder, and sphere. As shown in the drawing (Figure 20), the floorplan is circular, with a diameter of about 144 feet. Its height is exactly the same, thus creating the closest of all harmonic proportions, 1:1, or the unison in music. The dome is an exact hemisphere, which, if completed, would precisely fit into the allotted interior space. The horizontal axis in relation to the vertical height

Figure 18. Temple of Olympian Zeus, 5th century B.C. Agrigentum, floor plan.

Figure 19. Pantheon, Rome, c. A.D. 120. Height of portico 59′ (17.98 m).
Courtesy of Gabinetto Fotografico Nazionale, Rome.

could also be interpreted as the octave of the universe, while the
seven planets sing from their seven altars in the resplendent inte-
rior their heavenly diatonic chorus (Figure 21). The whole concep-
tion is truly a miracle of symmetry and harmony.

The Greek 5th-century B.C. sculptor Polyclitus is credited with
having been the first to formulate a rational theory of proportions
for the human body. It was based on a system in which all parts
become multiples or fractions of a basic common measure, the
module. His long-lost book was known to the Roman architect Vi-
truvius, who wrote that the beauty of the human figure consists
"in the proportions, not of the elements but of the parts, that is to
say, of finger to finger, and all the fingers to the palm and wrist,
and of these to the forearm, and of the forearm to the upper arm,
and of all the parts to each other, as they are set forth in the Canon
of Polyclitus."[10] According to Vitruvius, the head would be one-
eighth of the total height, thus indicating the octave relationship
of the musical intervals. The forearm would be one-quarter of the
height, and so on. In his adaptation, Vitruvius took the perfect

geometrical forms of the circle and square as the framework for the human figure and demonstrated the relationship. The drawing here (Figure 22) is by Leonardo da Vinci after the theories of Vitruvius, who considered the diagram of a man in a circle to be the image of the world order. And both hark back to Plato's *Timaeus,* where the cosmic soul is the macrocosm of the universe and the human soul is the microcosm.

Turning once more to the poets, John Dryden's "Ode for St. Cecilia's Day" echoes this idea:

> From harmony to heavenly harmony
> This universal frame began;
> From harmony to harmony
> Thro' all the compass of the notes it ran,
> The diapason [octave] closing full in man.

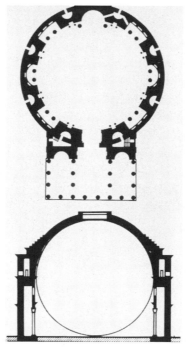

Figure 20. Pantheon, Rome.
Floor plan and cross-section.

Figure 21. Giovanni Paolo Pannini. *Interior of the Pantheon,* c. 1740. Oil on canvas, 4′ 2½″ × 3′ 3″ (1.28 × .99 m). Courtesy of the National Gallery of Art, Washington, D.C. Samuel H. Kress Collection.

Figure 22. Leonardo da Vinci. *Study of Human Proportions according to Vitruvius,* c. 1485–90. Pen and ink, 13½ × 9¾″ (34.29 × 24.77 cm). Courtesy of the Galleria dell'Accademia, Venice.

Medieval Continuations

Plato's theory of the correspondence between musical harmony and visual proportions was kept alive in early Christian times by both St. Augustine and Boethius. In *De musica* Augustine writes that both architecture and music are the children of numbers and that architecture is the mirror of cosmic harmony, while the tonal art is the echo of the music of the spheres. Boethius' *De musica* contained simular arguments. These two books, together with parts of Plato's *Timaeus,* were widely circulated and studied in medieval monasteries and universities. They had great influence on architectural thought in the Middle Ages, a time when the series of the first four whole numbers played a major role. Ever since

antiquity, uneven numbers were considered male and even numbers female. The number one was the symbol of the progenitive force and creative principle, and the number two was the female equivalent. Both joined together to form the first whole or complete number, three. According to the Renaissance theorist Francesco Giorgi, three was the first and divine whole number, because it contains the beginning, middle, and end.[11] Three is also associated with Plato's trinity of truth, goodness, and beauty. Of course, its Christian trinitarian symbolism is obvious. It also referred to the three parts of creation—hell below, the earth, and the heavens above.

Further medieval speculations dwelt on the first four digits in respect to their sequential order, their sums and multiplications, as well as their ratios with each other. The ratios of 1:2:3, for example, point to the octave plus a fifth, while the progression 1:2:4 equals the double octave. In medieval numerology, the number three stands for the spirit, while four points to the material elements of fire, air, earth, and water that compose the universe. When these are added together, the number seven signifies man who has both soul and body. Seven also symbolizes the divisions of medieval knowledge into the trivium and quadrivium of the liberal arts. The product of three and four points to the twelve apostles, while the numbers three, six, and nine are associated with the Virgin Mary.

In the ground plan and elevation of a fully developed Gothic cathedral as at Chartres (Figures 23, 24) the number three is found everywhere. The façade has triple entrance portals that correspond with the interior spatial divisions into the two side aisles and central nave. Vertically, the façade rises in three levels from that of the doorways through an intermediate story to the bell towers. In the interior, there are three rising levels, beginning with the nave arcade and ascending through the triforium space to the windows of the clerestory, which, in turn, usually has two lancets and one rose window. Horizontally, the groundspace is divided into the nave, transepts, and choir sections. In philosophy, medieval encyclopedias or mirrors of knowledge and summas were also divided into three parts. In music, the triple or ternary rhythm was considered to be the *tempus perfectus* because of its trinitarian

CHARTRES CATHEDRAL.

T. TOWER ABOVE

0 50 100 1
SCALE OF ⌐ FEI

Figure 23. Chartres Cathedral, 1194–1260. Floor plan.

symbolism, in contrast to the more worldly duple meter with its two-step, marchlike progress.[12]

At Chartres, which is dedicated to Mary, these numbers play an important role. Six, for instance, was seen as the first perfect number because the factors (1, 2, and 3) by which it can be divided add up to the number itself. In the floor of the Chartres nave near the crossing, there is a mysterious maze with a six-petaled rose at its center. The rose is also a Marian symbol. Also, the center of the ground plan at the crossing of the nave and transepts is a hexagon whose shape encompasses a circle, any radius of which is equal to one of the hexagonal sides. Dante stated that the number nine stood for the Virgin, because she is the square of the trinity. The original plan of Chartres called for nine towers. These numbers were also liberally incorporated in one way or another with the rhythmic beat and mensuration, the textures and forms of the musical compositions of the period.

The cathedral-like structure of Dante's *Divine Comedy* is also built on the symbolism of the number three. The rhyming scheme is the lilting *terza rima* (a b a, b c b, and so on). Each stanza consists of three verses; in three incidents Dante is frightened by three animals; each time he is rescued by three holy women; and he is piloted in his progress by three guides. The whole poem is divided

Figure 24. Chartres Cathedral, 1194–1260. Elevation.

into three parts—Hell, Purgatory, and Paradise; each section contains 33 cantos, the number of Christ's years on earth; and, finally, the introductory canto added to the three times 33 others, brings the total to an even 100, a number that is complete and perfect.

Brunelleschi and Dufay

The crossing from mystical medieval symbolism into the clarity of Renaissance thought was heralded by Brunelleschi's great engineering achievement in the construction of the dome for the Florence Cathedral (Figure 25). The cathedral was dedicated to Santa Maria del Fiore, Holy Mary of the Flowers, in a grandiose ceremony on the Feast of the Annunciation, March 25, 1436, with Pope Eugene IV presiding. After noting the splendor of the bright-robed company of viol players and trumpeters, the perfume of the flowers and incense, an eyewitness wrote in appropriately flowerly language: "the whole space of the temple was filled with such choruses of harmony, and such a concert of divers instruments, that it seemed (not without reason) as though the symphonies and songs of the angels and of divine paradise had been sent forth from Heaven to whisper in our ears an unbelievable celestial sweetness." [13]

Figure 25. Filippo Brunelleschi. Dome. Florence Cathedral, 1420–36. Height 367' (111.86 m). By permission of Alinari/Art Resource, New York.

This description alluded to the text and performance of the dedicatory motet *Nuper rosarum flores* (Flowers of roses), which was written for this special occasion by the eminent Flemish composer Guillaume Dufay. In it, the architecture of Brunelleschi's dome finds its exact musical counterpart. The text goes in part: "Recently blooms of roses, Gift of Pope Eugene" (actually it was a gold altarpiece with a rose motif), and references are made to "this mighty temple, a marvel of art" and to the "prayers of the people of Florence."

Brunelleschi and Dufay were the most important and progressive representatives of their crafts in the first half of the 15th century. Both were liberally educated. Brunelleschi's first biographer Gianozzo Manetti states specifically that he had studied Vitruvius and that he thought in terms of the ancient musical proportions. Both the dome and motet were constructed by late medieval methods, in one case by Gothic vaults, in the other by isorhythmic symmetries incorporating strict rhythmic progressions and formal

proportions. In such isorhythmic motets, the various sections are unified by the identity of the underlying rhythmic relationships but not necessarily by the same melodic patterns. Before Dufay's time, this music was never intended primarily to please the ear or stir the emotions, but more to mirror the hidden harmonies of the universe and thus to constitute a worthy offering to the ear and mind of its Creator. In Dufay's conception, however, the universe is no mere empty structure but is populated with shapely melodies, warm harmonic textures, and a rich variety of rhythmic forms. His special contribution was in clothing the austere skeletal structure of such a composition with smooth melodic lines and a fluency of sound that made it a joy to the ear as well as to the mind.

In a perceptive study, Charles Warren has demonstrated how both the dome and motet have the same modular scheme.[14] Brunelleschi took the preexisting octagonal base, a yawning chasm some 140 feet wide, and described a square inside to derive the basic module, so that the dimensions can be reduced precisely to the ratios of 6:4:2:3. Note the symbolism of the numbers. The first two, 6:4, can be reduced to 3:2, and the last two are 2:3. Both then are based on the interval of the fifth.

The cupola has two shells, an inner and outer, separated by intervening space. This, as Brunelleschi commented, was to allow for the outer visible shell to "vault it in a more magnificent and swelling form"—*piu magnifica e gonfiata*. This double dome arrangement is closely paralleled by the double tenor voices that constitute the two lower parts of Dufay's four-part motet. The word *tenor* (from the Latin *tenere*, "to hold") refers here to the parts that sing the same basic *cantus firmus* a fifth apart. The overall effect is to amplify the sonority to reflect Brunelleschi's "more magnificent and swelling form." The mensurations of the two tenors are the counterpart of the thickness of the two cupolas in the proportion of 2:3, while the upper two parts of Dufay's motet move freely in musical space. Thus the architectural concepts of Brunelleschi, the acoustical properties of his awesome dome, and the pattern of Dufay's motet combine to move away from Gothic rigidity and angularity and cross the bridge into Renaissance smoothness and symmetry.

The analogy that Renaissance theorists made between audible and visual proportions became an undercurrent throughout their designs. It fortified their deep conviction that architecture should reflect the harmonic-mathematical structure of all creation. Music also had a strong appeal to Renaissance artists; its theoretical aspects had always been considered as a mathematical science and, as such, it had been studied both in antiquity and in the quadrivium of medieval universities.

These proportions can be seen much more clearly in Brunelleschi's Pazzi chapel (Figure 26). Here, unlike the situation with the Florence Cathedral, he had complete control of the entire design. In the floor plan (Figure 27), it can be seen that the central axis is based on three circles that stand for the domed spaces above. The relationship of the two smaller circles to the larger one is in the

Figure 26. Filippo Brunelleschi. Façade, Pazzi Chapel. Cloister of Church of Santa Croce, Florence, c. 1429–33. Courtesy of Gabinetto Fotografico Nazionale, Florence.

Figure 27. Pazzi Chapel, floor plan.

ratio of 2:1. In the same way the two smaller squares above form an octaval relationship to the large square surrounding the central dome.

That Florentine universal man, Leone Battista Alberti, also cites the ancients for his authority on harmonic proportions. As he expresses it in his book on architecture: "the numbers by means of which the agreement of sounds affect our ears with delight, are the very same which please our eyes and minds . . . We shall therefore borrow all our rules for harmonic relations from the musicians to whom this kind of number is extremely well known."[15] In his geometry, Alberti prefers the perfect Euclidian forms of the circle and square. In the façade he designed for the church of Santa Maria Novella about 1456 (Figure 28), he was confronted with a problem similar to Brunelleschi's—that of fitting a Renaissance façade onto a medieval church.

Dating from the mid-1450s, all Alberti's new features—columns, scrolls, pediment, two-story arrangement—would seem to be isolated and unrelated were it not for the all-pervasive harmony of his unifying system of proportions. According to Alberti in his

Figure 28. Leone Battista Alberti. Santa Maria Novella, façade, c. 1456. Schematic drawings.

book *De re aedificatoria,* these proportions are simplicity itself—1:1, 1:2, 1:3, 2:3, and 3:4.[16] In musical terms these would be the unison, octave, fifth, and fourth. From the lefthand drawing it can be seen that the whole façade fits into a perfect square. The lower story is then divided into two equal squares, while the upper story has one single square, thus sounding the octave. The width of the lower story is also twice that of the upper, thus repeating the octaval relationship. On the righthand side it can be seen that the center section of the upper story is a perfect square, which is then divided into two equal rectangles. Also, the height of the entrance portal is one and one-half times its width, thus creating the relationship of width to height in the ratio of 2:3, the musical interval of the fifth. On the upper story, the scrolls become the curvilinear diagonal of the squares. With this interplay of the musical intervals, this façade could even be played as a short musical composition dominated by octaves, fifths, and fourths. It would sound something like a brass fanfare, which would be quite appropriate for a processional entry through its portals.[17]

High Renaissance Practice

At the turn of the 16th century, in the period known as the High Renaissance, there was a renewed interest in the mathematical implications of music and the visual arts. This interest was apparent

in the thought and designs of the period's major figures—Leonardo, Michelangelo, Raphael, Bramante, and Giorgione—all of whom were practicing musicians or poets and the prototypes of the artist as intellectual. Leonardo, for instance, was first invited to go to Milan by Duke Ludovico Sforza as lutenist, singer, and courtier. In his letter of self-recommendation to the Duke, Leonardo listed his many accomplishments, and only as a passing note did he mention that "in painting I can do as well as any man." Giorgione and Bramante were also adept lutenists, while Bramante, Raphael, and most important of all Michelangelo qualified as poets and composers of sonnets. Each wanted to elevate the status of architecture, sculpture, and painting to an intellectual plane equal to that of music and poetry, and to place their practitioners on a higher social level.

Traditionally the trivium of the seven liberal arts encompassed the disciplines of logic, speech, and writing. The quadrivium embraced mathematics, geometry, astronomy, and music. A new school of theorists joined these High Renaissance artists in their efforts to raise the arts of architecture, sculpture, and painting to a plane equalling that of literature, mathematics, and music. Their authority was Alberti, who had emphasized the concordances of architectural and musical proportions. All, in turn, cited the ancient authority of Vitruvius.

It is well known that Leonardo da Vinci considered music the sister art of painting. To him, each conveyed the sense of harmony—one to the ear, the other to the eye. He also equated the diminishing progression of the musical intervals as they divide the octave into the fifth, fourth, down to the whole and half tones with the lessening of the size of objects as they recede from the picture plane.[18]

The mathematician Luca Pacioli's treatise *Divina Proportione*, with geometrical illustrations by his friend and colleague Leonardo, was published in Venice in 1509 but it was written in the main around 1499, when both men were at the court of Milan. Pacioli points out that just as music is based on numbers, so also is architecture. It depends on geometry for its designs and especially the "divine proportion" of the golden section.[19] In his zeal to champion the cause of the visual arts, he argues that the sense of

sight with the eye as the window of the soul is superior to that of hearing. His goal was to make music in architecture and poetry in painting.

With the architectural setting of Leonardo's *Last Supper* in mind, Pacioli argued that the visual arts, especially in respect to their employment of mathematical perspective, are just as much entitled to a place among the liberal arts as music. Note, for instance, the musico-mathematical byplay of space with the three windows at the back and the four rectangular side draperies in the ratio of 3:4. The number three also alludes to the Trinity, while four indicates the Gospels. The product of these numbers is twelve, referring to the apostles and the passage of time (divided into the hours of the day and night as well as the months of the year). More recently, Martin Kemp has demonstrated that Leonardo's design was based on a systematic grid of squares (*quadratura*). The twelve apostles are deployed in four groups of three, each expressing a different emotional reaction to the words of Jesus in the manner of a four-part polyphonic choir.[20] Moreover, Leonardo himself observed that "just as from many different voices joined together at one time a harmonious relationship develops," so also the various parts of a pictorial design can be united musically.[21]

Another influential volume, Francesco Colonna's *Hypnertomachia Poliphili,* was printed in Venice in 1499.[22] Both Colonna and Pacioli advised architects to adopt the methods of musicians. Just as a composer chooses the mode and measure (*intonazione* and *mensurata tempo*) of his work, so also should an architect establish a grid or system of squares (*quadraturate*) as the basis of his design, thus to harmonize the proportions in each case. Both authors go beyond Alberti by including the symbolism of the musical scales in architectural design. Colonna goes back to Greek antiquity, citing Plato and Aristotle who associated the Dorian, Lydian, Ionian, and Phrygian modes with their geographical and ethnic origins, as well as certain characteristics of their musical temperaments. Dorian music was then characterized as strong, martial, and masculine; Lydian and Ionian, by contrast, were soft and feminine; Phrygian was wild, frenzied, even orgiastic.

From this point, it was but a step to equate the musical modes with the orders of architecture, an idea that can also be traced back to Vitruvius. The Roman writer noted that each of the classical orders was to be used according to the particular deity to whom the temple was dedicated. Dorian was right for Jupiter, Mars, and Minerva; the more slender, delicate, and matronly Ionic for Juno, Venus, and Diana; the leafy Corinthian for Bacchus and Flora. Colonna goes a step further by pointing out that the musical modes are not only equated with the architectural orders themselves, but with all the expressive and decorative aspects of all parts of a building. Pacioli extends the analogy by moving it into the Christian sphere, making the modal association appropriate to particular saints and the building and decoration of their churches. Thus were the orders of architecture associated with the ideational and emotional characteristics of the musical modes; their geometrical proportions, derived from the Pythagorean intervals, were also linked.

Bramante, whom his contemporaries called the most musical of architects, knew the writings of Colonna, Pacioli, and especially Franchino Gaffurio, with whom he had collaborated in 1490 on the design for the *tiburio* of the Milan cathedral.[23] Gaffurio's synthesis of the classical orders with their parallel musical modes may well have influenced Bramante's choice of the simple Doric order for his gemlike Tempietto (Figure 29), built in the cloistered courtyard of the Roman church of San Pietro in Montorio. Here the Doric symbolized St. Peter's elemental strength, powerful faith, and patriarchal status. In its time, Bramante's Tempietto was considered to be an architectural manifesto for centrally planned churches under the unifying aspect of a dome. Bramante's structure is also thought to be a miniature model for his projected plan of the future St. Peter's Basilica. The use of the circular shape for sacred structures, preferred by Bramante and later by Andrea Palladio, can be traced back to antiquity. For the ancients the circle was the perfect geometrical form, because, like eternity, it has neither beginning nor end. Palladio, writing of the sphere, paraphrases Plato's description of creation by the deity: "wherefore he made the world in the form of a globe . . . having its extremes in

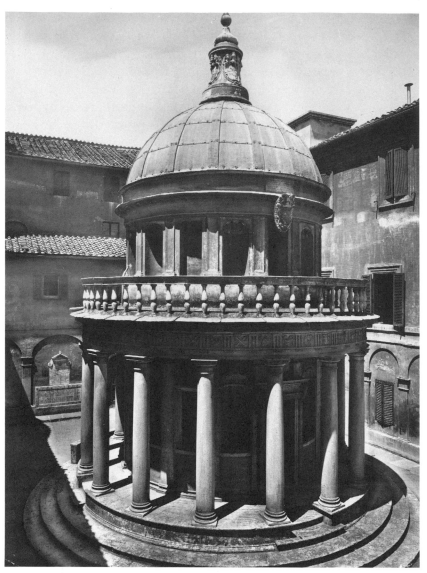

Figure 29. Donato Bramante. Tempietto. San Pietro in Montorio, Rome, 1504. Marble, height 46′ (14.02 m); diameter of colonnade 29′ (8.84 m). By permission of Alinari/Art Resource, New York.

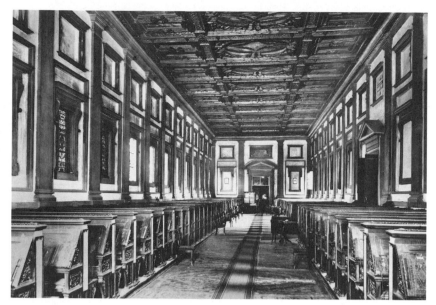

Figure 30. Michelangelo. Reading Room. Laurentian Library, Florence, 1524–44. By permission of Alinari/Art Resource, New York.

every direction equidistant from the centre, the most perfect and like itself of all figures."[24] The round Greek *tholos* was the traditional shape for ancient memorial buildings as it was for the circular Roman temples and tombs.

Michelangelo, who was one of Bramante's principal successors in building the new St. Peter's, used a complex set of harmonic proportions for the Laurentian Library in Florence (Figure 30), according to a recent study.[25] The measurements of the wall in relation to the width of the floor are in the ratio of 12:30, 17:30, 18:30, and 30:48. As expressed in musical intervals, these would be 2:5, or the major third; 8:15, the seventh; 3:5, the major sixth; and 5:8, the minor sixth. The entire height from the base of the brackets to the top of the arch yields the proportion of 5:10, the octave. The relation of width to height of the smaller upper windows is 4:5, the major third, while the ratio between the height of the inner and outer cornices is 3:5, the major sixth.

The High Renaissance use of musical proportions traveled to Spain with the work of Juan Bautista de Toledo and Juan de Her-

rera in their designs for Philip II's Escorial Palace (Figure 31). Toledo had worked with Palladio in Venice and with Michelangelo on the choir and dome of St. Peter's in Rome. Herrera, who qualified both as a mathematician and as an architect, was well acquainted with Renaissance thought on music theory and harmonic proportions. In his design for the façade of the Basilica of San Lorenzo el Real at the Escorial, he chose the sobriety of the Doric order and a complex system of arithmetic, geometric, and harmonic proportions.[26]

In northern Italy, Andrea Palladio was also a humanistic scholar, well read in the Greco-Roman classics. He published in 1544 a volume on the antiquities of Rome and another on Roman churches and shrines, all of which he had carefully studied at first hand. Both served as guide books to travelers for well over 200 years. His famous and widely read *Four Books on Architecture* (1570) encompass the whole field of the art of building. Finally in 1575 he put out a learned edition of Caesar's *Commentaries* with 41 original plates as illustrations. His knowledge thus ranged over the entire history of architecture as it was known in the 16th century.

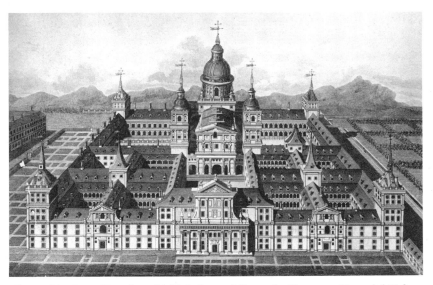

Figure 31. Juan Bautista de Toledo and Juan de Herrera. Escorial Palace, near Madrid, 1553–84. Engraving after Herrera. By permission of Hulton Picture Company/Bettmann Archive, New York.

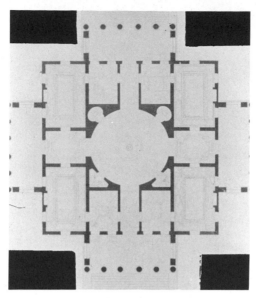

Figure 32. Andrea Palladio. Villa Rotonda, Vicenza, Italy, begun 1550. Floor plan.

The ancient doctrine of musical proportions also played a major role in Palladio's spatial thinking. The ground plan of his Villa Rotonda (Figure 32) is a marvel of geometric clarity, while its elevation reveals the symmetry of a cube crowned with a dome. Around the rotunda on the main floor are grouped the various reception rooms, with those on the corners measuring some 18 by 30 feet. Palladio insisted that the harmonic ratios be preserved not only in the length, width, and height of each single room, but also in the relationship of each room to the others. As he wrote: "in all fabrics it is requisite that their parts should correspond together, and have such proportions, that there may be none whereby the whole cannot be measured, and likewise all the other parts."[27]

Palladio was quite conversant with the works of the musical theorists of his day, especially with the ideas of his Venetian contemporary Gioseffe Zarlino, who synthesized all 16th-century musical knowledge in his famous compendium *Istitutione armoniche*, first published in Venice in 1558. Since this was the great age of counterpoint, Zarlino's system was based on the hexachord, or six-

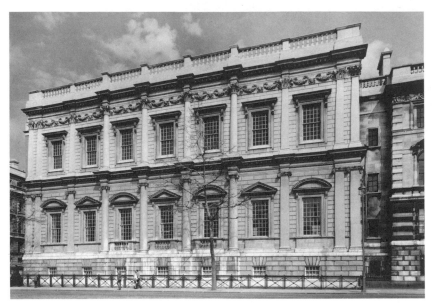

Figure 33. Inigo Jones. Banqueting House, Whitehall, London, 1619–22. Copyright by A. F. Kersting, London.

note scale from do to la. While Palladio discoursed on and designed rooms in the form of the circle and square, he showed a marked preference for rectangular shapes, especially those that measured 18 by 30 (both digits being divisible by 6) and 12 by 20 (both divisible by 4). In each case, the proportions yield the ratio of 3:5, or the major sixth. So in Palladio's thought the number six comes to the fore as his preferred module. If a room, for instance, is 6 feet wide (or some multiple thereof), its length would be double that number or 12, and its height would be the mean between, or 9 feet. "Such harmonies," he wrote, "usually please very much without anyone knowing why, apart from those that study their causes." [28]

Palladio's theories were introduced to England in the early 17th century with the work of the great architect Inigo Jones. Jones had traveled on the Continent, and in Venice he was struck by the lightning of Palladio's architectural ideas. He helped sponsor the first English translation of that master's *Four Books of Architecture,* which dealt with the theory and practice of architecture from the ancients to the then-modern era. In London Jones built the Ban-

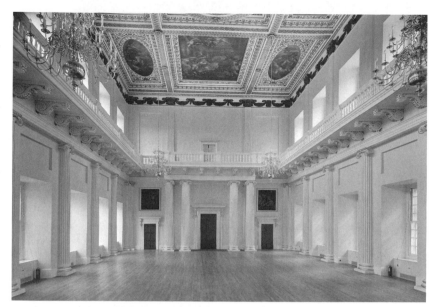

Figure 34. Inigo Jones. Banqueting House, Whitehall, London, 1619–22. Interior. Height 55′ (16.76 m), length 110′ (33.53 m), width 55′ (16.76 m). Ceiling paintings by Peter Paul Rubens, 1626–34. Copyright by A. F. Kersting, London.

queting House at Whitehall for King James I (Figure 33). It was originally intended as one unit of a large palace complex and government center. But the 17th century was a stormy time beset with civil war, so the Banqueting House was all that was ever built. Its geometry is based on the double cube, still another variation on the octaval relationship. The interior dimensions are 55 feet in width, 110 feet in length, and 55 feet in height, thus forming two equal cubes.

Major musical performances often took place in this harmonious room (Figure 34), with its ceiling paintings done in oil entirely by the hand of Peter Paul Rubens. Jacobean court masques were often performed here. These "compleat entertainments" included poetic readings, some spoken dialogue, solo singing, instrumental and choral interludes, plus some ballet sequences, all woven loosely around some mythological plot with topical allusions. At the end those guests still awake joined the participants in dancing and merrymaking to orchestral accompaniment. The music was

by the best composers available. Inigo Jones himself usually designed the elaborate and intricate "scenes and machines," and a masque at the end of Shakespeare's *The Tempest* was written for and first performed at the court of James I.

Another pertinent building is the Queen's House at Greenwich, part of which was built by Inigo Jones in 1635 for Henrietta Maria, the consort of Charles I. The two side wings were later additions, but Jones's center part is in the form of a single cube, which would correspond to the musical interval of the unison, since all the dimensions are multiples of the same basic measure or module.

Modern Echoes

Palladio's theories were later introduced into the United States by Thomas Jefferson, his foremost American admirer. The Rotunda at the University of Virginia is another adaptation of the Roman Pantheon, as seen through Palladio's eyes in the Villa Rotonda. Jefferson anonymously submitted a plan in the competition for the White House design that was also a variation on this theme.

In contemporary architecture, modular building according to ratios in which each part is either a fraction or multiple of the basic module has been revived. Le Corbusier, for instance, has used the average height of a human being with arms extended upward in designing apartment houses, such as his Unité d'Habitation complex in Marseilles (Figure 35). The module I. M. Pei used in the construction of the east wing for the National Gallery in Washington, D.C., derives from the trapezoidal shape of the building's site. Pei divided his space diagonally into two acute triangles corresponding to the dual function of the complex as a museum and research center and derived all the geometrical proportions from this basic modular scheme. Computer technology has greatly facilitated the complicated calculations needed for such modular building techniques.

Commenting on the proportions of some modern sculptures, Kenneth Clark called attention to the hidden "harmonies of humps and hollows" in the work of Henry Moore. Following this

Figure 35. Le Corbusier. *L'Unité d'Habitation,* Marseilles, 1947–52. Detail, Human Module.

lead, a recent study has shown that the proportions of width to height in Moore's *Vertebrae* in Seattle correspond to the golden section, whose ratio of 0.618 closely approximates that of the musical fifth of 2:3 or 0.666.[29]

In the postmodern phase of the late 20th-century, designers once more are concerning themselves with the creation of an architecture that approaches the conditions of music by moving away from static concepts toward dynamic directions. Recognizing anew the age-old idea that both architecture and music are governed by mathematics, these architects are once again applying the structural relationships of music to architecture. In this sense, architecture can be read. Since the reading process takes place in the time dimension, observing a building also unfolds in optical-

flow patterns as the observer takes in one angle and view after another. In this way the architectonic structure becomes a composition in motion. Such an architectural reading process allows the eye to encounter the elements of color, texture, dynamics, and visual ebb and flow just as the ear does with musical tone colors, textures, harmonic and contrapuntal densities, and dynamic swellings and subsidings. Architectural rhythms are perceived in repetitive patterns, as are textural values and linear directions. Time and space are thus experiences simultaneously as they are assimilated and synthesized in the mind's eye and ear. The psychological basis for such synthetic unifications lies, of course, in the experience of synaesthesia.

Also in the 20th century, the numerical basis of music itself has reasserted itself once again with the invention of electronic sound generated by synthesizers, a development that carries the art far beyond the limitations of the sonorities produced by traditional musical instruments. Computer technology has also led to the digital recording process by which sound waves are translated into their corresponding numerical equivalents.

In musical composition, the mathematical mode of construction is reflected in the rigorous manipulations of 12-tone serialism. The system first posits a complete row of 12 different notes, which can be played forward or backward, in inversion or retrograde inversion. The technique also permits the choice of parts of the row which can be used as motifs or modules for the various germinal elements of the composition. Beyond this point, the timbres or tone colors, the dynamics or varying volumes of sound, as well as the mensurated duration of the note values, all can be serialized according to number. Here also, the computer can be called upon to facilitate the compositional process.

Thus, the train of thought that began in ancient times with the Pythagorean discovery of the mathematical ratios of music, together with the relationships of music and architecture, has come full circle. The concordances of musical and visual proportions have once again come to the fore and are still a force to be reckoned with in the understanding and criticism of contemporary arts.

Music: Acoustical and Social Settings

To complete the picture, a look at the relationship of music and architecture from the musician's point of view is in order. Beyond the correspondences of musical and visual proportions, there are also the practical considerations of how music was originally designed for the particular architectural setting where it was to be performed. Composers who wrote for religious ceremonies were as sensitive to the acoustical aspects of the building where it was to be heard as they were to its appropriateness for divine worship.

In Gothic times, when Pérotin the Great conceived his grandiose vocal music for the Cathedral of Notre Dame in Paris, he took the reverberations of its vast vaulted surfaces into account. In such a Gothic edifice, the tones and overtones are enriched and prolonged as they echo through the cavernous interior spaces, and the sounds that precede mix with those that follow, so that the entire building resounds with their harmony. When performed elsewhere the empty fifth and octave intervals are open and exposed and thus seem barren and hollow in comparison. The unusual acoustical properties of St. Mark's in Venice provide another case in point, as they fostered the growth of an important musical style. This five-domed church has two organ lofts, one on each side of the chancel. Musical experimentation by choirmasters of the late Renaissance eventually led to the formation of the polychoral and concerting styles.

In the baroque period, a *sonata da chiesa,* or church sonata, was an instrumental work with slow movements of songlike or contemplative character alternating with faster-paced pieces of contrapuntal or fugal texture. By contrast, a *sonata da camera,* or chamber sonata, was more secular in spirit, with a series of dancelike movements suitable for social entertainments. In addition to church and chamber sonatas, concertos, and cantatas, various kinds of music have been designated as house music, or music for the home. Examples are keyboard music and vocal and instrumental solos and duets.

The Germans developed *tafelmusik,* table or dinner music, and *unterhaltungsmusik,* conversation or background music—the kind

that was played behind the potted palms in hotel lobbies by small ensembles before Musak was invented. Before the 19th century and the romantic period, music was not written for pure inspiration or for mere self-expression, but was ordered by a patron from a composer for a specific purpose. This adaptation of musical means to environmental ends was made by the composer, who had to take into consideration the size and purpose of the place where the music was to be heard as well as the number, specialization, and capabilities of the musicians who were to perform. Haydn's early symphonies, for instance, are stylistically distinguishable from the later ones in three ways: their dimensions (the size of the ensemble or orchestra as well as the length and complexity of the various movements), their instrumentation (the number of wind, brass, and percussion instruments), and their general character (whether the musical content explores the brighter, more external and extroverted sounds, or the more intimate, personal emotional spectrum).

When writing for a household orchestra in the Esterházy salon, Haydn had to tread lightly with his brass and kettledrums. But when he was composing for the large-scale Salomon Concerts in London, he could be much more expansive. Of Mozart's works in symphonic form, only the Prague Symphony (No. 38) and the great last three, including the famous G-minor No. 40, and the "Jupiter" No. 41 can be called symphonic in the public concert hall sense. The others are more suited to the small-scale salon. Beethoven, with a far wider choice of places for performance at his disposal, developed a correspondingly greater sensitivity to his architectural environment than did his Viennese predecessors. Composer Paul Hindemith has stated that Beethoven had the finest feeling for the proportional relationship between space and compositional technique. Today as we listen to music in surroundings far different from those conceived by the composer, we can enhance our musical experience by thinking about its original architectural surroundings.

Here is where knowledge and imagination must be summoned up to supply the frame of reference—the century, period, and style; the social, religious, or economic circumstances of the music's origin; the type of patronage; the social position of the com-

poser; and the architectural setting for which it was intended. Conjuring up these various adjuncts to listening is one of the paths to creative involvement in the musical process. In this way we can bridge the gap between the here and there, between the then and now. The "here," of course, is where the listening is being done; the "there" is the country, region, city, and place where the music originated. The "now" means that we are listening with late 20th-century ears; to get the fuller meaning we must try to project ourselves into the "then" of the appropriate historical period.

The electronic revolution of the 20th century, by which music has become so readily available via radio, television, recordings, and tapes, has turned every living room into a potential concert hall, opera house, and ballet theater. Until the advent of recorded sound, however, music was heard only in live performance, and the type and style of the composition was conditioned by and related to its appropriateness to the particular architectural and social situation. Commenting on the prevailing lack of knowledge about the specific purposes and places for which the music of the past was composed, the noted historian Alfred Einstein wrote: "How barbarous our concert life has become is shown principally by the fact that we no longer feel such distinctions."

As the confusion of form and function is so widespread, the only remedy is to make a conscious effort to conjure up the proper settings as part of the listening process. Thus, in any serious attempt to fathom the function music was designed to fulfill and to understand its fuller meaning, we must take into account its original social situation and architectural setting.

Our quest has led from the 6th century B.C. to the 20th century A.D., from Greek musical concepts to contemporary concerts, and from Pythagoras' mathematical proportions to Corbusier's modular building mode. Whether we think of architecture as frozen music or music as fluid architecture, an awareness of this harmonious complementary relationship will certainly contribute to a more complete understanding of both arts.

The Meaning of the Two Musical

Capitals at Cluny:

The Iconographical Mode

ICONOGRAPHY IS YET ANOTHER WAY of discovering how works of art are related both to one another and with other media of expression. As the study of images and imagery, iconography is concerned with the subject matter, content, and meaning of art works rather than with formal analysis or purely aesthetic considerations. Formalism always concentrates on elements within the work itself—textures, volumes, techniques, lines, colors, chiaroscuro, and composition. Iconography is the mode of finding a fuller meaning by looking beyond the surface for literary allusions, pictorial conventions, and representational traditions, all within a larger historical frame of reference. The search often leads into a shadowy world populated by symbols, metaphors, allegories, stories, themes, motifs, and ideas. The quest for wider meaning continues by delving into conventions, literary sources, and documents of a given time and place; into the religious, political, social, poetical, and philosophical climate of the period when the work was produced; as well as into the life, personality, and background of the artist in question.[1]

Iconographical Sources

Biblical and philosophical sources, for instance, came into play with the works illustrated in chapter 2. The first pair of paintings were on the theme of creation. For the meaning in both cases, there was no need to go further than the opening chapter of Genesis. The various objects in the Baugin still life depicted a range of sensory experiences that added up to an allegory of the five senses. The lute, as a musical instrument, became a metaphor for the passage of time, while all the objects signifying the good life recalled the words of the preacher of Ecclesiastes (1:1): "vanity of vanities; all is vanity." The objects in this context pointed to a 17th-century moralistic tradition of *memento mori*—reminders of the brevity of life and the imminence of death. Later on, in the analysis of Veronese's *Marriage at Cana*, it was noted that the hourglass and musical score indicate the passage of time, while the figures at the central table represent the neoplatonic idea of the three ages of man. Both tied in with Jesus' words on that occasion: "Mine hour is not yet come" (John 2:4). So in these cases the allusions were to be found in the Old and New Testaments and in the philosophy of the Platonists.

In the romantic period, when the arts were closely allied with literature, two novelists built themselves neo-Gothic castles. William Beckford's Fonthill Abbey was dubbed a Waverley novel in stone, while Horace Walpole's Strawberry Hill matched his famous *Castle of Otranto*, a story of Gothic horror and suspense. Eugène Delacroix's painting *Dante and Vergil in Hell* (see Plate IX) was taken from the eighth canto of Dante's *Inferno*, and his *Death of Sardanapalus* (see Plate X) came from Lord Byron's poetic tragedy. Music also had its iconographical sources with Hector Berlioz composing *Harold in Italy*, a symphonic work based on Byron's *Childe Harold*. Franz Liszt wrote symphonic poems such as *Les Préludes* inspired by Lamartine's verse, *Mazeppa* by Victor Hugo's ballad, and the *Faust Symphony* by Goethe's drama. More subtle examples of musical iconography can be discovered in Mozart's use of the trombone in the last act of *Don Giovanni* as an allusion to death and the Last Judgment, while a sly note on the horn in the *Marriage of Figaro*

becomes a playful reference to a cuckolded husband. To alert members of Mozart's audience, the meaning of the trombone and horn in such operatic situations would have been obvious. For the modern listener, however, these subtleties need to be pointed out and placed in their historical context for a full understanding of Mozart's instrumentation.

Architecture, like music, is mainly a nonrepresentational art. It can also be interpreted iconographically on the basis of certain designs and decorative motifs. The use of the classical orders, for instance, relate a building to the Dorian, Ionian, or Corinthian tradition, while the choice of decorative motifs can tend toward naturalism or stylization depending on the tenor of the times.

The preceding examples are all fairly clear, and their interpretations are hardly in dispute. In early medieval times, however, one encounters a tangled web of obscurities, ambiguities, and enigmas. The sculptured representations in Romanesque churches and monasteries depict some readily recognizable subjects, such as the journey of the three wise men, the flight into Egypt, and Moses on the mountain. Others, however, send the scholar scurrying beyond the scriptures into the highways and byways of then-contemporary sources such as bestiaries, etymologies, records of the lives of saints, and the like. One such source is found in the frequent diatribes against the art-loving Cluniac monks by St. Bernard of Clairvaux, the spokesman for the more austere Cistercian order. The fire and fury of his attack was ignited by what he considered the excessive profusion of subjects and figures drawn from surviving texts of pagan Greco-Roman writings. He thundered in one of his letters:

In the cloister under the eyes of the brethren who read there, what profit is there in those ridiculous monsters, in that marvellous and deformed beauty, in that beautiful deformity? To what purpose are all those unclean apes, those fierce lions, those monstrous centaurs, those half-men, those striped tigers, those fighting knights, those hunters winding their horns? . . . In short, so many and so marvellous are the varieties of shapes on every hand, that we are more tempted

to read in marble than in our books, and to spend whole days wondering at these things rather than meditating on the laws of God.[2]

And in a dialogue between a Cluniac and a Cistercian, Bernard also refers to the beauties of stained-glass windows, gold-embroidered vestments, jeweled chalices, and multicolored books, saying: "All these are not required for practical needs but for the concupiscence of the eyes."[3] Thus unwittingly, perhaps, does the dour saint provide posterity with a vivid account of life in a Cluniac cloister and furnish us with many clues to the imagery of the intricate carvings.

The way the mysterious medieval mind worked is revealed in one of the capitals at the abbey of Vézelay. It depicts a bearded figure pouring grain into a hand-turned mill while a barefooted man is gathering the flour into a sack with intense concentration (Figure 36). It would have to be interpreted as a genre scene from peasant life were it not for some lines penned by Abbot Suger of St. Denis after a visit to Cluny and Vézelay. Suger, the trusted confidant and advisor to a succession of French kings, wrote that the scene shows the old Hebraic law being poured into the mystic mill as it was ground into the meal of the new law by St. Paul:

By working the mill, thou, Paul takest
 flour out of the bran.
Thou makest known the inmost meaning
 of the law of Moses.
From so many grains is made the true
 bread without the bran,
Our and the angel's perpetual food.[4]

The Abbey at Cluny

In more obscure situations, the iconographical quest is similar to that of a detective in a mystery novel where the plot unfolds clue by clue until the full meaning is finally reached. Such a challenging and complex iconographical puzzle is found in the capitals

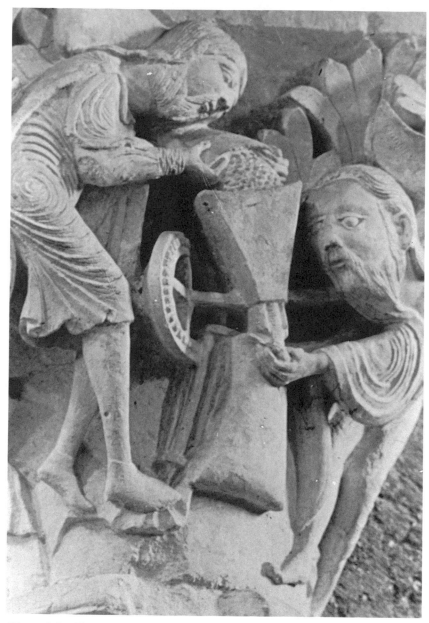

Figure 36. The Mystic Mill: Moses and St. Paul Grinding Corn. Nave Capital. Church of La Madeleine, Vézelay, France, c. 1130. Courtesy of the Archive Photographique, Paris.

surrounding the altar of the mother church of the Cluniac order. It is well known that the Burgundian abbey at Cluny was a major center of learning and that its monks had access to what is reputed to have been the finest monastic library in Christendom. The noted medieval scholar Joan Evans has described the profusion of sculptured capitals of this period as "illustrations of a great library of lost books."[5] The great third church at Cluny, dedicated to Sts. Peter and Paul, was once the largest and grandest in all Christendom, except for the old basilica of St. Peter in Rome itself. In French Revolutionary times, however, it was blown up in a wave of anticlerical fervor. Now only part of one transept is still standing (Figure 37), and only a few of the more than 1,200 sculptured capitals have survived. Among these are the mutilated remains of eight Romanesque capitals of the Corinthian type that once surrounded the high altar. Each was elaborately carved with four representations on each face, and they were placed so that the inscriptions could be read from the choir on the inner side and from the apsidal ambulatory on the other.

The dating of these capitals has been the subject of a lively debate. Stylists claim on aesthetic grounds that they belong to the early 12th century; historians argue on archeological grounds that they were carved in the late 11th century. The historians have pointed to the elegant workmanship of such mid-11th-century examples as the *Christ in Majesty* at the Rodez church and the Christ from the tympanum of Ste. Foy at Conques as confirmation of the presence of highly skilled craftsmen in central France at that time.[6] Surely then Hugh of Semur, the ambitious and intrepid abbot of the largest and richest monastic community in existence, could command the services of the finest craftsmen of his time. The eminent medieval archeologist Arthur Kingsley Porter placed the capitals sometime between the year 1088, when the great third church was consecrated, and before 1095, the year Pope Urban II dedicated the sanctuary. When the capitals were photographed in 1930, Kenneth Conant discovered that the sculptural hatching was carried over onto the tops of the blocks, proving that they were carved before being placed in the ambulatory arcade. He concluded that this is categorical evidence of Porter's dating.[7]

Figure 37. Third Abbey Church, Cluny, France. Surviving transept, 1088–1130. B
permission of Combier Imprimeur, Macon, France.

Medieval Maze

Now to set forth into the murky maze of medieval mysticism look-
ing for the light of logic to reveal a way out. Various iconographi-
cal interpretations of the overall sequence of the eight capitals
have been proposed. Emil Mâle, for instance, speculated that they
represent the seven liberal arts, with the two musical ones showing
the seven notes of the diatonic scale plus the final octave.[8] More
recent studies have attempted to find a common thread linking all
eight capitals to a single unified source.[9] Because extensive dam-
age rules out definite identification of so many of the mutilated
figures, all theories and solutions remain highly speculative. Yet
there is now general agreement that each of the choir capitals,
carved as they were with four faces, was based on one or another
of the medieval quaternities. Similar sculptures in other monaster-

ies of the Cluniac order support this belief. At Cluny itself, one Radulphus Glaber, a resident monk and chronicler, finished his set of five histories about the year 1047. The first volume dealt with the Creation and what he called the "divine and abstract" quaternities of the world. He noted that there were four rivers and trees of Paradise, four basic earthly elements, four periods of human history, four seasons of the year, four Gospels, and four Christian virtues. He then found many subtle and ingenious concordances between each and all of them. Among the quaternities portrayed on the extant Cluny choir capitals, there is one depicting the four rivers and trees of Paradise, another the four seasons, a third dealing with the four virtues (only two of which, Justice and Prudence, are recognizable), and the double pair on Music. The mystery and meaning of these two capitals has attracted the most attention and scholarly speculation.

In medieval thought numbers took on mystical significance, and the number eight was no exception. There were eight heavenly bodies known at the time, and the monastic day was divided by the observance of the eight divine offices. There were eight major feast days on the church calendar and eight beatitudes in Christ's Sermon on the Mount. In music the octave embraced the eight notes of the diatonic scale, the lyre had eight strings, and there were eight modes in the ancient Greek and medieval scale systems. The scales themselves were divisible into two tetrachords and the modes into quaternities called the authentic and plagal. The melodic intervals were also divided into quaternities of the perfect (the unison, octave, fifth, and fourth) and the imperfect (the second, third, sixth, and seventh). All these notions have played at least some peripheral part in the various attempts to solve the riddle.

The earliest study of the two musical capitals is by Abbé Poug-net, who built his theory on Pythagorean numerology, which he equated with the eight medieval modes.[10] He limited himself solely to the inscriptions and made no attempt to connect them with the visual representation. Later the Abbé Pouzet held that the eight inscriptions alluded to the octave of the universe, with each of the eight tones standing for one of the heavenly bodies. He saw the musicians as personifications of the eight tones of plainsong. The

first and second, he felt, expressed *monotonie en majeur et mineur* (uniformity in major and minor); the third, *l'élan passioné* (passionate ardor); the fourth, *tristesse* (sadness); the fifth, *la félicité suivie de la chute* (grace after sin); the sixth, *la grâce pieuse* (piousness); and the seventh and eighth, *solennité* (solemnity). His interpretation is so subjective that it reveals more of the venerable Abbé's personal emotions than of the generally accepted concepts of tonal ethos. Pouzet's other observations—such as, for example, the six strings representing the six sufferances of Christ on the cross as an explanation for the third tone—are equally farfetched and tenuous.[11]

Barbier de Montault then tried to connect the Cluny figures with the ethos of each of the eight modes as set forth in the *Micrologus* modes are far too varied and complex to permit us to assign a single mood or ethical principle to each one. Also, there is no general agreement among medieval theorists, who often contradict one another. Musicologist Leo Schrade expanded on this theory by seeking to connect the ethos implied in the inscriptions with the meaning of the sculptured figures. His method was first to find the sense of the mottoes from historical sources, then to analyze the carved figures and their instruments. Only when the verbal and visual aspects agreed, he thought, could an explanation be established. The common denominator, he felt, was to be discovered in Pythagorean number theory.[13]

The first carving as number one, Schrade states, represents the beginning, the progenitive source for all numbers and symbol of divine unity. The figure then symbolizes *nobilitas,* which is closely related to the ethos of the ancient Dorian mode. Schrade characterized the thoughtful expression of the young man as a *iuvenis morosus* (morose youth) which corresponds with the quality of *gravitas* (gravity) that Guido attributed to the medieval Dorian. By contrast, the second figure is of a woman, because two is the first feminine number. Schrade cites Guido's description of the second tone as proceeding by broken steps or leaps, which is substantiated by the merry mood of the dancing figure. It can also be noted here that the first inscription could indicate the Pythagorean interval of the unison, which fits with the motto. The second would then fit with the octave, an allusion to the ratio of 1:2. So far so good, but there is no further hint of Pythagoreanism in the third through

the eighth mottoes, and the second figure is the only one depicting a woman as a feminine number. Soon Schrade's sources begin to fail him. His inconsistencies outweigh his concordances, and his historical eclecticism ranges so far and wide in time and place that he sheds little light on the situation at Cluny in the 11th century.

New Light

The first successful bit of detective work can be credited to Joan Evans, who demonstrated a connection between the carved figures in the Cluny capitals and some manuscript illuminations in two 11th-century tonaries.[14] (Her theory has since been developed, expanded, and documented in studies by Kathi Meyer,[15] Tilman Seebass,[16] and Ruth Steiner.[17]) Such tonaries were practical guidebooks for choirmasters. In them are found the melodic formulas of plainsong grouped in eight different sections according to the medieval system of modes or scales. These incipits or intonations begin with the first words of a liturgical text as sung by the cantor or leader to set the mode before the full choir makes its entrance. Then come the psalm tones, antiphons, introits, responsories, and communion hymns, followed by the melodic terminal formulas.

Regino of Prüm, the author of a *tonarius* dating from the early 10th century, noted his reasons for compiling such a book in a letter addressed to his archbishop:

When frequently in the dioceses of your church, the choir singing the melody of the psalms resounded with voices in confusion because of disagreement of tone, and when I had seen your Reverence often disturbed by this sort of thing, I seized the Antiphonary; and, considering it diligently from beginning to end through the order, I distributed the antiphons which I found written in it accordingly, and I think, in their proper tones.[18]

Of the surviving tonaries of this period, two contain manuscript illuminations that show some striking resemblances to the figures depicted in the Cluny capitals.[19] Both come from monasteries of the Cluniac order and both date from the early 11th century. One

was produced at the Abbey of St. Martial at Limoges and is now in the Paris Bibliothèque Nationale. The other came from St. Etienne at Toulouse and is now in the British Library in London. In both, the sections devoted to the eight modes are illustrated with figures of minstrels and jongleurs. Three of the carvings at Cluny bear such striking similarities to these particular manuscript illuminations that it can be assumed that the Cluny sculptor used them, or a similar now-lost version, as the source material for his designs.

At first it may seem strange that images of popular entertainers should find a place in such serious manuscript studies and in sculptures for the most hallowed area surrounding the high altar. It must be borne in mind, however, that in all cloistered communities, prayer and praise were the central focus of monastic life. As such they were inseparably associated with the art of music. To the monks who sang the psalms and canticles so constantly, the musical experience was bound to be connected with the words, melodies, and modes chanted on particular feast days. Thus there were occasions for joy and sorrow, fasting and feasting, anticipation and fulfillment. At this time, however, the church sanctioned only solo and choral singing—despite the fact that the psalms and psalmody constituted a major part of the worship service and that, according to the scriptures, David and his friends sang while accompanying themselves on stringed instruments. Because of these restrictions, the search for models of musicians playing musical instruments could lead only to the popular music-making outside monastic walls. Hence the illuminated psalters of the time picture David and his friends as jongleurs and personified the modes of plainsong similarly. Since the mottoes for the modes in the tonaries were memory reminders for the choristers, the placement of the sculptured personifications and accompanying inscriptions in the choir at Cluny where they became a "tonary in stone" has a logic of its own. And the presence of jugglers and acrobats in sacred precincts? Even the redoubtable St. Bernard once described his Cistercian monks as "acrobats and jongleurs of the spirit who provide a most beautiful spectacle to the angels."[20] The abbey of Cluny itself was described by one contemporary observer as a "spiritual gymnasium."[21]

Figure 38. First Mode. Ambulatory Capital.
Third Abbey Church, Cluny, France, 1088–95.
Farinier Museum, Cluny.

The first musical mode is personified by seated male figures
playing on stringed instruments in both the tonaries and in the
Cluny capital (Figures 38, 39, 40). In the Limoges tonary the
crowned and bearded man is clearly King David, the author of
the Psalms. The Toulouse manuscript and the carved Cluny figure
portray solemn-faced youths that probably refer to the young Da-
vid as he played to Saul to drive away evil spirits. In both manu-
scripts David is playing different versions of medieval rebecs, while
at Cluny he is plucking what appears to be a lute.

The second mode at Cluny reveals a young woman dancing
and clapping two small cup-shaped cymbals (one is destroyed),
which are held together by a cord around her neck (Figure 41). In
both spirit and posture the Cluny figure corresponds closely with
the ninth or final figure in the Limoges manuscript (Figure 42).

The third mode figure at Cluny (Figure 43) closely resembles
that for the sixth mode in the Limoges tonary (Figure 44). Both
are seated and playing instruments that could be construed as dif-

Figure 39. First Mode. Manuscript drawing, Abbey of St. Martial, Limoges, France, early 11th century. Ms. lat. 1118, Bibliothèque Nationale, Paris.

Figure 40. First Mode. Manuscript drawing, Abbey of St. Etienne, Toulouse, France, early 11th century. Harl. Ms. 4951, British Museum, London.

Figure 41. Second Mode. Ambulatory Capital. Third Abbey Church, Cluny, France, 1088–95. Farinier Museum, Cluny.

Figure 42. Final Mode. Manuscript drawing, Abbey of St. Martial, Limoges, France, early 11th century. Ms. lat. 1118, Bibliothèque Nationale, Paris.

Figure 43. Third Mode. Ambulatory Capital. Third Abbey Church, Cluny, France, 1088–95. Farinier Museum, Cluny.

Figure 44. Sixth Mode. Manuscript drawing, Abbey of St. Martial, Limoges, France, early 11th century. Ms. lat. 1118, Bibliothèque Nationale, Paris.

ferent forms of the psaltery, David's biblical stringed instrument. Their heads are tilted in exactly the same way, and their chairs are similar. It seems almost certain that the Cluny sculptor must have known about this drawing or another similar to it.

For the fourth mode the Cluny figures plays a type of carillon with three or possibly four bells mounted on a horizontal bar (Figure 45). No such figure appears in the Limoges manuscript, but there is one in the incomplete Toulouse tonary now in London (Figure 46). Here one sees a much more elaborate carillon, and it is placed between the discussions of the third and fourth modes. Again the coincidence is far too close to be accidental.

In the second capital the carved inscriptions are intact, but the musicians are severely mutilated (Figure 47). Enough of the sixth and seventh mode musicians survive, however, to indicate the type of instruments they were playing. It can be seen in the fragmented sixth tone (Figure 48) that the player is strumming a type of zither, while the seventh holds a wind instrument (Figure 49). This would correspond roughly to the figure for the second mode in the Limoges manuscript (Figure 50). In the capital for the eighth mode at Cluny, the musician and the instrument are almost completely obliterated (Figure 51).

Consider the inscriptions themselves. The chart on pages 304–305 shows Regino's and Odo's mottoes in the lefthand column and the corresponding Cluny capital inscriptions in the righthand column. With Regino and Odo the texts are taken directly from the New Testament, seven from the Gospels and one from Revelation. Undoubtedly they were chosen because the first words of each phrase began with the numbers one through eight. In this manner they served as convenient mnemonic devices for the melodic formulas of each tone and as a practical way of keeping the singers from straying into the wrong mode. By contrast, in the Cluny inscriptions the number references are in several different places, and none of the mottoes is a direct quote from the scriptures. The Cluny writer obviously assumed that the New Testament sources were familiar to the monastic community at large and that he was at liberty to compose a free commentary on them.

The first two tones at Cluny are musical allusions to the first and second commandments of Christ: "And thou shalt love the

Figure 45. Fourth Mode. Ambulatory Capital. Third Abbey Church, Cluny, France, 1088–95. Farinier Museum, Cluny.

Figure 46. Fourth Mode. Manuscript drawing, Abbey of St. Etienne, Toulouse, France, early 11th century. Harl. Ms. 4951, British Museum, London.

Figure 47. Fifth Mode. Ambulatory Capital.
Third Abbey Church, Cluny, France, 1088–95.
Farinier Museum, Cluny.

Figure 48. Sixth Mode. Ambulatory Capital.
Third Abbey Church, Cluny, France, 1088–95.
Farinier Museum, Cluny.

Figure 49. Seventh Mode. Ambulatory Capital. Third Abbey Church, Cluny, France, 1088–95. Farinier Museum, Cluny.

Figure 50. Second Mode. Manuscript drawing, Abbey of St. Martial, Limoges, France, early 11th century. Ms. lat. 1118, Bibliothèque Nationale, Paris.

Figure 51. Eighth Mode. Ambulatory Capital.
Third Abbey Church, Cluny, France, 1088–95.
Farinier Museum, Cluny.

Lord thy God with all thy heart, and with all thy soul, and with all thy mind, and with all thy strength: this is the first commandment. And the second is like, namely this, Thou shalt love thy neighbor as thyself. There is none other commandment greater than these" (Mark 12:30–31). The third mode in both versions refers to the resurrection of Christ, and the instrument here assumes symbolic significance. In early Christian times the classical lyre with its gut strings stretched on a wooden frame was likened to Jesus nailed on the cross. With the fourth mode there is a variance; Regino's quotation refers to Christ's miracle of walking on the sea of Galilee, and the Cluny inscription alludes to a song of lamentation. Bells were associated with funerals, and acolytes ringing them are shown in the late 11th-century Bayeux tapestry in the funeral procession of Edward the Confessor. In each case the meaning of the fifth tone is similar, with the implication of pride going before a fall.

The sixth cites the story of the woman of Samaria in John's Gospel where the theme of the chapter is that faith and piety are the road to salvation and eternal life. The seventh in both cases coincide with references to the seven spirits of God, seven angels,

and seven trumpets (Rev. 8:2). There is also the association between the Latin *flatum* and *spiritus,* both words having to do with breathing as found in the cognate forms of "inflating" and "inspiring." Here the broken wind instrument (see Figure 49) is probably a trumpet. There is a discrepancy in the texts for the eighth mode; Regino cites the eight beatitudes and the Cluny version the blessedness or beatification of the saints. The latter can be considered as a free paraphrase on one level and, as will be shown later, as a liturgical reference to the post-Communion prayers on another.

The Liturgical Connection

The inscriptions and carved figures on the Cluny capitals can then be read as generalized representations of the spirit, substance, and practice of sacred psalmody. The final phase of our sleuthing, however, goes back to an earlier study of mine that proposed a liturgical connection for these mottoes and sculptural personifications.[22] The two levels of meaning—one practical, the other metaphorical—are by no means mutually exclusive; rather they complement each other quite harmoniously. So with a typical Cluniac twist, the octet can also be read as a subtle allegorical interpretation of the mass.

The first figure is that of a young man of sad countenance, seated and playing a version of the lute (see Figure 38). In the preliminaries to the mass, the celebrant and his attendants intone responsorially the words for the antiphon *Introibo ad altare Dei,* the text for which comes from the fourth and fifth verses of the 43rd Psalm: "Then I will go unto the altar of God; to God who giveth joy to my youth. To thee O God, I will give praise on the harp [*cithara* in the Vulgate]: why art thou sad, O my soul? and why dost thou disquiet me?" Since this antiphon begins the mass, it fits quite naturally with the motto: "This tone is first in the order of musical modulations." Many 11th-century sources use the word *cithara* as a generic term for various stringed instruments. The music, in this interpretation, becomes the force that banishes sadness and disquietude and brings the soul to the joy of God, just as David's music soothed Saul's dark humors. In the Christian sense, it symbolizes the victory of Christ over the Devil.

The second tone "follows . . . by number and law," according to the inscription, and the figure is that of a young woman dancing and clapping together small cup-shaped metal cymbals known as the *acitabula* (see Figure 41). Odo of Cluny described them as being made of brass, silver, or bronze that sounded with a smooth ring (*suavem tintinum*). After the opening psalm of the mass comes the antiphon *Ad introitum* (literally "on entering"), which was sung by the full chorus. This was one part of the mass that varied according to the church calendar. The *Liber pontificalis* ascribes the origin of the Introit to Pope Celestine in the 5th century: "This establishes and fixes the Psalm of David No. 150 to be chanted in the antiphon before the sacrifice."[23] It is important to note that this psalm mentions a series of musical instruments, specifically the tuba, *psalterio, cithara, tympano, cymbalis bene sonantibus,* and *cymbalis jubilationes,* the latter being translated as "high sounding cymbals," which would fit the description of the instrument depicted here. Also, according to the first Roman *Ordo,* the practice was for the *Schola cantorum* to begin the *Antiphon ad introitum* when everything was ready at the altar. When the deacons heard it, the processional began with the celebrant attended by deacons, subdeacons, acolytes, and singers, all moving toward the altar. Such a biblical procession is described in the 68th Psalm, part of which reads: "The singers went before, the players on instruments followed after; among them were the damsels playing with timbrels (*tympanistraria*)." The appropriateness of this passage for the Introit is clear. This psalm is still prescribed for use on Palm Sunday. Such processional chants emphasized movement and progress, and the mood is livelier and more festive than in the stationary chants found in other parts of the mass.

"The third strikes and tells that Christ is risen," according to the next motto (see Figure 43). Here the six-stringed instrument is a type of ancient lyre. Many have assumed the player to be David, but in 11th-century iconography David was almost universally portrayed with a crown. It is much more likely that the depicted musician is an allusion to Christ as Orpheus, both of whom descended to the underworld and triumphed over death. The liturgical connection is to be found in the section of the mass following the Introit, which begins with the Kyrie and continues with the

Credo. The number three figures in both instances. In the Kyrie, Christ is mentioned for the first time; and the first words, *Kyrie eleison,* are intoned three times in honor of God the Father; *Christe eleison* is repeated thrice in praise of God the Son; and *Kyrie eleison* again three times for God the Holy Spirit, thus alluding to the Trinity. Also in the Credo there are the significant words: "And the third day he rose again." The Credo was a latecomer in the mass, but it was prescribed for some in the Roman Missal beginning with the year 1014.

The fourth figure shows a young man playing three, or possibly four, chime bells, or *tintinabula* (see Figure 45). In medieval times these were often referred to as *cymbala.* This concurs with the frequent references in the psalms to cymbals. The Vulgate does not mention bells as such. This figure recalls a similar one at the Chartres Cathedral representing Music among the seven liberal arts, with Pythagoras striking the bells with a hammer to demonstrate the musical ratios. In medieval Latin, however, the word *planctus,* as in the Cluny motto, usually denoted a funeral dirge or a lament on the death of a distinguished person.[24] The prayers for the faithful came at this point in older liturgies. Ivo of Chartres (1040–1116) mentions their use in France in the 11th century. These prayers were for all classes of people, living and dead. This section varied considerably at different monasteries and cathedrals. One of the earliest English examples, which dates before the Norman conquest, is a prayer for the souls of relatives living and dead. It reads in part: "And for all the souls of whom the bodies are buried in this church or in this churchyard and for all the souls in purgatory and for all Christian souls . . ."[25] Then came the Psalm *De profundis,* which was followed by the prayer *Requiem aeternam dona eis, Domine, et lux perpetua luceat eis.* It is clear that in almost all of the older liturgies, the prayers for the living and dead were said just before the oblations were brought to the altar. The custom dated from the practice of the offerer, before approaching the altar, to mention the names of those in whom he was interested, and especially the departed so that they might rest in peace.[26] Symbolically, this prayer follows the tone alluding to the resurrection because Christ has led the way to the underworld so

that the souls of the departed coming after him would dwell in the hope of resurrection. It thus established a valid reason for this representation to appear fourth in the sequence.

Unlike the first capital, the second, representing the last four tones, is not arranged in panels. The badly damaged figures appear in the corners between the Corinthian foliage. The inscriptions are carved in a wide band running around the middle of the capital. The one for the fifth tone reads: "How low is fallen he who would exalt himself." This symbolism fits with the Offertory. Like the Introit, it was accompanied by action—in early liturgies the faithful brought bread and wine to the altar. Symbolically the gifts of humble bread and wine are to become the food of angels (*panis angelorum*). Likewise by participating in the sacrament, the sinners who have "fallen low" "would raise themselves." The words *Domine non sum dignus* (Lord, I am not worthy to presume to come to thy table) also fit. Thus the worshipers humble themselves and offer gifts so that Christ may raise them through the communion host to participate in his divinity (*eius divinitatis esse participes*). At this point the celebrant raises the gifts, symbolically offering them to God, with the prayer: "We humbly beseech thee Almighty God, to command that these our offerings be born by the hands of thy holy angel to thine altar on high, in the presence of thy divine Majesty, that as many of us that receive the most sacred body of thy Son by participating thereof from this altar may be filled with every heavenly blessing and grace."

The figure representing the fifth tone is almost completely missing (see Figure 47). The feet, however, can be identified as those of a person in movement. In the Limoges manuscript, the illuminated figure for the fifth tone has upraised arms (Figure 52), and the feet are in a similar position as those in the sculptured capital. The prayer beginning *Sursum corda* (Lift up your hearts), usually recited at the Offertory, also fits this symbolism. According to this theory, the figure would be either lifting up the arms as in the Offertory or an angel leaping from the ground. Two additional pieces of evidence support the Offertory theory. One is that the reference in the inscription to falling low possibly refers to the *preces in prostratione*, or prayers in prostration.[27] The other is that

Figure 52. Fifth Tone. Manuscript drawing, Abbey of St. Martial, Limoges, France, early 11th century. Ms. lat. 1118, Bibliothèque Nationale, Paris.

of *Epiclesis,* the invocation of the Holy Spirit, which occurs at this point in early liturgies. Because the Holy Spirit is symbolized by a dove, the connection with the fifth day of creation when birds were made should not be overlooked.

"If you desire the mood of piety, harken to the sixth." This allusion would be to the sequence of prayers that come between the Offertory and Communion, after the oblations are on the altar and the washing of hands has taken place. This section begins with the words *Orate fratres,* continues with the *Sanctus* and *Benedictus,* and includes the *Pater noster.* The tradition is that of praying before the meal in accordance with Christ's practice at the Last Supper when he took the bread and wine and gave thanks. The broken figure (see Figure 48) is playing a one-stringed instrument, which could be a monochord if the artist is to be taken literally. But since the carving is wide enough, it could, with artistic license, be an

instrument with several strings. The key to the iconography of this sixth tone lies in the *Sanctus,* the words of which come from the vision of Isaiah, so important to Christianity as the prophecy of the Messiah to come. The prophet saw the Lord sitting on a high, raised throne. Above are seraphim each with six wings, two to cover their faces, two to cover their feet, and two with which to fly. One cries to the others and says: "Holy, holy, holy, Lord God of hosts. The heavens and the earth are full of thy glory" (Is. 6:1–3). Frequent references are made in Isaiah to the singing of psalms with stringed instruments. Also in the chapter immediately before the text just quoted is a passage: "And the harp, and the viol, the tabret, and pipe, and wine, are in their feasts" (Is. 5:12).

"The seventh is the spirit bringing gifts to comfort the heart" becomes the motto alluding to the Communion. Seven was the mystical number that embraced the four corporeal elements (earth, air, fire, water) and the three spiritual visages of God as beheld in the Trinity. Hence the physical substances of the bread and wine are transubstantiated at the altar into the spiritual body and blood of the Savior. Ever since early Christian times, the Communion service had been associated with the seven loaves and fishes that fed the multitude in Christ's miracle.[28] Also, as previously pointed out, this Cluny inscription is a paraphrase of the Regino and Odo tonaries that alluded to the vision after the opening of the seventh seal as related in the book of Revelation: "And I saw the seven angels which stood before God; and to them were given seven trumpets. And another angel came and stood at the altar, having a golden censer . . . that he should offer it with the prayers of all the saints upon the golden altar which was before the throne" (Rev. 8:2–3).

The word *donis* in the motto, then, refers to the sevenfold gifts of the Holy Spirit that come with Communion. The first word, *insinuat,* refers symbolically to the breast and the idea of the gifts entering the heart. The word *flatum* also fits with the notion of the breath of new life animating the breast, recalling the classical Roman idea of the divine *afflatus.* The parallel Greek concept of *pneuma* (lungs) refers to breath as the metaphor of life; *spirit* is also philologically identified with breath. Thus the apocalyptical seven trumpets as wind instruments symbolize the breath of new life en-

tering the body. The 33rd Psalm, the Communion Psalm, with its reference to playing "skilfully with a loud noise" is further confirmation of the trumpet as depicted on the capital (see Figure 49).

"The eighth teaches that all saints are blessed." This indicates the post-Communion prayer and chant that deals with the intercession of saints, a petition that the worshipers may come into their blessed company: "And through the intercession of the glorious and immaculate Virgin Mary, Mother of God, of her spouse, blessed Joseph, of thy holy apostles Peter and Paul, and all the saints . . ."[29] It seems natural that Cluny would have stressed a prayer of this type as the high altar was dedicated to the Resurrection, Mary, and saints Peter and Paul. The third tone alluded to the Resurrection, and this prayer names the saints to whom the high altar and church were dedicated. The 11th-century Sarum Missal contains a post-Communion prayer for the feast of saints Peter and Paul: "We have received, O Lord, the divine mysteries, anticipating the desired feast of thy blessed apostles Peter and Paul; grant, we beseech thee that we may be defended by those whose rule we are governed."[30] The octave here is also the last of the tones, and the post-Communion is the finale of the mass, thus completing the liturgical sequence of the tones and their sculptured images.

By the inscriptions alone, we have started at a beginning, then followed it with that which came next by number and law. We have been told of the resurrection of Christ and prayed for those faithful departed. Then we were reminded of how low those are fallen who would raise themselves, and in raising our hearts have been put in a mood of piety by listening to the sixth tone. Thereafter we have received the sevenfold gifts of the Holy Spirit at Communion and invoked the intercession of the blessed saints with the final tone.

When this is combined with the symbolism of the sculptural images, we find a natural sequence. First we have approached the altar praising God with the *cithara* to ward off the evil spirits and find joy. Next came the processional chant of the *Introit* symbolized by the rhythm of the cymbals. In a stationary chant we have heard of the Resurrection with an instrument representing the cross of Christ, then recited the prayers of the faithful with the tolling of

bells. Next our hearts have been raised in a procession to the altar in the Offertory chant symbolized by the marching feet and re-called to piety with another instrument symbolizing the body of Christ. Then we have received the gifts and breath of new life at the altar, represented by the figure with the wind instrument, and finally departed with the knowledge of the blessed saints.

These works represent a subtle synthesis of the arts of sculpture, music, and literature combined with medieval allegorical allusions. If we shift from the letter to the spirit, it is clear that these sculptures are full of the motion and emotion typical of the high Romanesque style. They are representative products of the fantastic energy associated with the fast building of the second-largest church in Christendom and of organizing the crusades. In fact, the first such organizing speech was preached by a Cluny monk who became Pope Urban II just as this church was being built.

So at Cluny one hears once again an inspired concert of the arts with sculptured musical images sounding their silent songs, encircled by related Latin literary mottoes, all amid an awesome architectural setting. The total effect is one of abounding energy, dauntless faith, emotional ecstasy in religious worship, and the embodiment of the spirit expressed by St. Augustine, who ex-horted worshipers to "sing the new songs not only with your tongue but with your life."[31]

Michelangelo as Poet and Philosopher: The Personal Mode

THE PERSONAL MODE OF RELATING the arts occurs when artists express themselves in more than one medium. Such was frequently the case in the Renaissance when the ideal was that of the universal man. Michelangelo, who was first trained as a painter and sculptor, later became a major architect as well as an important poet and philosopher. Finding the common threads in his thought and output will be the subject of this chapter.

Michelangelo Buonarroti, Il Divino as he came to be known later in life, combined the qualities, attributes, and accomplishments that personified the Renaissance *uomo universale,* or universal man. As the sculptor of the early *Pietá* and *David,* he surpassed the ancients and eclipsed his contemporaries and successors. As the painter of the Sistine Chapel ceiling, he pictorialized the stories of Genesis in panoramic form and captured the very spark of the act of creation. As the architect of St. Peter's Basilica, he expressed the aspirations of all Christendom. Now regarded as the ranking Italian lyric poet of his century, he articulated the synthesis of the Greco-Roman world and that of the Renaissance. As a philosopher in marble, fresco, masonry, and words, his work rec-

onciled the opposite poles of the ancient and modern, paganism and Christianity, becoming and being, Plato and Dante, the city-state of Florence and the supranational center of Rome. Creating his own concert of the arts, he synthesized the various media into a unified choir emanating from the voice of a single myriad-minded man.

The image of the universal man had its roots in medieval chivalry and its flowering in the courts of Renaissance Italy. In Michelangelo's lifetime, its ideals were articulated in Baldassare Castiglione's *Il Cortegiano* (1518), a book in the form of a dialogue discussing the character and qualities of the ideal courtier.[1] The desirable attributes included a dignity of demeanor, a deportment equal to all social situations, a balance between the active and contemplative ways of life, a ready wit, scholarly interests, the ability to write a neat verse, a critical knowledge of the visual arts, and an ear for music.

As the social status of individual artists rose in Florentine and Roman society, the concept of the *uomo universale* came to include major achievements in the arts in addition to Castiglione's humanistic concept of a well-rounded life. Such a many-sided figure, one whose example influenced both Leonardo da Vinci and the young Michelangelo, is found in Leone Battista Alberti. He represented the union of the arts and sciences of his time. In his youthful years, this scion of a wealthy upper-class Florentine family was noted for his physical prowess, feats of strength, and superb horsemanship. Later, his interests turned to more serious pursuits. He became the master of the mathematical and physical knowledge of his time, a fine Latin stylist, a practicing musician and composer, a painter, sculptor, architect, city planner, and social philosopher. In his critical writings he viewed artists not only as skilled craftsmen but as practitioners of a creative activity based on rational principles under the guidance of the intellect. Dating from the mid-15th century, his three influential treatises *De pictura, De statua,* and *De re aedificatoria,* all of which were known to Michelangelo, furnished the Renaissance with a philosophy of art that has validity right up to modern times. Alberti once declared that men can do all things if only they have the will. As such he became a universal man in

his own right, as well as the prototype of such High Renaissance successors as Leonardo da Vinci, Raphael Sanzio, and Michelangelo Buonarroti.

Michelangelo, however, was not a suave man of the world like his colleagues Leonardo and Raphael. Instead he shunned the role of courtier and all the elegant surroundings, appurtenances, and repertory of social graces. But his lofty genius, preeminent position in the arts, his name and fame always assured him of more commissions than he could possibly fulfill.

Despite the turbulence of his time, he often suffered popes and princes to come to him. The gruff titan, with his fierce pride and independence, his uncompromising aesthetic principles, and his introspective, saturnine temperament, lived in a world apart, where he could concentrate on the monumental labors that occupied every moment of his long, prodigiously productive life. As he wrote in one of his verses, "in the shadow I remain/ When the sun despoils the world with its rays."[2]

As Buonarroti never allowed himself the luxury of living the ordinary life of *l'homme moyen sensuel,* his best biography is to be found in his works, all of which can be interpreted as revelations of his unique creative personality and as spiritual self-portraits. Michelangelo always resisted commissions for portraits because he was convinced that when portraying another person, an artist inevitably paints a picture of himself. As he commented in a poem, "If it is true that one working hard stone will liken/ The image of every other model to himself . . ."[3] His only two conscious self-portraits are to be found in the flayed skin upheld by St. Bartholomew in the Sistine Chapel *Last Judgment* (Figure 53) and the head of Joseph of Arimathaea in the *Deposition* (or *Pietá*) in the Florence Cathedral. The latter was originally intended for his own tomb. Toward the end of his life, envisioning himself as a modern Vulcan hammering away on the anvil of the gods, he wrote the powerful lines:

If my rough hammer gives a human face
To this or that of all hard blocks that wait,
It is another smith makes me create,

Controlling each my motion, each my pace.
But that high hammer beyond stars and space
Makes self, and others, with each stroke, more great
And bright; and since the first must generate
All hammers, *that* gives life to all, always.

And since the most effective is that blow
Which falls from highest in the smithy, mine
Shall fall no more—my hammer having flown.

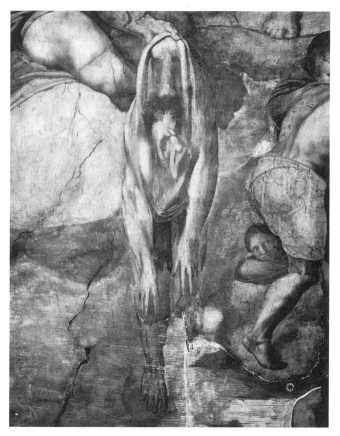

Figure 53. Michelangelo. *Last Judgment,* 1534–41. De-
tail with self-portrait on flayed skin. Fresco, Sistine
Chapel, Vatican Palace, Rome. By permission of Ali-
nari/Art Resource, New York.

Now here am I, unskilled, and do not know
How to go on, unless the smith divine
Teaches me how, who am on earth alone.[4]

The Making of Michelangelo's Mind

When 14-year-old Michelangelo left the studios of the Ghirlandaio
brothers to work in the Medici sculpture gardens, he found both
the heritage of the past and the promise of the future awaiting
him. There a rich collection of ancient Etruscan and Roman stat-
uary provided models for study. This so-called free school was
presided over by the elderly Bertoldo di Giovanni, who had been
a pupil and assistant to the late and great Donatello. Other artists
working under the Medici aegis were the sculptors Benedetto da
Maiano and Andrea Sansovino and the painter Lorenzo de Credi.
It was here that Michelangelo first learned the craftsmanship and
techniques of sculpture, and here that he first attracted the atten-
tion of Lorenzo the Magnificent, who invited the young genius to
live at his palace, where he was treated as a member of the family.

In the Palazzo Medici on the Via Larga, built by the architect
Michelozzo for Lorenzo's grandfather Cosimo, the young sculptor
found himself in the midst of a rarefied circle of humanistic schol-
ars and men of letters. These included the preeminent poet An-
gelo Poliziano (Politian), professor at the University of Florence
and tutor to Lorenzo's children; the philosopher Marsilio Ficino,
central figure of Florentine neoplatonism and translator of Plato's
works from Greek into Latin; the classicist Cristoforo Landino, au-
thor of commentaries on Vergil's *Aeneid* and Dante's *Divine Comedy;*
the dashing courtier Pico della Mirandola, theologian and neopla-
tonic scholar; and the outstanding northern composer Heinrich
Isaac, organist and choirmaster at the Florence Cathedral and mu-
sic instructor to Lorenzo's children. The family members included
the Magnifico's wife, four daughters, and three sons—Piero, who
was being trained to succeed his father; Giovanni, the boy cardinal
and future Pope Leo X; and Giulio, destined to be the second
Medici pope, Clement VII.

Other humanistic scholars and members of the Platonic Acad-

emy that Cosimo had founded earlier frequented the household; and, needless to say, illustrious heads of state, diplomats, church dignitaries, visiting poets and scholars always found their way to the Magnificent's princely table. Later, in one of the dialogues of Donato Gianotto, Michelangelo is quoted as saying: "There was not a learned man in Florence who was not my friend."[5]

In Lorenzo de' Medici himself, the young Buonarroti encountered a father figure and a truly many-faceted *uomo universale*. Of this cogent though often ruthless ruler, the historian Francesco Guicciardini commented: "If Florence was to have a tyrant, she could not have found a better or more pleasant one."[6] He could well have added that in addition to being one of the most adept power politicians of his day, Lorenzo was the patron with a formidable intellectual capacity who presided over the golden age of Florentine humanism. Not only was Il Magnifico well versed in all matters pertaining to the visual arts, philosophy, music, and literature of his time, but he was unique among princely patrons in that he took an active role in the creative labors he promoted and ranked as one of the foremost authors of his period. His prose was elegant, his poetry eloquent. Writing in the Tuscan tongue, he caught and articulated the spirit of his people in fresh, spontaneous verses as rich in fancy as they were melodious and colorful. He sang his own popular songs, as did merrymakers in the streets at carnival time. His poetry survives in its own right, in anthologies and in musical settings by many of the outstanding composers of the period.

Meeting daily in the Medici household with such eminent minds and participating in such learned conversations while at an impressionable age was an experience destined to carve and mold Michelangelo's thinking and conceptions of art quite as much as his growing mastery of the sculptural medium. The heroic image of man that underlies all Michelangelo's art was most powerfully and impressively championed by Pico della Mirandola, who projected the proposition that "man is the intermediary between creatures, the intimate of higher beings and the king of lower beings, the interpreter of nature by the sharpness of his senses, by the questing curiosity of his reason, and by the light of his intelligence, the interval between enduring eternity and the flow of time . . .

and by David's testimony, a little lower than the angels." He then continues: "You shall be able to descend among the lower forms of being, which are brute beasts; you shall be able to be reborn out of the judgment of your own soul into the higher beings, which are divine."[7] Pico also noted that in Plato's *Timaeus,* human beings and the human form were held to be the microcosm of the universe, and human proportions were a revelation of the divine order. Michelangelo took unto himself and made his own this exalted view of a humanity struggling for self-liberation by plumbing the depths and ascending to the heights. At this particular time, Pico was finishing his translation and commentary on Plotinus' *Enneads,* thus introducing contemporary Italian scholars to the works of Plato's great 3rd-century A.D. disciple.

The young artist also established a warm personal rapport with the resident poet Angelo Poliziano, who is known to have suggested the theme for the *Battle of the Lapiths and Centaurs* (Figure 54), one of Michelangelo's earliest surviving relief panels. Poliziano's famous bacchic song may also have been the inspiration for Michelangelo's life-size marble figure *Bacchus.* The seeds of the sculptor's later preoccupation with the poetic medium must also have been planted at this time, when the example of both Lorenzo and Poliziano was all-pervasive. Michelangelo, for instance, draws directly on Poliziano in two or three of his mature poems.[8]

All educated Tuscans may be said to drink of Dante's cup as soon as they have been weaned from their mother's milk. All of them also read him with various commentaries at hand. According to his biographer Ascanio Condivi, Michelangelo had a lifelong interest in the great Tuscan poet and knew most of Dante's works by heart. While he lived in the Medici circle, it is most probable that Buonarroti's knowledge and conception of the *Divine Comedy* was colored by Christoforo Landino's neoplatonic interpretation. The iconography, conception, and composition of the *Last Judgment* fresco certainly drew heavily on the *Inferno.* The Dante of the *Paradiso* permeates many of Michelangelo's poems, especially those that deal with the divine origin of the soul and the will to rise above the self. The artist's affinity with Dante shines through two of his sonnets addressed to him, one of which runs in part:

He from the world into the blind abyss
Descended and beheld the realms of woe;
Then to the seat of everlasting bliss,
And God's own throne, led by his thought sublime,
Alive he soared . . .
But gladly would I, to be such as he,
For his hard exile and calamity
Forgo the happiest fortunes of mankind.[9]

Michelangelo's idealized love for Vittoria Colonna, to whom so many of his finest sonnets are addressed, derives from Dante's worship of Beatrice and Petrarch's veneration for Laura. However, while the content and imagery of his poetry point toward Dante,

Figure 54. Michelangelo. *Battle of the Lapiths and Centaurs,* 1491–92. Marble, 33¼ × 35⅝″ (84.46 × 90.49 cm). Galleria Buonaroti, Florence. By permission of Alinari/Art Resource, New York.

the formal designs and constructive patterns of his verses veer toward Petrarch.

At the Medici table, Marsilio Ficino, the founder of Florentine neoplatonism, frequently commented on his translations of Plato's works. From the *Symposium* came the concept of beauty and love that Michelangelo adhered to all his life. Beauty, as beheld and perceived by the senses in nature, art, or human life, is but the reflection of the abstract absolute beauty that can be conceived only by the mind. This ideal derives from the platonic doctrine of reminiscences in which the mind recalls previous knowledge and experience. Love, then, in the platonic meaning is the force that motivates the human quest to rise to the heights. For Michelangelo love meant the intensification of his psychic and physical energies, the exaltation of the spirit, the illumination of the vast darknesses of human life, and the aspiring Dantean "fire which is moved upward by its form that is born to rise."

When one falls in love with a beautiful person, for instance, the mind, according to Plato, catches a glimpse of the divine and eternal beauty that shines through. In platonic thought, the world of appearances is always transitory, and physical beauty will inevitably be eroded in the course of time. But in the realm of ideas and forms, the concept of beauty itself is abiding. Only by achieving beauty through art can man escape from the doom of mortality through intimations of the eternal. Later Michelangelo was to translate these thoughts into the world of art and embody them in one of his poems.

> Sculpture, the first of arts, delights a taste
> Still strong and sound: each act, each limb, each bone
> Are given life and, lo, man's body is raised,
> Breathing alive, in wax or clay or stone.
> But oh, if time's inclement rage should waste,
> Or maim, the statue that man builds alone,
> Its beauty still remains, and can be traced
> Back to the source that claims it as its own.[11]

Note in the first line the allusion to God as the first sculptor, having modeled Adam out of clay.

In the platonic vein, Michelangelo's writings are studded with the words *concetti* (concepts), *immagini* (images), and *idée* (ideas or ideals). All are related to the unseen world of the mind that is revealed in nature and art. For Michelangelo, beauty implied the relationship of the form to the idea, but it is always the idea that directs the hand that brings out the form. To put it in philosophical terminology, his proportions and designs were not determined à priori or à posteriori. They were arrived at rather in a self-revealing process, a kind of becoming in search of being. But in Michelangelo's approach to artistic creativity, it is always the idea that comes foremost. He was convinced that sculpture and painting were done with the wits not with the hands, and as he writes in one of his sonnets:

> Give life to stone, but this is not achieved
> By skill. In painting, too, this is perceived:
> Only after the intellect has planned
> The best and highest, can the ready hand
> Take up the brush and try all things received.[12]

So Michelangelo began with the concept of the ideal form, then proceeded to realize it in stone or paint. The stone, however, always resisted the enormous emotional, intellectual, and artistic demands he imposed on it. Hence arose the need for him or any other artist to bridge the gap between the ideal form and the actual result, which at best can be only an approximation of the initial inspiration. The problem that all artists inevitably encounter is that the working-out process always involves making the necessary compromises that take into account the limitations of the material medium at hand. In sculpture, the question is how to get as close as possible to the ideal form with the properties of the particular block of stone one has to work with. In painting, the artist may envision the ideal blue. But only a limited range of blues is possible with the pigments that are available.

This idyllic, formative, and productive period in Michelangelo's life was rudely interrupted by the death of Lorenzo in 1492 and the succession of his inept and dissolute son Piero. From this point on philosophical and social disputes became more strident and di-

visive as political storm clouds began to gather. It was at this time that Michelangelo first heard the apocalyptical pronouncements and prophecies of doom uttered by Girolamo Savonarola in his sermons from the pulpit of the Florence Cathedral. In Savonarola's powerful personality Michelangelo beheld the heroic image of a man dedicated to his ideals with such ardor and passion that he could single-handedly take on the reform of the Roman church. As his friend and early biographer Condivi reports, Michelangelo once remarked that all his life he heard the thunderous voice and impassioned pleas of the fiery friar echoing in his ears.[13] The reverberations of Savonarola's words are heard in one of the poems from Michelangelo's early Roman period that reflects his struggle to reconcile his spiritual values with the venality surrounding him. The lines bespeak his deep disillusionment with his papal patron Julius II, who was preoccupied with his quixotic and overly ambitious war to bring all of Italy under church control. Hence, he had to melt down church plate to pay mercenary soldiers and resort to money changers.

> Here, to make swords and helmets, war devours
> Our chalices, and here Christ's blood is sold
> By the pint, and cross and thorns are cast into mold
> For shields and spears, and yet Christ's patience showers.
> But let Him not return to this land of ours,
> For here in Rome where sin is uncontrolled
> His blood would spurt to the stars, His skin be sold
> For any price in all the streets at all hours.[14]

Thus it was that the mind of Michelangelo took shape in these Florentine years. The poetry, philosophy, and humanistic learning of the Medici circle were all sifted through his sensitive and receptive psyche, and the imagery and forms of his later work reflect his own creative synthesis of all these influences. He then emerges as one of the most thoughtful and literate of artists, who was thoroughly conversant with the heritage of the past and who spoke the overall Renaissance vocabulary with fluency and intellectual understanding.

The Poetry

As a poet, Michelangelo wrote verses intermittently most of his life.[15] The earlier examples were usually fragmentary scrawls on the reverse sides of various drawings, most of which have been lost. The earliest surviving lines appear on a sketch for the famous *David*, probably dating from the year 1502:

David with a sling
And I with a bow.
Michelangelo.

Broken is the high column.[16]

David (Figure 55) is clearly a personification of Florence, the liberal Guelph city-republic that had to live by its ample wits among the Goliaths of its rapacious neighboring states. The reference to the "bow" makes a good rhyme here but is somewhat misleading. Michelangelo's word is *collarcho*, or *archetto* in modern Italian, referring to a sculptor's bow—a shaped metal hand drill twirled by a tight string.[17] The allusion to the broken column is an echo of Petrarch's words "*Rotta è l'alta colonna e il verde lauro* (Broken is the high column and the green laurel)," indicating that the 18-foot-high block of marble Michelangelo was carving had been blemished by the careless hand of a previous sculptor who had worked on it some 40 years earlier.

Condivi, Michelangelo's early biographer, reports that in the year 1503 the artist paused in his sculptural endeavors and "for some time he did almost nothing in that art to give himself to reading poets and orators in the vernacular, and to writing sonnets for his pleasure."[18] From then on he continued to write poetry addressed to a select few of his friends. None of it was published until the next century, and then only in a bowdlerized version by his grandnephew. Michelangelo was, however, recognized as a ranking poet in his day, as evidenced by the inclusion of his portrait in the *Parnassus* fresco that Raphael painted in the Vatican Palace's famed Stanza della Segnatura.

His poetry is far more earthy and direct than that of his more

Figure 55. Michelangelo. *David,* 1501–1504. Marble, height c. 18′ (c. 5.49 m). Galleria dell'Accademia, Florence. Courtesy of Gabinetto Fotografico Nazionale, Florence.

polished contemporaries. Michelangelo himself once character-
ized his verses as "rough-hewn," and in a postscript to one of his
sonnets honoring Cecchino Bracci, he described it as cut out of
rough "Romagnol" cloth. The poetry does indeed have certain
lithic and marmoreal qualities, but two of his contemporaries, the
composers Jacques Arcadelt and Bartolomeo Tromboncino, found
his madrigals musical enough for settings that satisfied Michelan-
gelo himself. These "rude and rough" qualities, however, are the
very ones that speak so clearly to us today, while the poetry of his
more sonorous and mellifluous colleagues—Bembo, Alamanni,
and Varchi—now gathers dust on library shelves. His fellow poets,
however, recognized a new, if rugged and intense, voice. Berni, for
instance, once commented to Sebastiano del Piombo:

> Enough of you, sweet pallid violets,
> And liquid crystals, and fair beasts astray:
> You babble words, but only *he* writes thoughts.[19]

All Michelangelo's poetry abounds in platonic metaphors and
symbols, and his absorption in neoplatonism was not only a viable
philosophical system in itself but, as Panofsky asserts, "a meta-
physical justification of his own self."[20] Michelangelo's poems are
particularly poignant because they reveal a more lyrical side of the
titanic nature that characterizes his heroic sculptural figures and
his epical painting cycles. The translations here, except when
noted otherwise, are those of Joseph Tussiani,[21] who casts them
more literally than John Addington Symonds and other Victorian
translators in their efforts to render the lines in more sonorous
and resounding phrases and who tried to make Michelangelo
sound more like Shakespeare.

The Medici Chapel

When Ascanio Condivi began his authorized biography, Michel-
angelo is said to have suggested that it be entitled *The Tragedy of the
Tomb*. The allusion, of course, was to the endless problems, revi-
sions, and compromises involved in the forever-unfinished mon-
ument for the imperious Pope Julius II and the contract with his

impecunious heirs. According to Vasari, the initial projection called for a vast freestanding pyramidal structure in the new St. Peter's, which was conceived as "surpassing every ancient imperial tomb in beauty and pride, richness of ornamentation, and abundance of statuary."[22] Finally, after several successive revisions, the project dwindled to the disappointing wall tomb in the unimportant church of San Pietro in Vincoli. The drama of the Medici tombs, though also unfinished, was far more fruitful, and it became the most fully realized of all the master's mighty sculptural projects.

Commissioned in 1520 by his childhood friend Cardinal Giulio de' Medici, youngest son of the great Lorenzo, who later ascended the papal throne as Clement VII, Michelangelo was directed to build a memorial chapel for the younger branch of the family. It was to be located in a new sacristy added to the church of San Lorenzo in Florence, which had been built many years before by Filippo Brunelleschi. Brunelleschi's presence is felt everywhere in the fabric of Florentine architecture, and the dome of San Lorenzo was conceived as a kind of lunar satellite of his mighty cathedral dome. The old sacristy housed the tombs of the founders of the Medici dynasty—Cosimo, Piero, Giuliano, and Lorenzo Il Magnifico. The new sacristy was to memorialize the younger members—Lorenzo, Duke of Urbino, and Giuliano, Duke of Nemours (Figure 56).

Michelangelo was to have complete control of the entire complex, and he planned it to correspond with Brunelleschi's older chapel. Conceived as a cosmic structure mirroring the universe, the chapel rises in three zones. The lower—containing the tombs, an altar, and a choir section—signifies the earthly level. The intermediate area denotes the transitory aspect, while above is a coffered hemispheric dome in the manner of the Roman Pantheon surmounted by a lantern tower symbolizing the heavenly realm. This lantern, together with the windows in the supporting lunettes, constitutes the principal sources of lighting descending from on high. When viewed from below the light gradually intensifies as the eye moves upward, thus creating a dynamic sense of rising and falling. The sculptural compositions at floor level are thus bathed in a warm but subdued glow, and the carved figures

Figure 56. Michelangelo. New Sacristy, c. 1530. Church of San Lorenzo, Florence. Cross-section.

were wrought to take full advantage of this illumination from above.

In harmony with the tripartite architectural deployment, the triangular composition of the individual wall tombs begins with the sarcophagi, a reference to the underworld. Originally there were to have been recumbent figures of fluvial deities personifying the Styx and other mainstreams of Hades watered by the tears of the living at floor level. As Michelangelo expresses the thought in Dantean *tèrza rima* (triple rhyme):

For all this anguish and for all this sighing
Fountains and rivers would now be drying,
Had they not been replenished by my crying.[23]

The idea of equating the four rivers of the underworld with the four aspects of grief derives from Dante's *Inferno,* where Vergil says that the rivers originate with the *lagrime goccia* (teardrops) of humanity.[24] In Landino's commentary, which Michelangelo knew so well, he equates the four underworld rivers with the four faces of grief—Styx as sorrow, Acheron as repentance, Phlegeton as passion, and Cocytus as weeping. The river gods, however, did not progress beyond the modeling stage, as can be seen in the unfinished figure in the Florentine Accademia (Figure 57). The pairs of figures on top of the sarcophagi allude to the transitory period of earthly life unfolding in the course of time. In Duke Lorenzo's case they are *Aurora* and *Crepuscolo,* or Dawn and Dusk; for Giuliano they are *Giorno* and *Notte,* or Day and Night (Figure 58). Above these at the apex of the triangle are the idealized images of

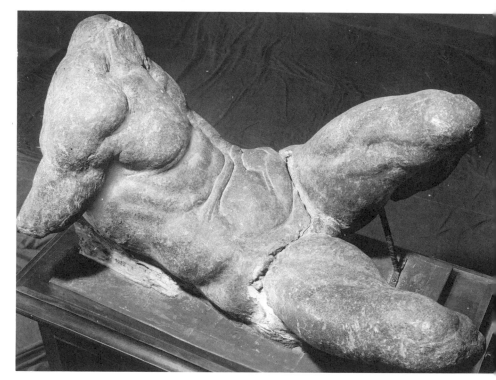

Figure 57. Michelangelo. Model for *River God,* c. 1526. Galleria dell'Accademia, Florence. By permission of Alinari/Art Resource, New York.

Figure 58. Michelangelo. Tomb of Duke Giuliano de'Medici, 1524–34. Marble, height of central figure 5′11″ (1.80 m). New Sacristy, San Lorenzo, Florence. By permission of Alinari/Art Resource, New York.

the dukes, envisioned as heroic figures who have achieved immortality by conquering time. The decorative details that adorn the walls are all derived from classical antiquity—the oil jars, garlands, shells allude to eternal life; the grimacing and laughing masks symbolize death and the darkness of the underworld.

Many interpretations of the iconographical program of the Medici Chapel have been offered. Two German scholars have attempted to tie it to the liturgy of the Requiem mass,[26] while Frederick Hartt sees it as "an allegory of the princely and papal power of the Medici and their apotheosis."[27] By far the most plausible and convincing theories, however, are the platonic programs proposed by Erwin Panofsky and Charles de Tolnay.[28] The interpretation presented here owes a deep debt to both these scholars, but the prime source is to be found in the letters, poetry, and works where Michelangelo speaks for himself.

First of all, the number three plays an important part in Michelangelo's thinking and designs, not only in the Medici Chapel but in all his large-scale works. This magical number permeates platonic as well as Christian thought. In ancient numerology, three is the first complete number, since it is the sum of the preceding two. As such it represents the union between the masculine progenitive force of the number one and its feminine equivalent two. Together they add up to fertility, life, and creativity. Also as a series, three contains a beginning, middle, and end.

With Plato three stood for the unity of his absolutes—the eternal verities Goodness, Truth, and Beauty. Plato's image of the world, society, and the individual was built on this tripartite symbolism. Society, in his view, was composed of workers, free citizens, and philosophers. The individual soul had three parts: the vegetative, the emotional, and the intellective—located in the abdomen, chest, and head. Human life was divided into the stages of youth, maturity, and old age, corresponding in his educational system with ignorance, opinion, and rational truth. In tandem, these latter two categories became a frequent subject for neoplatonic paintings during the High Renaissance.

Plato's general theory of knowledge held that the human being has prenatal awareness of divine truth. At birth, according to the poetic image, one drinks of the waters of the river Lethe, which

induce forgetfulness, so that one becomes oblivious of one's divine origin and begins life in a state of ignorance, which is likened to the darkness of night. Hence the road to knowledge is the arduous process of education, which means recollecting through our sense perceptions some aspects of divinity in the world about us. Thus by observing works of justice and good deeds, by beholding beauty in human form and art, and by studying mathematics and astronomy, reverberations of divine truth are awakened in the human consciousness. In all cases, this theory points to a dynamic upward progression founded on the urge to rise from the lower to a higher state of being, from darkness into the light. Michelangelo translated this threefold upward process of struggling and striving into spatial proportions in all his media and forms, and it shines through all his major works.

Another triadic concept in Michelangelo's thinking is that of God, nature, and the artist, a neoplatonic idea found in Dante's *Inferno*.[29] Ficino took up this idea in his neoplatonic commentaries, where he notes that "God, nature and art hold this order among themselves, that one prepares matter for the others, God for nature, and nature for art."[30] This thought also underlies Michelangelo's conception of the godlike powers of the artist as a metaphor for the creation of the world.

The triangle and pyramid are the plane and solid geometrical forms that correspond to Plato's tripartite system. This idea is manifested in the designs of Michelangelo's early *Pietá,* the late *Deposition* for his own tomb, the original project for Giuliano's tomb, and here in the Medici Chapel in the ducal tombs.

In the *Aurora* one sees a young woman who seems to be awakening reluctantly to the dawn of a new day while fully aware of the futility of life and the blind hopelessness of existence. Her counterpart is found in the flaccid figure of Crepuscolo, who is portrayed as a flabby old man, resigned to a seemingly endless struggle, his strength spent. Movement is suggested in his posture, but it is in vain and without purpose.

Giorno (Figure 59), by way of contrast, reveals the Herculean strength of an athlete in the prime of life. With powerful muscular torsion the body rolls toward the wall behind, while the face betrays a raging anger symbolizing a revolt against the slavery to

Figure 59. Michelangelo. *Giorno* (Day), detail of Giuliano's Tomb. By permission of Giraudon/Art Resource, New York.

time. This wrathful figure with its tortuous, writhing, rotary movement expresses true Michelangelesque awe-inspiring *terribilità,* as do the twisted, soul-searching figures in the *Last Judgment. Day* is also a prime example of the master's particular version of the traditional *contrapposto,* the posture Panofsky calls the *figura serpentinata,* or "revolving view,"[31] which creates an impression of insecurity and instability quite in keeping with a character personifying the flow of time. Standing versions of the *figura serpentinata* are found in the "slaves" or "prisoners" of Giuliano's tomb with their powerful musculature as they seek to free themselves from their material and spiritual bondage.

The face of the appealing *Notte* (Figure 60) is bowed in shadow and her closed eyes denote sleep, but the expressive countenance and restless bodily posture tell of haunting, uneasy dreams. Night

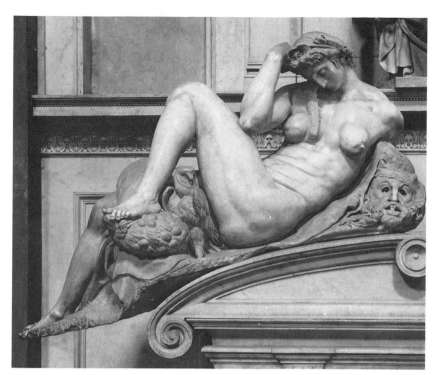

Figure 60. Michelangelo. *Notte* (Night), detail of Giuliano's Tomb. By permission of Alinari/Art Resource, New York.

always had a special significance for Michelangelo, and he refers to himself in his poetry as "son of the night" and "fruit of the night." But unlike the Job of the Old Testament, he does not curse the night that he was conceived. Darkness for him was a great germinal force, a brooding prelude to creativity, chaos preceding order, a fearsome striving from darkness toward light, a struggle from the depths of ignorance to the heights of knowledge, a progression from the vegetative condition of the body to a state of spiritual awareness and the clarity of reason. As he expressed it in poetic lines addressed to Night:

Wrong are all those who praise her qualities:
She is so dark, lost, lonely, that the birth
Of one small firefly can make war on her;[32]

And later in a sonnet dedicated to Vittoria Colonna, he writes:

> The *night* they gave to me and to my art
> That very day my body met my soul.
> Now like the one who blames his destiny,
> As night grows darker since it has begun,
> I, darker with the night, bemoan my fate.
> And yet, one thought is dear and comforts me—
> to warm my darkest hour within that sun
> Which on your birth was given you as mate.[33]

Love and beauty, then, are like the flicker of a firefly that momentarily lights the vast darkness that surrounds the human spirit.

Significantly, *Night* was the first figure to be finished and the only one of the four to have a detailed iconography. The crescent moon and star in the diadem bespeak the fecundity of Night, who appears as a mother figure (Figure 61). The owl (Figure 62) is also an attribute of Night, and in Christian art it is sometimes a sign of Christ because he sacrificed himself "to give light to them that sit in darkness and in the shadow of death" (Luke 1:79). There is also a bunch of poppies under her left foot, denoting fertility and dreams, while a tragic mask refers to man's dark destiny (Figure 63).

Notte was also the inspiration for a provocative poetic dialogue. Giovanni Strozzi, a scion of an old Florentine family, wrote a quatrain to the sculptor. Note his *double entendre* on the word "angel" (*angelo*):

> An Angel sculpted in this marble block
> The Night you now see sleeping sweet and deep:
> She is, therefore, alive, being asleep.
> Don't you believe me? Wake her up: she'll talk.

And Michelangelo answers in a corresponding quatrain:

> While all about are harm and shame and woe,
> How good to sleep and be but marble block!

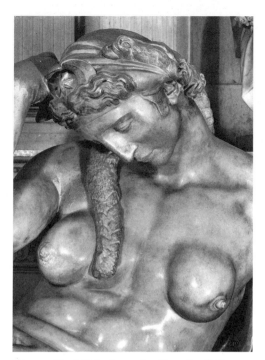

Figure 61. Michelangelo. Detail of *Notte.*
By permission of Scala/Art Resource,
New York.

Not to see, not to hear is my great luck;
So do not rouse me then, but please, speak low.[34]

Ever since the 19th century, these verses have been read as a
political protest. The Strozzis belonged to an anti-Medicean fac-
tion and, depending on the date of the poem, Michelangelo's reply
could be considered as a veiled social criticism. If 1545 is the cor-
rect date for the exchange, it would be protesting the tyrannical
regime of Duke Cosimo I. The more probable date, however, is
around 1523, soon after the carving was done. It would then be a
lament for the division of Italy caused by the successive invasions
of Francis I of France and the threats of the Spanish mercenaries
of the newly elected Holy Roman Emperor, Charles V. My own
feeling is that the earlier date is correct, but that the poem was

Figure 62. Michelangelo. Owl, detail of
Notte. Courtesy of Gabinetto Fotografico
Nazionale, Florence.

Figure 63. Michelangelo. Tragic mask,
detail of *Notte.* Courtesy of Gabinetto Fo-
tografico Nazionale, Florence.

written in Michelangelo's usual ironic vein as he was being pressed to finish the job just after Clement VII was elected pope in 1523. Furthermore, since Michelangelo envisaged himself as "the son of the night," he saw her sculptured body as the prison of her soul, and his words then give voice to his own morose, melancholy platonic musings on the frustrations and transitoriness of life and the longing for the serenity of an ideal world.

Above these four forms representing the all-devouring power of time and constituting the apex and climax of the triangular composition rise the ducal statues as great personages who have conquered the temporal realm. As Michelangelo wrote on a drawing for the tomb of Lorenzo:

The Day and the Night speak and say:
"With our swift course we have led
Duke Giuliano to death.
Now it is right that he should take his revenge as he does.
And his revenge is this:
Because we have killed *him*,
He, being dead, has stolen the light from us and,
 by closing his eyes,
Has closed our own, which now no longer shine on earth.
What, then, would he have done for us, if alive?"[35]

And there is a further comment on a drawing for Giuliano's tomb: "Fame holds the epitaphs of the dead; she moves neither forward nor back because they are dead and their labor is at a standstill."

Lorenzo's elbow rests on a closed cashbox, signifying the saturnine temperament. His fingers are held to his mouth in a gesture of silent meditation. It was Vasari who first referred to the statue as "The Thinker," and it was obviously the inspiration and model for Rodin's famous figure of that name. Here the iconographical reference is clearly to the introverted, contemplative side of life. Giuliano, as his opposite number signifying the active life, is alert as if responding to a call. In his hands are several coins indicating his outgoing, extroverted personality. Indeed, he seems to be speaking to the viewer in the very words of one of Michelangelo's poems:

Happy am I at each your courteous call,
Bidding my spirit rise where time can flit
No more, where I can gaze upon my God.[36]

By avoiding actual portraiture from life, Michelangelo was able to endow his figures with greater grace and grandeur, thereby achieving a higher truth than more exact representations could provide. The costumes are also not of their own time but of a triumphing, all-conquering Roman emperor. The eyes of both Lorenzo and Giuliano gaze toward the altar, where, flanked by the two Medici patron saints Cosmo and Damian, Mary is nursing the child Jesus (Figure 64). Above them there was to have been a fresco depicting the resurrection of Christ. Thus the architectural framework, the design of the tombs with their sculptured figures, the iconographic scheme focusing on the contemplation of the divine truth all come together in a single, climactic physical and spiritual whole.

Grand Architectural Finale

Michelangelo was in his 60th year when his friend and admirer Cardinal Farnese was elected Pope Paul III in 1532. The great artist then returned to spend the rest of his life in Rome, where he enjoyed honorary citizenship, was venerated by the populace as *Il Divo* (the divine), and was among an intimate circle of friends that included Vittoria Colonna, the Marchioness of Pescara, and the young Roman nobleman Tommaso Cavaliere. During Paul's 15-year pontificate Michelangelo had a learned, art-loving, humanistically inclined patron whose admiration for the master was unbounded. It was Paul who commissioned the Sistine Chapel's *Last Judgment*, then the frescoes in the adjacent Pauline Chapel. After that came a succession of architectural projects that were rapidly changing the face of Rome from a haphazard medieval morass into a shapely Renaissance metropolis. The most monumental of these were the redesigning and rebuilding of the Capitoline Hill; the completion of Paul's family home, the Farnese Palace; and, of course, the building of the new Basilica of St. Peter. Collectively,

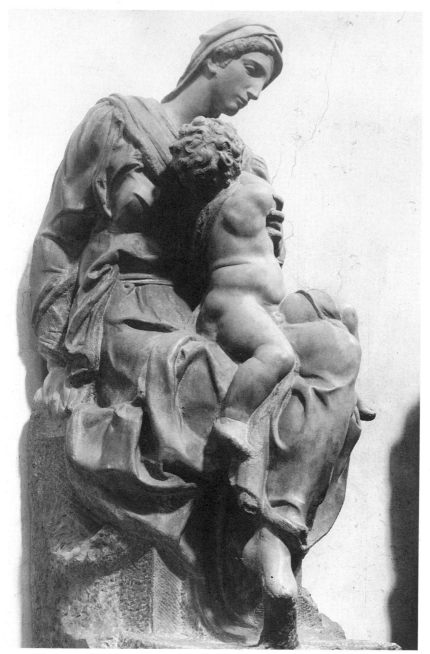

Figure 64. Michelangelo. Altar. Medici Chapel, Florence, 1521–34. Detail. Marble, height 7′ 6″ (2.26 m). By permission of Marburg/Art Resource, New York.

they were destined to define the now-familiar profile of the Eternal City's skyline.

It was with considerable reluctance that Michelangelo undertook the staggering task of continuing the work on St. Peter's. But once the die was cast, the master moved with religious zeal on this pilgrim's progress that occupied him until his final hours. Michelangelo always approached his buildings as living, breathing organisms rather than as cool mathematical abstractions. Hence the edifices have an animation and dynamism all their own. For St. Peter's, he rejected the plan of his immediate predecessor Antonio da Sangallo that called for an extended vestibule entranceway with lofty bell towers in front and reverted to a variant of Donato Bramante's original idea of a centralized Greek-cross domed structure. With a square enclosing a circle, Michelangelo's ground plan and super-structure had the simplicity and elegance of the union of these two most perfect geometrical figures. In Michelangelo's inspired hands, however, the proportions were shaped with a sculpturesque approach in a rhythmic flow of open and closed spaces.

The full implications of Michelangelo's contribution to the basilica will be discussed in the following chapter. Here it is sufficient to say that the master conceived the edifice as a titanic struggle between opposing forces—the soaring spirit of man versus the material masses that hold him down (Figure 65). As with all Michelangelo's major monuments, the theme was the platonic concept of the soul being held prisoner by the body. Man's ultimate destiny was the release from earthly bonds, the victory of the spirit over matter, the limitless over the limited, eternity over the ebb and flow of time, immortality over mortality.

Vertically the final ascent starts with the ribs of the dome that rise irresistibly to the lantern at the apex, which is surmounted by the perfect form of the sphere symbolizing the completion of the universe and above it the cross alluding to redemption. The three vertical leaps from the substructure to the mid- and superstructure are here resolved in the timeless geometry of the orb and cross as the Alpha and Omega, the beginning and the end, of the platonic *ritorno a dio,* or union with God. Poetically and philosophically Michelangelo achieved the ultimate resolution of the Dan-

Figure 65. Michelangelo. St. Peter's, Rome. Apse and dome, begun
1547. Height of dome 452′ (137.77 m). By permission of Marburg/Art
Resource, New York.

tean ascent of man from purgatory to paradise and the platonic rise from earthly confines to eternal freedom; from spatial limitations to infinity, from the bonds of time to timelessness.

Thus it was that form united with meaning in Michelangelo's oeuvres, and the twain were knit together into one seamless fabric. Such was the tie that binds all his works together—sculpture and architecture, poetry and painting. With St. Peter's, the master's touch was able to make visible the invisible world of ideas. Here in the timeless geometry of space, the tragedy of the tomb was transcended and the victory over human bondage finally won. In this mode of personal synthesis there walked, in truth, a man for all seasons and for all centuries.

S I X

Birth and Progress of the Baroque: The Stylistic Mode

THE BAROQUE PERIOD WAS one in which irresistible modern forces met immovable traditional objects. Out of all the theological conflicts, philosophical discussions, scientific arguments, social tensions, political strife, bitter warfare, and artistic creation came both the baroque style and the beginnings of the modern age. While the baroque period is mainly centered in the 17th century, its extreme limits extend from the mid-16th to the mid-18th centuries, or to put it into human terms, from late Michelangelo to Bach and Handel. During this span of time, a number of crucial changes took place. The concept of the world moved from an earth-centered to a sun-centered universe. Philosophical speculation turned from metaphysics to a naturalistic world view. The fundamental processes of thought shifted from the acceptance of authority on faith to the beginnings of scientific experimentation. The unity of Christianity symbolized by one universal church was now opposed by a number of Protestant sects. The theoretical political unity of the Holy Roman Empire gave way to a balance of power distributed among a rather quarrelsome family of nationalistic states.[1]

From this fermentation arose a distinct and discernible baroque style, and at this point the approach to the stylistic mode of interrelationship clearly calls for a definition of the concept. Stylistic analysis entails the search for and sorting out of certain common characteristics, attitudes, and meanings shared by the major architects, artists, writers, and composers of a given time and place. Individual artists are said to have personal styles when their vocabularies, idioms, and craftsmanship lead to the recognition of their art as uniquely their own. Rembrandt, for instance, has an unmistakable personal style based on his choice of subjects, his particular color pallette, his emotional spectrum, and above all his way of handling light and shade.

Moving from the particular to the general, a style in the larger historical sense, such as Renaissance or baroque, becomes apparent when each and all the arts of an era or locale show certain common features that can be classified as conventions, formulas, patterns, or tendencies. The very concept of style presupposes a commonality and relationship among the works of art in a given place and time based on established patterns of expression, commonly accepted vocabularies, and generally understood conventions—in short, the sum of all the factors that make it possible for the works of various artists to be understood by their contemporary audience.

Such a situation by no means rules out the expression of individuality, caprice, and personal touches. It merely points to a balance between samenesses and differences, between convention and invention. If all an artist's output is based on a conventional sameness, the work would be dull and boring. If all the works are departures, inventions, and innovations, the total effect will be quite bewildering.

Within a given stylistic context, there is always a conflict between stable and unstable forces, static and dynamic tendencies, evolutionary and revolutionary factors. Art, like politics, has its reactionaries and conservatives, who are content with previously established past traditions; liberals, who work with greater freedom within the structure of a common vocabulary of formal conventions and accepted symbols of their period; and progressives, radicals, or revolutionaries, who cultivate change for its own sake,

depart from the currently accepted order, and hope to lead the arts into a projected future. All these approaches are apparent in past styles. A style, then, by definition presupposes a relationship among the various art media, because they share a common locality, a focus in time, a background of ideas, similar sources of patronage, and general sociocultural patterns.[2]

This study of the birth and progress of the baroque will begin with a review of the new scientific worldview, as well as the conscious departure by architects, visual artists, and composers from the Renaissance ideal of stability, symmetry, and the harmonious reconciliation of opposites. The baroque reflects the expansion of space brought about by the new astronomy of Galileo and Copernicus and the exploration of new worlds by navigators. As the finite world gave way to the infinite, a new awareness of the flow of time arose with a feeling of urgency, transitoriness, and dynamic movement. The Renaissance description of nature yielded to dramatic illusionism and visionary flights of the imagination. The single vanishing-point perspective of Renaissance painting was replaced by broken-up, multiperspectives, while the balanced pictorial forms gave way to slashing diagonal accents and swirling pyramidal compositional forms.

We will then follow the evolution of the structure of the new Basilica of St. Peter in the Vatican as it extends from Bramante's initial static idea of a synthesis of the Greek Parthenon and the Roman Pantheon to the tremendous dynamic pile bequeathed by Michelangelo and Bernini. We will pause to listen to the Roman "colossal baroque" music that attempted to fill the awesome building with vibrant sound. The unified four-part choral practices of the Renaissance were later replaced by the restless Venetian *chori spezzati*. Here the full choir was opposed successively by the component parts of a second choir as well as solo voices. This new concerting style in instrumental music paralleled this development, as a full ensemble alternated with a *concertino* part made up of one or more individual instruments. We will follow the progress of the baroque as it traveled from Rome with the erecting and decorating of churches and palaces westward to Spain, northward to France, England, southern Germany, Austria, and thence to the new world of the Americas.

Baroque Panorama

Baroque art was born in a period that has variously been called the Age of Reason, the Age of Exploration, the Age of Observation, and the Splendid Century. The 17th century was all of these and much more. In the late 16th century it was already evident that a transformation in man's ideas about nature and the universe was coming about. Before Copernicus, Galileo, and Kepler, the prevailing view of the universe was that of a spherical shell "thick inlaid with patines of bright gold." This expanse of stars circled eternally around the earth, and beyond it rose the *habitaculum Dei et omnium electorum*—the mansions of God and his chosen ones. The baroque scientific revolution involved the relationship of the earth, the sun, and the other celestial bodies. Galileo's telescopic observations supported the Copernican theory of a solar system in which the earth revolved about the sun instead of vice versa. When baroque man came to realize that his hitherto serene and immovable earth was but a cosmic speck of dust whirling around the sun together with the other planets, and that the limits of the universe were only those of his own unaided vision, a whole new world view presented itself. *The Starry Messenger,* Galileo's book of 1610, struck the intellectuals of his time like a bolt from the blue. Within months its revelations were being discussed all over Europe, and within a few years copies found their way as far afield as Beijing. *The Starry Messenger* was destined to usher in a new age in which the finite gave way to the infinite. The static Euclidean geometry had to be replaced by a new mathematics that could take motion and infinity into account, thus leading to Isaac Newton's and Baron Leibniz's simultaneous invention of the integral calculus.

Pope Urban VIII, who as Maffeo Barberini was a fellow Florentine and student with Galileo at the University of Pisa, had supported the scientist's researches as long as they were merely theoretical speculations. But as pope, when the new world view was sweeping all before it, he felt compelled to endorse the traditional dogmas of the Roman Catholic Church. Galileo, consequently, had a life-long confrontation with the traditional-minded clergy. The new astronomy, however, found fertile soil in the Reformation countries of northern Europe, and particularly in the British and

Dutch universities. It became the basis for speculations on terrestrial and celestial mechanics by Christopher Wren and Isaac Newton. The 17th-century vocabulary is still in use, for instance, in describing the features of the moon. When Galileo first saw our satellite through his telescope in 1609, he described the dark, shadowy areas as *maria,* or seas such as the Sea of Tranquility and the Sea of Storms. And the new imagery appeared in English letters in the poetry of John Donne and the so-called metaphysical poets and later in that of John Milton. Donne's famous lines from *An Anatomie of the World: The First Anniversary* (1611) were:

And new Philosophy calls all in doubt,
The Element of fire is quite put out;
The sun is lost, and th' earth, and no man's wit
Can well direct him where to looke for it.

The new infinite baroque world, as revealed through the telescope and microscope, shattered the idea that the earth and humanity were the center of the universe. It also released human imagination to soar through unlimited expanses and gave the European consciousness a new intellectual and emotional freedom, since the exploration of the human soul is just as important and vast as the study of the universe. Descartes was the philosopher who first articulated the cosmic discoveries of Galileo and Copernicus in terms of their consequences for the human psyche. If the Copernican revolution turned the cosmos inside out, with the sun as the new center of the solar system, the Cartesian revolution effected a new individual-centered instead of God-centered inner world. Descartes's declaration, "I think, therefore I am," and his statement that only the things that the mind perceives clearly and distinctly were true required a redefinition of selfhood, of the individual in personal relationships with others, of a person's role in society, and of a human being's place in the universe. For the artist "I think, therefore I am" becomes "I feel, therefore I am," because art, music, and literature must always be revealed in perceptual terms as expressed through personal senses and sensibilities.

Time, which Plato so eloquently described as the moving image of eternity, became of greater importance when the medieval and

Renaissance emphasis on the eternal gave way to preoccupation with the transitory. In his perceptive book *Technics and Civilization*, Lewis Mumford declares that "The clock, not the steam-engine, is the key-machine of the modern industrial age."[3] Primitive forms of mechanical clocks, of course, dated back to the monasteries of late medieval times. But when the clock and pocket watch became common in the baroque period, a real revolution was in progress. "Timekeeping," as Mumford states, "passed into time-serving and time-accounting and time-rationing. As this took place, eternity ceased gradually to serve as the measure and focus of human actions."[4] As the clock replaced the sun as the regulator of human life, the new time consciousness shifted from seasons and months into measurements of hours, minutes, and seconds. There was thus a new sense of urgency and concern with the more immediate passage of time in personal affairs. The ideal of making life as regular as clockwork and translating time into money dates from the baroque period. One has only to glance at some of the amazingly ingenious clocks to grasp their significance. In some, the hours were personified by doll-like figures that paraded with automatic precision. In others, the hours were twittered off by gilded birds or the tinkling of music boxes. Above all, they were mechanically precise and accurate. So much did the mechanical image of time take hold that both Newton and Leibniz projected a universe in the form of a colossal machine with God as a kind of cosmic clockmaker who created, would up, and regulated the world. These new concepts of space and time set the stage for a new worldview and new styles in the arts.

While Galileo was training his telescope on the heavens, others were peering into microscopes. Atomism, or corpuscularianism, as the 17th-century scientists called it, became the microscopic counterpart of the Copernican macrocosm. While the microscope did not make such a sensation as Galileo's telescope, it nevertheless flashed significant light on the obscure corners of plant and animal life. The minute and accurate treatment of the world of appearances in the still-life studies of Flemish, Dutch, and German painters amply supports the designation of the 17th century as the age of observation.

All these developments brought about a quickening in the pulse of human affairs, and the baroque period was accompanied by dynamic movement, passionate intensity, and ceaseless exploration of space and time. Baroque art was essentially a synthesis of diverse trends inherent in a restless, expanding age of geographical exploration, scientific discovery, and religious regeneration. In Roman Catholic countries the image of this brave new baroque world was expressed in liturgies staged like theatrical pageants, architectonic crescendoes of light refracted from alabaster and gilt-bronze surfaces, gardens with vast vistas, parks populated with stony nymphs and silent satyrs, and ceiling frescoes that dissolved the masonry and opened church interiors and palatial rooms into heavenly apotheoses of saints or Olympian deities. Andrea Pozzo's mural *St. Ignatius in Glory* (see Plate III), for instance, vividly demonstrates how a baroque ceiling dissolves into a cosmic vision of figures ascending to empyrean heights.

Such precipitous intellectual and artistic progress and the flood of new knowledge did not go unchallenged. The period was rife with struggles and tensions. In this age of discovery, the new science of optics was accompanied by the development of pictorial illusionism and theatrical transformation scenes. The mechanical revolution brought about a renewed spiritual resurgence. The new material universe was opposed by the belief in miracles. Reason and logic vied with faith and mysticism, reality with dream worlds.

Reverberations of the great religious crisis that had split Europe into Reformation and Counter-Reformation camps in the 16th century were still heard from all sides. Within the ranks of Protestantism were found traditionalist and pietistic sects that were at odds with one another. Within Roman Catholicism the conservative and more liberal forces were at work. The spiritual interpretation of the universe was indeed threatened by the new mechanistic materialism. The rationalism of the scientists was challenged by the militant mysticism of such Counter-Reformation saints as Theresa of Avila, John of the Cross, and Ignatius Loyola, who founded the Jesuit order or Society of Jesus. In France the Jesuits and Jansenites were at opposite poles, while England was

split by the Great Rebellion with the proponents of Parliament pitted against those upholding royal absolutism. The international view of the Church of Rome conflicted with the rise of sovereign national states. Within the new states, there was the internal struggle between provincial aristocratic prerogatives and more centralized governments, as well as the tensions between the landed nobility and the growing wealth and power of the merchant class. It is hardly a cause for surprise, then, that the baroque became a style of restless oppositions, of uneasy equilibriums, of violent clashes, of polarities brought momentarily into precarious balance, and of passions brought briefly under control.

Building St. Peter's Basilica

One aspect of the baroque had its inception in the mighty proportions Michelangelo projected for St. Peter's Basilica, which went far beyond Renaissance thinking. The edifice is the work of a succession of 13 architects serving under 20 popes over a century and a half. When Julius II ordered the demolition of the early Christian church of Constantine in 1505, he had no particular plan in mind except that the new church be grand in scale, provide space for his colossal tomb, which Michelangelo was then designing, and enclose all the sacred precincts. Bramante, the original architect, projected a domed central structure that was to pile the Pantheon on top of the Parthenon, as he expressed it. His immediate sucessors, including Raphael, made little progress. And Michelangelo, the seventh architect, got as far as the base of the dome at the time of his death in 1564. Carlo Maderno later added the long nave and imposing façade. Finally Gianlorenzo Bernini finished off the grand design by a spectacular elliptical approach with its fourfold colonnade surmounted by statues of saints marching like holy pilgrims in stately procession toward the grand entrance.

This momentous pile is at once the focal center of Roman Catholic Christendom and a pantheon of saints from Peter, the first apostle, to the present time. The site is also the stage, along with its early predecessor, Old St. Peter's, on which almost 2,000 years

Figure 66. St. Peter's, Rome. View of apse. Drawing by S. du Perac after a drawing by Michelangelo.

of sacred and secular historical drama were played. Until the 20th century its five-and-one-half acres of enclosed space marked it as the largest building on earth. And up to the advent of the skyscraper, the 455-foot-high dome and lantern tower stood as the world's tallest structure.

This architectural pilgrim's progress begins with the exterior of the apse (Figure 66) with its gigantic Corinthian pilasters, and continues with the massive supports of the four mighty pillars that support the dome. The tremendous size of these 60-foot square piers can be grasped when it is realized that the whole of Borromini's church of San Carlo alle Quattro Fontane would fit into one of them with room to spare. These massive blocks of masonry move upward to the huge pendentives that mediate between the square ground-level area, symbolic of the earth, and begin the transition to the circular rim of the drum on which the high-pitched dome rises heavenward (Figure 67).

Moving forward along the ground plan chronologically and horizontally, Bramante's and Michelangelo's centralized domed basilica, surrounded by the equal wings of the Greek cross, eventually yielded to Maderno's long-naved Latin cross plan. The shift came about partly because of the urgings of the Council of Trent

Figure 67. St. Peter's, Rome. Aerial view of
apse and dome, begun 1547. Courtesy of the
Vatican Photographic Archive.

for a return to the traditional Western church plan, partly owing
to the need for larger spaces to accommodate the ever-increasing
population of Rome and the growing influx of pilgrims, as well as
the desire for ever-grander papal processions and ceremonials.
The genius of Carlo Maderno was in his reconciliation of these
diverse directions of thought with a structure that was more than
half finished. That his solution was only partially successful was
inevitable.

In the interior of the nave, the reduced scale from Michelan-
gelo's expansive proportions is noticeable as one enters through
the front portals. On the exterior, the full effect of Michelangelo's
unified composition is visible now only from the apsidal side, since

it is marred from the front approach by the uncomfortable illusion that the dome, partially eclipsed by the nave, seems to be tipping backward. The major features of baroque church architecture, however, are present in Maderno's façade and nave interior: the emphasis on the whole rather than on the separate parts of the spatial composition; the activation of interior space by the setting up of the rhythmic alternation of pilasters and wall reliefs; and the flowing movement of lines and light to accent points of climax.

Bernini and St. Peter's

If Michelangelo's dome dominates the vertical axis and the exterior silhouette of St. Peter's Basilica, Gianlorenzo Bernini's gigantic colonnaded approach, his huge canopy over the papal altar, and his majestic Throne of St. Peter in the apse sweep all before them in the horizontal dimension. The sheer immensity of his conception had to correspond to the vast dimensions of Christendom's largest edifice. And the colonnades at the beginning, together with the Cathedra and Glory in the apse over one-third of a mile away, constitute the longitudinal axis of the grand design.

The spacious elliptical piazza, with its heroic parade of mammoth columns, was executed during Bernini's peak years of 1656 to 1667. It comprises some 284 Doric pillars, set in double rows four abreast that allow for a shaded ambulatory between. Above and crowning the entablature, a single file of 96 statuesque saints and martyrs of heroic dimensions marches toward the basilica. By means of some complex perspective computations, there is a single point toward the center at which all the lines converge so that only the inner row of columns is visible. The elliptical area then narrows into an irregular trapezoid or rhomboid, called the Piazza Obliqua, immediately before the façade. While the scale of the collonades is baroque in its sweeping design, the decorative detail is simple to the point of austerity. Bernini was far too shrewd a dramatist to steal his own thunder, which was wisely reserved for the climactic interior.

An adaptation of one of Bernini's drawings (Figure 68), together with his own commentary, shows how he conceived the overall completed edifice in human rather than superhuman

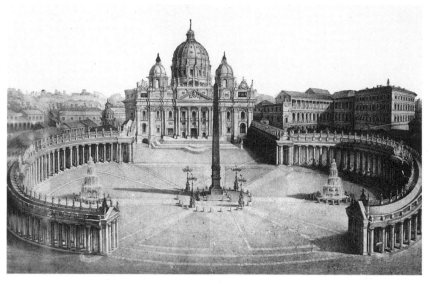

Figure 68. St. Peter's, Rome. Colonnades, piazza obliqua, and façade, 1659–66. After a drawing by Gianlorenzo Bernini. Courtesy of the Vatican Photographic Archive.

terms. Michelangelo's magnificent dome becomes the head, the basilica itself the torso, while the outstretched colonnades complete the image of Ecclesia, or Mother Church, "with arms wide open to embrace" as Robert Browning wrote, "the entry of the human race."

As one enters through the impressive bronze portals (Figure 69), the eye is first arrested by the sheer immensity of Maderno's spacious nave, then swept along toward Bernini's Baldachino, the sculpturesque papal altar complex directly beneath the great dome, and finally to the impressive Cathedra, or Chair of St. Peter in the exact axial center of the apse, again one of Bernini's multimedia extravaganzas.

Spreading canopylike over the papal altar and resting on marble plinths decorated with the three bees of the Barberini coat of arms, the four mighty bronze twisted columns of the Baldachino spiral upward a full 100 feet toward Michelangelo's lofty cupola. The order is the classical combination of the voluted Ionic and foliated Corinthian in a style known as Composite, with sunbursts in the center thrown in for good measure. The bronze

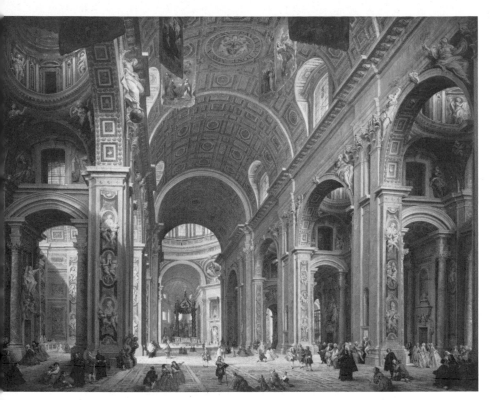

Figure 69. St. Peter's, Rome. Nave interior, 1607–26. Engraving. Courtesy of the National Gallery of Art, Washington, D.C. Alisa Mellon Bruce Fund.

shafts are garlanded with vines in gleaming gilt. Inside, directly over the altar, is the dove of the Holy Spirit with golden rays spreading out toward the simulated drapery decorated with a pattern of the Barberini heraldic bees alternating with winged cherubs. On the entablature are pedestals on which four angels stand with festoons in each hand. Between them are pairs of seated cherubs, one holding the keys of St. Peter, the other the papal tiara. Crowning the whole composition is a gilded orb surmounted with the cross. Bernini's corkscrew columns, derived from slender early Christian prototypes that symbolized the grapevine and alluded to the sacramental wine, soon became a leitmotif of baroque religious art. Adaptations began springing up all over Roman Catholic Christendom, from Europe to the colonial dominions overseas.

Complementing the great Baldachino is the Cathedra of St. Pe-

ter in the axial center of the apse. As seen from the entrance portal some 600 feet away at the opposite end of the basilica, the Cathedra appears as a colorful picture enframed by the writhing pillars of the Baldachino. Only on closer inspection can the immense scale be comprehended. The principal material is gilded bronze to match the Baldachino, but Bernini goes considerably further in creating a baroque mixed-media extravaganza. The base, which encompasses the high altar, is an elongated block of rich polychromed marble (Figure 70). On it stand the heroic-sized bronze statues of the four great church fathers. The two wearing bishop's mitres are Saints Ambrose and Augustine, while the two bareheaded figures are the Eastern patriarchs Saints Athanasias and John Chrysostom. Above them, surrounded by stucco clouds, hovers the bronze throne of St. Peter (his ancient wooden chair is said to be enclosed within). This apotheosis of the papacy proclaims the primacy of the popes and Rome as the center of Christianity. Over it two angels are poised with the papal keys and triple tiara, while above them is a Glory, with the heavenly host clustered around an oval, translucent, yellow alabaster window that silhouettes the image of the Holy Spirit in the form of a dove. A mellow golden light streams outward as Bernini's gilded-bronze shafts capture the sunlight suffusing the entire choir section with a soft golden glow.

Colossal Baroque in Music

There is also a contemporary musical counterpart to this vast paean to space, in the acoustical experiments and polychoral practices of the Roman and Venetian composers of the time. With the division of choral and instrumental forces into two or more separate groups deployed in various parts of a large church so that they could answer and echo each other antiphonally, many new and fascinating sonorous possibilities came into play. In the early 17th century Virgilio Mazzochi wrote a mass for St. Peter's in Rome that was described by his contemporaries as a *gran musicone*. Multiple choirs were distributed laterally along the nave, while vertically an echo choir was placed in the large gallery at the base of the dome high above Bernini's 100-foot Baldachino over the papal altar. Farther up on top, a double echo choir was located at

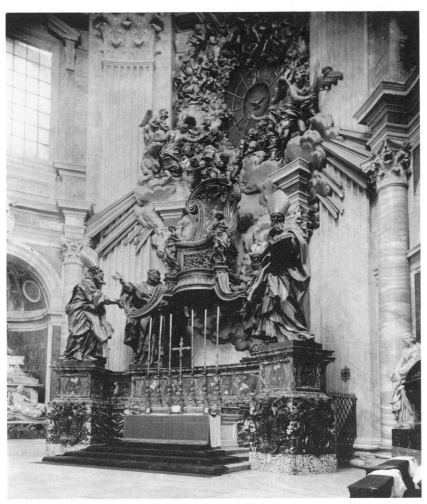

Figure 70. Gianlorenzo Bernini. Throne of St. Peter, 1657–66. Gilt bronze, marble, and stucco. Apse, St. Peter's, Rome. Courtesy of the Vatican Photographic Archive.

the base of the lantern tower some 400 feet above the pavement below.

Orazio Benevoli was one of the authentic practitioners of the so-called colossal baroque style, as exemplified in his 53-part mass for the dedication of the Salzburg Cathedral in 1628. The full score, measuring some two feet nine inches in height, gives at least a physical idea of its massiveness. Musically, the work includes two

8-part choruses, each with separate *continuo* and solo quartets. There are also six instrumental ensembles—two with strings, one for woodwinds, and three for brasses. Two groups of trumpeters with tympani are marked *in loco* to indicate their placement on opposite sides of the cathedral chancel. The most dramatic moment comes with the Gloria: Glory to God in the highest, and on earth peace to men of goodwill. Benevoli skips the first phrase altogether and starts off with the words: *et in terra pax.* Throwing all the choirs and soloists together in one great outburst, he has them shout in pleading tones over and over again that single word *pax, pax.* In 1628 Germany and Austria were already a decade into the Thirty Years War, one of the most bloody and devastating in European history. So prayers for peace had a particular poignancy for the people of that time.

Later, when Benevoli became *maestro di cappella* at the Vatican, he composed another grandiose mass for the Roman church of Santa Maria sopra Minerva. This time it was in 48 parts, with 150 choristers and soloists distributed in 12 choirs that echoed and reverberated around the vaulted spaces with telling effect. One ear-witness to such a performance, André Maugars, a viola player and politician-musician attached to the French court as secretary to Cardinal Richelieu, wrote:

> This church is rather long and spacious and has two large organs erected to either side of the main altar. Two choirs were placed near these. Along the nave were eight more choirs raised on scaffolding eight or nine feet high. . . . The master composer beat the principal measure for the first choir, composed of the most beautiful voices. For each of the other choirs there was a man who did nothing but keep his eyes on the original beat to make his choir conform. In this way all the choirs sang together without dragging.[5]

The results of such explorations of sound in space permeated the entire baroque style and led to such standard dramatic effects as the echo nuance and the instrumental structure of the *concerto grosso* with its interplay between the *ripieno,* or full ensemble, and the smaller *concertino* of solo instruments. As Manfred Bukofzer

has aptly remarked, "Rarely again have music and architecture been so closely associated as in the baroque period when space as such became an essential component of musical structure."[6]

Spread of Bernini's Illusionism

Bernini the magician is again seen at work in the *Scala Regia*, the staircase that connects the Vatican Palace with St. Peter's (Figure 71). Through illusionistic perspective, Bernini creates a vista of vast depth and boundless continuity in a space but half its seeming size. This marvel of palatial scenic design is accomplished by making the wide steps gradually shallower toward the top and by drawing the rising double file of Ionic columns imperceptibly closer together as they diminish in height. As the name implies, this royal flight of steps is used on ceremonial occasions by visiting heads of state to approach the papal reception rooms. The visitor first passes through a triumphal arch emblazoned with pontifical heraldry, while two figures personifying fame blow a silent fanfare on their trumpets. At the second level, under a descending flood of light from overhead apertures, Bernini's equestrian statue of Constantine is discovered on the right (Figure 72). The emperor is shown as he approaches the battlefield. The horse rears up as Constantine beholds the image of the cross in the heavens bearing the words *In Hoc Signo Vinces*—In this sign you will conquer.

Bernini's earliest biographer, Filippo Baldinucci, remarked that it was "common knowledge that he was the first who undertook to unite architecture, sculpture, and painting in such a way that they together make up a beautiful whole"[7] Bernini mobilized all the possibilities of the many media at his command in order to make a maximum assault on baroque sensibilities. Even in his early work Bernini revealed an impatience with the limits imposed by the sculptural medium. In his hands marble took on a new meaning and his designs approached a pictorial plasticity comparable to painting. In architecture, Bernini handled masses and voids in an almost sculpturesque fashion. His edifices seem to be cut out of the surrounding space much as a sculptor carves a marble block.

This reaching out into regions above and beyond matter and

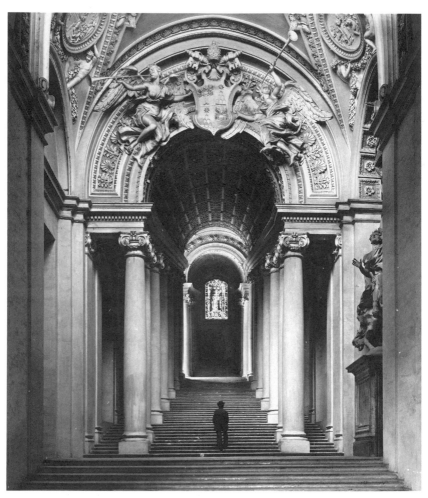

Figure 71. Gianlorenzo Bernini. Royal staircase, 1663–66. The Vatican Palace, Rome. By permission of Alinari/Art Resource, New York.

medium was the aesthetic equivalent of the new Jesuit psychology. Bernini was both temperamentally and spiritually attuned to the Jesuit teachings, and regularly practiced the Spiritual Exercises of St. Ignatius. By opposing austerity in religion, the Jesuits were trying to bring the pursuit of worldly gains into a balance with spiritual benefits. Their appeal to the senses as well as to the popular feeling for festivity, pageantry, and drama, their emphasis on sensory experience as the means of evoking more vivid imagery

and more intense spiritual experience, created a new climate for the arts. It was in this sunny atmosphere that Bernini's genius flourished.

Just as the baroque social and religious orientation broke down the barriers between the visible and visionary, reason and faith, natural and supernatural, material and spiritual, so Bernini broke down the distinctions between reality and art; architecture and sculpture; marble, bronze, and stucco; sculpture and painting. In so doing, he was able to open up new worlds of the mystical and

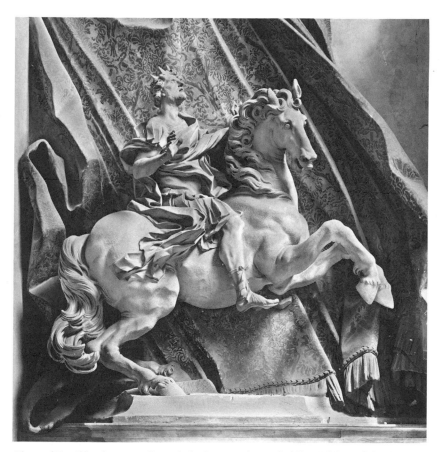

Figure 72. Gianlorenzo Bernini. *Constantine Beholding Vision of the Cross,* 1654–70. Marble, monumental size. Main landing, royal staircase, the Vatican Palace, Rome. By permission of Alinari/Art Resource, New York.

miraculous. Furthermore, with Bernini the beholder does not remain outside like an innocent bystander, but is actively drawn into the orbit of the event and experiences it from the inside as an actual participant. In all such projects, the eye must surrender to the illusionary conventions. In so doing the whole takes precedence over the particular parts, the complete design over the industrial figures, and the dramatic impact over the incidental subject matter.

Something of Bernini's formidable reputation can be gleaned from the diary of John Evelyn, an English visitor to Rome at the time. He was dazzled by Bernini's virtuosity and versatility, and in his quaint and inimitable 17th-century prose he notes: "Cavaliero Bernini, a Florentine Sculptor, Architect, Painter and Poet: who a little before my coming to the city, gave a Publique Opera (for so they call those Shews of that kind) where in he painted the Seanes, cut the Statues, invented the Engines, composed the Musique, writ the Comedy and built the Theater all himselfe."[8] In retrospect, this tribute is a bit too generous, although it is known that Bernini wrote theater pieces (six comedies have recently been published) and that he also designed scenic spectacles. But some professional composer undoubtedly provided the music, and the Teatro delle Quattro Fontane, accommodating some 3,000 persons, was definitely designed and built by Pietro da Cortona.

Evelyn also gives us a lively glimpse of Roman baroque pomp and pageantry with his description of a papal parade on the accession of Innocent X, Urban VIII's successor, in 1644.

> First went a guard of Swizzers, next follow'd those who caried the robes of the Cardinals . . . then the Cardinals Mace bearers . . . The masters of their horse: The Popes Barber, Taylor, Baker, Gardner, and other domesticall officers all on horse back in rich liveries: . . . 5 Trumpeters: . . . After them 14 drums . . . Six of his holynesse's Mace-Bearers: . . . Then next the Pope himself carried in a Litter, or rather an open chaire of Crimson Velvet richly embrodered, and borne by two stately Mules; as he went holding up his two fingers, and blessing the people and multitudes upon their knees, looking out of the windoes and houses with lowd viva's and accla-

mations of felicity to their new Prince: . . . The night ended with fire-workes; . . . Thus were the streetes this night as light as day, full of Bonfires, Canon roaring, Musique pla[y]ing, fountaines running Wine in all excesse of joy and Triumph."[9]

Bernini's flights of sculptural fantasy were paralleled in painting by a school of pictorial illusionists also at work in Rome—most notably Pietro da Cortona, Giovanni Battista Gaulli, and Andrea Pozzo. In his ceiling fresco for the barrel-vaulted nave of the church of Sant' Ignazio, Pozzo brought all the theories and practices summarized in his influential treatise to bear on *St. Ignatius in Glory* (see Plate III). Through the use of bold aerial perspective and extraordinary foreshortening, the sky seems to open up, while the saint spirals upward from the earth to heaven, where he is received by an angelic choir. Beams of light illuminate the convergence of the simulated architectural lines, just the way Pozzo advised his fellow painters "to draw all points thereof to that true point, the Glory of God."[10]

Borromini's Dynamic Geometry

After the death of his generous patron, Bernini was still occupied with many unfinished projects, including that of Urban VIII's monumental marble tomb in the nave of St. Peter's. But his star was temporarily in eclipse, while that of his archrival, Francesco Borromini, was in its ascendancy. Borromini had already made a great reputation with his ingenious and gemlike church of San Carlo alle Quattro Fontane. Now, however, new commissions were forthcoming for the reconstruction and renovation of the basilica of San Giovanni in Laterano, the continuation and finishing of Sant' Agnese in Piazza Navona, and the building of the Oratory of St. Philip Neri. Among his projects of this time was the chapel for the college of the Sapienza, later a part of the University of Rome. It was dedicated to St. Yves, patron saint of lawyers, and placed at the end of a handsome courtyard previously built by his colleague and kinsman, Carlo Maderno (Figure 73).

Bernini had always thought of architecture as the stage for his

bold, dramatic innovations in the sculptural field. Consequently, his designs remained within the more conservative classical Renaissance heritage. What Bernini had done with sculptural space, Borromini was to accomplish in the architectural domain. It was Borromini, with his dynamic geometry, who made the breakthrough into the more imaginative phase of the baroque style.

Sant' Ivo alla Sapienza is generally acknowledged to be Borromini's masterpiece. For its iconography, the architect looked to the Book of Proverbs: "Wisdom [*sapienza*] hath builded her house, she hath hewn out her seven pillars . . ." (9:1) The words are familiar to modern readers from the title of T. E. Lawrence's *Seven*

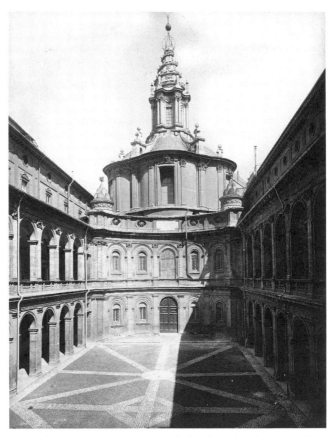

Figure 73. Francesco Borromini. Church of St. Ivo alla Sapienza, Rome, 1643–48. Façade. Courtesy of the Vatican Photographic Archive.

Figure 74. Francesco Borromini.
Church of St. Ivo alla Sapienza,
Rome. Floor plan.

Pillars of Wisdom. To carry out this symbolism, a colonnade of seven pillars was originally designed for the space in back of the altar. Borromini's ingenious geometry, as seen in the ground plan (Figure 74), is based on two equilateral triangles that intersect to make a six-sided figure in the form of a star. The points all touch on the perimeter of a circle, and the series of straight lines drawn from point to point outline the hexagonal shape. The three semicircular outward-swelling bays create a fascinating rhythm as they alternate with the inward-pointing indentations, which in turn are broken up to create a system of acute angles and inward curves. The walls then move upward in accordance with this alternating convex-concave rhythm at they rise toward the dome. By allowing the dome to rest directly on the walls without using intermediary arches, squinches, or pendentives, Borromini effects a smooth and seamless transition. Thus the vibrant rhythm promised in the ebb and flow pattern of the ground plan and continuing with the convex-concave contours of the rising walls is uninterrupted as the organically unified interior space reaches completion.[11]

Figure 75. Francesco Borromini. Church of St. Ivo alla Sapienza, Rome, c. 1645. Interior of dome. By permission of Alinari/Art Resource, New York.

The interior of the dome (Figure 75) is studded with heraldic stars that carry out the symbolism of the hexagonal ground plan. Progressively diminishing in size as they ascend, they create a sensation of accelerated motion. At the base of the lantern, the stars converge on a cloud of cherubim that encircles the hovering dove of the Holy Spirit—still another allusion to wisdom. On the exterior of the lantern tower, a spiral motif reinforces this idea (Figure 76). The dove is now released from an open birdcagelike structure as it soars heavenward. All is intended to suggest the flight into infinity.

Pozzo's work in large-scale mural painting (see Plate III) provides a direct link with the spread of illusionism and dynamic geometry into northern Europe. In 1702, the year his treatise was translated into German, he was summoned to design and paint some churches and palaces in Vienna, where he spent the last few years of his life. A productive synthesis of the various innovations

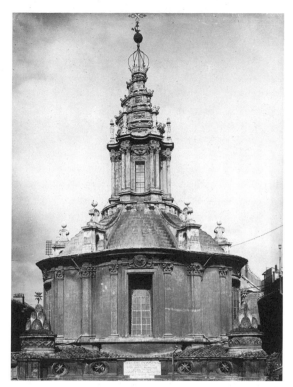

Figure 76. Francesco Borromini. Church of St. Ivo alla Sapienza, Rome, 1648. Detail of lantern tower. Courtesy of the Vatican Photographic Archive.

and inventions of the Roman baroque was to characterize the progress of the style as it moved first into northern Italy and then to Austria and Bavaria. It was the freedom of elasticity of Borromini's spatial forms, the dynamic plasticity of Bernini's sculptural fantasies, and the illusionism of Pozzo's mural painting that came together to shape the later manifestations of the baroque and rococo churches in these centers.

French and English Baroque

As a counterpart to the religious revival, baroque art was also drafted into the service of the ambitious monarchies of Spain and France, as they sought for power and glory in the field of inter-

national politics. Since papal architect Bernini was the most famous artist of his day, he was invited to Louis XIV's court to help design the projected new Louvre Palace. His plans were rejected in favor of those of the French architect Claude Perrault, thus initiating a period of French nationalism and a refusal by Louis to allow Paris to be Italianized. The only tangible result of Bernini's visit was a superb lifesize portait of Louis in marble, a model for an equestrian statue of the king, and a series of drawings for the Louvre that had a minor influence on the final design. In short, the French preferred to make a synthesis of their own.

Besides his plans for Paris, Louis had a far more grandiose idea in mind: moving the entire court and government to Versailles and constructing a palace that would outshine every other royal residence on earth, so as to become a worthy setting for the Sun King, as he liked to be known. André Le Nôtre's masterpiece of landscape geometry is the epitome of baroque thought in its field (Figure 77). Beginning at the bottom and reaching upward, the axis starts in Paris some 20 miles away, runs along the Avenue de

Figure 77. André Le Nôtre. Plan for gardens, Versailles Palace, 1662–88.

ure 78. Jules Hardouin Mansart and Charles Lebrun. Versailles Palace, Hall of
rrors, c. 1676. Height 43′ (13.11 m), length 240′ (73.15 m), width 34′ (10.36 m).
urtesy of Editions d'Art "Lys," Versailles.

Paris, bisects the palace in its exact center, sweeps along the artifi-
cially constructed grand canal, and moves across the horizon to
infinity. Gardens and sylvan paths radiate outward in star-shaped
avenues, creating delightful vistas in all directions. The impor-
tance of this concept for later times can hardly be overestimated.
Christopher Wren's plan for the rebuilding of London after the
disastrous fire of 1666 was based on it, as was his design for the
new wing of the Hampton Court Palace outside London. Pierre
L'Enfant's plan for Washington, D.C., and George Haussmann's
post-Napoleonic expansion of Paris, involving the Place de l'Etoile
with the Arch of Triumph as the axial center and the radiating
avenues, were all derived from Le Nôtre's design.

The whole design was a complete departure from the idea of a
royal residence as a fortress or castle. The idea was to incorporate
all of nature into a single complex. The famous Hall of Mirrors
(Figure 78) was created to reflect the gardens and increase the
sense of expanding space. Modern architects have recognized Ver-

The Baroque

sailles as the prototype of the garden apartment. Frank Lloyd Wright's concept of the freedom of exterior and interior started here. Through the windows the gardens became part of the interior design, and the interior space reaches outward (Figure 79).

In baroque political thought, such a palace, a quarter mile in width, with all its rich appurtenances, was a stroke of astute statecraft. The ambassador from Siam wrote back to his king that Louis XIV must be the most powerful of monarchs because he had a palace for his orange trees that was more sumptuous than any other earthly king's dwelling. And what country would dare to make war on a state that could employ 10,000 artisans to build such a mighty structure? The training of all these skilled craftsmen also paid off handsomely, as it gave France undisputed leadership in the production of furniture, porcelain vases, chinaware, rugs, and tapestries.

By founding and supporting a system of academies, the French court affirmed patronage of all the arts and artists by bringing them into a kind of civil service supervised by the crown. Aesthetic principles were hotly debated, high standards of production were maintained, and the education of students was carefully supervised. Academicians controlled patronage and determined who

Figure 79. Jules Hardouin Mansart. Versailles Palace, garden façade, c. 1680. Courtesy of the French Government Tourist Office, New York.

would receive commissions, appointments, licenses, prizes, pensions, and the privilege of exhibiting work in the annual salons.

One of the raging controversies in the 17th century was in the field of painting. The opposite poles were personified in the personalities and paintings of Nicholas Poussin and Peter Paul Rubens, both of whom were active at different times in the decoration of French royal palaces. Poussin was a classicist who preferred living and working in Rome, where he was free from courtly intrigue. Pictures such as his *Holy Family* (see Plate IV) were composed with a cool geometrical clarity, his figures posed with statuesque dignity, and he emphasized clear-cut linear definition over color and chiaroscuro effects. Looking at a Poussin picture induces a mood of quiet meditation and thoughtful contemplation. By contrast, Rubens's canvases abound with physical vitality, robust passion, and the celebration of life force (see Plate V). Violent motion and emotion, dramatic interplay of light and shadow, and vivid color characterize his pictures. The battle of the Poussinists and the Rubenists was fiery and furious. The academic scales, however, eventually tilted in Poussin's favor, largely because balanced pictorial geometry, the technique of linear drawing, and formal values are more easily taught and demonstrated to succeeding generations than Rubens's impetuosity and impassioned emotional aspects.

English Baroque

Not content with his victories in the arts, Louis, to his everlasting regret, thought that this future glory could be enhanced on the battlefield as well. He took advantage of Germany's weakness after the Thirty Years War by pushing his armies across the Rhine as far as Bavaria. There he met his match in a small town called Blenheim, where he was disastrously defeated by English and allied forces under the command of John Churchill. The grateful British nation voted Churchill a dukedom, and with Queen Anne's patronage John Vanbrugh built him a smaller version of Versailles near Oxford, appropriately named Blenheim Palace (Figure 80). Baroque architecture crossed the English Channel with the work of Vanbrugh, who combined the careers of soldier of fortune,

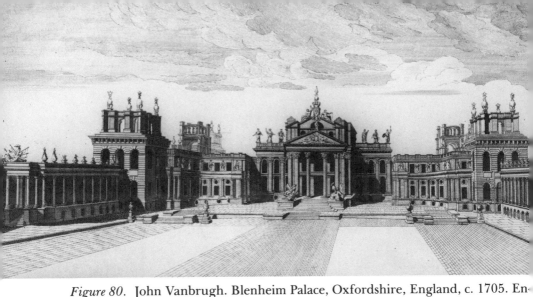

Figure 80. John Vanbrugh. Blenheim Palace, Oxfordshire, England, c. 1705. Engraving. By permission of Hulton Picture Company/Bettmann Archive, New York

playwright, and architect. Another of Vanbrugh's extravaganzas is seen in Castle Howard in Yorkshire.

The English baroque stood on far more solid ground with the works of Christopher Wren. After the fearful devastation of the Great Fire of London in 1666, the old Gothic Cathedral of St. Paul had to be demolished. Under the newly restored monarchy of Charles II, a completely new structure was projected. Wren, then a professor of mathematics and astronomy at the universities of London and Oxford, was the chosen architect.

Unlike St. Peter's, with its long succession of architects and popes, the new St. Paul's turned out to be the only great cathedral in the world to be built in the lifetime of a single architect, one master mason, all under the episcopate of one bishop. The 78-year-old Wren was present in 1710 when the final stone was put in place atop the lantern tower. Along with Bramante and Michelangelo, Wren had projected a powerful centralized edifice under the all-embracing, unifying force of a dome. As with St. Peter's, compromises had to be made; a long nave as well as a larger choir had to be added. But Wren was able to effect these changes without sacrificing the essential unity of his original design.

The heartbeat of the structure is felt in the magnificent octag-

onal rotunda beneath the lofty dome (Figure 81). Eight openings in the form of Roman triumphal arches lead into the choir, transepts, nave, and their intervening corridors. The complexity of these spatial divisions and subdivisions, the ingenious way they interlock with one another, the impression of constantly expanding upward and outward moving space, plus the rich but restrained decorative detail all point to Wren's affinity with the classically tempered phase of the baroque. Continental baroque features are also seen in the paired Corinthian columns of the façade of St. Paul's, a motif Wren borrowed from Perrault's new wing of the Louvre Palace. The landscaping at Versailles inspired his projected but unrealized city plan for the reconstruction of London, with its starlike radiating avenues, Versailles also influenced his layout for the Fountain Court and formal gardens surrounding the new wing of the royal residence he built for William and Mary at Hampton Court.

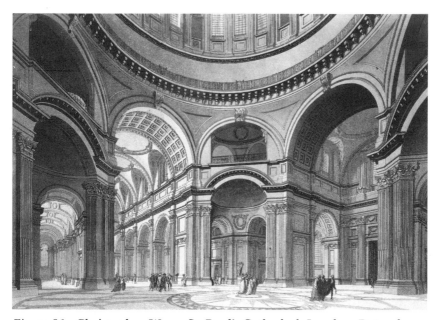

Figure 81. Christopher Wren. St. Paul's Cathedral, London. Rotunda. Aquatint by Thomas Malton, 1798. Reproduced by courtesy of the Trustees of the British Museum, London.

South German Baroque

The movement Bernini, Pozzo, and Borromini had begun gradually reached the popular level with the proliferation of late baroque and rococo palaces and churches in southern Germany and Austria. Here the designs shaped up as theaters where sacred and courtly dramas were enacted. Many of these architectonic metamorphoses were produced with great facility, but nonetheless attained ethereal heights of lofty expression. The Wieskirche (Church in the Meadow), built by Dominikus Zimmermann in Upper Bavaria, is an inspired example (Figure 82). Such churches became gay fantasies and gilded dreams of heaven, where ecstatic, waltzing angels swooped and swirled in a whirlwind of gauzy drapery (Figure 83). Quite airily and effortlessly the distinctions among architecture, sculpture, painting, and liturgy dissolved to produce a single *Gesamtkunstwerk,* or complete work of art, wherein lines, lights, shapes, colors, and musical sounds meet and merge into a unified and harmonious whole.

As at the Wies, these pilgrimage churches appear surprisingly in quite rural surroundings, where the faithful believed some saint or angel had appeared to rescue those in distress or deliver the local populace from some actual or impending disaster. Their proportions, like those of the great Gothic cathedrals before them, far exceeded the spatial needs of the adjacent farming communities and were obviously built to attract pilgrims and vistitors from far and wide.

All sadness is banished from these peasants' visions of heaven, and their designs echo hymns of praise rather than the pangs of remorse. On entering, the pilgrim is swept up in a swirl of curvilinear forms and crescendos of luminous pastel colors. Here as elsewhere, the movement begins in gentle waves. A procession of saints is punctuated by busts of apostles peering out from their rococo cartouches and is modulated by the rising polychrome columns of pink and grayish blue surmounted by white and gilt capitals, playful variants of the Corinthian order with their scrolls and volutes coiling upward. The motion gathers momentum with the irregular scallops of the marble and gilt side altars, with their chubby cherubs darting about amid the spiraling columns. Then

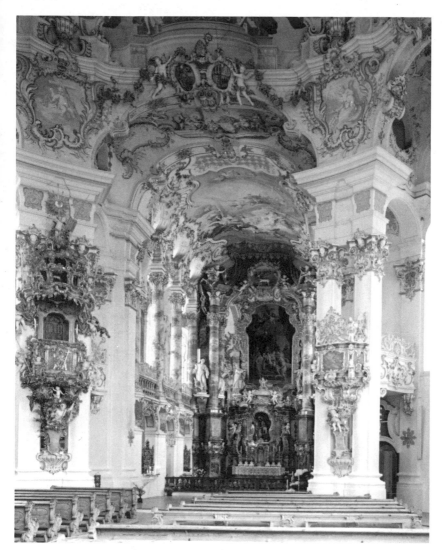

Figure 82. Dominikus Zimmermann. Wieskirche, Upper Bavaria, 1745–54. Interior, view toward the high altar. By permission of Hirmer Verlag, Munich.

the movement leaps outward into the open arms of the transept and upward into the clerestory level, creating a swirling spatial vortex with the conjunction of lines and flood of light. Ultimately it all dissolves into the empyrean heights of the cupola murals and their concentric rings of the heavenly host—some peering earth-

ward, others hovering in midflight, still more soaring upward toward infinity.[12]

A proliferation of aristocratic residences also reflect late manifestations of the baroque. Louis XIV's Versailles was, of course, the prime but unattainable precedent. However, every *grand seigneur* sought to replicate as much palatial grandeur as his princely purse would allow. The pleasure palace Balthasar Neumann built for the Prince Bishop of Würzburg is a masterpiece of this kind (Figure 84, and see Figure 9).

Baroque architecture always strove for the magnificent and the stupendous. Display, not comfort, was its goal. More decorative

Figure 83. Johann Josef Christian. Dancing angel at foot of altar, 1737–66. Gold and white stucco, lifesize. Benedictine Abbey Church, Ottobeuren, Franconia, West Germany. By permission of Hirmer Verlag, Munich.

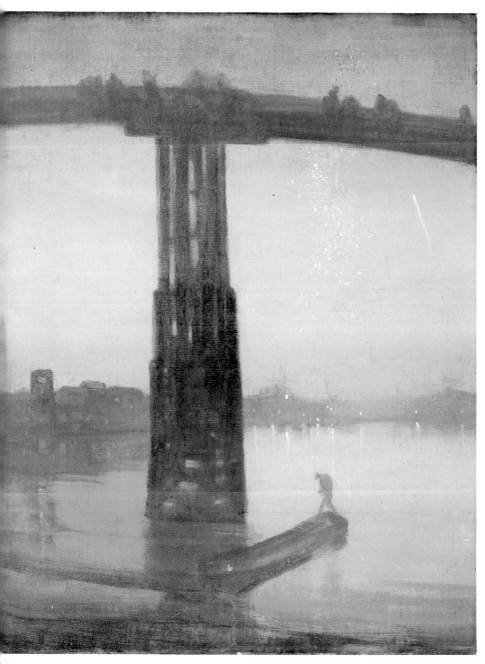

Plate I. James Abbott McNeill Whistler. *Nocturne in Blue and Gold: "Old Battersea Bridge,"* c. 1875. Oil on canvas, 26½ × 19¾″ (67.31 × 50.17 cm). By permission of the Tate Gallery, London / Art Resource, New York.

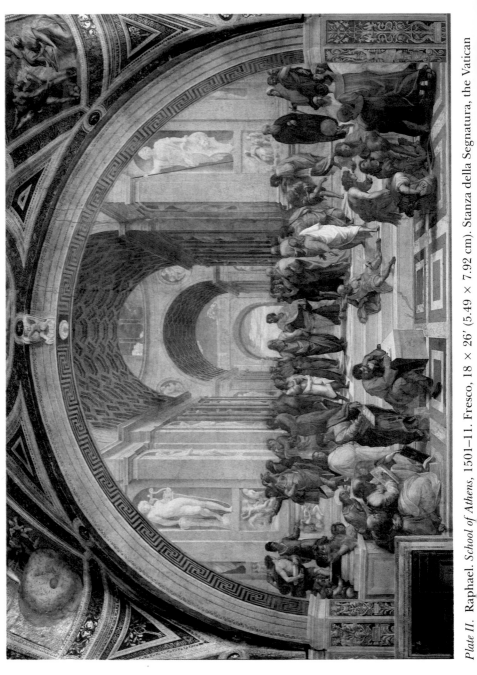

Plate II. Raphael. *School of Athens*, 1501–11. Fresco, 18 × 26′ (5.49 × 7.92 cm). Stanza della Segnatura, the Vatican

Plate III. Andrea Pozzo. *St. Ignatius in Glory*, c. 1691. Fresco, nave ceiling. Sant'Ignazio, Rome. By permission of Scala/Art Resource, New York.

Plate IV. Nicholas Poussin. *Holy Family.* 1651. Oil on canvas. 38½" × 51" (97.79 × 129.54 cm) Courtesy of

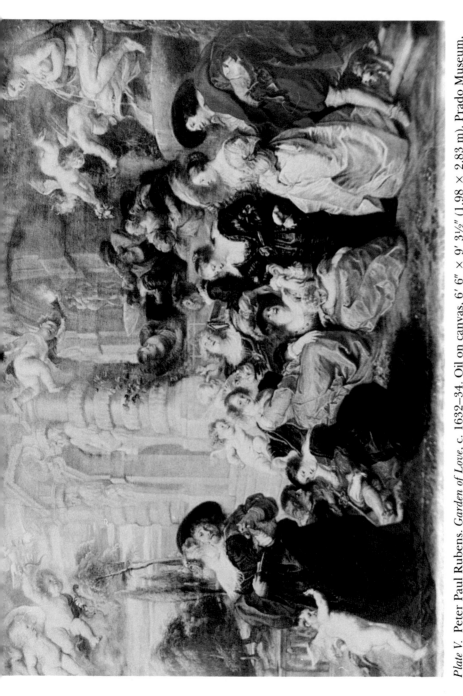

Plate V. Peter Paul Rubens. *Garden of Love,* c. 1632–34. Oil on canvas, 6′ 6″ × 9′ 3½″ (1.98 × 2.83 m). Prado Museum, Madrid.

Plate VI. Germaine Boffrand. Salon de la Princesse, Hôtel de Soubise, Paris, c. 1732.

Plate VII. Jean-Antoine Watteau. *The Music Party*, c. 1719. Oil on canvas, 25½ × 36¼″ (64.77 × 92.08 cm). Reproduced by permission of the Trustees of the Wallace Collection, London.

Plate VIII. Eugène Delacroix. *Self-Portrait,* c. 1837. Oil on canvas, 64 × 21″ (165 × 54 cm). The Louvre, Paris. By permission of the Musées Nationaux, Paris.

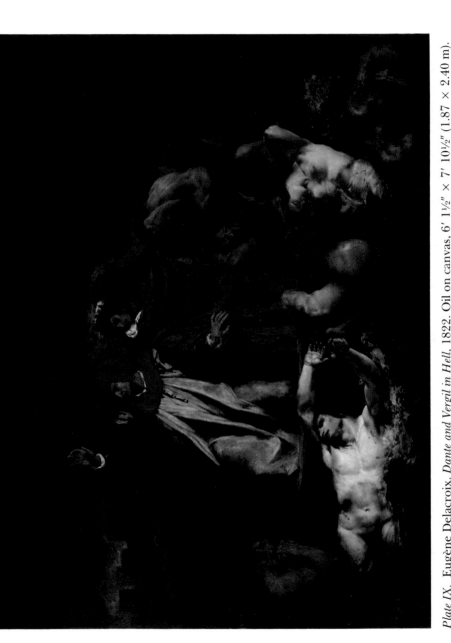

Plate IX. Eugène Delacroix. *Dante and Vergil in Hell,* 1822. Oil on canvas, 6′ 1½″ × 7′ 10½″ (1.87 × 2.40 m). The Louvre, Paris. By permission of the Musées Nationaux, Paris.

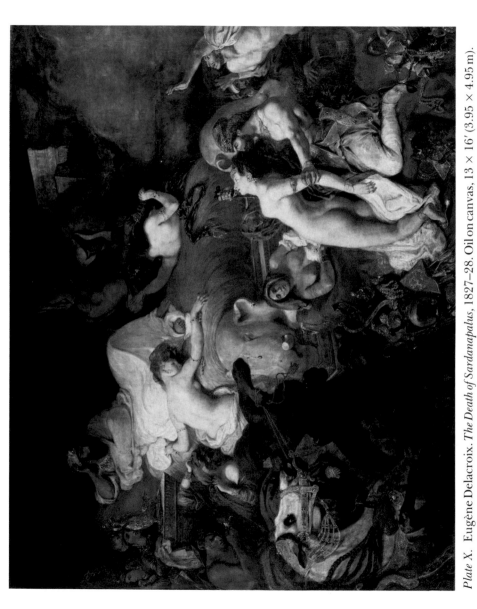

Plate X. Eugène Delacroix. *The Death of Sardanapalus*, 1827–28. Oil on canvas, 13 × 16′ (3.95 × 4.95 m). The Louvre, Paris. Reproduction of the Musée National, Paris.

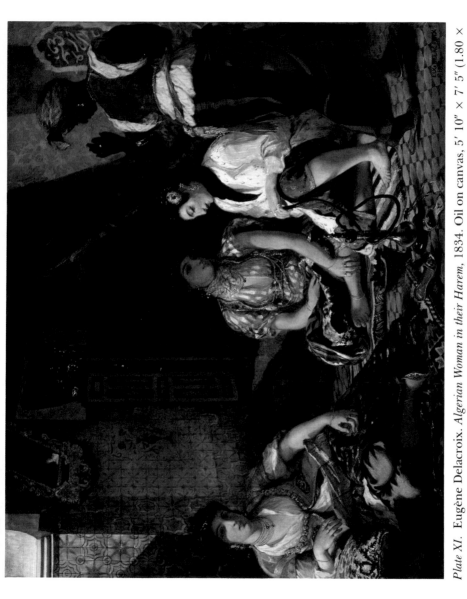

Plate XI. Eugène Delacroix. *Algerian Woman in their Harem,* 1834. Oil on canvas, 5′ 10″ × 7′ 5″ (1.80 × 2.29 m). The Louvre, Paris. By permission of the Musées Nationaux, Paris.

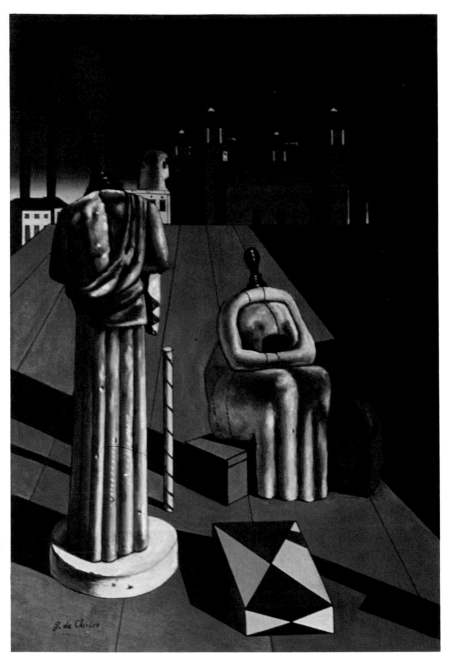

Plate XII. Giorgio de Chirico. *The Menacing Muses (Le muse inquietante)*, 1917. Oil on canvas, 37¾ × 27⅞″ (95.89 × 70.80 cm). Private collection.

Plate XIII. Piet Mondrian. *Broadway Boogie Woogie,* 1942–43. Oil on canvas, 50 × 50 ″ (1.27 × 1.27 m). By permission of the Collection, the Museum of Modern Art, New York.

Plate XIV. Henri Matisse. *Dance* (first version), 1909. Oil on canvas, 8' 6" × 12' 9½" (2.59 × 3.90 m). By permission of the

Plate XV. Sandro Botticelli. *Allegory of Spring (Primavera)*, c. 1478. Tempera on wood, 6′ 8″ × 10′ 4″ (2.03 × 3.15 m). Uffizi Gallery, Florence. By permission of Scala/Art Resource, New York.

Plate XVI. Carlo Maria Mariani. *Constellation of Leo (The School of Rome)*, 1980. Oil on canvas, 12 × 14¾ (3.40 ×

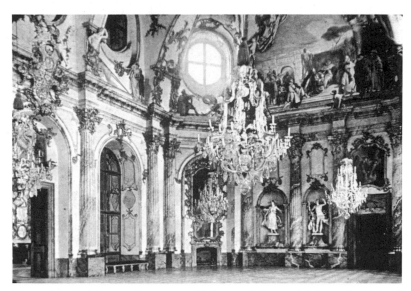

Figure 84. Balthasar Neumann. Kaisersaal (Imperial Room). Bishop's Palace, Würzburg, Germany, c. 1719–44. Frescoes by G. B. Tiepolo. Courtesy of Deutscher Kunstverlag, Munich.

than structural, the buildings were loaded with ornamentation. The palace, as an adjunct to the cult of majesty and the divine right of rulers, reflected the worldly splendor of the nobility. The contrast with our present informal and relatively drab times could hardly be greater. As Aldous Huxley points out:

Formality and pomp were one of the essential features of ancient government. Tyranny tempered by transformation scenes—that was the formula of all governments in the seventeenth century, particularly in Italy. Provided you treated your people to a procession or some similarly spectacular function once a month or thereabouts, you could do whatever you pleased. It was the papal method *par excellence.* But it was imitated by every grand seigneur, down to the most piddling little count in the peninsula. Look how all the architecture of the period is conditioned by the need for display. The architect was there to make backgrounds for the

incessant amateur theatricals of his employers. Huge vistas of communicating saloons to march down, avenues for processions, vast flights of steps to do the Grand Monarch descent from the skies. No comfort—since comfort is only private—but an immense amount of splendour to impress the spectator from outside. Napoleon was the last ruler to practise it systematically and scientifically on a grand scale. Those reviews, those triumphal entries and exists, those coronations and weddings and christenings, all those carefully prepared stage effects—why, they were half his secret. And now these pomps are no more. Are our rulers so stupid and so regardless of the lessons of history that they neglect these aids to government? Or can it be that tastes have changed, that the public no longer demands these shows and is no longer impressed by them?[13]

Baroque Musical Forms

Baroque music, like other manifestations of the style, also mirrored the dynamic new image of a world in motion. The development of the *concerto grosso* and the aristocratic palace, for instance, are parallel in both time and spirit. The concerting idea first took shape in Venice, where the term indicated a style or texture rather than a defined form. It implied the opposition and juxtaposition of unequal tone qualities, volumes, and intensities, just as the palace contrasted textures, varying spatial rhythms, and solid masses versus open spaces. The palace and concerto are both worldly, proud, and often pompous expressions. In each case, the rhythmic reiterations in space and time describe the shift from classical balance, repose and closed composition to a lively sense of increasing movement and open form. The alternation of individual units of decorative design with larger structural masses, as in the façades of palaces, can be compared to the principle of opposing lighter sonorities in the *concertino* with the larger masses of the *tutti* in concerted instrumentation. Juxtaposing thick energetic volumes with slenderer and more transparent sounds might also be compared to the development of the dramatic contrasts of light and shade in baroque painting.

The title of one of J. S. Bach's secular cantatas—*Vereinigte Zwei-tracht der wechselnden Saiten* (Unified Dueling of Shifting Strings)—captures the essence of the concerting style. Appropriately enough, the opening chorus with orchestra is adapted from the third movement of his first Brandenburg Concerto. The composer was alluding, of course, to the Italian verb *certare*, meaning to strive or contend. The *concerto grosso* thus represented a striving between the many and the few, between a majority and a minority. The two contending sides are the *ripieno* of the full ensemble and the *concertino* of solo instruments. These *ripienos* or *tuttis*, with the ripeness and fullness of their opaque sonorities, are in the mainstream of one aspect of the baroque style. On the other hand, the throwing back and forth of the larger and smaller groups, the alternations of loud and soft dynamics, the sequence of fast and slow movements, the constant shifting of tonal balances, all heighten the effect of the increasing mobility of the parts in respect to the whole.

The rise of the variation form also takes place during this time. The great appeal that the theme-and-variation idea made to the baroque mind seems to lie in demonstrating how simple thematic material could become extremely complex by adding flourishes and ornamentation. They were in fact themes and complications. The themes were usually chosen for their neutrality and their radical simplicity, and then embroidered through the process of musical rhetoric and decoration until they seemed to develop ornamentation for its own sake. One typical plan in the early period was to use several popular tunes with ornamental variants in between. Another was the ground bass plan, with a constantly repeated figure as in the passacaglia and chaconne. The bass part then provided a skeletal unity to the work as a whole, while for variety it served as a basis for all sorts of elaborate ornamental variations. The rather rigid ground part became simply an excuse for a maximum of ornamentation and was employed for the sole purpose of saving the whole from riding off in all directions.

Still another favorite variation formula was to choose a slow theme and shorten the note values to produce the illusion of constantly increasing motion, an idea that threads through all the baroque arts. This type of variation was sometimes called the *air et*

doubles, because the first variation doubled the rhythmic pattern of the theme, while the subsequent variations tripled and quadrupled the note values. A well-known illustration is the set of variations by Handel known as the *Harmonious Blacksmith.* This rhythmic device of doubling and tripling the auditory rhythms is strikingly similar to the technique employed in the façades of baroque palaces. There the functional elements of columns and windows are deemed insufficient for expressive purposes, and purely ornamental pilasters and columns are introduced into the design merely to heighten the feeling of activity and increase the tempo of the visual rhythms.

Above all, however, it is in the sumptuousness and grandiloquence of the opera productions that all the musical ideas of this period reach fruition. Opera fascinated the baroque mind, and the theaters built for its performance brought the arts of architecture and music together in close unity. The mounting of these performances involved the invention of mechanical marvels: the revolving stage, elaborate lighting and scenic effects, gadgets to produce the illusion of angels in flight, derricks to effect the passage of the gods from heaven to earth, as well as mechanisms for floating whole choirs of saints and angels across the proscenium on papier-mâché clouds.

The constant changes of scene reflect the restless urge for movement. Pietro Cesti's *Pomo d'Oro,* for example, calls for a continuous shifting of some 67 different scenes, which moved all the way from the underworld, through the earthly regions, and upward into seventh heaven. But beyond these theatrical effects, there was the deeper feeling for dramatic confrontation. A close tie exists between the motional and emotional aspects of expression; and with the styles of Monteverdi in Venice and Alessandro Scarlatti in Naples, opera was established as an intensely dramatic medium. The essence of this music was designed to appeal to the affects, temperaments, and passions of the listeners. As a philosopher of the time put it: "Musick hath two ends, first to please the sense . . . and secondly to move the affections or excite passion." [14]

The growth of the instrumental style is another of the distinctive contributions of this period. New instruments were invented and older ones perfected by new mechanical processes. The violin

reached the pinnacle of its development at this time, in keeping with the trend away from the vocal, toward a more purely instrumental, type of expression. The violin was the coloratura among coloraturas. It satisfied the baroque need for faster tempos, greater technical agility, more florid embellishments. Speed and movement were realized more freely and completely when unencumbered by the limitations of the human vocal mechanism.

Baroque World View

The conflicts and achievements of the baroque world took place within a tremendously enlarged sense of space. The astronomers told of remote regions populated by an infinite number of stars. Pascal and Newton speculated on the new mathematical implications of infinity. The gardens and avenues of Versailles were laid out in keeping with this vastly extended concept of space. The vistas led the eye toward the horizon and invited the imagination to continue beyond. The unification of the vast buildings and gardens there brought baroque society wholly within the scope of nature, and declared it to be a measurable part of the new physical concept of the universe.

In music there was a corresponding expansion of tonal space. The organs and other keyboard instruments were built to include a wider range from bass to soprano. Both wind and stringed instruments were constructed in families, ranging all the way from the great double bass to the high register of the violin, and they were brought into such ensembles as Louis XIV's *Vingt-quatre Violons du Roi*, the first permanent orchestra in history. The use of chromatic harmony, with all the half tones of the octave, was the internal extension of the same idea. So baroque music also mirrored a moving universe. Its restless forms took on the color of this dynamic age, and its sound patterns floated freely through their tonal spaces freed from gravitational laws.

In isolation, particular baroque works of architecture, sculpture, painting, and music may suffer in comparison with individual masterpieces of Renaissance art, such as a statue by Michelangelo, a painting by Leonardo, or a motet by Josquin des Prez. Baroque art, however, did not aim at isolated perfection, but

rather a concert in which each art played its orchestral part. It is the complex synthesis of all the arts that distinguishes such works as Bernini's Cornaro Chapel, the sweeping grandeur of Louis XIV's Versailles, Wren's all-embracing design for the London skyline, and the spectacular operas of the period. This concert of the arts is also apparent in such heavenly fantasies as the Wieskirche in Bavaria and the Imperial Room at Würzburg. Here the full baroque stride is attained. Furthermore, these concerts of all the arts are not bound only by aesthetic considerations. They are, rather, reflections of broad religious, social, scientific, and political trends that form the base of modern views on the psychology of religion, centralized government, and the unified states, as well as the relationships of human beings to their spiritual, psychological, and natural environment.

Musical Classicism:

Mode of Stylistic Synthesis

THE BRAVE NEW WORLD of the 18th century formed a fertile field for new ideas, new religious orientations, new social theories, and new styles in the arts. Some were evolutionary outgrowths from roots planted in the previous century; others were revolutionary outbursts diametrically opposed to traditionally held world views. As the baroque synthesis began to wane, a host of novel notions, literary attitudes, and stylistic gestures sprouted up and jostled with one another for a place in the sun. Among these were the rationally ordered movement known as the Enlightenment; the aristocratic rococo or gallant style; the bourgeois orientation known as sensibility; and the storm and stress, a violently anti-rational outburst of young artists angry at the artificial restraints of the social codes of polite society. This chapter will explore some of these new tendencies as they competed for attention, reacted with one another, and eventually merged into the new synthesis known as classicism in musical circles and neoclassicism in the visual arts. In the process, still another mode of interrelationship among the arts will come to the fore—that of stylistic consolidation or synthesis.

The scientific discoveries and psychological breakthroughs of

the baroque Age of Reason began to reach a wider constituency among thinkers and educated people. The movement known as the Enlightenment in England and America, and the *Aufklärung* in Germany, enlisted the attention of the greatest minds of that time. A central concept of the Enlightenment was that of a mechanical universe in which all physical phenomena could be understood and predicted if only all the facts could be discovered, collected, and collated. To this end, Denis Diderot devoted a lifetime to assembling and publishing his widely circulated, monumental *Encyclopédie*, or *Classified Dictionary of Sciences, Arts, and Trades* (1751–1765), a staggering contribution to the dissemination of scientific knowledge to a wide public.

All human knowledge, it was believed, could be understood in the light of reason. And the formulation and application of rational rules could regulate all aspects of human existence, from the loftiest abstract speculations to the minutiae of daily life, from the organization of society to forms of government, from the formulation of ethical principles to the writing of poetry and music. Translating this cosmic design of a world that ticked like a well-regulated clock into philosophical, religious, social, and aesthetic terms was the object of specialists in each field. The goal of the arts, in Enlightenment thought, was to represent beauty as the concrete manifestation of order, clarity, symmetry, and harmonic proportions, all with a proper skill and elegance of presentation. This desire for balance and logical order dominated thought in all the arts, from musical forms to city planning (Figure 85).

Eventually and inevitably, the image of this enlightened, euphoric world was challenged by opposing viewpoints, notably by those of Voltaire, Edmund Burke, and Jean-Jacques Rousseau. Voltaire took issue with the Enlightenment world outlook and satirized it incisively in his famous novel *Candide* (1759). The main character is the philosophically minded Dr. Pangloss, who is convinced that he and all humanity inhabit the best of all possible worlds. When the optimistic Pangloss and his friends set out on their travels, they are victimized in turn by such natural and human disasters as earthquakes, floods, shipwrecks, pirates, social uprisings, slavery, superstition, and rampant religious fanaticism.

igure 85. Place de la Concorde, Paris. From a Daguerreotype. By permission of
Hulton Picture Company/Bettmann Archive, New York.

As a resolution to these appalling experiences, Voltaire counsels
against speculating too much on unanswerable questions and ad-
vises his readers to retire to the country, cultivate their gardens,
and not expect too much of life.

The English statesman and writer Edmund Burke published
an influential essay, *A Philosophical Enquiry into the Origin of Our
Ideas of the Sublime and Beautiful,* in 1756. To him the beautiful was
the prevailing concept derived from classical times, which was con-
cerned with order, clarity, and the reconciliation of opposites as
expressed in balanced, contained, idealized forms. Opposed to
this was the sublime, which manifested itself in the wild and mag-
nificent aspects of nature—torrents and tempests, the elemental
forces of wind and weather, avalanches in the Alps, the awesome
majesty of volcanoes. Burke extolled the infinite over the finite,
the uncontained over the contained, the untamed over the tamed.

With the sublime there was a place for the awesome and terrifying, the ugly and malignant powers of nature and human nature. Burke's theory led to an awakening interest in the grandeur of medieval cathedrals and castles, picturesque landscape paintings, and the dark and gory heroic deeds of mysterious past times.

Jean-Jacques Rousseau, being Swiss, loved rugged alpine scenery, and his novels are replete with descriptions of wild torrents, fearsome precipices, and impenetrable forests. Rousseau rejected the Enlightenment belief that human progress had reached the brink of a golden age. Surveying the social scene of his time, he found human nature basically good. Only the corrupting force of civilization was vile. He believed that only natural laws were to be recognized. The first lines of his *Social Contract* (1762) ring out with the famous opening pronouncement: "Man is born free and is everywhere in chains. One man thinks himself the master of others but is more of a slave than they are." In his enthusiasm for going back to nature, he advised leading the simple rural life and set forth the ideal of the "noble savage," who lives at peace with nature and is friendly with all fellow creatures. When he sent his essay on this subject to Voltaire, it drew this pungent reply:

> I have received your new book against the human race, and thank you for it. . . . One longs, in reading your book, to walk again on all fours. But as I have lost that habit for more than sixty years, I feel it impossible to resume it. Nor can I embark in search of savages in Canada, because war is going on in those regions, and because the example of our actions has made those savages nearly as bad as ourselves." [1]

The tenets of the Enlightenment and the reactions to it found expression in all fields, most vividly in the arts. The two styles most closely associated with the new thought were the refined aristocratic rococo and the more bourgeois-oriented sensibility, or *Empfindsamkeit*. In the visual arts the rise of the elegant rococo style accompanied the decline of the grandiloquent baroque. After the death of Louis XIV in 1715, the marble halls of the Versailles Pal-

ace were closed, as the younger generation of aristocrats preferred the more exhilarating life of the Parisian salons. Instead of directing their efforts toward the approval of a single sovereign, writers, artists, and musicians now had to take the tastes of various individual patrons into account.

When the robust baroque architect bowed to the rococo interior decorator, the long vistas and spacious chambers were replaced by intimate glimpses and small salons; the pomp and circumstance of baroque decoration yielded to the delicate ornamentation of the elegant rococo; royal purples and golds softened into a rainbow of pastel hues; the majestic mural became the precious miniature; monumental sculpture descended from the pedestal and shrank to the size of figurines for the mantelpiece; the center of life shifted from the grand ballroom to the boudoir; heroic passions and grand emotions melted into subtle shades of personalized expression and amorous intrigue; and grandiloquent language modulated its voice and entered into witty, tête-à-tête conversations (Figure 86, see also Plate VI).

In operatic circles the lofty lyric tragedies of J. B. Lully gave way to comic and ballet operas. The new chamber and keyboard works veered away from the complexities of contrapuntal construction toward more transparent homophonic textures. From the larger forms and massive sonorities of the baroque, the rococo moved in the direction of the slender proportions of the dance suite with its attendant gallantries and short diverting programmatic genre pieces. These tinkling musical bonbons for the ear were characterized by witty melodic twists and turns, by delicately wrought embellishments and ornaments, and by piquant rhythmic nuances.

As the century ran its course, the three principal components of the new musical orientation were revealed in the *style galant,* or gallant style; the *empfindsamer Stil,* or sensibility; and the *Sturm und Drang,* or storm and stress. Each had its own attitudes, idioms, and techniques. Later they began to interact one with the other, and by so doing they helped to shape the overall musical synthesis known as the classical style, which dominated the latter part of the 18th and the first quarter of the 19th centuries.

Figure 86. Germaine Boffrand. Hôtel de Soubise, Paris, Salon de la Princesse, c. 1732.

The Gallant Style

Under the Enlightenment, music was still seen as a mathematical discipline. In the previous century, Baron Leibniz had described music as "an unconscious mathematical exercise of the soul." His words were echoed in the new thought by Gotthold Ephraim Lessing, who wrote:"Music stands for the science of the art of tones . . . it is a science inasmuch as its rules can be justified on certain grounds, and an art because the demonstrable rules can be brought to reality."[2]

Music's mathematical measurability had, of course, its roots in the classical soil of ancient Greece and Rome, and was studied as such in the quadrivium of the medieval university curriculum. The Enlightenment thinkers were also aware of the ancient Greek theory of art as the imitation or representation of nature. As the motions of music unfold in time, it was thought, they correspond to the motions of the human soul. Music, it was held, could convey emotions and moods. Their theories assumed the shape of a doctrine of affects, or *Affektenlehre* as the Germans put it, which cor-

related certain mental states and feelings with corresponding tonalities, melodic patterns, rhythmic pulsations, and harmonic progressions.

The problem for the Enlightenment composer and theorist was, and still is, that music alone cannot represent abstract ideas, concepts, or specific emotional situations, except when associated with a verbal text as in hymns, songs, oratorios, and operas. When words are involved, however, musical considerations as such are liable to sink to a subordinate role. In Jean Philippe Rameau, an ardent follower of Descartes's psychological researches as expressed in the *Traité des passions de l'âme* (1649), the Enlightenment found a champion of the purely musical approach. Rameau insisted that verbal and textual settings are successful only when they coincide with the processes of the overall tonal design. Rameau's *Traité de l'harmonie* (1722), as well as his musical compositions, not only founded the modern art of harmony but also demonstrated the method by which the new emotional orientation of music could be realized.

Many of these new ideas were incorporated in the *style galant,* which became the musical equivalent of the visual rococo in architecture, sculpture, painting, and the decorative arts. As such, it readily found its way into the aristocratic ballrooms and drawing rooms of a privileged leisure class. But it also had a more serious side as an art based on formal logic and controls that appealed to the thinking person. The essence of the rococo spirit is captured in the elegant canvases of Antoine Watteau, who pictured languid figures against idyllic landscapes as in his *Music Party* (Figure 87, see also Plate VII).

The rise of the gallant style has both sociological and musical implications. A typical figure of the period was the *homme galant,* the gentleman amateur. Traditionally he was an aristocrat, though the rise of a wealthy middle class expanded the ranks to include members of a younger generation eager to emulate the manners and accomplishments of the aristocracy. Early in the century, increasing numbers of instructional books in social decorum and musical performance began to appear. Notably among them was one that Johann Mattheson published in 1813, the complete title

Figure 87. Jean-Antoine Watteau. *The Music Party,* c. 1719. Oil on canvas, 25½ × 36¼" (64.77 × 92.08 cm). Reproduced by permission of the Trustees of the Wallace Collection, London.

of which reveals what the gentleman was expected to know about music: *The Newly Inaugurated Orchestra, or Universal and Basic Introduction on How an Homme Galant May Acquire a Perfect Understanding of the Loftiness and Majesty of Noble Music, Form His Taste Accordingly, Understand the Technical Terms, and Argue Cleverly about This Admirable Science.*

The favored instrument of the *homme galant* was the flute, and Mozart's flute quartets and concertos, commissioned by such gentlemen amateurs, are among his most typically gallant-style compositions. The *galant,* then, became a musical reflection of good manners, and its moods were confined to a surface play of emotions that could be shared with others in decorous salon entertainments—the joyful, lively, playful, amorous, and pensive. Any overtly dramatic or impassioned expressions would have been considered quite out of place in such social situations and surroundings (Figure 88).

Figure 88. Adolf Menzel. *Flute Concert of Frederick the Great.* Engraving of 1852 after earlier painting. Reproduced by courtesy of the Trustees of the British Museum, London.

Sensibility and Empfindsamer Stil

The sophistication and polish of the rococo and gallant style were restricted in the main to international aristocratic circles. Their stylized elegancies, however, were too artifical to appeal to the growing bourgeois audience who desired expressions of more substance and depth. The spreading prosperity and the educational advantages now available to these merchants, professional people, and their families created a new audience and new tastes. After the day's business was concluded, these solid citizens would gather in the spacious parlors of their comfortable houses to read, socialize, and make music at their new pianofortes. To them, the mighty deeds of mythological heroes and the pastoral amours of charming shepherds and shepherdesses reflected the extravagances, frivolities, and profligate behavior of titled playboys. Instead, they fostered and patronized a new orientation based on moral principles and social responsibility. So the frills, flourishes,

and furbelows of the courtly rococo yielded to a new style that can be considered its middle-class equivalent. In England it came to be known as sensibility, in France *sensibilité,* and in the Germanies as the *Empfindsamkeit* or the *empfindsamer Stil.*

Sensibility implied a proneness to more intense personal feeling and an exploration of a broader scope of emotional reactions. As articulated by the Irish philosopher Francis Hutchison in his provocative *Essay on the Nature and Conduct of the Passions and Affections* (1728), the purpose of music is first to please the senses, and "second to move the affections or excite passion." In a baroque *concerto grosso,* church or chamber sonata, one tempo, one affect, and one mood had sufficed for each movement. In French or English suites the titles of the dances—allemande, sarabande, courante, gigue—were sufficient to set the tempo and project the mood. In other words, an *allegro* was, as the word implies, a lively, brisk, cheerful piece; an *andante* was leisurely and calm; an *adagio* stately and solemn. The sensibility and *empfindsamer Stil,* however, demanded a far greater emotional range and a larger number of affects. So the older doctrine was revised and expanded. The new nuances were reflected in musical scores, where tempo and mood indications began to reflect a far wider emotional range. *Allegro con brio* (breezy), *allegro agitato* (agitated), *allegro giocoso* (joyous), and *presto furioso* (fast and furious) were some of the qualifications called for. *Largo* or *lento* indicated expansiveness; *mesto,* gravity or sorrow. Moreover, every detail of a composition had to be endowed with its special affect or feeling. As one theorist commented: "The player should change—so to speak—in every measure to a different affection, and should be able to appear alternately sad, joyous, serious, etc., such moods being of great importance in music."[3]

Rousseau, as the champion of the world of the senses, advocated the conscious adaptation of musical materials to express more natural human emotions. As such, he was the arch-opponent of the lighthearted rococo and one of the earliest exponents of *sensibilité.* In his famous *Lettre sur la musique française,* he made a stinging attack on its class-conscious artificiality. In operatic circles, he opposed the stylized sung recitatives of the through-composed operas and argued for the spoken lyric play with inter-

posed musical sequences. With his zeal for the expression of simple and natural sentiments, he composed both the words and music of a folksy little opera, *Le Devin du Village,* in 1752. The rural setting and picture of peasant life set the stage for a departure from the heroic gestures and stilted stances of serious opera. *Le Devin* received immediate critical acclaim, and it became the model for many similar works, among them Mozart's early operetta *Bastien und Bastienne* (1768).

The ethical tenets of the Enlightenment were pungently expressed in Denis Diderot's pronouncement that the arts should celebrate the victory of virtue and the vanquishing of vice. In his critical writings, he strongly supported the paintings of Jean Battiste Greuze, who represented the *sensibilité* in his moralistic genre scenes bearing such titles as *The Paralytic Cared for by His Children, Family Reading the Bible, The Father's Curse,* and *The Prodigal Son. Fatherly Love* (Figure 89) a popular picture of the time by one of

Figure 89. Etienne Aubrey. *L'amour paternel (Fatherly Love),* 1775. Oil on canvas, 31 × 40″ (0.79 × 1.02 m). Copyright by the Barber Institue of Fine Arts, University of Birmingham, Birmingham, England.

Greuze's younger colleagues Etienne Aubry, illustrates the type of art that appealed to the middle-class partisans of sensibility.

In English letters, sensibility first found expression with Samuel Richardson's novel *Pamela* (1740). In this real-life story with believable characters, the poor but proud heroine of humble origin seeks service in the household of a bachelor gentleman of means. As he proceeds to assail her virtue, she resists with prudence and dexterity until her frustrated suitor is pushed into a proposal of marriage. This triumph of virtue over vice was praised in pulpit and press, winning the author a wide readership and international acclaim.

In Germany, the *empfindsamer Stil* found a persuasive exponent in the critic and dramatist Gotthold Lessing. With his prose play *Miss Sara Sampson* (1755), he established the new genre of the bourgeois drama. The central figure is the intrepid and appealing Sara, who is caught up in a web of worldly circumstances, family entanglements, and temptations destined to elicit the compassion and empathy of the playgoers. As she strays into an illicit affair with her lover Mellefond, the integrity of her family life as well as the emotions of the audience are torn asunder. Finally the play ends on notes of forgiveness, understanding, and redemption. Lessing's dramaturgy was concerned with the portrayal of real people caught up in gripping human situations, and his plays still survive on the boards of German repertory theaters.

In music, Lessing's counterpart is found in Christoph Willibald Gluck, whose operas became the basis of modern music drama. His noble lyricism communicates the gamut of emotional and mental states. In instrumental as well as vocal music, sensibility was expressed in pleading appoggiaturas, gentle dissonances reluctant to resolve, and palpitating rhythmic and melodic contours that tugged at the heartstrings. Sensibility songs had folklike settings and were usually of simple strophic construction, which made them easy to read or learn. Typical products of the period were J. F. Reichardt's *Lullabies for Good German Mothers* (1798) and C. P. E. Bach's plangent pianistic lament, *Farewell to My Silbermann Clavier* (1781).

As sensibility ran its course, its doctrine of affects came perilously close to affectation and its sensitivity began to border on sen-

timentality. At the end of the century, the novelist Jane Austen seems to have been the woman with the last word in her delightful book *Sense and Sensibility* (1811). Here the conflicts and comedy of middle-class manners were treated with good humor, delicious wit, and gentle irony as she portrays the attitudes and problems of two sisters. Elinor, with sound good sense, possessed "strength of understanding, and coolness of judgement. . . . her feelings were strong: but she knew how to govern them: it was a knowledge . . . which one of her sisters had resolved never to be taught . . ." Her sister Marianne, with an excess of sensibility, "was eager in everything; her sorrows, her joys, could have no moderation. She was generous, amiable, interesting: she was everything but prudent." As the story develops, needless to say, it is Elinor who finally marries for love and Marianne who discovers common sense and prudence as a foundation for family life.

Sturm und Drang

While the rococo, gallant style, sensibility, and *Empfindsamkeit* were all the children of the Enlightenment, each with different social and national orientations, the militantly anti-Enlightenment *Sturm und Drang* struck out in bold new directions. The Enlightenment's projection of a benign and rational universe, ready to unlock its secrets to the inquiring mind, was now in question. By contrast, the storm-and-stress world was dark, mysterious, elusive, malignant, even demonic. Nature was a wild and untamable force. The emotional range of the earlier styles had always remained within the bonds of propriety, politeness, and social decorum. The *Sturm und Drang*, however, broke out from these restraints with violent outbursts of energy and passion as well as powerful protests against arbitrary social conventions. All blocks to intense personal expression and free creativity were swept aside. Irrationalism, intuition, and the rights of the imagination replaced reason.

The poets and dramatists of the new movement tossed the Apollonian poise and polish of classical tragedy to the winds in favor of a Dionysian intoxication and heaven-storming seething of the creative soul. They projected the image of the hero-genius Prometheus, who stole the sparks of divine fire from the hearth of

the gods to animate the spirits of humanity, and of Ganymede, the mortal youth who rose to Olympian status. Goethe's Ganymede, however, found divinity not in the embraces of Jupiter, but in the bosom of mother nature. Like Narcissus he gazes into a spring, but in its reflections he discovers not only himself but the natural world. As he drinks of its waters, he becomes the image of the young storm-and-stress artist, intoxicated by the powers of this new source of inspiration and revelation. Taking its name from the title of a drama by Maximilian von Klinger (1776), the full force of the movement ran its course mainly in the 1770s. Its reverberations, however, were heard during the rest of the century, throughout the romantic movement, and as late as the late 19th century in Nietzsche's concept of the *Übermensch* and in Dostoyevsky's *Crime and Punishment,* where the self-proclaimed superior person defies the laws and limitations of society that he feels apply only to the common herd.

Storm-and-stress plays and novels were redolent with melancholy, mystery, and opposition to the corruptive influence of a society that suppressed the expression of natural feeling. The inception of the *Sturm und Drang* movement in literature can be traced to Goethe's encounter with Johann Gottfried von Herder in Strasbourg, where the poet was then studying law. Herder posed the question: What are men but "lightning flashes in the night?"[4] And Goethe maintained that "poetry is found only where dwell intimacy, need, and inward feeling."[5] Herder, who had studied with the rationalistic philosopher Kant and had absorbed the teachings of Rousseau, concluded that nature was not to be revealed in books and laboratories but directly in nature itself. As he ignited the young poet's imagination, he became Goethe's mentor. Herder was later immortalized as the prototype of Faust who, in the drama, also abandons his books and rational researches to experience the fresh air of intuition and feeling. "In the beginning was the deed," he declares as he plunges into a world full of human restlessness, turbulence, conflict, and dark primal urges.

Herder and Goethe's fateful meeting had still other ramifications. It was in Strasbourg that the philosopher introduced the poet to the sublimities of Gothic architecture in the cathedral

there, the grandeur of Shakespearean drama, the delights of folk-lore as the poetry of the common people, the wonders of bardic ballads in Macpherson's *Ossian*. The results of this excursion into the past can be read in Herder's *Von deutscher Art und Kunst* (1773) and Goethe's *Von deutscher Baukunst* (1772). While the Enlighten-ment, in the spirit of the new science, tended to consign historical considerations into the ashheap of ignorance and superstition, the *Sturm und Drang* embraced a new historical consciousness asso-ciated with the majestic sagas, epics, eddas, and the lyric literature of the medieval period. Following Burke's lead, the storm-and-stress movement was joined to the aesthetics of the sublime and the Gothic revival movement. This rediscovery of the northern European past proved to be an effective antithesis to the arbitrary acceptance of classical standards, as well as an assertion of north European nationalistic pride in the face of the more international orientation of the Mediterreanean Greco-Roman heritage.

The earliest version of *Faust* was written during Goethe's *Sturm und Drang* period in the early 1770s, although it was not published until 1887. This first draft, known as the *Urfaust,* was based on an actual case in the Frankfurt courts where Goethe's uncle was one of the lawyers. On the social level, the play can be read as a plea for understanding the plight of unwed mothers, who were led to infanticide in the face of stern, uncompromising social conven-tions. The tragic level is disclosed in the development and beauty of Gretchen's inner feelings and tender emotions, as she fulfills her womanhood only to come into conflict with the judgments of her fellow human beings. So also with Faust himself, whose rise to passion and intensity of feeling results in the destruction of the woman he loves. Later, when the full-scale, five-act drama ap-peared in 1808, the gestures of the *Sturm und Drang* are still ap-parent in the satirical treatment of university life and especially in the fire, fury, and frenzy of the nightmarish Walpurgis Night scene, done with all the demonic fantasy at the master's command.

It was the tremendous success of Goethe's novel *Sorrows of Young Werther* (1774), however, that brought the full impact of the movement to the popular level and gave voice to the longings and disillusionments of the younger generation. Werther, an aspiring

painter, passionately loves Lotte, but loses her when her family insists on a marriage of convenience. In his melancholy musings, he turns to reflections on the failures of judges and lawyers who interpret the letter of the law and the arbitrary rules of society rather than the spirit and motivations of individual men and women on whom they presume to sit in judgment. In his reaction against the rule of reason, this personification of the force of nature and storm-and-stress subjectivism comments: "We often find that with our loitering and veering, we get farther than the others with their sails and oars."[6]

The visual aspect of the storm and stress finds expression in the works of the Swiss-born artist Henry Fuseli. His inspiration came from the fearsome figures of Michelangelo's *Last Judgment*, Dante's *Inferno*, and the haunting ghosts and witches of Shakespeare. This master of the sublime eschewed the powdered wigs and stately poses of classical heroines in order to represent the face of fear. His *Nightmare* (Figure 90), a "Gothick" novel in paint, anticipates the psychological exploration of the subconscious dream world that was to color certain aspects of 19th-century romanticism and 20th-century expressionism. In the 1790s the great Goya was to take up this theme in his series of etchings known as the *Caprichos*. The title page, depicting a sleeper surrounded by creatures of the night—owls, bats, cats—bears the inscription "The Sleep of Reason Brings Forth Monsters." Fuseli's *Nightmare*, painted in 1781, was an instant *succès de scandale*, and it inspired a poetic description by the poet–natural-scientist Erasmus Darwin, grandfather of the famous Charles. The poem, written in 1782, begins and ends with the following quatrains:

On his Night-Mare, thro the evening fog,
Flits the squab fiend o'er fen, and lake, and bog,
Seeks some love-wilder'd maid, by sleep opprest,
Alights, and grinning, sits upon her breast.

.

On her fair bosom sits the Demon-Ape
Erect, and balances his bloated shape;
Rolls in their marble orbs his Gorgon eyes,
And drinks with leathern ears her tender cries.

Figure 90. Henry Fuseli. *The Nightmare,* 1781. Oil on canvas, 40 × 50″ (1.02 × 1.27 m). Copyright by the Detroit Institute of Arts. Gift of Mr. and Mrs. Bert L. Smokler and Mr. and Mrs. Lawrence A. Fleischman.

The Musical Scene

At the half-century mark in 1750, Johann Sebastian Bach was still working on his monumental *Art of Fugue,* while the young Joseph Haydn was composing his first string quartets. Bach's works are, of course, replete with complex counterpoint and number symbolism, which caused some critics of his time to classify him as a scholastic or "Gothic" composer. His successors, who wanted to move music away from mathematical manipulations to a more spontaneous expression of emotion, saw this sovereign command of musical resources as the antithesis to natural feeling. Champions of both the gallant style and of sensibility then characterized Bach's work as too severely cerebral. In France, the Bach approach was known as the *style travaillé;* in Germany, as *gelehrt or gearbeitet;* and in England as the learned or rigorously worked style. By contrast, Haydn's Quartet Opus 1, No. 1, was a light, charming diver-

timento totally different in spirit from the intellectual complexities of Bach's fugues. This contrast between Bach's last works and Haydn's first serves conveniently to point out that a profound stylistic change was already underway by the middle of the 18th century. The reaction against the older baroque manner can be noted in the keyboard works of Bach's son, Carl Philipp Emanuel, who was among those influential in shaping the new orientation. The older learned style, however, made a dramatic reappearance later on in the output of both Haydn and Mozart.

Beginning in the late 1760s and early 1770s, the fire and fury of the *Sturm und Drang* began to be heard in the works of both Joseph Haydn and Wolfgang Amadeus Mozart. Sultry passions and turbulent emotional outbursts now contended with the elegant artifices of the gallant style and the sturdier sentiments of the *Empfindsamkeit* for expression. Some music historians have referred to this time as a personal or romantic crisis in Haydn's life. It was indeed a crisis, but one in his art, not his personal life. Just as his colleagues in German letters had felt the need to override many outmoded, stereotyped poetic conventions and broaden the expressive scope of their art, so it was with Haydn. By his 35th year, Haydn had already written scores of symphonies, string quartets, trios, and sonatas for various combinations in the accepted gallant manner. But as a mature composer aware of the artistic currents of his time, he clearly felt the constraints and limitations of the style and the need to expand the expressive possibilities of his music.

For Haydn, it was a question of transforming the divertimento-type symphony from courtly entertainment into a vehicle for more profound and thoughtful expression. Significantly, the change is heard in the first of his orchestrated works in minor tonalities, those symphonies that bear the designations of "Lamentation" in D minor and "Passion" in F minor. Both were composed in the years 1767 and 1768. These were followed in 1771 and 1772 by the E-Minor *Trauer-Symphonie,* or "Symphony of Mourning," and the "Farewell" in F# minor. Curiously enough, Haydn's striking out in new directions also caused him to look back to find traditions and techniques that could help contain the intensified emotional forces and bring them under control. When emotional

drives reach their most feverish pitch, the composer often feels the need to tighten up the formal balances in order to keep control of the situation. Later in the romantic period, for instance, when Hector Berlioz was at his most demonic in the Finale of the *Symphonie Fantastique,* he ends the movement with a strict academic fugue. Also in the 20th century, when expressionism reached its high point, Arnold Schoenberg devised the rigorous technique of 12-tone serialism to contain its more violent climatic excesses.

So Haydn perceptively combined the musical languages of the past and future. A few specific examples will clarify the point. The *Trauer Symphonie,* for instance, begins with a sharply angular unison figure coupled with abrupt forte-piano dynamic accentuations (Example 1). Later, in 1786, Mozart was to open his C-minor Piano

Example 1. Haydn. Symphony No. 44 in E Minor ("Mourning") (c. 1771). First movement, bars 1–12.

Concerto (*K* 491) with a strikingly similar bold stroke (Example 2). Ludwig van Beethoven admired this work so much that he used the same tonality and a similarly heroic statement for the opening of his third Piano Concerto, Opus 37, of the year 1800 (Example 3). A striking new-old departure is also heard in the "Mourning" Symphony when Haydn comes to the third movement, traditionally a gracious and elegant minuet. In the somber key of E minor, he treats his theme with a contrapuntal twist as he casts it in the mold of a strict canon at the octave. This obvious reference to the older learned style makes this minuet a dance for the mind rather than the feet (Example 4).

Example 2. Mozart. Piano Concerto in C Minor, *K* 491 (1786). First movement, bars 1–8.

Example 3. Beethoven. Piano Concerto in C Minor, Op. 37 (1800). First movement, bars 1–4.

Example 4. Haydn. Symphony No. 44 in E Minor ("Mourning") (c. 1771). Third movement, bars 1–16.

The symphony called "La Passione" (1768) steers a stormy course through the dark waters of F minor. Once again in the turbulent and hard-driven *Allegro di molto* of the second movement Haydn balances his ship with a wheel from the past, this time a baroque *basso continuo*. Then three of his stormy series of six string quartets, Opus 20 (Nos. 2, 5, and 6), written in 1772, finish off with old-fashioned fugues. The Fifth, described by some as one of Haydn's most tragic statements, ends with a double fugue master-

fully crafted on an old baroque subject (Example 5). The genesis of his fertile theme can be traced back to the 17th century in the works of such composers as Buxtehude, Pachelbel, and Kuhnau. Bach uses it as the subject of one of the fugues in his *Well-Tempered Clavier,* where it appears in the same F-minor tonality as Haydn's string quartet (Example 6). Handel also builds one of the choruses in the *Messiah* on it: "And with His stripes we are healed" (Example 7). Mozart, then in his teens, was also fascinated by the discovery of this theme in Haydn's music and wrote two quartets of his own with fugal finales (*K* 168 and *K* 173). The first

Example 5. Haydn. String Quartet in F Minor, Op. 20, No. 5 (1772). Fourth movement, bars 1–7.

Example 6. J. S. Bach. *The Well-Tempered Clavier* II (1744). BWV 881. Fugue in F Minor, bars 1–4.

Example 7. Handel. *Messiah* (1742). "And with His stripes we are healed," bars 1–5.

And with His stripes we are heal - ed

of these features as a second movement an *Andante con sordini,* where the same subject appears once more, again in f minor (Example 8). Mozart chooses it yet again as the first subject of one of his most impassioned *Sturm und Drang* pieces, the Symphony in G Minor (*K* 183) (Example 9). The jagged and angular melodic shapes, the surging and churning rhythms, and the syncopated and explosive accents of this work, which was also written in his teens, far exceeded the more controlled and contained writings of

Example 8. Mozart. String Quartet in F Minor (1773). *K* 168. Second movement, bars 1–5.

Example 9. Mozart. Symphony No. 40 in G Minor (1773). *K* 183. First movement, bars 1–9.

Example 10. Mozart. *Requiem* (1791). *K* 626. "Kyrie eleison," bars 1–2.

the more mature Haydn. Significantly, this anguished subject reappears once again in the "Kyrie" of Mozart's *Requiem,* the work he was struggling to complete while on his deathbed (Example 10). This time, however, the theme is treated with a lofty calm and spiritual resignation that rises well above and beyond the earlier fiery and frenzied treatment.

Sonata Form and Style

Meanwhile, amid all the strident strife of the battle of the styles, a major musical phenomenon was taking place: the gradual growth of the sonata as the dominant vehicle of instrumental music. As it took shape in the 18th century, the creation of the classical sonata, the form that underlies all the symphonies, concertos, chamber, and large-scale solo works of the period, was perhaps the most significant and enduring musical achievement of the Enlightenment era.

This invention was the fruit of the collective efforts, experiments, and inspirations of countless composers in Italy, France, Austria, and the Germanies beginning in the 1720s. To mention but an outstanding few, Domenico Scarlatti can be cited for his numerous keyboard "exercises" or "sonatas" that matched contrasting materials in related tonalities; G. B. Pergolesi for the vivacity and vitality of his instrumental writing; François Couperin for his piquant rhythms and picturesque tone painting; Rameau for his codification of modern harmonic laws and his idea that melody had its roots in harmony. In Berlin there was the great Carl Philipp Emanuel Bach, and in London his younger brother Johann Christian Bach, both of whom deepened the expressive content and expanded the emotional spectrum of chamber and

clavier music. Their work commanded the respectful tributes and admiration of their illustrious successors of the Viennese School: Haydn, Mozart, and Beethoven.

In the broader sense, the social music of the time also played a leading role in the sonata's development. The divertimento, as its name implies, was an entertaining musical diversion for social occasions. Included in this category are similar compositions variously entitled serenades, cassations, and night music. Works of this type could be scored for any number of available instruments from small string or wind ensembles to whole orchestras. Like the earlier dance suites, they had a number of movements, varying from two to ten, depending on the particular occasion for which they were commissioned. As a whole, they comprised a casual sequence of marches, minuets, airs, themes with variations, and rondos, all held together by common key relationships. Expressively the spirit of this music was sparkling and lighthearted without undue complications or intricate devices that might overtly tax the attention of the casual listener. But in the hands of the major masters, the works began to include an occasional sonata-type movement. Eventually these pleasant meandering series of pieces began to condense into the stylized sequence of the three or four movements of the cyclical sonata.

In any discussion of the sonata there inevitably arises a tangle of technical terms that are often both ambiguous and ambivalent. The very word *sonata*, for instance, may refer to the organization of a specific movement with a recognizable pattern of distinctive sections, or it may indicate a three- or four-movement cyclical work. Also, symphonies, concertos, string quartets, trios, duos, and solo works are actually sonatas for various instrumental combinations. The sonata eventually became a synthesis of all the major formal patterns and principles of its time. These included the simple binary and ternary patterns, the song and aria, march and dance rhythms, the rondo, theme with variations; as well as the sonata design itself, with its set of structural principles, divisions into predictable parts, and its emphasis on the all-important idea of development.

The most distinctive feature of the sonata as it matured was that it avoided a set mold in favor of a process or style of shaping

the musical materials according to their inherent development potentials. The sonata has aptly been described as a strategy of key relationships opening with one or more thematic groupings clustered around a principal key center. A transition then leads to a subsequent thematic grouping in a closely related key, while a cadential passage concludes the exposition. The ensuing working-out, or argument, section makes full use of a wide variety of procedures and techniques, depending on how the composer wants to spin the thread. In the process he may choose to alter and elaborate the previously presented materials by expansion or contraction, extension or compression, sequences and consolidation, segmentation and motivic dissection, contrapuntal combinations and manipulations, making modulatory journeys into near and remote regions of harmonic space, building up dynamic climaxes and making coloristic changes of instrumentation, intruding unexpected episodes involving new twists and turns with contrasting materials. The development became the dramatic proving ground, where the thematic power struggle took place. As such, it became the center of gravity for the whole movement. Eventually the development wends its way toward the tonic tonality, in which the original material is presented once again in a recapitulation.

Here the previous themes, having gone through the crucible of the development, now appear in a new refining light, transformed by the psychological processes of memory and anticipation. The recapitulation was never an exact repetition because, as the ancient philosopher Heraclitus once observed, in the flow of time one cannot step into the same river twice. Later, with Beethoven, the recapitulation was often followed by a "terminal development" wherein still further vicissitudes and experiences were in store. The essence of sonata style was its fluidity and flexibility, and its ultimate destiny was thus toward constant and continuous development as it reflected the course of human life and growth.

An analogy may prove illuminating. The theater was by far the most popular and flourishing form of entertainment in the 18th century. All major centers, especially on the Continent, featured noted dramatists and actors. The overall picture of the sonata may be likened to a three-or four-act play, and an individual movement to a play within a play or an abstract distillation of the period's

dramaturgy. The themes, like characters, make their entries and exits in the first act (the exposition). Their interactions and reactions to each other take place as the plot thickens in the development. After this follows the dénouement, with the appropriate reconciliation of opposites and relaxation of tensions when the characters are transformed in the light of their experiences as the play concludes with the recapitulation.

In the form and content of the sonata, the elegancies of the rococo, the soulful sentiments of the sensibility, and the violent outbursts of the *Sturm und Drang* could all come together in one contrasting and interlocking whole. The moods run a gamut from the tragic to the comedic, from sorrow to joy, from anger to reconciliation, from the profound to the witty, from the foreboding to the playful. In the overall cyclical sense the outer movements of the sonata framed the structure with more sophisticated formal contours and serious, searching declarations. The inner components then explored a more intimate spectrum with songlike lyricism and dancelike expressions. In this guise the sonata, with its capacity to shape and contain the infinite variety of musical thought and invention of its time, became a miniature world in itself. Like a self-revealing mirror, it reflected the face of the life, times, and ideas of the era.

Stylistic Synthesis

All these stylistic developments, as previously pointed out, had their own separate vocabularies, orientations, and techniques. Yet as the century progressed they began to come together within particular musical works in a type of cross-fertilizing and coexistence process. The composers of the *empfindsamer* persuasion began to borrow certain idioms of the gallant style, while the *galant* in turn became a dramatic foil to its complete opposite, the *Sturm und Drang*. In the operas of the period, for instance, the different styles could be used to delineate various characters and their social backgrounds as they interacted with one another. In his *Don Giovanni*, Mozart starts the Overture with some foreboding, fortissimo, fire-and-brimstone chords in the key of D minor, and follows them

with spine-tingling ascending and descending scale passages. He then slips into some rollicking gallant comedy music for the second half. The "stone-guest" opening section of the Overture, however, functions like a premonition of the final scene, when the Don, who has single-handedly defied all social conventions and man-made laws, descends unrepentant into the flames of hellfire and damnation. Mozart also gives the amorous Don arias in pseudogallant style as he tries to seduce the peasant girl Zerlina and later as he woos Donna Elvira's maid. But for Don Ottavio, the amiable but staid and stereotyped aristocrat, he writes two pure *galant* arias.

Mozart's *Magic Flute,* half fairy tale and half allegorical morality play with multiple meanings, shows a similar range of styles. The opera opens with a scintillating overture clearly in the gallant style. Then each character is delineated in appropriate musical terms. Tamino is a prince whose love for Pamina leads him, with the aid of his magic flute (note the aristocratic connotations), through trials by fire and water into the realm of enlightened knowledge. His companion Papageno, as the guileless Rousseauian child of nature, first plays on the rustic panpipes before receiving his magic bells. The Queen of the Night then appears in a storm-and-stress, D-minor clap of thunder. Later she proclaims in a series of fiendish fioraturas that the fires of hell rage in her heart. Sarastro, at first a supposed sorcerer, presents himself as the personification of the Enlightenment, as he advocates the rule of wisdom tempered by social responsibility and the Free Mason ideals of equality and fraternity. Pamina, believing Tamino to have deserted her, sings possibly the most affecting *Empfindsamkeit* aria in all the literature: "*Ach, ich fühl es . . .* " (Ah, I feel it, the joy of love is lost forever). Thus the gallant, storm and stress, and sensibility all function effectively side by side within the greater dramatic context as the plot unfolds.

The formal structure of the *Magic Flute* has been likened in a recent revealing study to that of a large-scale sonata movement based on the unfolding of its plot, character development, and key relationships.[7] This first act then becomes the exposition, with the fairy-tale element as the first series of events and the Finale with

the scene in Sarastro's temple as the second and contrasting subject. The greater part of Act II would constitute the development with its stresses, strains, and processes of growth and change as the forces of darkness and light contend for supremacy. Sarastro's aria then becomes the harmonic and dramatic turning point, while the Finale is concerned with the reconciliation of opposites as it sums up the opera's dramaturgy in the manner of a recapitulation and coda.

On the instrumental scene, the dramatic distinctions of the separate styles also began to soften, and an accommodation process set in as the various vocabularies were absorbed into a more unified musical language. This is evident in the overall range of a composer's output as well as within the scope of single works. Mozart's Flute Concerto (K. 313) of 1778, for instance, begins with a typical gallant-style subject (Example 11). A few years later in 1785, he opens his G-minor Piano Quartet (K. 478) with the same theme now transformed into a statement in the storm-and-stress manner (Example 12). Similarly, the slow introduction of Haydn's B-flat major Symphony No. 98 starts with a jagged, angular, unison gesture in the minor tonality, quite typical of the *Sturm und Drang* (Example 13). But when it reappears in the tonic major of the subsequent *Allegro*, it becomes a blithe, charming gallant-style theme that would be at home in aristocratic circles (Example 14).

This accommodation process is also evident as the previously clear-cut distinctions of the various musical media—opera, church music, concert music, and various instrumental forms—began to mix and merge. Symphonies and concertos began to borrow from the opera, and vice versa. Sacred music turned to secular idioms, as operatic elements permeated the masses and motets written for church performance.

So it was in the 18th century that the separate and distinctive styles of the aristocratic rococo and gallant style, the bourgeois sensibility, and the antirational storm and stress all met and merged into the synthesis of classicism. It was as if these expressions in the arts were mirroring the changes in the structure of society, as the aspirations of the rising middle-class audience began to replace the

Example 11. Mozart. Flute Concerto in G Major (1778). *K* 313. First movement, Allegro maestoso.

Example 12. Mozart. Piano Quartet in G Minor (1785). *K* 478. First movement, Allegro.

Example 13. Haydn. Symphony No. 98 in B-flat Major (1792). First Movement: (Introduction) Adagio.

Example 14. Haydn. Symphony No. 98 in B-flat Major (1792). First Movement: Allegro.

supremacy of the previously exclusive aristocratic patronage. With the opening of public concert halls and opera houses, both classes now rubbed shoulders with each other as they heard the symphonies, concertos, and dramatic works of the many great masters of the Enlightenment.

The interweaving of all these different elements and trends by the collective hands of a legion of composers, patrons, and performing musicians eventually created a brilliant new synthesis as the mode of stylistic consolidation led to the creation of musical classicism. In this light, the classical style can be viewed as the emergence of unity out of diversity, the one out of the many.

Romantic Self-Revelation:

The Autobiographical Mode

IN THE PROFOUNDEST SENSE, every composer, author, poet, or painter records his or her autobiography in tone, ink, print, or pigment. Each succeeding work reveals some facet of the mind, imagination, and personality that identifies it as a passing image of the intellectual and creative course of the artist's life. Cumulatively then, an artist's complete works stand as the most important monument he or she bequeaths to posterity and the most complete record of a creative life. Some artists—such as Poussin, Haydn, and Jane Austen—have no significant biographies outside their craft. Others, such as Caravaggio, Beethoven, and Byron, led such individualistic lives that their viewers, listeners, and readers thirst for biographical details that may or may not illuminate their works.

Rembrandt recorded his attitudes and outlook from youth to old age in some sixty-odd surviving self-portraits. These are supplemented by drawings and etchings of himself, his family, and friends. From this visual autobiography one can follow his life from youthful follies to dutiful son in the portraits of his mother; from joyous bridegroom with Saskia to proud father in the portraits of his son Titus; and from a prosperous man of the world to

the increasing introspectiveness and self-examination in his lonely later years.

With the poet Goethe, in addition to the self-revelations in *Dichtung und Wahrheit,* the two great works that occupied him from his twenties almost to the year of his death—the poetic drama *Faust,* parts I and II, and the developmental novel *Wilhelm Meister*—form an intellectual autobiography. Therein one follows the transition from the youthful outbursts of the *Sturm und Drang* to the mature clarity and serenity of classicism. Beethoven's series of thirty-two piano sonatas form an abstract autobiography that extends from the buoyant and brilliant early years, through the power and glory of his mature middle period, to the profound and prophetic last five sonatas that probe unchartered territory and point toward the future course of musical composition.

Biography and Autobiography

The usual biographical pattern starts chronologically with forebears and parentage and the geographical and social milieu into which the subject was born. It continues with childhood and schooling, emotional attachments and sexual orientation, friendships and enmities, religious or philosophical commitments, marriage and family relationships, professional practices and problems, social and political activities, championship of causes, participation in or reaction to external events. And it ends with triumphs and failures. Where insights into art works are the primary concern, however, these biographical data are important only when they impinge upon the creative process and contribute to the understanding of a particular work. Otherwise, they are so much extraneous detail. Facts must be sorted out from fancy, life's trivia separated from art's activity, so that expression in word, deed, sound, and paint can come to the fore.

How much, for instance, can episodes in the lives of artists tell about their works? What role do biographical events play in the creation of the art? How much does a particular life experience contribute to the understanding of a specific work? The decisive events in the life of Michelangelo, for instance, were his meetings and subsequent relationships with his major patrons—the art-

loving Lorenzo de' Medici, the imperious Pope Julius II, the ambitious and frustrated Clement VII, and the shrewd and devious Paul III. In the 19th century no such personal relationships with all-powerful individual patrons was possible. Delacroix's principal patrons were a faceless succession of French government officials with their committees, juries, bureaucrats, and occasionally a minister,[1] who chose which pictures to purchase and commissioned the decorative embellishments for certain public buildings.

In any period, patronage and commissions—or lack thereof—play a vital role in the life of every artist. The old adage "Who pays the piper calls the tune" should never be forgotten. Also the amount of influence the patron had over the final design and over the artist himself must be determined. Further questions come to mind. With literature, what was the intended readership? Where and for whom was the play to be produced? With painting and sculpture, where was the picture to be hung? Who would see it? Where was the statue to be placed? With music, for what audience was the concerto or symphony originally intended? Where was it to be performed? With architecture, where was the building to be erected? What social function was it designed to fulfill?

Beyond this point, the autobiographical quest leads to original letters, diaries, journals, reported or recorded conversations, memoirs, and in rare instances actual autobiographies. Such sources must be searched and researched for any light they may shed on the intentions of the artist in executing particular commissions and, it is hoped, to find clues and keys to the meaning of their works. The autobiographical mode is most appropriate to the fuller understanding of the works of the artists in this chapter because for Hector Berlioz there is a full-scale autobiography plus a mass of critical writings, and for Eugène Delacroix there are his *Journal,* his essays, and the many surviving letters. Together, these documents provide the most complete personal, intellectual, and artistic portraits of any composer or painter in history. Beyond their special creative achievements in their respective fields, their writings alone would ensure them a place in history. More widely these documents record an illuminating commentary on the course of the romantic movement itself as well as constituting a vivid cultural-historical picture of the mid-19th-century.

Delacroix and Berlioz

Eugène Delacroix and Hector Berlioz were two quintessential and climatic figures of the French romantic movement, and their lives, aspirations, and arts closely parallel each other. Both were born in the turbulent days of the Napoleonic wars, and they witnessed the rise and fall of the empire and the restoration of the Bourbons under Louis XVIII and Charles X. Both reached maturity in the 1820s with critically controversial works that challenged the accepted academic style. Both championed the cause of Greek independence, Delacroix with his heroic canvas *The Massacre at Chios* (1824), and Berlioz with his *Scène héroique, la Révolution grecque* (1825). Both reacted strongly to the events of the July Revolution of 1830 that overthrew the old line of the Bourbon dynasty, the academically oriented neoclassicism in the arts, and ushered in romanticism as the officially recognized new style.

The imaginative flames of both painter and composer were ignited by the poetry, drama, and literature of ancient and modern times. Each in turn was inspired by Vergil's *Aeneid* and Dante's *Divine Comedy*. Delacroix painted *Dante and Vergil in Hell*, Berlioz composed his opera *Les Troyens*. The collective titles of Delacroix's pictures read like an anthology of Lord Byron's poetry, while *Childe Harold's Pilgrimage* took shape in Berlioz's works as the symphonic *Harold in Italy*. Both produced early works based on the conflagration scene from Byron's tragedy *Sardanapalus*, Delacroix with his sensational canvas, *Death of Sardanapalus*, Berlioz with his cantata that won him the coveted Prix de Rome. Both were in turn inspired by Goethe's *Faust*—Delacroix created 17 lithographs to illustrate the first French translation of the drama in 1827, and Berlioz composed his early cantata, *Huit scènes de Faust,* and the later full-scale oratorio *Damnation of Faust*. Both fell in love with Shakespearean actress Harriet Smithson when the bard's plays took Paris by storm in the theater season of 1827. In their full maturity they experienced the February Revolution of 1848 that gave birth first to the Second Republic, then the empire of Napoleon III. Both died before the second Napoleonic fall and the beginning of the Third Republic. Both composed epical works, large in scale and grand in manner. Both incorporated color as a pri-

mary component in their respective styles, Delacroix with his glowing canvases, Berlioz with his vivid orchestrations. Both were brilliant verbal stylists who could have made literature their major métier had they so desired, and both still hold a place in French letters and criticism apart from their painterly and musical specializations. Finally, both had powerful minds and personalities that stamped their images on their age.

Though the two great men knew each other personally and often met on social occasions, a friendship or meeting of minds never developed. Delacroix was a lifelong music lover and great admirer of Mozart and Rossini. Only Chopin, however, among his contemporaries measured up to his ideal of elegant craftsmanship. He termed Berlioz's music "a heroic mess,"[2] and Victor Hugo he dubbed "a blundering man of talent."[3] All his life Delacroix steadfastly resisted being classified as a romantic or as a member of any movement. "Men like Berlioz and Hugo, and the rest of those so-called reformers," he wrote in his *Journal,* "have not yet managed to abolish the laws which I have just mentioned; but they have brought about a belief in the possibility of working along the lines other than those of truth or reason."[4]

Eugène Delacroix

Although he lived in mercurially changing times, Delacroix remained aloof from political strife on the whole, except for the events of the Greek war of independence and the July Revolution. He never identified himself with a party or faction, whether political, academic or artistic. He reserved his passionate participation for one cause only—his art. Consciously or unconsciously, his attitude reflected the dictum that discretion is the better part of valor, since his artistic career and personal well-being depended mainly on public commissions. Above all, he viewed both life and art with objectivity and a certain diffidence. According to his letters and the *Journal,* the incidents that most directly influenced his art were his youthful encounter with the painter Théodore Géricault, his sojourn in England, his identification with the burning issue of Greek independence, and his journey to Morocco and Algeria.

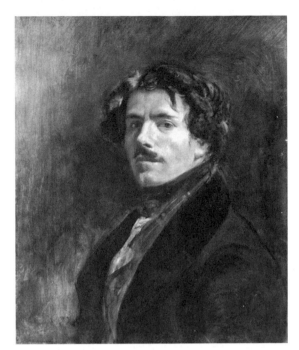

Figure 91. Eugène Delacroix. *Self-Portrait,* c. 1837. Oil on canvas, 64 × 21″ (165 × 54 cm). The Louvre, Paris. By permission of the Musées Nationaux, Paris.

Delacroix's self-portrait (Figure 91, see also Plate VIII) is that of a fiercely proud man in his late thirties, swarthy of complexion with thick dark hair, piercing black eyes, and a determined mouth—a person quite conscious of his place among the intellectual aristocracy of his time. His friends and contemporaries remarked on his brilliant conversational powers, flashing wit, biting irony, and searching intelligence. Beyond this visage of the man of the world, however, there was the artist full of inner tensions, incandescent imagination, strong will, and smoldering passions. As the poet Charles Baudelaire noted: "He was like the crater of a volcano artistically hidden by bouquets of flowers."[5]

Delacroix first came under the spell of Théodore Géricault, some seven years his senior, in the studio of their mutual master, Baron Guérin. At the time Géricault was working on his huge mas-

terpiece, the *Raft of the "Medusa"* (Figure 92), and its painter forthwith became Delacroix's master and mentor. Delacroix followed the work as it progressed and posed for the dying sailor lying face down in the foreground center at the corner of the raft. "What hands, what heads!" he wrote in his *Journal*. "I cannot express the admiration it inspires in me."[6]

The subject was a topical one, a major political scandal caused by the sinking off the West African coast of the *Medusa*, a French government frigate. When the ship began to founder, the reactionary royalist captain and his officers commandeered the only available lifeboats and set the 150 hapless passengers and crew adrift on a ramshackle raft. Exposure to the tropical sun, plus hunger and thirst, took its grim toll. Only fifteen survivors were rescued by a passing ship. While the subject was one of romantic realism, the magnificently modeled musculature of the male nudes was inspired by Michelangelo's frescoes, which Géricault knew from his studies in Rome. Later when regarding the picture as it was hung at eye level, Delacroix told a friend that the raft seemed to be weighed down by the bodies of the forlorn survivors and that he felt as if he were actually standing with his feet in the water. In his *Journal* of 1853, he recalled Géricault's "great relationship with Michelangelo. The same power, the same precision . . ."[7] The productive relationship with his mentor had another happy outcome—Géricault passed on one of his own contracts for a Virgin of the Sacred Heart, which became Delacroix's first major commission.

Géricault's *Raft* was the taking-off point for Delacroix's famous *Dante and Vergil in Hell* (see Plate IX), which was exhibited in the Paris Salon some three years later. Both pictures had epical implications, tragic overtones, and were based on the monumentality of statuesque figures. Delacroix's inspiration, however, was fired by the medieval mysticism and romantic sublimity he found in Dante's poetry. Baudelaire must have been thinking of the *Dante* when he wrote in his poem *Les Phares:*

Delacroix, lake of blood by evil angels haunted,
Shadowed by a green wood's mad mysteries,

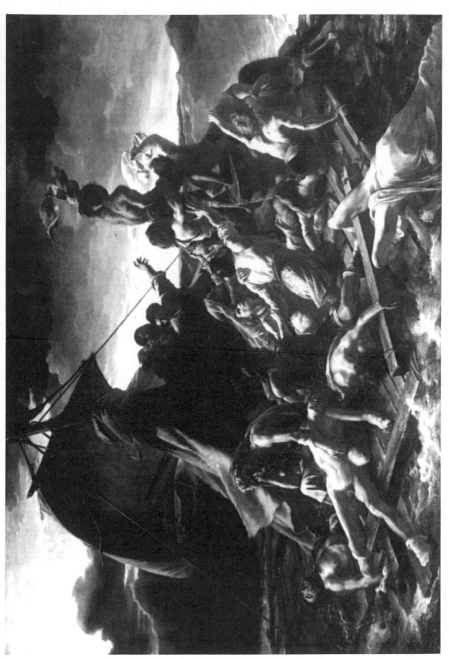

Figure 92. Théodore Géricault. *Raft of the "Medusa,"* 1819. Oil on canvas, 16 × 23½′ (4.88 × 7.16 m). The Louvre, Paris. By permission of the Musées Nationaux, Paris.

Where, under an angry sky in the night undaunted,
Pass stifled shadows, Weber's, to their destinies.[8]

The chosen scene is that of the eighth Canto of the *Inferno* as the two poets cross the sulfurous waters that surround Dis, the city of Satan. Within its molten iron walls, the damned are forever tormented by eternal flames. The poets are rowed by Phlegyas, the sepulchral boatman, whose muscular back appears at the right. As they cross, wrathful souls, essences of evil, tug at the bark and vainly try to climb aboard. Delacroix recalled later in his *Journal* that he had a friend who "used to read Dante to me while I was working on my *Dante and Vergil*."[9] He also noted that "The best head in my Dante picture was swept in with the greatest speed and spirit while Pierret was reading me a canto from Dante which I knew already but to which he lent, by his accent, an energy that electrified me. That head is the one of the man behind the boat, facing you and trying to climb on board, after throwing his arm over the gunwale."[10]

The canvas is executed with dramatic chiaroscuro effects lighted by flaming color with tints of livid green and sulfurous yellow tones. As models Delacroix cited Rubens's heroic canvases for their sweeping color dynamics and Rembrandt's dramatic compositions with their subtle shading and accents of intense light. Delacroix's infernal shades and tormented spirits, however, succeeded in stirring up the critical furies of the Paris press, who poured their molten vituperative invectives on his head. "A splattering of color," muttered one, while another castigated the combination of "all parts of the composition in view of one emotion."[11] This, however, was exactly what Delacroix was trying to convey. For him, color *was* painting, and the symbolic values and turbulent emotional implications of color were the essence of the painting process. "Gray," he declared, "is the enemy of all painting . . . let us banish from our palette all earth colors . . . the greater the opposition in color, the greater the brilliance."[12]

The new approach, the heightened emotionalism, and the critical controversy surrounding *Dante and Vergil* catapulted Delacroix into an egregious prominence that assured him the undisputed leadership of the romantic movement in painting for the rest of

his career. In spite of the critical furor, Delacroix was able to write to a friend: "The principal painters of the school, who comprised the jury for the Salon, were extremely pleased with my picture, and I shall have in the next few days to take a number of steps to try to sell it to the government and get another commission: this would follow almost inevitably, and it would be very important for me. Once I have the commission I can do the work at leisure."[13] The *Dante* was indeed bought by the authorities, and it now hangs in the Louvre.

Delacroix embarked for England in 1825 on a pilgrimage to the land of Shakespeare and Byron, Constable and Turner. As an ardent theater lover, he was also to discover Goethe's *Faust* in the first of its operatic versions and hear another production of Weber's *Freischütz:*

I saw here a play about Faust which is the most diabolical thing imaginable. The Mephistopheles is a masterpiece of character and intelligence. It is an adaptation of Goethe's *Faust;* the principal elements are retained. They have made it into an opera with a mixture of broad comedy and some extremely sinister effects. The scene in the church is played with priests singing and distant organ music. Theatrical effect can go no further. I have seen *Freischütz* in two different theatres, with some music that was omitted in Paris. There are some very remarkable things in the scene where they cast the bullets. The English understand theatrical effect better than we do, and their stage sets, although they are not so carefully carried out as ours, provide a more effective background to the actors. They have some divinely beautiful actresses, who are often more worth seeing than the play itself: they have charming voices and a grace of form which is not to be found in any other country.[14]

The painter also had the good fortune to experience Shakespeare as played by the renowned Edmund Kean who, as William Hazlitt once noted, acted Shakespeare by flashes of lightning. Delacroix wrote back to Pierret: "I have seen *Richard III* played by Kean, who is a very great actor . . . I also saw his *Othello.* No words

are strong enough to express one's admiration for the genius of Shakespeare, who created Othello and Iago."[15] He also reported that Kean's Shylock was "wonderful," and in the succeeding letter he mused on the great liberties these actors took with the plays in contrast to the greater textual faithfulness observed in the French classical theater: "I don't know by what strange caprice of nature Shakespeare was born in this country. He is undoubtedly the father of all their arts and one is quite astonished to see what methodical disorder they introduce into these."[16]

Delacroix had first seen the work of John Constable in the Paris Salon of 1824. Three Constable landscapes were displayed, including the masterpiece *Haywain*, in addition to pictures by Delacroix himself and his archrival J. A. D. Ingres. Delacroix immediately seized upon Constable's unique color techniques. In England he learned from Constable the subtle method of setting various shades of the same hue side by side in separate brushstrokes, rather than blending them as flat mixtures on the palette. The result was a variegated and vibrating surface that allowed the eye itself to fuse the colors, a technique that was to be central to the later impressionists.

Massacres and Revolutions

The two contemporary events to engage Delacroix's attention and art were the struggle of the Greek people for freedom from Turkish tyranny and the July Revolution of 1830, when the French liberated themselves from the chains of the old Bourbon dynasty. The classically oriented and educated Europeans and Americans saw Greece as the birthplace of the ancient ideals of democracy, free philosophical inquiry, and beauty in the arts. So in the early 1820s the reverberations of the Greek cause resounded through educational circles, literary salons, political corridors, and the halls of the general public. When Delacroix's beloved Byron espoused the cause and laid his life and fortune on the line, the painter took to his brushes and produced his heroic canvas, the *Massacre at Chios,* which was exhibited in the Salon of 1824, the year of Byron's death at Missolonghi. Two years later there was a sequel, the allegorical *Greece on the Ruins of Missolonghi.*[17]

Figure 93. Eugène Delacroix. *Massacre at Chios,* 1824. Oil on canvas, 13′ 7″ × 11′ 10″ (4.14 × 3.61 m). The Louvre, Paris. By permisison of the Musées Nationaux, Paris.

The impetus for the *Massacre at Chios* (Figure 93) came when Western Europe learned that Turkish forces had burned the town and slaughtered or enslaved its inhabitants. A letter from a Greek reporter in Smyrna was published in the French press, and went in part: "Throughout Chios only fifteen houses are standing . . . our mothers, our sisters, and our daughters, reduced to the most dreadful slavery . . . Upwards of forty villages have been con-

sumed by the flames. The ferocious incendiaries then scourged the mountains and the forests ... Every day women of the first families in the island are exposed for sale in the Public markets."[18] After such carnage, fire, and plunder, the population was reduced from 90,000 to a pitiful 900 survivors. From his reading of these atrocities, Delacroix constructed a composite picture of some of the dismal incidents.

As he sketched out the overall structure of the picture, Delacroix chose a few grisly details to dramatize his desolate composition. Under an ominous, lowering sky, the smoking city is seen in the distance. By their bodily attitudes and postures the figures in the foreground betray emotions ranging from bitter resentment to resignation and despair. Above them a turbaned Turkish Janissary rides impassively over this sea of tortured flesh. The novelist and critic Théophile Gautier called attention to the "feverish convulsive drawing and the violent coloring," while the Napoleonic painter Baron Gros, usually well disposed toward Delacroix, labeled it the "massacre of painting."

The baron's challenge may have motivated Delacroix to undertake what he called his "second massacre," the *Death of Sardanapalus*, in 1827 (see Plate X). This massacre was one of ancient vintage. The scene derives from the dénouement of Byron's poetic drama, which recounts the tragic tale of the legendary Assyrian satrap who was besieged and subsequently conquered by the Medes in the fall of Nineveh. In a diagonally descending composition, the stately monarch is portrayed reclining on a huge couch of Oriental splendor supported by two elephant heads. With fatalistic calm, he is directing his eunuchs to slay his intimate circle of wives, concubines, page boys, even his favorite horse and hunting dogs. Only his beloved Myrrha is spared so that they can have one final embrace on the flaming funeral pyre. The self-immolation has already begun as the bright glow of the burning palace mixes with the dark gray tones of the billowing smoke in the upper right. The climax of the orgiastic scene is declaimed in Byron's play by Sardanapalus' soliloquy:

—and the light of this
Most royal of funeral pyres shall be

Not a mere pillar form'd of cloud and flame,
A beacon in the horizon for a day
And then a mount of ashes, but a light
To lesson ages, rebel nations, and
Voluptuous princes.

Then Myrrah enters, and an operalike love-death duet ensues:

Sar. Now, farewell; one last embrace.
Myr. Embrace, but *not* the last; there is one more.
Sar. True, the commingling fire will mix our ashes.
Myr. And pure as is my love to thee, shall they
 Purged from the dross of earth, and earthly passion
 Mix pale with thine.[19]

This "pandemonium of passions," as Walter Friedlaender described it, is replete with writhing movement, animal ferocity, and voluptuous eroticism.[20] As blood and fire mix, Delacroix dwells lovingly on such painterly details as the sumptuous drapery, bejeweled sword hilts, the translucence of pearl necklaces, and the golden cup containing the potion of poison at Sardanapalus' side. One can only wonder at the turbulence of Delacroix's composition, the theatrical spectacle of violent gesticulation, and the magic of his coloring. It is truly a tour de force of the painter's craft.

Critical reaction was sharpened by the raging battle between the neoclassicists and romanticists, which was particularly strident in the year 1828, when the *Sardanapalus* was accepted for the Salon of that year. Victor Hugo had just published his controversial play *Cromwell.* Its notorious preface quickly became the manifesto of romanticism. Of the *Sardanapalus,* one critic wrote "you would not call this confusion a painting but a 'Persian carpet' or even a 'kaleidoscope.' " Another likened Delacroix's technique to that of Rubens "with his warm and vibrant color," but he deplored the canvas for its want of decorum and hoped that the artist would eventually "put a salutary bridle upon his picturesque and poetic imagination." Victor Hugo, however, hailed the work as a "magnificent thing," while at the same time it was being lampooned by a journalistic wit who wrote: "M. Delacroix has ordered two moving vans

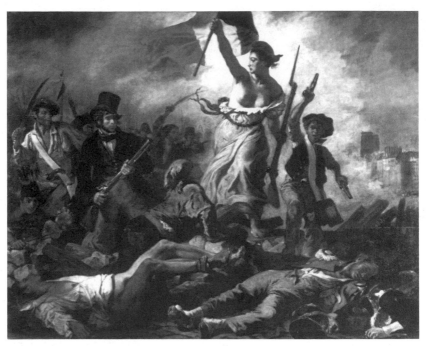

Figure 94. Eugène Delacroix. *Liberty Leading the People,* 1830. Oil on canvas, 40 × 50″ (1.02 × 1.30 m). The Louvre, Paris. By permission of the Musées Nationaux, Paris.

to carry off the furniture of the *Sardanapalus,* three hearses for the dead and two buses for the living."[21]

Political events, however, intervened to awaken the romantics from their technicolor drams of past glories to witness the stirring developments in what has been called the Romantic Revolution of 1830. The last vestiges of royal absolutism expired that year in the Paris street riots, and a limited monarchy of a "citizen king" in the person of Louis Philippe was installed after the July Revolution. In a letter to his brother General Charles Delacroix, Eugène wrote: "I have undertaken a modern subject, *A Barricade* . . . and if I have won no victories for my country at least I can paint for it. This has restored my good temper."[22] The picture referred to was his *Liberty Leading the People to the Barricades,* 1830 (Figure 94).

Delacroix was as usual more involved with his picture than with the political cause as such. He did, however, imbue the scene with

a sweeping passion as the revolutionists storm roughshod over the bodies of the fallen on their way toward realizing the ideal of freedom. Liberty herself, a rifle in one hand, the tricolor banner in the other, appears more as a bare-breasted woman of the people than an abstract allegorical personification. Like her, the composition finds its unity more in its onward and upward sweep toward the barricades than in static posturing. The brilliant colors assume a life of their own with the blue of the flag and that of the sky symbolizing the pursuit of freedom, the white blending with the smoke of battle, and the red mingling with the blood of those who were giving their lives to the cause.

Morocco and Algiers

The year 1830 was memorable for another political event, the French conquest of Algeria. At first their control was tenuous, and the famous Foreign Legion was formed to extend and consolidate their holdings in the interior. The sultan of neighboring Morocco, however, viewed these developments with some alarm, and in 1832 the French government decided to launch a diplomatic mission to reassure the uneasy ruler and negotiate a treaty with him. Count Mornay was chosen as the chief emissary, and his friend Delacroix was invited to join the group. On this momentous four-month journey, the painter's whole world outlook was changed. In addition to the local color, so dear to the romantic heart, he experienced the conjunction of two cultures—the majority Moorish-Arabic and the minority Jewish communities. His *Journal* now changed into a sketchbook, and the text became mainly titles for the hundreds of hasty drawings and watercolors he made on the spot.

As Delacroix wrote back to one Paris friend: "This place was made for painters . . . there are subjects for pictures at every street corner." To another, "The picturesque is here in abundance. At every step one sees ready-made pictures, which would bring fame and fortune to twenty generations of painters." And to yet another: "I am really sorry, now, for those artists, endowed with any degree of imagination, who are fated never to get a glimpse of these unspoilt, sublime children of nature."[23]

With his keen eye for detail, Delacroix's notes and drawings record mulatto slaves in canary-yellow caftans and white turbans pouring mint tea, dashing Moroccan warriors mounting their fiery steeds, and an emissary from the sultan in a "very fine white burnous, pointed cap without turban, yellow slippers with gilt spurs, violet belt embroidered in gold, heavily embroidered cartridge belt, the bridle of his horse violet and gold."[24] He was also enchanted by the calls of the muezzins and the dithyrambic dances he saw in the Jewish quarter. Listening to the sultan's ceremonial band at a diplomatic reception inspired the later painting *Jewish Musicians from Mogador,* now in the Louvre.

The landscapes proved to be a romantic's dream of the picturesque. Riding over the plains to Meknes, he noted the variegated carpets of yellow, white, and violet flowers with the mountains providing a backdrop that was blue by day and violet at dawn and dusk. He passed almond trees in full flower, Persian lilacs in bloom, gray-green olive and dark-leaved orange trees bearing fruit. The hilltops along the way created a mosaic of reds, blues, greens, and yellow against the gray rock formations. Under this "sky of purest azure" and in the crystal-clear air, he discovered for himself the idea of objects casting shadows of complementary colors, with yellow making violet shadows and the reds greenish reflections, a principle he was to incorporate in his later oil paintings.

Events he sketched at this time inspired two major paintings. In each case Delacroix provides the most eloquent commentary. *Arab Horses Fighting in a Stable,* 1860 (Figure 95) depicted an incident that happened in Tangiers when two shiny stallions engaged in combat:

Two of these horses fell out with one another, and I witnessed the fiercest battle you can imagine: all the furies invented by Gros and Rubens are tame in comparison. After biting one another in every conceivable way, climbing on top of each other like men—having first, needless to say, got rid of their riders—they then plunged into a stream and went on fighting there with unheard-of ferocity. It was the deuce of a business getting them out of it.[25]

Figure 95. Eugène Delacroix. *Arab Horses Fighting in a Stable,* 1860. Oil on canvas, 25 × 32″ (64 × 61 cm). The Louvre, Paris. By permission of the Musées Nationaux, Paris.

The other was the *Jewish Wedding in Morocco* (Figure 96), first shown in the Salon of 1841. Here he was allowed the rare privilege of being present with his sketchbook at a marriage ceremony in a Moroccan home. His detailed notes read like a script that was nine years later to be transcribed into paint:

> . . . Blackness between the two musicians below. The body of the guitar on the knee of the player; very dark toward the belt, red vest, brown ornaments, blue behind his neck. Shadow from his left arm (which is directly in front of one) cast on the haik over his knee. Shirtsleeves rolled up show-ing his arms up to the biceps; green woodwork at his side; a wart on his neck, short nose.
>
> At the side of the violinist, pretty Jewish woman; vest, sleeves, gold and amaranth. She is silhouetted halfway

Figure 96. Eugène Delacroix. *Jewish Wedding in Morocco,* 1841. Oil on canvas, 26⅜ × 32¼″ (66.99 × 81.92 cm). The Louvre, Paris. By permission of the Musées Nationaux, Paris.

against the door, halfway against the wall; nearer the foreground, an older woman with a great deal of white, which conceals her almost entirely. The shadows full of reflections; white in the shadows.

A pillar cutting out, dark in the foreground. The women to the left in lines one above the other like flower pots. White and gold dominate, their handkerchiefs are yellow. . . .

At the side of the guitarist, the Jew who plays the tambourine. His face is a dark silhouette, concealing part of the hand of the guitarist. The lower part of his head cuts out against the wall. The tip of a gelabia under the guitarist. In front of him, with legs crossed, the young Jew who holds the plate. Gray garment. . . .

Against the door of the stairway, Prisciada; purplish handkerchief on her head and under her throat. Jews seated on the steps; half seen against the door, strong light on their noses, one of them standing straight up on the staircase; a cast shadow with reflections clearly marked on the wall, the reflection a light yellow.

Above, Jewesses leaning over the balcony rail. One at the left, bare-headed, very dark, clear-cut against the wall, lit by the sun. In the corner, the old Moor with his beard on one side; shaggy haik, his turban placed low on the forehead, gray beard against the white haik. The other Moor, with a shorter nose, very masculine, turban sticking out. One foot out of the slipper, sailor's vest and sleeves the same.

On the ground, in the foreground, the old Jew playing the tambourine; an old handkerchief on his head, his black skullcap visible. Torn gelabia; his black coat visible near the neck.

The women in the shadow near the door, with many re-flections on them.[26]

On the voyage home, Delacroix spent a few productive days in the city of Algiers where, sketchbook in hand, he was accorded the unprecedented honor of a visit into a harem. According to his friends, he left in such a state of excitement that he had to be cooled down with refreshing ices. The happy consequence was the masterpiece *Algerian Women in Their Harem* (see Plate XI), first seen in the Salon of 1834. The work combines a rainbow of color harmonies offset by the undulating rhythm of the indolent bodies, all contained within a dreamlike unity of space. In the lefthand figure, one can note the juxtaposition of the orange-reddish blouse with a greenish-blue lining and the background cabinet with its alternating stripes of green and red. Cézanne noted that the "color of the red slippers goes into one's eyes like a glass of wine down one's throat." Renoir remarked that when he looked at it, he could actually smell the incense. Picasso paid the painting the ultimate compliment by using it as a theme for a series of 15 different variations that he painted in the 1950s.

The Mature Years

Delacroix returned, after his journey into exotic climes, to a Paris where romanticism was now the accepted style. With his professional reputation secure, he needed only the recognition that officialdom could confer, and this was soon forthcoming. Earlier, the historian and future statesman Adolphe Thiers, who had hailed Berlioz as a true genius, had been a friend and admirer. Thiers subsequently played an important role in placing Louis Philippe on the throne, and he was at this time Minister of the Interior. In this post he had large government contracts at his disposal, and Delacroix received a series of large-scale commissions that occupied him throughout his mature years. While he never abandoned easel painting, where he worked on a more intimate emotional scale, he was now able to explore the more expansive mural medium, where he could reach out with an orchestral palette and speak in symphonic tones with accents of romantic grandiosity.

The themes Delacroix chose ran a gamut from Greco-Roman mythology to Old Testament subjects. He now worked with a corps of apprentices and several experienced artists whom he entrusted with transferring his sketches and designs onto the enormous canvases for later mounting. Like Rubens before him, he always reserved for himself certain sections and the finishing touches. For the library of the Chamber of Deputies, the ceiling space extended some 137 feet in length with five cupolas, each with four curved pendentives, and two semicircular lunettes over the doorways at each end. For the latter the subjects were War, typified by the ravages of Attila the Hun at one end; and Peace, symbolized by Orpheus organizing and educating the Thracians to the tune of his lyre at the other. In between, the domes with their pendentives presented a program of human achievement in a cycle of five subjects centering on philosophy, science, religion, law, and letters.

For the Apollo Gallery in the Louvre (Figure 97), he chose the legend of the sun-god's slaying the serpent Python to typify the epical contest between light and darkness. The next project was for the Salon de la Paix at the Hôtel de Ville, the Paris town hall, where he assembled a whole galaxy of gods. On the ceiling were the earth goddess Cybele bringing Neptune, Venus, and Bacchus

Figure 97. Eugène Delacroix. *Apollo Vanquishing the Python,* 1850–51. Ceiling mural, Apollo Gallery. The Louvre, Paris. By permission of the Musées Nationaux, Paris.

together to promote peace and heal the wounds of human conflict. The walls below depicted an allegorical version of the labors of Hercules. Only the preparatory sketches and some drawings, however, survive—the room was razed by a fire set during the proletarian insurgency in the fateful year 1871.

Delacroix's next commission was to paint the expansive dome with its adjoining lunettes in the library of the Luxembourg Palace. The subjects he chose were scenes exalting the epic poets Homer, Vergil, and Dante, together with a series celebrating Al-

exander the Great's campaigns that spread classical Greek culture throughout the ancient world. His final monumental public commission was the decoration of the walls and ceiling of the Chapel of the Holy Angels in the Paris church of St. Sulpice. On one wall three avenging angels drive off the Roman emperor Heliodorus as he tries to rob the holy treasures from the temple at Jerusalem. The opposite mural depicts Jacob wrestling with an angel, while above a mighty combat between good and evil is personified by the archangel Michael vanquishing Satan.

In all these projects, Delacroix had to contend with poor and uncertain lighting as well as awkward placement from the observer's point of view. Even today, except for the Louvre murals and those in St. Sulpice, they are quite inaccessible to the general public, as they are in busy government buildings open only on rare occasions. For this reason, they have received far less attention than they deserve.

These are the highlights of the notable career of this poet in paint, who single-mindedly and devotedly lived for his art and wrote his intellectual, emotional, and pictorial biography not only with the words in his letters and *Journal,* but with each brushstroke of his paintings.

Hector Berlioz

Hector Berlioz has passed down to us twin autobiographies, one in tones, the other in words; one recording his dream life, the other his personal and professional life. These works are the early symphony, *Episode in an Artist's Life,* with its two parts, the *Symphonie fantastique* and *Lélio, or the Return to Life;* the other, Berlioz's later written *Memoirs.* Both are supplemented by his voluminous correspondence, critical writings, and essays and are fascinating mixtures of fact and fancy, truth and fiction, reality and romance, with fantasy ultimately victorious over facts. Objectivity and factual exactitude, however, are hardly to be expected in the autobiography of an artist so completely involved and immersed in his own creative work and in the musical life of his times.

Emile Signol's portrait (Figure 98), painted after Berlioz had won the coveted Prix de Rome, reveals a young man in his late

Figure 98. Emile Signol. *Portrait of Berlioz,* 1832. Oil on canvas. French Academy, Rome.

twenties with the penetrating, deep-set eyes of a fiery dreamer consumed by an inner vision. It reflects the flamboyant personality, burning idealism, and Byronic melancholy of a dedicated romantic. There is also a certain defiance leavened by a spontaneous sense of humor, enthusiasm mixed with sarcasm. Above all, the face bespeaks a person of volcanic energy; but with Berlioz it was no smoldering Vesuvius masked by flowers, but rather a perpetually erupting crater. The shock of flaming red hair and aquiline nose commanded universal attention. When seeing him for the first time in a Paris salon, an acquaintance wrote: "I looked round and saw a young man literally shaking with rage, his fists clenched, his eyes blazing, and a head of hair—how can I describe it? An immense umbrella or movable canopy overhanging the beak of a bird of prey."[27] Here indeed is the image of a man destined to lead an adventurous life that would become legendary in his lifetime, a man determined to live his life as a work of art, a man who drew no distinction between the seen and unseen, the real and imaginary, life and art. Later Berlioz was to be portrayed by many of the major painters of the mid-19th century—Daumier, Doré, Cour-

Figure 99. Gustave Courbet. *Portrait of Berlioz,* 1850. Oil on canvas, 24″ × 18⅞″ (61.54 × 48.41 cm). The Louvre, Paris. By permisison of the Musées Nationaux, Paris.

bet, and Fantin-Latour (Figure 99). At this point, however, he was depicted more as a man of thought and contemplation.

Berlioz's intellectual and emotional life proceeded in a series of violent shocks. Musically it was his discovery first of Gluck's serious operas and reform ideas, then of the Weber of *Der Freischütz,* which he said intoxicated him with "its wild, subtle fragrance . . . poetry, passion and contrast. The melody, harmony, and rhythm alike thunder, burn and illumine."[28] Then he tells his readers: "I had scarcely recovered from the visions of Shakespeare and Weber when I beheld Beethoven's giant form looming above the horizon. The shock was almost as great as that I had received from Shakespeare, and a new world of music was revealed to me by the musician, just as a new universe of poetry had been opened to me by the poet."[29]

In literature, the first shock occurred with Vergil, when Berlioz's father was teaching him Latin at the tender age of seven. He recalled how it was the "epic passion of the Latin poet that first ignited my smouldering imagination. How often I felt my heart throb and my voice quiver and break when construing the fourth book of the *Aeneid* to my father." The climactic year, however, was 1827, when he discovered both Goethe's *Faust* and Shakespeare's *Hamlet* and *Romeo and Juliet,* as well as the *femme fatale* of his life, the Irish actress Harriet Smithson. "Another of the most remarkable events of my life was the deep and wonderful impression made on my mind by Goethe's *Faust,* which I read for the first time in a French translation by Gérard de Nerval." And he continues: "It was immediately after this, my first effort at setting *Faust,* and while I was yet strongly under the influence of Goethe's poem, that I wrote my *Symphonie fantastique.*" [30]

In the Goethean sense, it was the eternal feminine that always drew Berlioz ever onward. The first of the two enduring passions that illuminated his art and life was the "*Stella del monte*" who like Dante's Beatrice, Berlioz glimpsed only briefly in passing. "The moment I set eyes on her," he recalls, "I felt an electric shock, in fact, I fell in love with her, desperately, hopelessly . . . Whenever I think of her I see a vision of large brilliant eyes and equally brilliant pink shoes . . ." He first espied the lovely Estelle on a summer visit to his grandfather in a tiny mountain village near Grenoble. He was but 12 and she 18 when he first awakened to love and feminine beauty. It was she who inspired the love song he wrote at the time, which was later to become the recurring motif, or *idée fixe,* of his *Fantastic Symphony.* After his father's death in 1848, he returned once again to his youthful haunts, revisited the village where he had first seen her, longed to see her again, but contented himself with writing a passionate love letter to the now 51-year-old widow, telling her that "her radiant beauty had illuminated the morning of his life," which must have startled the good lady half out of her wits. Needless to say, the letter went unanswered, but the full text appears in the *Memoirs.* [31]

The other love was Ophelia and Juliet in the person of the actress Harriet Smithson. Later she was to become his wife and the mother of his only child, Louis. In 1827 an English touring com-

pany had come to Paris to mount Shakespeare plays, then largely unknown to the Parisian public. At the opening performance of *Hamlet* he beheld Smithson as Ophelia: "I can only compare the effect produced by her wonderful talent, or rather her dramatic genius, on my imagination and my heart, with the convulsion produced on my mind by the work of the great poet whom she interpreted . . . This sudden and unexpected revelation of Shakespeare overwhelmed me. The lightning flash of his genius revealed the whole heaven of art to me, illuminating its remotest depths in a single flash." [32]

He was next to be carried completely away by *Romeo and Juliet*, speaking of "the hot sunshine and balmy nights of Italy—to the love, quick as thought, burning as lava, imperious, irresistible, illimitably pure and beautiful as the smile of an angel; the raging revenges, delirious embraces, and desperate struggles between life and death." [33] All this came about without his knowing a syllable of English, although he knew the play in French translation. Harriet herself was completely ignorant of French. So, according to Berlioz's friend, the German composer Ferdinand Hiller, it was a love affair of the imagination and Shakespeare, not of the heart. As Berlioz noted in the *Memoirs:*

> I have no more to say with regard to the two great passions which influenced my heart and my intellect so long and so powerfully. The one was a memory of my childhood. It comes to me radiant with smiles, adorned with all the charms of a perfect landscape, the mere sight of which was sufficient to move me. Estelle was then the hamadryad of my valley of Tempe; and at the age of twelve I experienced for the first time, and together, love and the love of nature.
>
> The other love came to me in my manhood, with Shakespeare, in the burning bush of Sinai, amid the thunders and lightnings of poetry entirely new to me. It prostrated me, and my heart and whole being were invaded by a cruel, maddening passion, in which the love of a great artist and the love of great art were mingled together, each intensifying the other.

After a desperate romance leading both to the brink of suicide, he finally married the beautiful feminine package whom he thought of as Ophelia and Juliet wrapped up in one. When his wife turned out to be merely Miss Harriet Smithson, now Mme H. Berlioz, he wrote with acute anguish to a friend: "She is an ordinary woman." The cold dawn of disillusionment brought years of personal misery, compensated for by some happier results on the musical side. None of these momentous happenings, however, was a transitory fancy, since reverberations of these successive shock waves were to resound and reecho throughout the rest of Berlioz's life. All were interwoven into the fabric of his thought and creative work. His only religion was art, and Gluck, Weber, Beethoven, Vergil, and Shakespeare were his pantheon of prophets.

Episode in an Artist's Life

Berlioz's dream autobiography, Part I of the *Symphonie fantastique,* is the summation of his musical powers and poetic ideas from youth to maturity. The composer's program notes, distributed to the audience in advance, made his intentions quite explicit. The background is colored by Alfred de Musset's free translation of Thomas de Quincey's popular book of the time, *Confessions of an English Opium Eater.* The literary prelude to the symphony describes a young musician of extreme sensibility and morbid imagination who has loved and lost. In his amorous despair, he has taken enough opium to plunge him into a world of strange visions and sensations, as he longs for his beloved who always appears to him as a recurring musical thought.

The first movement, entitled "Reveries and Passions," a typical Berliozian polarity of opposites, starts off with a *Largo* describing the hero's melancholy soul-searching. It continues with an *Allegro agitato e appassionato assai* that introduces the object of his passions with a motif derived from the youthful love song, which now becomes the theme that links all five movements. This *idée fixe,* as he calls it, changes shape in each of its reappearances, providing the listener with a note of continuity as the dramatic episodes unfold. The second movement corresponds with a symphonic scherzo.

There the hero beholds his beloved dancing the waltz in a brilliant ballroom scene. The slow movement is set in an expansive pastoral landscape where he hopes to find solitude and solace, only to discover that nature has its malignant as well as benign aspects.

The fantastic and convulsive elements now take over with the "March to the Scaffold." The hero has dreamed that he has killed his beloved and now must pay the price. The muted sounds of muffled drums accompany his grim progress toward the guillotine. As the blade is about to fall, his last thoughts are heard with the familiar *idée fixe* now transposed to the high, piercing register of the clarinet. A final crash is followed by a dull thud and a roll of the drums as the grimacing crowds roar their bloodthirsty approval. In one of his notebooks, Berlioz described the execution of the French Revolutionary poet André Chenier, who had been killed during Robespierre's grim reign of terror. Later this event became a symbol for the martyrdom of poetry at the hands of the unheeding mob. Berlioz also thought of himself at various times as "an Attila ravaging the musical world, a revolutionary to be guillotined."

Now a tempestuous pandemonium conjures up a satanic nightmare as triumphant witches and ghouls compete for the possession of the fallen hero's soul. The beloved is also present, casting her fatal spell. Her theme now appears in a lurid, vulgarized guise. The title of this tumultuous phantasmagoria alludes to the "Witches' Sabbath," or "Ronde du Sabbat," of one of Victor Hugo's Gothic ballads.[35] It also evokes the spirit and imagery of the "Walpurgis Night Scene" of Goethe's *Faust* where sorcerers mount he-goats, giant bat's wings whir overhead, fireflies light up the night sky, and Mephistopheles trips the steps of a devilish dance, while the demonic forces

> . . . crowd and jostle, whirl and flutter!
> They whisper, babble, twirl and splutter!
> They glimmer, sparkle, stink, and flare—
> A true witch-element! Beware![36]

Introducing a note of true romantic irony, Berlioz writes a parody on the melody of the *Dies irae*, the Gothic hymn once part of every

Requiem mass that tells of the awesome moment when all sinners shall be called before God's throne at the Last Judgment.

The *Symphonie fantastique* is now followed by Part II, *Lélio, or the Return to Life,* a complementary work designed to be performed as a sequel on the same program. It was conceived as the other side of the same coin. The first was a programmatic autobiography superimposed on a symphony that was completely self-contained within its own boundaries.

In *Lélio,* the artist steps forward and occupies stage center in a fusion of theater and concert. With the symphony the theatrical part is imaginary; with *Lélio* the imaginary becomes theater. While the *Fantastic* had dwelt on the typical romantic theme of unrequited love and the tortuous despair of the lovelorn artist, *Lélio* became the vehicle for expressing Berlioz's views on the musical and theatrical life of his day. The *Fantastic* can be interpreted on several different levels—that the hero is Berlioz himself, that it represents the plight of the artist in general alienated from an uncomprehending society, or more objectively as a romantic fantasy. With *Lélio,* however, no one is ever in doubt that the subject is Berlioz himself. Here the composer steps out of his dream fantasies into the reality of the world of ideas and is ready to discourse directly with his assembled audience about his hopes and fears, likes and dislikes, prejudices and passions. The work then becomes an autobiographical self-portrait in sounds and words.

When *Lélio* was first performed with the *Symphonie fantastique* in 1832, Berlioz directed that the orchestra, chorus, and vocalists for *Lélio* were to be concealed behind the curtain, while the actor-narrator personifying the artist occupied the forestage. The music consists of a suite of six different numbers that had been composed some two to five years earlier. Variety was not the problem, but unity was. Intervening soliloquies, as a type of stream-of-consciousness commentary, functioned as connecting links between the numbers, as well as providing Berlioz with a platform for declaiming his thoughts on life and death, freedom and repression, heeding the magic sounds of nature, his deification of Shakespeare, and his condemnation of musicians and theatrical producers who rearrange, disarrange, and derange the works of the great masters.

The first number is Berlioz's strophic setting of Goethe's poem *The Fisherman,* which he casts as a lilting barcarolle for tenor with piano accompaniment. The *idée fixe* of the symphony is heard between two of the verses. The narrator then comments on Hamlet's thoughts of death, which cues in the choir for the next piece, the "Chorus of Shades." Mysterious syllables of Berlioz's invention produce eerie effects, while the orchestra plays with divided strings, a muffled bass drum shrouded with a black cloth, and a clarinet covered with a sack. A wild note of Rousseauian primitive savagery follows to cue in the "Brigand Song," scored for baritone and chorus. At the time brigandage was equated in the romantic vocabulary with the revolt against authority, hence it was a metaphor for freedom. Then comes the contrasting "Song of Bliss," a reincarnation of a number from Berlioz's earlier *Orpheus* cantata. The mood continues with the "Aeolian Harp." Concluding the work is the "Fantasy on the *Tempest* of Shakespeare," scored for full orchestra. Ethereal sounds depicting the sprite Ariel mix with the crude growling notes for Caliban, together with some magical moments for Prospero and Miranda. Finally, the *idée fixe* is intoned by the strings, with the artist declaiming his exit line: "Once more—and for ever."

Formal Freedom and Hybridization

The *Lélio* is one of many such Berliozian formal hybrids. He first called it a "melologue," a term invented by the poet Thomas Moore, who had written a theater piece called *Melologue upon National Music,* a succession of verses alternating with music to bring together the folksongs and dances of various nations. Berlioz defined his version as a "mixture of recitation and music," a prose scenario connecting various musical interludes. He later billed it as a "monodrama," and in his *Memoirs* he sometimes refers to it as a "lyrical drama" and also as a "melodrama." The format had ample precedent in operas with spoken dialogue, such as Mozart's *Magic Flute* and Weber's *Freischütz,* as well as in plays with incidental music, such as the Goethe-Beethoven *Egmont.* Twentieth-century parallels can be found in Stravinsky's *Histoire du Soldat,* in

Schoenberg's two monodramas, *Erwartung* and *Die Glückliche Hand,* and in William Walton–Edith Sitwell's *Façade.* In all of them a single speaker bears the weight of the dramatic action.

Reviewing the first performance of the *Lélio,* the critic in *Figaro* called it "bizarre" and "monstrous." In the 20th century, it has been dubbed as "the craziest work ever sketched out by a composer not actually insane."[37] Madness, however, was woven also into the *Symphonie fantastique.* The image of the mad musician was one of the stock-in-trade characters of the romantic movement, as can be read in the tales of E. T. A. Hoffmann and heard in the piano music of Robert Schumann. In all events, the novelty-seeking Paris audience considered the work a good evening's entertainment, especially with its topical comments, and the piece established Berlioz as a person of thought and action as well as a practicing musician and composer. Berlioz used both parts in all his major concert tours, with appropriate translations and topical allusions and variations suitable for his English, German, and Russian audiences.

As the *Episode in an Artist's Life* so abundantly demonstrates, Berlioz was determined to live his life as a work of art. No composer ever absorbed his personal experiences, his conflicts, and contradictions, so completely into his musical works, and his music cannot be fully understood without reference to them. With him there are no objective abstractions in his forms, orchestrations, or any other external devices. All is intensely personal and above all expressive. Expressiveness took precedence over all else and, as he once told Liszt's mistress the Princess Wittgenstein, his problem was always to "find the musical form, the form without which the music does not exist."

Hence the forms of all Berlioz's works are atypical to a degree. Even when writing competition cantatas as a student, he strained the stipulated form to the breaking point. Later each work had to grow out of the poetic idea and assume its individual shape according to the dramatic subject at hand. His symphonic works seem to be all exposition and development. Instinctively he felt that repetition and recapitulation were antidramatic. Violent and vehement contrast was for him the essence of life and art. In his

last years he commented that "music lives only by contrast," and an ingenious juxtaposition of opposites that are never quite reconciled characterizes his compositional forms.

Every work of Berlioz's assumes its unique shape, each has a form that derives from its own particular content. So it was with his overtures to plays, novels, and poems—Shakespeare's *King Lear*, Scott's *Waverley* and *Rob Roy*, Byron's *Corsair*. A concerto commissioned by Paganini for a Stradivarius viola he had acquired evolved into a symphony with viola obbligato. Songs and symphonies became united. His concertos are symphonic, his oratorios operatic, and he wrote operas with and without words. Then one finds such original designations as "melologue" and "monodrama" for the *Lélio;* "dramatic symphony" for the *Romeo and Juliet,* scored for vocal soloists, choir, and orchestra; "dramatic legend" for the *Damnation of Faust,* with vocal soloists and orchestra; and his greatest work, *Les Troyens,* a truly epical grand opera after Vergil in five acts, grew to such gigantic proportions that it had to be subdivided into two parts, the *Fall of Troy* and the *Trojans at Carthage.*

Berlioz also was one of the pioneer composers to use tone colors as the building blocks of his musical forms. Just as Delacroix had discovered the principle of color in constructing his pictures, so Berlioz explored and exploited a full palette of rich instrumental sound. In addition to the incomparable spectrum of his orchestrations, the sheer weight he added to his ensembles is spectacular. Seldom composing in any but the largest media, he delighted in the use of orchestral and choral combinations of extraordinary complexity. To assemble all the necessary forces for a Berlioz performance is always a logistical challenge, and the demands he makes on the time and talent of his performers are considerable. In his massive *Requiem,* he employs an immense principal orchestra, a chorus of 500, a tenor soloist, and four huge brass bands facing the four points of the compass—all to suggest the vast space and enhance the acoustical effects when they sound the call for Judgment Day. This, with the additional efforts of 16 kettledrums, caused the newspapers to comment that Paris had not heard such a volume of sound since the fall of the Bastille.

There was always something of the conqueror in Berlioz as he

marshalled his orchestral and vocal forces in such a composition. Each orchestra had its own conductor, and the choruses were signaled by commanders of lesser rank, while all of them took their cues from the generalissimo himself, who appeared in the role of a musical Napoleon storming over the battlefield. Berlioz was the first of the great orchestral conductors and the prototype of the great maestros of today. No wonder his contemporaries did not know what to make of him, and they found both his personality and his compositions somewhat difficult to absorb. He always appeared to be somewhat monstrous. The poet and critic Heinrich Heine found the most apt expression. "Here is the wingbeat that reveals no ordinary songbird," he wrote in a critical review, "it is that of a colossal nightingale, a lark the size of an eagle, such as must have existed in the primeval world."

Berlioz the Writer

For Berlioz, as for Delacroix, the need to write was compulsive. In terms of sheer volume, the pages of Berlioz's prose far outweigh those of his musical compositions. One reason for his journalistic career was, of course, the need to pay off his always sizable debts. But beyond that, he felt a burning desire to play with ideas, to express his partisan viewpoints on the musical life of his time, to change and educate public opinion, and also to keep his name constantly in print. He quickly built up and held the attention of a wide readership. Everybody who was anybody read Berlioz, and it is safe to say that he was far better known in his lifetime for his journalism than he was for the rather sporadic performances of his opera and concert music. His compositions rarely brought him more recognition than an occasional *succès de scandale*, or at best a *succès d'estime*.

While Berlioz was quite aware of his position at stage center in journalism and took genuine pride in his critical craftsmanship, he nevertheless longed for "works to write, orchestras to conduct, and rehearsals to direct." Fate willed it, however, that he had to write for his bread—"to write nothings about nothings! to bestow lukewarm praises on insupportable insipidities! to speak one day of a great master and the next of an idiot, with the same gravity,

in the same language! to employ one's time, intelligence, courage, and patience at this labour, with the certainty of not even then being able to serve Art by destroying abuses, and putting men and things in their proper order and place! This is indeed the lowest depth of degradation!"[38]

The best of Berlioz's workaday writings, however, eventually found a permanent place in literature through a series of anthological compilations variously entitled *A travers chant, Soirées de l'orchestra, Voyage musical en Allemagne et en Italie,* and finally the *Memoires.* Thus the incomparable brilliance of his writing, the rapierlike wit, the deft turn of phrase, all mark him indisputably as the greatest musical journalist of all time.

Romanticism

Romanticism was a style with many faces. One of its recurring battle cries was "any time but now, any place but here." Delacroix and Berlioz, though they were among the principal exponents of romantic innovation, made it clear in their works that their feet were firmly planted in the fertile soil of the classical heritage as opposed to the dry academic stereotypes of neoclassicism. Each was haunted in turn by the epic and lyric poetry of Vergil, Dante, and Shakespeare. Delacroix's favorite painters were Rubens and Poussin, while Berlioz founded his dramatic style on the principles of Gluck and Beethoven.

Both men were partisans of the romantic sublime in their epical pronouncements, and both delved deep into the heroic "Gothic" past—Delacroix most notably in his *Dante* picture, and Berlioz in his thunderous *Requiem.* This by no means prevented them from dramatizing current revolutionary events, which they saw against the background of age-old conflicts in the heroic past. Both were ardent admirers of the glories of nature, and both were fascinated by the heady perfumes of exotic climes. Above all, however, it was the emancipation of the individual person, as opposed to the growing collectivization of society promoted by the Industrial Revolution, that motivated their lives so intensely. Both artists felt themselves as personalities standing out from the crowd and as

being above any political or artistic movement. In this way they could assume leadership and chart the future course of their respective arts.

As recorded in their autobiographical writings, both succeeded in leading lives that in turn became works of art. Thus both were able to pull out all the stops of the stylistic organ so as to play their impressive parts in this colorful romantic concert of the arts—for the eye with Delacroix, for the ear with Berlioz.[39]

The Space-Time Continuum and

Relativistic Mode

NEW CONCEPTS OF SPACE and time in the 20th century have caused as many radical consequences in the arts as they have in the sciences. The general theory of relativity, for instance, has projected a world in which the dimensions of space and time are hyphenated as different aspects of a four-dimensional continuum. Einstein has demonstrated that the same flash of lightning will happen at several different times in relation to observers placed in different locations. Time, as it approaches the speed of light, also has a way of bending back on itself in Einstein's finite but unbounded universe. As recounted in a popular limerick when an intrepid space voyager took off at the speed of light, he traveled all day, in a relative way, and came back the previous night.

In this new relativistic world, unity has yielded to diversity, and the universe has become the multiverse as prophesied by William James.[1] Absolutes are ruled out since all known theories and beliefs are constantly subject to scrutiny in the light of continuing new knowledge. Relativism, in the manner of Soren Kierkegaard's either/or theory of knowledge, now becomes a tenable position. In this vast new multiverse contending theories and evaluations jostle

each other as randomly as electrons within the atom, and atoms within the molecule.

In the realm of quantum physics, the Newtonian notion of cause-and-effect certitude has been shaken to its foundations, and with it the concept of scientific materialism. Einstein, for his part, still believed that God does not play dice with the universe, and that atomic reality was comprehensible and predictable. But the quantum theory has demonstrated that some events are unpredictable even with all the relevant data at hand. So quantum uncertainty has replaced scientific determinism. To put it in human terms, the notion of free will as opposed to determinism has been reinstated in the scheme of things. The multiverse or pluriverse view now becomes one of the possibilities and probabilities. All human experience is both permanent and transient. The resonances of the past still resound meaningfully in the present. Every plan and phase of the past is inseparably woven into the present, and in turn will become a part of the cumulative future. All cultures, all scientific and humanistic events, all historical data past and present are contained within this ongoing, constantly expanding current spatio-temporal continuum.

This new relativistic viewpoint has fundamentally changed the ways of looking at history. The former linear concept of time has now become simply a convenient way of ordering events chronologically as to which came before or after. The cyclical theory of history, with its notion of recurrences and history repeating itself, has also been transcended. In the expanding cultural multiverse, all events may be seen as contained in a space-time continuum in which human happenings and works of art—ancient as well as contemporary—coexist side by side in a constantly growing and expanding sense of the present. Friedrich Nietzsche was one of the philosophers to articulate this situation when he made his cynical comment that history is the process by which the dead bury the living. Whether they like it or not, living artists have to coexist with their colleagues and the vocabularies of the past. Nowhere is this more apparent than in the postmodern arts, when forms, ideas, motifs, and quotations from the past permeate present-day works.[2]

The expanding sense of time has been nurtured by the diligent work of scientists, archeologists, historians, and musicologists. It is an awesome thought that astronomers have now sighted a galaxy near the known limits of outer space. Its distance is some 15 billion light-years away, and the light they observed left its source shortly after the creation of the world. The discovery of our homonid ancestors in Africa has pushed the frontiers of the human species back by almost four million years. More also is known of past civilizations and cultures in the 20th century than the people of any previous period have experienced. When study and documentation confirmed the authenticity of the Cro-Magnon cave paintings, the time span of art in Western civilization receded more than 30,000 years. The continuous unearthing of great works from the past is one of the most stimulating aspects of modern times. The discovery of Tutankhamen's almost-intact tomb in 1922 yielded a rich trove of art works that had lain dormant some 3,000 years. Also, the beginnings of Western civilization in the Mesopotamian cultures were quite obscure until in that same year the royal tombs at Ur came to light. New Greco-Roman, medieval, and Renaissance artifacts are constantly turning up, and our knowledge of non-Western peoples and their arts is constantly increasing.

Turning to the present, what is relevant for the contemporary artist and the modern audience is the almost unlimited access everyone now has to the vast body of the world's literature, art, and music. So with the multiplicity of media at their command, with the tremendous extension of the range of human experience, with so many levels of taste, with such a variety of educational backgrounds that comprise an audience, and with the multinational and global frames of reference, both artists and audiences now have an almost unlimited range of choices.

In this extended geographical and historical now, the arts today are whatever contemporary audiences choose to look at, listen to, and read. With our access to the great picture collections of the world, the El Grecos and Rembrandts still communicate with the force of great living art quite as much as do the contemporary surrealists and abstract expressionists. Recital and symphony programs in concert halls, plus the availability of recordings, quickly reveal that Bach, Mozart, and Beethoven are still the most popular

classical composers of the present day. In this sense they are just as relevant to contemporary times as such avant-garde figures as John Cage with his improvised happenings, Karlheinz Stockhausen with his electronically synthesized fantasies, or Philip Glass with his operatic extravaganzas.

The relativistic mode, by judiciously balancing the constants and variables of history, points out an important pathway toward understanding the arts of the present by viewing their reflection in the light of the whole range of human experience. Relativity also implies searching out the relationships of a particular work of art to similar past, present, and anticipated future works, tendencies, and developments, thereby placing it in its longest, broadest, and deepest perspective.

In this picture of the 20th century, this chapter will look at the modern and postmodern phases of contemporary art. We will then be concerned with the ways and means by which major art movements of our time can be reinterpreted in the relativistic mode with its spectrum of space-time concepts. In examples from literature, music, painting, sculpture, and architecture, the past will be shown to be still an ever-important part of the constantly expanding present. We will discuss how new light can be shed on the verbal, auditory, and visual expressions of the present day and how the ancient deities Chronos and Gaea still rule the times, tides, and spatial expanses of our time.

Modernism and Postmodernism

In the visual arts, a dominant trend of the modern movement has been a preoccupation with the time motif, plus the probing of the subjective dream world of the subconscious mind. This is especially true among the surrealists. Beginning with the cubists, emphasis has been on the spatial motif, with the progressive fragmentation of the objective world into geometrical components so as to create the impression of seeing all sides and angles of the object.

Salvador Dali's *Persistence of Memory* (Figure 100) is one of the pictures he called his "handpainted dream photographs." It depicts a desolate, eroded landscape located in some vague geological time. A strange evolutionary animal form has washed up on

Figure 100. Salvador Dali. *Persistence of Memory,* 1931. Oil on canvas, 9½ × 13' (2.90 × 3.96 m). Courtesy of the Collection, the Museum of Modern Art, New York.

the beach and a dead tree is draped with limp, melted watches, suggesting the debris of human time.

Marc Chagall's *Time Is a River without Banks* (Figure 101) encompasses an even broader expanse. In this fantasy, millions of years are suggested by the course of the river; evolutionary developments by the half-bird, half-fish creature; the briefer span of human time by the clock; and a more personal, subjective perception of the flow of musical time by the floating violin played by disembodied hands.

Still another pictorial space-time continuum is found in *Le muse inquietante* by Giorgio de Chirico (Figure 102, see also Plate XII). The title can variously be rendered as the Disquieting, Disturbing, or Menacing Muses, who are here personified by three classical statues. The standing figure in the foreground is modeled after a Roman copy of Phidias' *Athena Lemnia,* which once stood on the Athenian Acropolis. With a wry ironic twist, the artist depicts the missing head of the goddess of wisdom as a balloon, giving her hot

Figure 101. Marc Chagall. *Time Is a River without Banks,*
1930–39. Oil on canvas, 39⅜ × 32″ (1.00 × .81 m).
Courtesy of the Collection, the Museum of Modern
Art, New York.

air where her brains ought to be. The seated figure would be a
Demeter, the goddess of the fruitful earth and fertility. The head
here is a milliner's hat rack, and her ample bosom meant to suckle
all earth's creatures has a conspicuously empty hole in it. Lurking
in the deep shadows is a figure of the Artemis-Diana type, but
here the swift goddess of the chase is frozen in marble.

The architectural setting is that of a Renaissance arcaded piazza
in the city of Ferrara where Chirico was living at the time. The
medieval castle is that of the Este family, the old line of local rulers.
In the foreground are an assortment of objects—a harlequinade
box, a barber's pole, and a fencing mask. Such were the stage

Figure 102. Giorgio de Chirico. *The Menacing Muses (Le muse inquietante)*, 1917. Oil on canvas, 37¾ × 27⅞ (95.89 × 70.80 cm). Private collection.

props used in the 18th-century comedies improvised by troupes of strolling *commedia dell'arte* players. In the background is a modern factory building with smokestacks, and beside it a strangely futuristic phallic tower. The painting, with its theatrical deep perspective, mysteriously haunted empty space, and elongated shadows is what Chirico pointedly called a "metaphysical picture," signifying that it crossed the boundary separating the mere physical description of the objects represented and reached into the unseen realm of nonmaterial essences. By bringing together in one time framework objects from all the ages—ancient, medieval,

Renaissance, and modern, past, present, and a premonition of the future—Chirico succeeds in creating a metaphor for what some modern philosophers have called "the eternal now."

The notion of modernism can be traced back to the romantic movement. After the social and political revolutions of their time, such painters as Géricault and Delacroix and such composers as Berlioz and Robert Schumann projected the image of a metaphorical militant advance guard marching into new artistic territory. Left behind were the ever-entrenched conservative forces, bound as they were by what the artists and composers considered to be the fetters of outmoded conventions.

These pioneer avant-gardists thought of their arts as radical departures from the prevailing neoclassical style, with its glorification of the past and especially the codification of its aesthetic canons and creeds as taught in the academies and conservatories. In their view the sterility of academe constituted the enemy of their then-modern art. With their works—Géricault's scathing social and political protest in the *Raft of the Medusa* (Figure 92), Delacroix's revolutionary declaration in his *Liberty Leading the People to the Barricades*, 1830 (see Figure 94), Berlioz's dreams and nightmares of his *Symphonie fantastique* (see pp. 239–42), and Schumann's *Carnaval*—these artists and composers became the early advocates of modernism. In *Carnaval*, for instance, Schumann projected a mythical revolutionary Society of David (*Davidsbund*) that set forth to slay the Goliaths of Philistinism. He hailed the designated musical members of this intrepid group in pianistic cameo portraits—Schubert, Chopin, Paganini, Schumann's future wife Clara, and himself in the Florestan and Eusebius episodes.

In the middle of the 19th century the concept of modernism was embodied in the various styles that departed from the academic norm—social realism in the novels of Balzac and the paintings of Courbet; psychological naturalism in the works of Dostoyevsky, Ibsen, and Zola; symbolism in the poetry and plays of Baudelaire and Maeterlinck, replete with their sonorous syllables and eloquent silences; impressionism with the landscapes of Monet and the pieces by Debussy with their fleeting images and quickened sense of time; postimpressionism with the emotional intensity of Van Gogh, Gauguin, and Cézanne; expressionism with

Schoenberg and Berg and all the alienations and anxieties of Freudian psychology. In short, there arose all the *isms* that laid claim to being avant-garde styles. Each in turn shocked the solid citizenry of bourgeois society, each was frowned upon by officialdom and the recognized academic institutions, and each became the target of conservative journalistic fulminations and epithets.

In the mainstream of 20th-century styles, the torch of modernism was carried by the experiments and innovations of James Joyce, Gertrude Stein, T. S. Eliot, and their literary colleagues; in music by Stravinsky with his relentless rhythmic dynamism, as well as by Schoenberg, Berg, and Webern with their serialism and emancipation of dissonance; in painting with the surrealists and abstractionists; and by the developers of the International style in architecture with their strict functionalism and steel-and-glass vocabulary. Collectively, the frontiers of modernism could be pushed no farther, and it reached its climax as the reigning recognized style in the 1960s. In all the arts it was only a question of time when basic human urges and directions would once again make a return appearance. The advance guard then became the rear guard. Yet as the modern movement recedes into history, like all the forms and forces of the cumulative past, it is still a factor on the current scene if only as a point of departure.

A pair of painters have caught the spirit of the rise and fall of styles in their series called *Scenes from the Future* (Figure 103). They depict the destruction of modernism just as modernism had destroyed the styles that preceded it. Evoking the symbols of modern architecture in ruins—the Guggenheim, Museum of Modern Art, the Kennedy and Dulles airports amid rural landscapes with farmers plowing the fields—Komar and Melamid have created metaphors of the passage of time and the eternal historical process of growth and decay. Just as the builders of early Christian basilicas had re-used the columns of ruined Roman temples, so postmodernists are picking up the fragments of the past to build their dreams of the future.

Postmodernism should not be considered as a unified style or as a cohesive system of organized principles, but rather as a collection of reactions to the rigid canons of modernism. It opposes the

Figure 103. Vitaly Komar and Alexander Melamid. *Scenes from the Future: The Guggenheim Museum,* 1974. Paint on Masonite panel (40.32 × 30.72 cm). Courtesy of Ronald Feldman Fine Arts, New York.

standardization, rigid structuralism, and systematic repetitiveness of modernism with its reliance on technological solutions to formal problems by opening up doors to a wide range of possibilities. These include an emphasis on imaginative inventiveness and a felt need to create a continuity with the past. Postmodernism also recognizes the profound changes inherent in the many diverse directions of the current pluralistic society. It is also aware that the concept of the pluralistic society in Darwinian terms takes into account the possibility of mutations along with the immense variety of evolving forms, and that nature does not operate on a well-planned definitive system. Variety and the unexpected are in as-

cendancy over the uniform and predictable just as are the transitory over the permanent, the accidental over the predictable. In short, no single viewpoint can prevail. In its many manifestations postmodernism also seeks to come to terms with past tried-and-true human values that have been relevant over the centuries and that still have much to say to the present generation.

In literature, stream-of-consciousness writing and the theater of the absurd have yielded to a return of characterization, narrative, and plot. In music, tonality, consonance, and diatonic harmony have once again come to the fore. In painting—when abstraction could go no further—nature, the object, the human figure, and subject matter have staged a return engagement. The modernistic shock of the new has been replaced by the postmodern shock of the old. And postmodern architects now embrace past styles, ornamental embellishments, and metaphorical allusions as they try to reach out to people with many varying levels of taste and many different notions of what constitutes the good life.

Postmodern architecture, for instance, has made a conspicuous departure from the bureaucratic, monolithic towers of the International style with their rectilinear steel-and-glass boxes and their self-conscious avoidance of all forms of ornamentation—in short, all the elements that can give a building meaning. A postmodern edifice, by contrast, needs to be read on a number of different levels, much as ancient temples used to be. Then the structures and their sculptures could be interpreted one way by the general populace and in others by the educated few. Inevitably this present-day trend leads to certain forms of eclecticism. It is not, however, the eclecticism of the romantic picturesque or that of the late 19th century fitting together pieces of the past. It is a new historicism and a new selective eclecticism that opens up new vistas, a pluralism in which everything relevant from the past can find a place in the contemporary picture. It is also not a return to ornament for ornament's sake as with art deco, but rather an attempt to add symbolic levels, humanistic meanings, and relationships to past cultures in terms of contemporary expressions.

In the case of the new classicism, for example, what has arisen is not the more archeologically-exact correctness of 19th-century neoclassicism, but a free and fanciful adaptation of Greco-Roman

motifs and themes that is compatible with current technologies and tastes. The underlying idea is to create a pluralism of expression that allows for a maximum of diversity in a constantly expanding heterogeneous society. However divergent the directions, postmodernism in the final years of the 20th century is an adventure in the rediscovery of the past as well as a reassertion of the continuity of human experience. It is the style that may very well become the prelude to a new synthesis in the century to come.[3]

The Literary Dimension

In the development of the modern novel, its leading exponents all wrote with a keen awareness of the expanded temporal present. For them the present was no longer a knife-edge between past and future but an enlarged period encompassing a simultaneity of events emerging from chaos. Both Marcel Proust and Franz Kafka found mechanical clock time unsuited for describing the many different faces of inner temporal experience. In Proust's search to recapture the past and make it permanent, he wove a tapestry of time wherein the threads reveal only the before and after, the past and future. The reader cannot really tell when the book will begin or end. Proust likened the feeling to the moment after dinner, drowsily drifting off in a state of reverie, when "the magic chair will carry him off at full speed through time and space, and when he opens his eyes again he will imagine that he went to sleep months earlier and in some far-distant country."[4] When reading Franz Kafka's longest work, *The Trial* (1925), the question arises whether the action is taking place in the protagonist K's imagination, in reality, in the labyrinthine expanse of space and tortuous span of time that unfold in a dream or waking state, or some subtle and ambivalent combination of all three.

It is James Joyce, however, who emerges both as the leading literary figure of modernism as well as the prophet of postmodernism. Like the philosopher Henri Bergson with his novel theory of time, Joyce was captivated by film, that art form unique to the 20th century. With film techniques mercurial flashes backward and forward in time can be portrayed as well as movement here and there in space. In both his major novels Joyce is concerned

with re-creating in verbal forms some of these motion-picture montage effects. The development of stream-of-consciousness writing also mirrors this expanding and contracting sense of time and space.

In *Finnegans Wake* (1939) Joyce consciously constructs a vast verbal cosmos, which starts in midsentence and concludes more than 600 pages later with the first words of the same sentence. So in this spatiotemporeal continuum the end becomes the beginning: "A way a lone a last a loved a long the"; and the beginning becomes the end, "riverrun, past Eve and Adam's, from swerve of shore to bend of bay, brings us by a commodius vicus of recirculation back to Howth Castle and Environs." In Joycean fashion, the very title becomes a microcosmos of his finite but unbounded macrocosm. The name "Finnegan" can be read as *fin* in the French or Latin sense of *finis* or the end, and "egan" as "again," implying another beginning. Likewise "Wake" can be either a death-watch or an awakening. So metaphorically the title can be interpreted as the seasonal fall and springtime renewal, man's original-sin downfall and subsequent redemption, or as death and resurrection.

In the broader sense, Joyce's microcosm is Ireland seen through the daily nonevents in the lives of an ordinary Irish family. The reverberations of their activities are transmuted into the macrocosm of epical developments that, as in *Ulysses*, reveal themselves as modern echoes of ancient mythic events. Joyce's view of history is cyclic rather than linear. Events, for him, repeat themselves in a constantly recurring circle of birth and rebirth. At one point he conjures up a series such as "eggburst, eggblend, eggburial and hatch-as-hatch can," which suggests birth and baptism, marriage, burial and rebirth.

Finnegans Wake, like the universe, develops by the accumulation and constant expansion of its characters, places, incidents, plus its many correspondences and recurrences. Nothing is constant, nothing has fixed meaning, everything is in flux. Inanimate objects become human and vice versa, and ordinary humans assume historic and archetypal stature. In Joyce's words, "every person, place and thing in the chaosmos of Alle anyway connected with the gobblydumped turkery was moving and changing every part of the time." With its sound-play of words and repetitious rhyth-

mic flow, the book has been praised for its musical byplay. Such names as Anna Livia Plurabelle and such onomatopoetic phrases to describe the seashore as "the hitherandthithering waters" become leitmotifs in a verbal tone poem. *Finnegans Wake* is truly a work without a single point of view, a beginning or an end. The reader can start at any point and move forward or backward. As Joyce once remarked to a friend, the book was for him "like a mountain that I tunnel into from every direction, but I don't know what I will find."[5]

Joyce's *Ulysses* (1922) foreshadows the postmodern preoccupation with the presence of the past on the contemporary scene, especially with the continuity of the classical tradition.[6] With *Ulysses* current events are mirrored on past times so that the modern and ancient worlds meet and merge in a mutually enlightened way. For Joyce as well as for André Gide, T. S. Eliot, and Eugene O'Neill, classical themes, motifs, and allusions helped to contain and formalize the amorphous and fragmentary experiences of the chaotic century in which they lived. For *Ulysses,* that landmark in contemporary letters, Joyce found his formal framework in Homer's *Odyssey.* He also adopted the classical unities of time, place, and action to contain so long a book in such a short period of time. While Ulysses' ancient journey took some 20 years, Leopold Bloom's was compressed into less than a single day. Likewise, the classical odyssey was spread over the entire Mediterranean region, but Joyce's journey is confined to downtown Dublin.

In Joyce's epic parody, his three main characters parallel those in Homer's *Odyssey.* Odysseus, or the Latinized equivalent Ulysses, becomes the antihero Leopold Bloom, a wandering Jewish advertising salesman in a Catholic city; the faithful Penelope is transformed into the wanton, faithless Molly Bloom; and the son Telemachus whom Ulysses seeks is the schoolteacher and failed artist, Stephen Dedalus. The Greek world is contracted into the Dublin of 1904, as a microcosm of modern human existence seen through the eyes of the three main characters. At the same time Joyce invites readers to distill the essence of life in general from the mundane happenings of a long succession of ordinary daily experiences. While Homeric allusions predominate, and this discussion will concentrate on them, the book abounds with literary

references of all sorts—the Shakespeare of *Hamlet,* the Dante of the *Inferno,* the Goethe of Faust's "Walpurgis Night," to name but a few.

The book is divided into 18 episodes corresponding to those in the *Odyssey,* and each originally bore headings taken from Homer. Before publication, however, Joyce deleted these chapter titles, but they remain of major importance in making the classical allusions and the book intelligible. There is no plot in the usual sense, just a version of the familiar domestic homecoming theme—the errant husband's return and his reunion with his wife and son. The long, tortuous journey is marked by a series of tragicomic scenes dealing with lost love, betrayal, adultery, the death of a child, as well as a host of incidental encounters spiced with earthy humor.

The opening episode, "Telemachus," finds that character's counterpart, Stephen Dedalus, waking up in his rented tower. Like Ulysses' house in Ithaca, it has become a haven for usurpers and freeloaders who have moved in without invitation. He has rejected his own father and is searching for a substitute paternal figure. Will it be found in theological studies? in the church? in literature? in art? in a person? His indecision is reflected in "Proteus," where the mercurial, ever-shifting Greek sea god makes a single answer, or even the identification of the nature of change, impossible. All experience, he reflects, is in a state of perpetual flux, like the sea he walks beside.

Bloom first appears in the "Calypso" chapter, which takes its name from the goddess Ulysses had lived with for seven years, exactly the length of time Bloom has resided with Molly. His own odyssey begins after breakfast with the "Lotus Eaters," in the land where Ulysses' sailors had eaten the flowers of forgetfulness that made them oblivious to their home and destination. In "Hades" Bloom goes to the cemetery for the funeral of a friend, just as Ulysses had descended to the underworld to consult the seer Teresias. Thoughts on the past, present, and future of their lives and the nature of father-son, husband-wife relationships are invoked in each case. And, like Ulysses of old, Bloom finds his future direction in the father-son motif and metaphor.

"Aeolus," the following episode, treats, as the name implies, of the winds of oratory, political speeches, and journalistic report-

age—the winds that blow nobody good. In the *Odyssey,* Aeolus gave Ulysses a bag enclosing unfavorable winds so that he would have smooth sailing. The crew, however, opened the bag and the ship was blown off course. Joyce parodies the story with the release of social and political hot air by the newspapers. The last of these Aeolian windy allusions comes when Bloom, perusing some advertisements, discovers a remedy for flatulence.

The "Scylla and Charybdis" episode takes place in a library where both Bloom and Stephen encounter all manner of intellectual contradictions and pitfalls, just as Ulysses had to steer his ship between the Straits of Messina, with the six-headed monster Scylla on one side reaching out to pick up unwary seamen from passing ships and the whirlpool of Charybdis on the other. "Sirens" introduces a musical note. Having been warned that the seductive siren songs the sailors would hear could lead them to a rocky grave, Ulysses stuffed their ears with wax. The scene is set in a bar where the waiter is deaf and the barmaids sing bawdy ballads mixed with popular opera arias. The form of the chapter has been likened to a fugue, but it is more like a montage of polytonal free counterpoint with dissonant overtones.

The "Cyclops" sequence begins with a sentence that starts with "I" and ends with "eye," an allusion to the one-eyed giant Polyphemus: "I was just passing the time of day with old Troy of the D.M.P. [Dublin Metropolitan Police] at the corner of Arbour Hill there and be damned but a bloody sweep came along and he near drove his gear into my eye."[7] The dark bar is an obvious metaphor for the cave where Ulysses and his men have been imprisoned by the one-eyed giant. After they get Polyphemus into a drunken stupor, they blind him with a torch so they can escape. One of the pubcrawlers tells a story that is blown up into gargantuan proportions to become still another comic allusion to the classic myth. At midnight the "Circe" chapter finds Bloom and Stephen in a brothel where the madam, like her counterpart of old, turns men into swine. Both freely hallucinate with Witches' Sabbath imagery.

Later in "Ithaca," Bloom and Stephen as the would-be father and son are walking home only to find themselves locked out. "Penelope," alias Molly Bloom, then brings the book to an end with a coda in the form of a stream-of-consciousness soliloquy of drowsy

ruminations. Here she appears as an earth-goddess Gaea figure of mythic dimensions, who takes all men's suffering, strife, and discord to her ample bosom, bringing reassurance and affirmation to those who search for resolution and ambiguity and ambivalence to those who doubt. Her subconscious monologue pulls all the various themes and motifs together in a new and different perspective. It all takes place in a record-breaking, breathtaking single sentence 46 pages long before the reader reaches the final period.[8]

On the contemporary scene, one of the leading figures in postmodern letters is the scholarly novelist Umberto Eco. Going beyond his critical linguistic studies and the science of semiotics, he has revived the historical novel with his *Name of the Rose* (1980) and *Foucault's Pendulum* (1989). Both have reached a wide readership and have received critical acclaim. The first is set in a 14th-century monastery where one encounters stories within stories and labyrinths within labyrinths, both physical and metaphysical. The symbolic search is for the lost half of Aristotle's *Poetics,* the part dealing with comedy and laughter. This marked Aristotle's break with Plato on the proposition of freedom of the arts versus moral censorship. *Name of the Rose* is intended to be read on many different levels. Historically it marks the time when the age of faith was waning and the era of reason waxing. It is also a murder-mystery thriller with William of Baskerville, a student of Roger Bacon, the scholastic philosopher, playing the detective's part. The book is also an allegory in which the late medieval period becomes a metaphor for the postmodern world, as well as a reminder that all history is contemporary history. Eco's romance with history continues with *Foucault's Pendulum.* In it he says that his primary concern is with a "yearning for mystery, for revelation, for illumination." Here one finds more mazes within mazes. Every event is symbolic in that it stands for something else, and every something else stands for still something else.

The Musical Continuum

The modern movement in musical composition in the first half of the 20th century was marked by the emancipation of dissonance as an independent entity apart from the need for resolution.

Tonality became more relative than absolute, while the 12-tone techniques of serialism were developed to contain the expansion of chromaticism as well as the excessive emotional outbursts of expressionism. Relativistically, shorter motifs and entire 12-tone rows could be manipulated to move forward in time or backward in retrograde motion. They could be presented right side up or upside down in inversion, just as cubist painters were able to show objects from various angles, from interior and exterior viewpoints, breaking them up into fragments, then reassembling them in new and revealing constellations.

Philip Glass and his postmodern colleagues once again reasserted the forthright power of diatonic harmony, negotiated a return to traditional tonality, and sought models for their rhythmic structures in the repetitive rhythms of Oriental music. Glass has consciously contrived his own personal late 20th-century space-time continuum by abandoning the Western sense of form with a beginning, middle, and end and with its feeling for sequential development and arrival at points of climax.

His most significant achievement to date is a trilogy of portrait operas beginning with *Einstein on the Beach* for the scientific dimension; continuing with *Satyagraha* highlighting Mohandas Gandhi's struggle to promote racial equality in South Africa for the social aspect; and concluding with *Akhnaten,* the pharaoh who initiated monotheism, for the religious side. In the trilogy Glass has created a relativistic continuum that encompasses the postmodern predilection for mythic characters from the past woven into the texture of the present. Glass also brings dead languages to life in his operatic texts—archaic Hebrew, the Egyptian of the hieroglyphics, classical Sanskrit, and Coptic. The use of such remote and deliberately unintelligible languages frees the audience from following the words and adds a sense of liturgical spectacle as well as archaic ritual to the theatrical experience.

Glass's music itself is clearly anti-intellectual, a deliberate rejection of the cerebration and spiky intervallic leaps of serialism with all their mathematical manipulations. His music just *is,* without any sense of being or becoming. It simply goes back and forth, up and down and sideways. In the process he has cooked up a particularly piquant musical stew, the recipe for which calls for a mix-

ture of such unlikely ingredients as voices singing bland solfège formulas, instrumentalists playing Czernylike five-finger exercises, scampering diatonic arpeggios, long baroque organ and pedal points that seem to have no beginning or end, orchestrations of traditional and electronic instruments, and a sprinkling of TV-drama sci-fi clichés. All are spiced heavily with the curry of intricate Indian ragas with their repetitive rhythmic cycles and served up with rocklike pounding insistence aided by electronic amplification. The operas are plotless dream fantasies with tableaux that unfold in synchronization with slow, almost imperceptible rhythmic changes. As Glass himself has noted, his writing is not based on a text but on "an idea, a drawing, a poem, an image."

Precedents for Glass's style can be found in the Gertrude Stein-Virgil Thomson surrealistic *Four Saints in Three Acts;* in Carl Orff's *Carmina Burana;* and in John Cage's musical happenings. His principal point of departure, however, is the spare aesthetic of minimalism. The musical version of this style involves selecting and capitalizing on a single aspect of the total experience, then expanding it until it dominates an entire composition. A *reductio ad absurdum* will illustrate the point. In his "Four Minutes and Thirty-Three Seconds," John Cage chose to accent silence, and in performance he sat for that length of time before the keyboard without making a sound. Eric Satie took repetition and wrote a banal tune for piano called "Vexations" and directed it to be repeated 840 times. Repetition, of course, is a familiar factor in daily existence, with the same boring chores to be done over and over again. Anyone who has learned to sing or play an instrument knows the endless repetitions involved in the practicing process. In religion, repetition is an integral part of ritual; and the recitation of prayers, litanies, the telling of worry beads, or the saying of the rosary means repeating the same words countless times. By its very predictability, however, there is something soothing, comforting, and reassuring about repetition. At the same time, it can become monotonous and boring. In Philip Glass's music, the repetitive process is expanded to such proportions that it becomes a veritable mesmerizing sea of sound.

Einstein on the Beach was written with the collaboration of Robert

Wilson, who directed and designed the impressive stage production at the Brooklyn Academy of Music in 1975. It was as much a visual spectacle as a musical event. The staging involved film sequences, shifting slides, complex machinery, magical lighting effects, and an overall ingenious use of mixed-media effects. Glass and Wilson seized on the Einsteinian time perception of relative speeds and on how the fastest-moving trains and planes on earth crawl in comparison with the speed of light in outer space. Instead of Blake's search to capture eternity in a single second, however, Glass and Wilson stretch the time span to the limits of what can be encompassed in a long evening at the theater. The train motif also refers to the movements of the trolley cars that crystallized the idea of relativity in Einstein's mind. The music resembles a numerical countdown before a space launch. It starts with a single cell of notes that is compounded in additive cycles such as one plus two, then one plus two plus three, and so on—all building up to a vast extension of the formal framework. In the construction process, bass lines figure so prominently that the whole composition has been likened to a passacaglialike ground-bass formula with a vast series of rhythmic variations superimposed on it.

The vocal parts proceed in a kind of stream-of-consciousness succession of fleeting images with hypnotic, spell-weaving effect. The dances are accompanied by wild jazzy roulades on the saxophone, while plangent Hebrew melodies are intoned on the violin—a reference to Einstein's prowess on that instrument. One scene pictures the solar eclipse that tended to confirm the general theory of relativity. Another evokes the nuclear apocalyptic imagery of $E = mc^2$, when mass was converted into the appalling energy of the atom bomb. Protesting crowds gather around an industrial plant while a teenager scribbles graffiti in the form of equations on its walls. The finale is set in the interior of a huge spacecraft. There are clocks everywhere, as well as luminous watches on the dancers' wrists. Some clocks move fast, others slow; some forward, others backward, suggesting the theory that time slows down as the speed of light is approached. Einstein fiddles away furiously, while astronauts are hibernating in clear Plexiglass boxes that resemble grandfather clocks floating weightlessly in

space. A corps of engineers, encapsulated in transparent cubicles, punch their computer buttons and manipulate their dials to the play of flashing psychedelic lights.

Satyagraha is an opera in seven acts based on Gandhi's struggle for racial equality in South Africa. The theme of social protest is sounded by imagery taken from the countercultural movement of the 1960s featuring communes, sit-ins, draft-card burnings, hard-hat violence, nonviolent political demonstrations, and bell-ringing pseudo-Buddhist monks draped in saffron-colored sheets. All these disparate episodes help to modernize and intensify the memory of Gandhi's efforts. In the music, Glass has full opportunity to explore the meditative power of Buddhism, which, coupled with ragalike rhythmic formulas, attempts to block out the conscious mind in order to release the inner awareness of the subconscious. The entire libretto is intoned in Sanskrit, and the text is taken mainly from the *Bhagavad-Gita* to create a metaphor of Gandhi's Indian origin and add a mythic dimension.

Akhnaten is the long three-acter that concludes the trilogy. The opera unfolds as one continuous ritual, opening with the funeral cortège of Amenotep III, the pharaoh's father, who represents the old order with its inflexible conservatism, rigid conventions in the arts, and polytheism with its vast number of deities. The stage is set with a montage of Egyptian motifs and symbols, against which the story of the short 17-year reign of the new ruler is told. As soon as he is crowned, the new king announces his break with the religion of his ancestors in favor of the one god Aten, and he changes his name from Amenotep IV to Akhnaten, meaning "spirit of the sun god Aten." He also abandons the customary polygamy of the pharaohs for the sole love of his beauteous queen, Nefertiti. To symbolize his break with the past, he builds the new city of Akhetaten, or "horizon of Aten," on the banks of the Nile at Tel-el-Amarna, halfway between the old traditional capitals of Thebes and Memphis.

From time to time a scribe speaks in the language of the audience, while the rest of the text is chanted in approximate transliterations of three ancient languages—Akkadian, the *lingua franca* of the Near East, which was written in the cuneiform script of the

surviving clay tablets found at Tel-el-Amarna and which was used for diplomatic and commercial correspondence; the Egyptian of the hieroglyphics, the tongue of the court and upper classes and the language of the *Book of the Dead;* and Biblical Hebrew with the chanting of Psalm No. 104, since the Israelites at this time were still in Egyptian bondage.[9] The one exception comes at the end of the second act when Akhnaten chants his eloquent Hymn to Aten in the modern language of the audience. Redolent with profound personal religious emotion, the words go in part:

> Thou hast filled every land with thy beauty
> Thou art fair, great, dazzling,
> High above every land
> Thy rays encompass the land
> To the very end of all thou hast made.[10]

Dark clouds, however, begin to gather on the horizon as disastrous foreign invasions occur, the priests and people rebel, and the new city falls into ruins, while Akhnaten sacrifices his life rather than recant his ideas. The operatic excursion back to ancient Egypt then ends, as the final scene reverts to the present time with tourists tramping about among the ruins, while ubiquitous guides drone clichés from Fodor's and Frommer's travel books. Banality, once again, has won the day.

All three Glass operas typify the new postmodern, postcountercultural psychology of sensibility and involvement. He chooses to portray three outstanding figures—Einstein, Gandhi, and Akhnaten—who, with the power of their inner vision, changed the thought as well as the intellectual, social, and religious attitudes of their times. His revival of ancient languages places his heroes in historical perspective and raises them to mythic stature.

Glass began his meteoric career as a far-out, groupie freak-out figure in the lofts of Manhattan's Soho. As his works caught on, he made the quantum leap into the far-in, high-art circles of Carnegie Hall, the Brooklyn Academy of Music, City Center, and Metropolitan Opera House. Some critics have labeled his music trite, trivial, and as repetitious as a needle stuck in a groove. They also

point out its desperate seriousness untempered by a single touch of humor. Others have admired its driving propulsive energy, sophisticated sonic images, and strong sonorous harmonies. Over the years Glass has become a kind of international cult figure with an assorted following of youthful pop-rock fans plus a group of superannuated avant-gardists whose modernistic futures are long since behind them.

To describe his productions, Glass prefers the term *music theater* to *opera* in the conventional sense. He regards himself primarily as a theater person. His creations involve much give-and-take between producer, stage manager, librettist, corps of designers, electricians, singers, dancers, mimers, and conductor. His prime concern is more with the immediate relationship between the performers and the audience than it is with writing for posterity. By bridging the gap between opera and pop music, he has succeeded in bringing a whole new audience into the opera house—no small achievement.[11]

The Visual Aspect

Abstraction, by which the formal construction of a work of art becomes its principal expressive content, was also one of the major aspects of the modern movement. Abstract painters such as Kandinsky and Mondrian looked to the nonrepresentational arts of music and architecture for models of pure art regulated by their own inner dynamics and free from the need to describe objects in the external world. This freedom, of course, was relative, because music can refer to a type of programme or evoke the sounds of nature. Architecture also can go beyond its structural and schematic abstractions to include decorative motifs derived from natural and symbolic sources. Hoping to approach the conditions of music, however, the abstract painters attempted to disentangle their visions of colors and shapes from the natural world. They aimed at creating a new kind of visual experience beyond the barriers of time and space that would enter a new world of pure form and feeling and distill the essence of natural appearances.

The shift to abstract art can be compared with that of the mathematical movement away from Euclidean geometry. Tied as the

ancient forms were to a static worldview, they proved to be quite inadequate for the new forces of field physics and the dynamics of expansion. In moving away from natural phenomena, new logics and patterns of structural coherence had to be developed to deal with complex shapes, colors, and movement.

Ever since Renaissance times, of course, abstract elements have crept into representational art, with such devices as the geometrical principles of perspective drawing and the canons of proportion that regulate the size of objects or figures as they recede from the picture plane. Both are based on a system of abstract numerical relationships. In sculpture Polyclitus' ancient Greek canon of proportions projected a similar modular system for portraying the human body based on an underlying series of numbers.

In his zeal for pure abstraction, it was Piet Mondrian who pursued the ideal of raising the particular to the general and the general to the universal. Mondrian's grid patterns, like Plato's ideal forms, consciously departed from random natural phenomena and casual human vagaries by attempting to distill the essences of visual experience into pure lines, colors, and shapes so as to give glimpses into a world of eternal harmony. Consequently much of his work is cold, cerebral, and remote. In his *Broadway Boogie-Woogie* (Figure 104, see also Plate XIII), however, he relaxed a bit in order to liven up the abstract scene by capturing the flow of musical time and the busy rhythms of urban life. He saw the big city and the fast pace of metropolitan life as a kind of collective work of art; and as the title of his picture suggests, he captures the spirit of urbanism in a visual representation of the sounds of popular music and the dance. The canvas can be read on a number of different levels. Topographically, the crisscrossing lines on the grid become a kind of horizontal city plan of streets and intersections as in central Manhattan. In an architectural sense, the vertical patterns of bright color flicker like skyscraper windows blinking on and off against the night sky, with the larger rectangles recalling the illuminated billboards in Times Square. Musically, Mondrian had championed the lively style of jazz in 1920s Paris against its detractors. In this work, he incorporates his love of jazz in a scintillating composition that conveys his ideas in a work of compelling and colorful visual music.

Figure 104. Piet Mondrian. *Broadway Boogie Woogie*, 1942–43. Oil on canvas, 50 × 50″ (1.27 × 1.27 m). By permission of the Collection, the Museum of Modern Art, New York.

Structurally, *Broadway* is based on a grid of horizontal and vertical bars like sections of a musical score, richly varied in space, width, and length. The color scheme allows the grays and blues to recede while the brighter reds and yellows advance in a kind of vibrating and ever-shifting visual counterpoint. As in the steps of the dance, the four colors alternate with different groupings of two to set up a type of syncopated rhythm. The constant shifts, akin to improvisation, allow for a feeling of randomness to relieve the regularity. Toward the center, larger rectangular blocks appear as accents. Some are solid red and blue, others are divided into two or more colors like chords or tone clusters. Similar to a rhythmic rubato effect, the rich variation in spacing keeps the rhythmic progress from becoming too regular or symmetrical.[12]

Two paintings from the present and past—Henri Matisses's *Dance* and Sandro Botticelli's *Primavera*—will illustrate the constancy of an ever-recurring theme within the 20th-century space-time continuum.

From ancient to modern times, the celebration of the changing seasons has played an important role in human affairs. The Greek Eleusinian rites, Orphic mystery cults, and Roman Bacchanalia all were associated with the seasonal change. Images of these pagan festivals are found in Euripides' tragedy *The Bacchae* and in the springlike dances of the three Graces, a favorite subject in Hellenistic and Roman painting and sculpture. The dynamics of space and time come into play here in dance forms.

Matisse's *Dance* (Figure 105, see also Plate XIV) is a powerful evocation of the primal life force expressed with joyous abandon. The high tensions and vibrant relaxations of movement are intensified by the stark spatial voids in which the dancers are placed. The sources for his mural-size canvas can be traced back to the maenads depicted on ancient Greek red-figured vases. They appear here in the same vivid red-ocher hues, which are intensified by their placement against the green ground and deep-blue sky. Other sources can be cited, such as the traditional *ronde-du-printemps* dances celebrated in medieval poetry and tapestries, Botticelli's *Primavera,* the well-known sculptural group on the façade of the Paris Opéra by J. B. Carpeaux, and the Parisian cabaret dancing at such night spots as the Moulin de la Galette. While Botticelli's *Primavera* is heavily weighted down with symbolism derived from classical mythology and Roman and Renaissance literary sources, Matisse distills the essence and spirit of the dance with its sheer animal energy and human *élan vital.* Some three years later Igor Stravinsky composed his balletic evocation of these springtime primitive rites and revelries with his *Sacre du printemps.*

Within a more formal framework, Botticelli's *Primavera* (Figure 106, see also Plate XV) can also be visualized as a rondo, or round dance, in celebration of springtime and the rites of love. The central figure of Venus, who appears to be pregnant, can be equated with the traditional Mary Annunciate, whose feast day is March 25, just nine months before the birth of Christ. The Florentine Cathedral is dedicated to Santa Maria del Fiore, and the flower theme is also featured on the panel. The elaborate Florentine carnival festivities always included Venus and her attendant mythological companions in street parades, communal dances, and

Figure 105. Henri Matisse. *Dance* (first version), 1909. Oil on canvas, 8′ 6″ × 12′ 9½″ (2.59 × 3.90 m). By permission of the Collection, the Museum of Modern Art, New York. Gift of Nelson A. Rockefeller in honor of Alfred H. Barr, Jr.

masked balls. There is also musical symbolism; the eight foreground figures (constituting an octaval relationship) are presided over by the Cupid above with his fiery golden arrow poised to pierce participants' hearts.

Mercury, who appears at the extreme left, is usually represented as the leader of the Three Graces, but here he is turning his back on them. While this enigmatic and baffling posture has puzzled scholars for decades, I propose a grouping that can account for this apparent iconographic discrepancy. Botticelli, bound by the conventional Renaissance cliché of representing the Madonna flanked by saints and angels, places his cast of characters spaced along the picture plane. But his composition can be read as a circle of figures beginning with the fleet-footed god of the winds. Here he is dispelling the clouds and mists of winter by raising his magical caduceus and directing the flying Zephyr on the far right to usher in the warm breezes of springtime. As Vergil

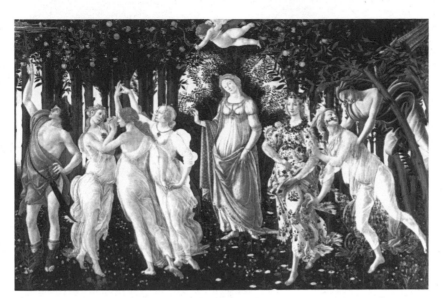

Figure 106. Sandro Botticelli. *Allegory of Spring (Primavera),* c. 1478. Tempera on wood, 6′ 8″ × 10′ 4″ (2.03 × 3.15 m). Uffizi Gallery, Florence. By permission of Scala/Art Resource, New York.

expressed it, "With his staff he drives the winds and skims the turgid clouds." This in turn becomes a neoplatonic metaphor for lifting the clouds that veil the intellect so that enlightenment and clarity can direct human affairs.

On the right, the circle continues as Zephyr is about to embrace the shy nymph Chloris, who tries to elude him. When he impregnates her, flowers form from her breath as she is transformed into Flora, who can also be read as Florence, the city of flowers. As the Roman poet Ovid put it, "I was once Chloris who am now called Flora." The corresponding group on the left is that of the Three Graces, whose dance steps and gauzy drapery form a circle within a circle, a ballet of flowing lines. They are the virginal purity of Castitas (chastity), the attraction of Pulchritudo (beauty), and Voluptas (consummation), who together personify the three phases of love. In the words of the philosopher Pico della Mirandola, "the unity of Venus is enfolded in the trinity of Graces." Presiding in the central axis is the goddess of love herself, with her offspring Cupid over her head. Together they proclaim that love is the link

Figure 107. Duane Hanson. *Rock Singer,* 1971. Polyester resin and fiberglass, polychromed in oil, lifesize. Collection of Jan Streep, Amsterdam. Courtesy of O. K. Harris Works of Art, New York City.

Figure 108. Satyr Playing Scabellum, 2nd century B.C. Marble, life-size. Uffizi Gallery, Florence. By permission of Marburg/Art Resource, New York.

that binds the octave of humanity and the universe together, as well as the force that makes the world go around.[13]

The dynamics of the dance and the continuity of human experience can also be observed in present-day sculpture when compared with classical prototypes. Realism is yet another dimension of postmodernism, and Duane Hanson's life-size and startlingly lifelike *Rock Singer* (Figure 107) is an arresting evocation of the sights and sounds of the popular music scene. As he comments, "I've tried to recreate the ridiculousness of all that action, the stamping of the feet, the music, the noise."[14] The ancient Hellenistic *Satyr Playing Scabellum* of the 2nd century B.C. (Figure 108) strikes a similar note of Bacchic frenzy. Both musicians communicate a state of ecstatic involvement in their music; both are possessed by the same dithyrambic divine madness; both portray the same Dionysian intoxication with dance rhythms. These images of youthful passion, however, made their respective societies uneasy, worried, and suspicious that somehow the younger generation was getting out of hand. Modern critics confronted with the orgiastic gatherings of thousands of young people at rock festivals feel that today's youth is on the verge of abandoning traditional social values and are heading straight back to the jungle. This age-old conflict between ethos and pathos is developed in the dialogues of Plato, who expressed similar misgivings and warned in his *Republic* that when the modes of music change, the basic institutions of society change with them. Both Plato and Aristotle looked askance on such emotional outbursts and advocated a more traditional approach to music based on rational principles and forms.

Carlo Maria Mariani is a Roman painter of the postmodern persuasion who has contrived a productive liaison with the intricate 18th-century neoclassical technique as well as with the 19th-century academic approach of David and Ingres. His *Constellation of Leo* (1980) (Figure 109, see also Plate XVI) shows the skill of his drawing, the delicacy of his figure modeling, and a sense of formal balance in a rather overcrowded composition. Subtitled "The School of Rome," the work is an elaborate self-invented allegory of the contemporary Roman and New York art worlds inspired by the 18th-century circle that included such illustrious names as the poet Goethe, the classical scholar Winckelmann, and the painters

Angelica Kauffmann, Henry Fuseli, and Raphael Mengs. Mariani's picture is, in fact, a postmodern "Parnassus" after the celebrated mural of that name by Mengs in 1761. Mengs's model in turn was Raphael's famous *Parnassus* fresco in the Vatican Palace.

Mengs's rather rhetorical ceiling mural (Figure 110) was commissioned by Cardinal Albani, a noted patron of arts and letters as well as a connoisseur of feminine beauty. Tradition has it that the laurel-crowned Apollo appearing as patron of the Muses is an idealized youthful portrait of the cardinal himself, while the other figures represent the women in his life, including, for propriety's sake, his mother and sister. On Apollo's right is the seated figure of Mnemosyne, mother of the Muses, whose face is that of a celebrated beauty of the day. Her nine daughters with their attributes are symmetrically deployed on either side. Mengs, not to be outdone, includes his wife as the Muse on Apollo's left holding a scroll with the painter's signature: Ant. Raph. Mengs/ Saxo/ MDCCCLXI.

Mariani's far more complex fictional "School of Rome" (see Figure 109 and Plate XVI) combines 18th-century grandiloquence with contemporary critical satire. The artist challenges his viewers to decipher his allegory with all the mythological and scholarly baggage they can carry. The picture can be taken as a serious statement, as a parody, or as some ironic combination of the two. In the axial center sits the artist himself, cloaked in ample folds of blue drapery and holding a sketch. Grouped around him on all sides is a fancy-dress "rogue's gallery" of art critics and dealers as well as the artist's friends and foes, all in various mythological guises and disguises. Above hovers Ganymede as he is being abducted to Mt. Olympus on Jupiter's eagle wings. There he will be cupbearer to the gods as well as Jupiter's bed-fellow. The model, appropriately enough, was a well-known high-wire circus performer, hence the hoop and stick. Below on the far left reclines a river god personifying the Tiber. Above him is a portrait of a German art dealer wearing the same type of hat Goethe did in Wilhelm Tischbein's familiar portrait of the poet in the Roman campagna. In the right center one beholds a Muse gazing raptly at the artist. Below her reclines a nude hermaphrodite, while on the far right are portraits of international art figures—one on horseback

Figure 109. Carlo Maria Mariani. *Constellation of Leo (The School of Rome),*
1980. Oil on canvas, 12 × 14¾' (3.40 × 4.51 m). Courtesy of Sperone
Westwater Gallery, New York.

as a Roman centurion with the traditional SPQR banner in his
hand; another is Hercules standing in a bathtub; a third, disguised
as a turtle, is waddling toward the water. Overall Mengs's painting
is a paean in praise of feminine pulchritude, while Mariani's is a
masculine celebration of Greek love.[15]

On the architectural scene, before the modernism of the Inter-
national style swept away all before it, the clustered skyscrapers of
major American cities were the archetypal expression of 20th-
century activities and aspirations, just as were the ancient Greek
acropolises, the Roman forums, the Romanesque monasteries, the
Gothic cathedrals, and the Renaissance and baroque palaces dur-
ing their florescence. Skyscrapers define the profiles of today's
metropolitan centers just as the domes and church steeples did in
times past. A helicopter tour of New York's Manhattan Island, for
instance, will quickly and convincingly reveal the contemporary
architectural affinity with the past. Here the pre-International-

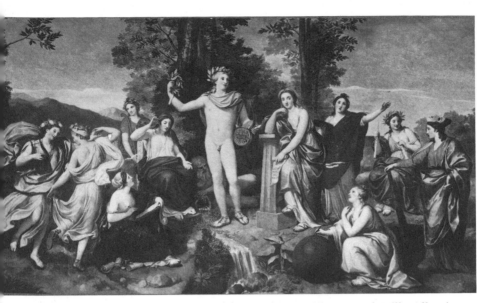

igure 110. Anton Raphael Mengs. *Parnassus,* 1761. Ceiling mural. Villa Albani, tome. Courtesy of Gabinetto Fotografico Nazionale, Rome.

modern skyscrapers are topped off with a potpourri of styles ranging from Babylonian ziggurats, Egyptian stepped pyramids, Greco-Roman classical colonnades, the Mausoleum of Halicarnassus, and medieval towers. Impressive also is the Gothic detail of the Woolworth Building and the art deco fantasy of the Chrysler Building with its gleaming cadmium-plated spire. Outstanding among the International-modern contributions are the sleek glass-curtained walls of Lever House, the rich metallic textures and smoky-glass sheath of the Seagram Building, and the rising lines of Philip Johnson's Citicorp with its asymmetrical slashing diagonal roof silhouetted against the sky.

Some credit Philip Johnson's and John Burgee's AT&T Building, called the "Chippendale" skyscraper (Figure 111) as leading the architectural way into the promised land of postmodernism. Completed in 1983, its curvilinear contours provide a pleasant lyrical interlude amid the surrounding rectangular steel-and-glass boxes with their "less is more" aesthetic, simplistic shapes, and claustrophobic honeycombed office cells. The façade sounds a welcoming note with the rich textures of the elegant pink granite

The Space-Time Continuum

Figure 111. Philip Johnson and John Burgee. AT&T Building, 1973–84. Madison Avenue, New York. Photograph copyright by Brian Rose, New York.

from Connecticut. The massive 80-foot triumphal archway leading into the spacious colonnades of the open lobby combine to communicate a classic solidity and dignity that approaches the monumental. The whole structure combines the picturesque tradition of romanticism with a desire once again to construct an edifice that gives visual pleasure. Its nickname comes from the split-level top, an architectural caprice alluding to an 18th-century cabinetry motif invented by the furniture maker Thomas Chippendale. Some critics have hailed it as a breakthrough into the postmodern wave of the future. Others, deriding it as "Johnson's folly" and a grandfather's clock enclosed in a granite cage, have dubbed it the gravestone of the movement. It does, however, revert to the pre-International-modern conception of a skyscraper that acknowledges the past while creating a link between historical and present-day vocabularies.

The most impressive single structure of postmodern architecture to date is James Stirling's Neue Staatsgallerie in Stuttgart, West Germany (Figure 112). Completed in 1984, it is both a popular and a profound statement that takes the full range of public taste into account. While the dominant theme is classically oriented, there are occasional references to Egyptian and Romanesque vocabularies—an eclectic combination of motifs quite in keeping with a museum setting. These historical allusions, together with the warm, varicolored sandstone and tawny travertine marble masonry, combine to give the complex a massive and monumental appearance, while the structure itself is borne by the tight controls of contemporary steel supports.

On the exterior, the colorful stone masonry is interrupted at certain points by a witty architectural caprice whereby some of the stone blocks of the wall appear to have fallen to the ground (Figure 113). These seemingly classical "ruins" invite visitors to sit as if they were in the Roman campagna setting of an 18th-century Piranesi print while pondering on the glories of antiquity. Ironically, however, these "holes in the wall" supply the needed ventilation for the interior parking garage. At the same time, the apertures allow the viewer to see the steel-frame construction that actually supports the building, while the seemingly solid stone wall is but a one-inch-thick sheath. Thus the decorative "ruins" motif can also

Figure 112. James Stirling. New State's Gallery, 1984. Ramps and stairways. Stuttgart, West Germany. By permission of Richard Bryant/Arcaid, Surrey, England.

claim to be functional as it creates a bond between illusion and reality.

Above the garage an expanding open-air "acropolis" leads by way of a curvilinear ramp to a sculpture court (Figure 114). The space seems like a domeless rotunda in the manner of the Roman

Figure 113. James Stirling. New State's Gallery, 1984. Detail of wall. Stuttgart, West Germany. By permission of Richard Bryant/Arcaid, Surrey, England.

Pantheon, with overtones of Giorgio de Chirico's haunted Italian piazzas (see Figure 102 and Plate XII). A short Tuscan-Doric portico that seems to be sinking through the pavement continues the ruins metaphor (Figure 115). This lively interplay of geometrical forms, vibrant polychromatic fittings, and their symbolic embellishments all combine to create a piquant opposition between formal and informal, monumental and incidental, traditional and modern, classical and contemporary. All these thematic devices, in sum, are quite in keeping with the essential nature of a museum—to preserve past values and treasures for the edification and delight of a technologically oriented, present-day pluralistic society.

Symphonic Finale

Viewed in the light of the relativistic mode, all media of contemporary expression came together in a convincing concert of the arts. In this all-inclusive orchestration, philosophy contributes

Figure 114. James Stirling. New State's Gallery, 1984. Sculpture court. Stuttgart, West Germany. By permission of Richard Bryant/Arcaid, Surrey, England.

the conceptualizing process; literature gives verbal voice to the heights, depths, and breadth of the human experience; music measures the flow of time; painting pictorializes the real and dream worlds; sculpture personifies human shapes and drives; and architecture articulates the spatial environment. As in a symphony, each orchestral choir plays its variations on related themes, while the conductor cues in present-day and past motifs and metaphors to round out the complete range of human experience.

With the mode of relativity, the cross currents of modernism and postmodernism become a reflection of the broadening range of taste that characterizes the current pluralistic social scene. In our libraries, stream-of-consciousness fantasies are shelved side by side with novels that stress narration and plausible characters. On

the stage, improvised theater-of-the-absurd pieces alternate with classical repertory and plays with sequential plots. In concert halls, one hears atonality alongside tonality, emancipated dissonance together with traditional consonance, mathematically controlled serialism alternating with random improvisations, computerized formulas opposed by free fantasias. The minimalistic musical theater now bridges the gap between opera and popular music, between traditional formulas and happenings. In museums modern abstract canvases now hang adjacent to those of the photorealistic persuasion. Cubistic nudes descending their staircases are seen in the company of naturalistic human figures. Works showing the fragmentation of objects into systems of angles and planes now appear on the same walls as realistic still lifes. In the streets of our cities, stark steel-and-glass skyscrapers line up beside postmodern structures that have picturesque decorative designs alluding to various historical styles. Thus all sections in this orchestral interplay of the arts join together in a *stretto finale* celebrating a cumu-

Figure 115. James Stirling. New State's Gallery. Detail of sculpture court. Stuttgart, West Germany. By permission of Richard Bryant/Arcaid, Surrey, England.

lative and continuous human adventure among masterpieces extending from antiquity to our ongoing modern and postmodern times.

In the postmodern world, the ideal of the *Gesamtkunstwerk* or complete work of art is once again receiving serious thought. Unification—the merging of several art media into a working synthesis—is now being explored as an answer to the phenomenon of fragmentation by the creation of new media. It is a movement away from the exclusive to the inclusive, from analysis to synthesis, from specialization and compartmentalization to broader horizons. Artists are now considering the "musicalization" of the visual arts "to produce abstract architectonic structures that possess fluid transformability in visual space." [16] The ancient Greeks had seen in the Pythagorean harmonic concordances the underlying basis for understanding their universe, the foundation for architectural proportions and structural principles, the proportions of the human body, and the psychological constitution of the human soul. The unification of all the arts in the collective concept of music (*mousike*) meant the united presence of all the Muses. Thus the Greek drama reflected the complete experience and rational organization of all attributes of the Muses—poetry, dance, drama, history, aural music—as they functioned within the all-inclusive concept of a universal harmony. In the 19th century Richard Wagner had projected the *Gesamtkunstwerk* in his music dramas as a synthesis of both Greek and medieval liturgical drama with philosophical and religious overtones. In the early 20th century Wassily Kandinsky in an essay "Concerning the Spiritual in Art" had proposed the idea of an art form that would include a synthesis of all art media. The painter, he theorized, "naturally seeks to apply the methods of music to his own art. And from this results that modern desire for rhythm in painting, for mathematical, abstract construction, for setting colour in motion. . . . And so the arts are encroaching on one another, and from a proper use of this encroachment will rise the art that is truly monumental." [17]

Experiments have been made at first with the manually-controlled color organ and now with computer-generated techniques to project and mix color as it gradually changes in hue,

shadings and saturations to produce a type of visual music. The color organ attracted the sensibilities of such composers as Scriabin, Schoenberg, and Stravinsky. Paul Klee and Moholy Nagy conducted such experiments at the Bauhaus including simultaneously heard sounds, projected colors, film sequences, and olfactory sensations. Some of their ideas later reached the popular level with Walt Disney's *Fantasia* in the Bach Toccata and Fugue section. Also at the Bauhaus, Kandinsky, the architect Walter Gropius, and the sculptor Oscar Schlemmer set up experiments in stage design that led to combinations of drama, dance, and architecture. As Gropius described the operation: "My own impression of Schlemmer's stage work was to see and experience his magic transforming of dancers and actors into moving architecture. . . . His are the only murals of our time I know which approach a complete fusion and unity with architecture."[18] More recently Philip Glass and Robert Wilson have conceived their productions as new forms of *Gesamtkunstwerke*. Their subjects are great figures from the past, and their productions are theatrical spectacles that combine text, sound, dancing, singing, scenic design, costume, electronic lighting, and a host of mixed media.

The relativistic broadening of visual, verbal, and sonic experience has led to novel ways of seeing, speaking, and hearing. In the new universe, multiverse, or pluraverse, there are no absolutes, only possibilities and probabilities; no permanence only transience. Relativism also involves a new way of looking at history in which all known past events are part and parcel of the expanding present. The mode of relativism now points to the relationship of works of art to the social and cultural environment in which they are produced, as all such works grow out of and are addressed to a particular socio-cultural milieu of a given time and place. Their relationships can then be established by seeking out the common ideas that underlie the various media of expression.

The time theme runs like a leitmotif throughout 20th-century expression. Present-day artists are concerned with the relativity and subjectivity of the temporal experience, and how true time is to be found in the subconscious, in dreams, in states of reverie, in the reading process, and in the experience of listening to poetry,

drama, and music. Artists are also fascinated by the way the past moves in a continuous flow as it encompasses, expands, and transcends the present on its way into the future.

The 20th century has thus become the focal point of all the ages, and the past is ever alive and present on the current scene. In this constantly expanding space-time continuum, the past permeates the present while an expected future shapes the direction of that present. It thus becomes possible to go forward into the past, and backward into the future. It is as if all our human yesterdays, todays, and anticipated tomorrows have come together in one single time capsule. Subjectively, one can consider this continuity as an extended metaphor for what the American philosopher Josiah Royce called the "eternal now," but which I prefer to call the "expanding present." The course of contemporary culture thus resembles a journey through an Einsteinian finite yet unbounded universe without limits. In this relativistic mode, all human experience comes together in a continuous constant unit, while the many variables and variations continuously evoke an unlimited number of adventurous temporal and spatial challenges. So it is that the people of the 20th century hold the whole known world in their hands, while reaching out to other worlds yet to be discovered. As this cultural spatiotemporal continuum moves into the future, the distant resonances of the ancient music of the spheres join with the sonic reverberations of the expanding present to celebrate and articulate the always ongoing and ever-continuing concerts of the arts.

Notes

Chapter 1

1. The term *Gesamtkunstwerk* was first given currency by Richard Wagner to describe his music dramas, which included scenic design, costume, poetry, sung dialog, dance, and full orchestral participation.

2. Friedrich Nietzsche, *Die Geburt der Tragödie aus dem Geiste der Musik* (1872); translated by Walter Kaufmann as *The Birth of Tragedy* (New York: Vintage Press, 1967).

3. Heinrich Wölfflin, *Renaissance und Barock* (1888); translated by Kathrin Simon as *Renaissance and Baroque* (Ithaca, N.Y.: Cornell University Press, 1966).

4. Marquis de Condorcet, *Esquisse d'un tableau historique des progres de l'esprit humaine* (1797); translated by June Barraclough as *Sketch for a Historical Picture of the Progress of the Human Mind* (New York: Noonday Press, 1955).

5. Edward Gibbon, *The Decline and Fall of the Roman Empire* (London, 1776–88).

6. Johann Joachim Winckelmann, *Geschichte der Kunst des Alterthums* (1764); translated by Henry Lodge as *History of Ancient Art* (Boston: Ticknor and Co., 1872).

7. René Descartes, *Selections* (New York: Charles Scribner's Sons, 1927), 6.

8. See Emery Neff, *The Poetry of History* (New York: Columbia University Press, 1947), 6.

9. Johann Gotfried von Herder, *Ideen zur Philosophie der Geschichte der Menscheit* (Thoughts on the philosophy of human history) (1784), *Herder's Sämtliche Werke* (Berlin: critical ed. by B. Suphan, 1877–1909) 4:439.

10. Ibid. 14:144–49.

11. Georg Wilhelm Hegel, *Phänomenologie des Geistes* (1807) (Hamburg: F. Meiner, 1952); translated by J. B. Baillie as *The Phenomenology of Mind* (New York: Harper and Row, 1967).

12. E. H. Gombrich, *In Search of Cultural History* (Oxford: Clarendon Press, 1969).

13. Arnold Hauser, *Social History of Art* (New York: Alfred Knopf, 1951).

14. Jules Michelet, *Histoire de France,* 19 vols. (Paris: A. Lemerre, 1885–87), quoted in Neff, *Poetry of History* (New York: Columbia University Press, 1947), 139.

15. Ernest Renan, *Vie de Jésus* (Paris, 1863, 1893), 472.

16. Hippolyte Taine, *History of English Literature* (New York: Henry Holt and Company, 1896), 9.

17. Ibid., 2.

18. Ibid.

19. Ibid., 21.

20. Jakob Burckhardt, *Die Kultur der Renaissance in Italien* (1860) (Leipzig: E. A. Seemann, 1912); translated by S. B. C. Middlemore as *Civilization of the Renaissance in Italy* (New York: Oxford University Press, 1950).

21. Ibid. See also Gombrich, *Cultural History,* 20.

22. See Rudolf A. Makkreel, *Dilthey, Philosopher of Human Studies* (Princeton, N.J.: Princeton University Press, 1975).

23. Wilhelm Dilthey, *Gesammelte Schriften* (Göttingen: Vanderhoek und Ruprecht, 1966) 8:180.

24. Ibid., *Der Aufbau der geschichtlichen Welt in der Geisteswissenschaft (Plan und Fortsetzung)* 7:269. *See also* Dilthey, *Das Erlebnis und die Dichtung* (Leipzig: B. G. Teubner, 1929); and *Von Deutscher Dichtung und Musik* (Leipzig: B. G. Teubner, 1933).

25. Dilthey, *Von Deutscher Dichtung und Musik.*

26. Heinrich Wölfflin, *Kunstgeschichtliche Grundbegrisse* (1915); translated by M. D. Hottinger as *Principles of Art History* (New York: Dover Publications, 1950).

27. Benedetto Croce, *Teoria e Storia della Storiografia* (Theory and history of historiography) (Bari, Italy: G. Loterza, 1963), 66–67.

28. Benedetto Croce, *Estetica come Scienza dell'Espressione e linguistica Generale* (1909); translated by Douglas Ainslie as *Aesthetics as Science of Expression and General Linguistics* (London: Macmillan, 1922).

Notes

292

29. Karl Lamprecht, *Die Kulturhistorische Methode* (1900). Several of his essays appear in translation in Karl Lamprecht, *What is History?* (New York: Macmillan, 1905).

30. Oswald Spengler, *Decline of the West* (New York: Alfred Knopf, 1926–29).

31. Neff, *Poetry of History*, 217.

32. Aby Warburg, letter of 18 August 1927, quoted in E. H. Gombrich, *Aby Warburg, An Intellectual Biography* (London: Warburg Institute, 1970), 322.

33. Arthur O. Lovejoy, *The Great Chain of Being: A Study in the History of an Idea* (New York: Harper Torchbooks, 1960), 15.

34. Arthur O. Lovejoy, *Essays in the History of Ideas* (New York: Harper Torchbooks, 1960), xii–xiii.

35. See Edward Pechter's cogent analysis in "The New Historicism and its Discontents: Politicizing Renaissance Drama," *PMLA* 102, 3:292–303.

36. William Fleming, *Arts and Ideas*, 8th ed. (New York: Holt Rinehart and Winston, 1991).

37. Gombrich, *Cultural History*, 45.

38. Ibid., 46.

Chapter 2

1. Joseph Tusiani, *Complete Poems of Michelangelo* (New York: Noonday Press, 1960), sonnets 83 and 84, pp. 76–77.

2. E. M. Forster, *Howard's End* (1910), chap. 5.

3. William James, *Principles of Psychology* (1890) (New York: Dover, 1958).

4. William Blake, *Jerusalem* (London, 1804–20), chap. 1, plate 10, lines 20–21.

5. Forster, *Howard's End*, chap. 22.

6. Charles Baudelaire, *Les Fleurs du Mal* (Flowers of Evil) (1857), *Oeuvres Complètes* (Paris: Bibliothèque de la Pléiade, 1954).

7. My interpretation of Veronese's *Marriage at Cana* is indebted to the article on musical themes in Renaissance painting and the three ages of man by Patricia Egan, "'Concert' Schemes in Musical Paintings of the Italian Renaissance," *Journal of the American Musicological Society* 14 (Spring 1961).

8. Tusiani, *Poems of Michelangelo*, sonnet 84, p. 77.

9. Carl Sandburg, "Trying to Write," *Atlantic Monthly* 186, no. 3 (September 1950):33.

10. For other viewpoints on artistic creativity see John Hospers, "Artis-

tic Creativity," *Journal of Aesthetics and Art Criticism* (Spring 1985):243–55. *See also* his selected bibliography on the subject, 254–55.

Chapter 3

1. See John Onians, "On How to Listen to High Renaissance Art," *Art History* 7, no. 4 (December 1984):411–37.

2. Pythagoras is credited with being the first to demonstrate that a string tuned, for example, to middle C could be stopped off at the exact center, and the two equal segments would each sound C, the octave higher. If the same string were stopped off in three equal parts, the tone of each segment would be G, an octave and a fifth above middle C. And if divided four equal ways, the tone would render the fourth. These three so-called perfect intervals can be expressed mathematically as 1:2 equals the octave, 2:3 the fifth, and 3:4 the fourth. The other intervals follow in narrower relationships for the notes in between until one has the seven intervals of the diatonic scale from C to the octave above.

3. For the ethos of the Greek modes, see Plato, *The Republic,* bk. 4; and Aristotle, *Politics,* bk. 8.

4. Henri Poincaré, *Les Méthodes de la mécanique celeste,* 3 vols. (1892–99); published in English as *The Foundations of Science* (1913).

5. Plato, *Timaeus,* section 35, in *The Dialogues of Plato* (New York: Random House, 1937) 2:17–19.

6. Galilei Galileo, *The Starry Messenger* (1610).

7. Johannes Kepler, *Harmonia Mundi* (1619).

8. William Shakespeare, *Merchant of Venice,* act 5, sc. 1.

9. See ground plan and reconstruction drawings in Bannister Fletcher, *History of Architecture,* 8th ed. (New York: Charles Scribner's Sons, 1928), 76, 82.

10. Vitruvius, *De architectura.*

11. Francesco Giorgi (Zorzi), *De harmonia mundi totius* (Venice, 1525).

12. For the role of musical proportions in medieval church architecture, see Otto von Simson, *The Gothic Cathedral* (New York: Pantheon, 1956), 37–38 et passim.

13. F. X. Haberl, *Bausteine zur Musikgeschichte,* vol. 3 (1888).

14. Charles Warren, "Brunelleschi's Dome and Dufay's Motet," *Musical Quarterly* 59, no. 1 (January 1973):92–105.

15. Leone Battista Alberti, *De re aedificatoria* (c. 1450), bk. 9, chaps. 5 and 6.

16. Ibid.

17. See Rudolf Wittkower's classic and seminal study *Architectural Principles in the Age of Humanism* (New York: Norton, 1971).

18. See J. P. Richter, ed., *The Literary Works of Leonardo da Vinci* (London: Oxford University Press, 1939), 59, 72ff, 76ff.

19. Pacioli expounds on the "golden ratio" in his treatise *Divina proportione*, written before 1499 and printed in Venice in 1509. The Pythagoreans thought that the golden ratio was the most beautiful of all proportions. The formula is the square root of five minus one over two ($\sqrt{5} - 1)/(2)$. The "golden rectangle" has sides in that proportion. When a line is divided into a "golden section," the ratio of its two parts is equal to the ratio of one part and the whole. This means that the ratio reproduces itself within itself. The diagonal lines of a pentagon, for instance, divide in this ratio. When a square is formed by one side of a golden rectangle, a golden rectangle remains. See also H. E. Huntley, *The Divine Proportion: A Study in Mathematical Beauty* (New York: Dover, 1970).

20. Martin Kemp, *Leonardo da Vinci: The Marvelous Works of Nature and Men* (London: J. M. Dent, 1981).

21. See E. H. Gombrich, "Leonardo's Method for Working out Composition," in *Norm and Form* (London: Phaidon, 1966), 58ff.

22. Francesco Colonna, *Hypnertomachia Poliphili* (Venice: Aldus Manutius, 1499).

23. See Franchino Gaffurio, *De harmonia musicorum instrumentorum* (Milan, 1518). While this treatise was published after Bramante's death, it summarizes many of the ideas expressed in his earlier published works dating back to 1481.

24. Plato, *Timaeus*, section 33.

25. Caterina Pirina, "Michelangelo and the Music and Mathematics of His Time," *The Art Bulletin* (September 1985): 368–82.

26. See Catherine Wilkinson, "Proportion in Practica: Juan de Herrera's Design for the Façade of the Basilica of the Escorial," *The Art Bulletin* 67, no. 2 (June 1986):229–42.

27. Andrea Palladio, *Quattro libri dell'architectura* (1570), bk. 1, chap. 20.

28. See James Ackerman, *Palladio* (Harmondsworth: Penguin, 1966). *See also* O. Howard and M. Longair, "Harmonic Proportions and Palladio's *Quattro Libri*," *Journal of the Society of Architectural Historians* 41:116–43, esp. part 3, p. 128ff.

29. See Gyorgy Doczi, "Hidden Harmonies of Henry Moore's Sculpture 'Vertebrae,'" *Leonardo* 16, no. 1 (1983):36–37.

Chapter 4

1. Erwin Panofsky, *Studies in Iconology* (New York: Harper and Row, 1939), Introduction.

2. G. Coulton, *Life in the Middle Ages*, 3rd ed. (Cambridge, England: University Press, 1935), 174ff.

3. Martène and Deschamps, *Thesaurus novus anecdotorum* (Paris, 1717), vol. 5, column 1584.

4. Erwin Panofsky, *Abbot Suger on the Abbey Church of St. Denis and its Art Treasures* (Princeton and London: Princeton University Press, 1946).

5. Joan Evans, *Cluniac Art of the Romanesque Period* (Cambridge, England: University Press, 1950), 120.

6. See Meyer Shapiro, "A Relief in Rodez and the Beginnings of Romanesque Sculpture in Southern France" (1963), reprinted in *Romanesque Art* (New York: George Braziller, 1977).

7. See Kenneth J. Conant, "Medieval Academy Excavations at Cluny, V: The Date of the Ambulatory Capitals," *Speculum. A Journal of Medieval Studies* 5 (1930):79.

8. Emile Mâle, *L'Art religieux du XIIe siècle en France*, 2nd ed. (Paris: Colin, 1902).

9. See K. Grimson, Jr., "An Original Interpretation of the Cluny III Ambulatory Capitals: Paradise Present in a Mansion of God" (Ph.D. dissertation, University of North Carolina, Chapel Hill, 1981). Charles E. Scillia, "Meaning and the Cluny Capitals: Music as Metaphor," *Gesta* 28, no. 1, 2 (The International Center of Medieval Art, 1988). Peter Diemer, "What does Prudentia Advise? On the Subject of the Cluny Choir Capitals," *Gesta* 27, no. 1, 2 (The International Center of Medieval Art, 1988).

10. Abbé Pougnet, "Theorie et symbolisme des tons de la musique grégorienne," *Annales archéologique par Didron* 26 (1869):380–87; 27 (1870):32–50, 151–75, 287–338.

11. Abbé Pouzet, "Notes sur les chapiteaux de l'Abbaye de Cluny," *Revue de l'art chrétien* 62 (1912):1–17, 104–10.

12. Barbier De Montault, *Traité d'iconographie chrétienne* (Paris, 1898).

13. Leo Schrade, "Die Darstellung der Töne an dem Kapitellen der Abteikirche zu Cluni. Ein Beitrag zum Symbolismus in mittelaltericher Kunst," *Deutsche Vierteljahrsschrift für Literaturwissenschaft und Geistesgeschichte* 7 (1929):229–66.

14. Evans, *Cluniac Art*, 118–21.

15. Kathi Meyer, "The Eight Gregorian Modes on the Cluny Capitals," *The Art Bulletin* 34, no. 2 (June 1952):75–95.

16. Tilman Seebass, *Musikdarstellung und Psalterillustration im früheren Mittelalter* (Paris: Bibliothèque Nationale, fonds Lat. 1118, vol. 1 Textband, vol. 2 Bildband; Bern: Francke Verlag, 1973).

17. Ruth Steiner, "Music for a Cluny Office of St. Benedict," chap. 4,

Monasticism and the Arts, ed. Timothy Verdon (Syracuse, N.Y.: Syracuse University Press, 1984).

18. Mary Protase LeRoux, "The 'De Harmonica Institutione' and 'Tonarius' of Regino of Prüm" (Ph.D. dissertation, Catholic University, 1965) 23.

19. *Liber troparium et prosarium,* St. Martial, Limoges (Ms. Lat. 1118, Bibliothèque Nationale, Paris); and *Tonarius,* St. Etienne, Toulouse (Ms. Harley, 4951, British Library, London).

20. See Meyer Shapiro, "On the Aesthetic Attitude in Romanesque Art," reprinted in *Romanesque Art.* See also Shapiro's article on musicians and acrobats in the Romanesque period, *The Art Bulletin* 21 (1939).

21. *"Quoddam virtutis gymnasium fuit."* The quotation appears in a letter of St. Peter Damian (d. 1072), and in Hildebert du Mans's life of St. Hugh, *Vita sanctissimi Patris Hugonis Abbatis Cluniacensis* (Marrier), 431–32.

22. William Fleming, "The Musical Iconography of Two Capitals at Cluny," *Symposium* 6, no. 1 (May 1952):22–50.

23. Quoted from Adrian Fortesque, *The Mass, a Study of the Roman Liturgy* (London: Longman Green and Co., 1912), 217.

24. See Kathi Meyer, "The Eight Gregorian Modes," ibid., 88.

25. Quoted from *Lay Folks Book of the Mass* (London, 1879), 32. This was a source book for early documents. The prayer was a so-called Bidding Prayer and is from the York order of the mass.

26. Ibid.

27. The 11th-century *Sarum Missal,* which was copied under the Norman Count Osmund, Bishop of Salisbury (1078–99), contains the following reference: "Be it known that at every ferial Mass, prostration is to be made by the whole quire directly after the Sanctus up to the Peace of the Lord throughout the whole year except from Easter to the first Sunday after Trinity." *The Sarum Missal in English* (London: De La More Press, 1911), 1:58.

28. See, for instance, the writings of St. Hilary of Poitier (c. 315–c. 367).

29. See *Sarum Missal* for prayers after Mass.

30. Ibid., 83.

31. St. Augustine, *De musica.*

Chapter 5

1. Baldassare Castiglione, *Il Cortegiano* (1514; Venice: Aldus Manutius, 1528); first English translation by Thomas Hoby, as *The Book of the Courtier* (London, 1561).

2. Robert J. Clements, *The Poetry of Michelangelo* (New York: New York University Press, 1965), poem G2, p. 182.

3. Ibid., poem G242, p. 178.

4. Joseph Tusiani, *Poems of Michelangelo,* translated into verse with notes and introduction (New York: Noonday Press, 1960), poem 101, p. 86.

5. Ascanio Condivi, *Michelangelo, La Vita,* ed. A. Mariani (Florence, 1928), 98.

6. Francesco Guicciardini, *Storia fiorentina* (History of Florence), first English translation 1859.

7. Pico della Mirandola, *Oratio de dignitate hominis* (1486). See "Latin Writings of the Italian Humanists," ed. F. A. Gregg (New York: Charles Scribner's Sons, 1927).

8. See Clements, *Poetry of Michelangelo,* 7–8, 326–27.

9. Ibid., poem G248, 316–17, translated by Robert Southey.

10. Dante, *Purgatorio,* Canto 18, lines 28–29.

11. Tusiani, *Poems of Michelangelo,* 77.

12. Ibid., sonnet 134, pp. 146–47.

13. Condivi, *Michelangelo, La Vita,* 37.

14. Tusiani, *Poems of Michelangelo,* sonnet 10, p. 25.

15. Michelangelo's poems first appeared in a modern edition in 1863, edited by C. Guasti. The 1960 edition by E. N. Girardi contains corrections and a new chronology which is now accepted as standard. Two recent volumes are useful as commentaries: David Summers' *Michelangelo and the Language of Art* (Princeton, N.J.: Princeton University Press, 1981); and Glauco Cambon's *Michelangelo's Poetry, Fury of Form* (Princeton, N.J.: Princeton University Press, 1985).

16. Tusiani, *Poems of Michelangelo,* poem 1, p. 21.

17. Charles Seymour, Jr., *Michelangelo's David* (Pittsburgh, Pa.: University of Pittsburgh Press, 1967).

18. Condivi, *Michelangelo, La Vita,* 38.

19. Tusiani, *Poems of Michelangelo,* 3.

20. Erwin Panofsky, *Studies in Iconology* (New York: Harper and Row, 1939), "The Neoplatonic Movement and Michelangelo," 180.

21. Tusiani, *Poems of Michelangelo,* poem 101, p. 86.

22. Giorgio Vasari, *Le vite de' più eccelenti pittori, scrittori, ed architettori,* 9 vols. (1550). Translated into English as *Lives of the Artists,* 10 vols. 1912–14.

23. Tusiani, *Poems of Michelangelo,* no. 99, p. 84.

24. Dante, *Inferno,* Canto 14, lines 103ff.

25. Charles De Tolnay, *The Medici Chapel* (Princeton, N.J.: Princeton University Press, 1948), 65.

26. See H. Brockhaus, *Michelangelo und die Medici-Kapelle* (Leipzig, 1909).

27. Frederick Hartt, *Essays in Honor of Georg Swarzenski* (Chicago: University of Chicago Press, 1951), 145–46.

28. Charles De Tolnay, *Encyclopedia of World Art,* "Michelangelo Buonarroti" (New York: McGraw Hill, 1959) 9:861–914; also *L'Arte,* New Series, 5, no. 1:5–44; and Panofsky, *Iconology.*

29. Dante, *Inferno,* Canto 11, 99–105.

30. Marsilio Ficino, *Theologia Platonica: "De deo, natura, et arte"* (1482). *See also* P. O. Kristeller, *The Philosophy of Marsilio Ficino* (New York: Columbia University Press, 1943), 101, 284.

31. Panofsky, *Iconology,* 176.

32. Tusiani, *Poems of Michelangelo,* 9.

33. Ibid.

34. Ibid., 96.

35. Ibid., 28.

36. Ibid., 51.

Chapter 6

1. See William Fleming, "Baroque Art," *Encyclopedia Britannica* (1963) 3:190–92. See also William Fleming, "The Element of Motion in Baroque Art and Music," *The Journal of Aesthetics and Art Criticism* 5, no. 2 (December 1946).

2. See James S. Ackerman and Rhys Carpenter, *Art and Archeology* (Englewood Cliffs, N.J.: Prentice Hall, 1963), "Style," chap. 3.

3. Lewis Mumford, *Technics and Civilization* (New York: Harcourt, Brace, 1934), 14.

4. Ibid.

5. André Maugars, *Response faite à un curieux sur le sentiment de la musique d'Italie, escrite à Rome le premier Octobre 1639* (printed pamphlet, October 1639).

6. Manfred Bukofzer, *Music in the Baroque Era* (New York: Norton, 1947), 68.

7. F. Baldinucci, *Vita di Gian Lorenzo Bernini* (Florence, 1682), modern ed. by Sergio Samek Ludovici (Milan, 1948).

8. E. S. Beer, ed., *The Diary of John Evelyn* (London: Oxford University Press, 1959), 138.

9. Ibid., 147–49.

10. Andrea Pozzo, *Perspectiva Pictorum et Architectorum* (Rome, 1692); translated by John James as *Rules and Examples of Perspective Proper for Painters and Architects* (London, 1707).

11. For a complete geometrical analysis see L. Benevolo, "Il Tema geometrico di S. Ivo alla Sapienza," *Quaderni*, no. 3 (1953).

12. For an extended discussion of the Bavarian churches see Karsten Harries, *The Bavarian Rococo Church* (New Haven, Ct.: Yale University Press, 1983).

13. Aldous Huxley, *Those Barren Leaves* (London: Chatto and Windus, 1925), 34.

14. Francis Hutcheson, *An Essay on the Nature and Conduct of the Passions and Affections* (1728).

Chapter 7

1. Voltaire, letter to Rousseau, 1755.

2. Gotthold Ephraim Lessing, *Historisch-kritische Beiträge zur Aufname der Musik* (1754–78).

3. Johann Joachim Quantz, *Versuch einer Anweisung die Flöte Traversière zu Spielen* (1752) (Leipzig: Schering, 1906), 108.

4. Johann Gottfried von Herder, letter to Caroline, *Briefwechsel* 2:119.

5. Johann Wolfgang von Goethe, *Aus Goethes Brieftasche*, Morris ed., 4:347.

6. Johann Wolfgang von Goethe, *Die Leiden des Jungen Werthers*, Morris ed., 4:274.

7. Judith A. Eckelmeyer, "Structure as Hermeneutic Guide to *The Magic Flute*," *The Musical Quarterly* 72, no. 1 (1986): 51–73.

Chapter 8

1. The historian and statesman Adolphe Thiers, a keen admirer of Delacroix, became Minister of the Interior under Louis Philippe and held a succession of cabinet posts. He was instrumental in awarding a number of important commissions to Delacroix.

2. Eugène Delacroix, *Journal*, trans. Walter Pach (New York: Grove Press, 1937), entry for 19 February 1850, p. 210.

3. *"Brouillon d'un homme de talent,"* ibid.

4. Delacroix, *Journal*, p. 198.

5. Charles Baudelaire, *Eugène Delacroix, His Life and Works*, trans. Joseph M. Bernstein (New York: Lear Publishers, 1947), 56.

6. Delacroix, *Journal*, entry for 31 March 1824.

7. Ibid., entry for 8 March 1853.

8. Baudelaire, *Eugène Delacroix*, title page.

9. Delacroix, *Journal,* entry for 22 February 1849.

10. Ibid., entry for 4 December 1853.

11. For a cross-section of critical comments, see Jack L. Spector, *Delacroix: "The Death of Sardanapalus* (New York: Viking Press, 1974), 80–88.

12. *Ecrits d'Eugène Delacroix, extraits du journal, des lettres, et des oeuvres littéraire* (Paris, 1942).

13. *Eugéne Delacroix: Selected Letters,* trans. Jean Stewart (New York: St. Martin's Press, 1970), letter of 7 May 1822.

14. Ibid., letter of 18 June 1825, pp. 124–25.

15. Ibid., letter of 27 June 1825, p. 126.

16. Ibid., letter of 1 August 1825, p. 127.

17. The usual title is *Greece Expiring on the Ruins of Missolonghi,* but this is a misnomer since Delacroix's own title was *La Grèce sur les ruines de Missolonghi (allégorie).* In all his references to the picture, the word *expirant* is never used. See Lee Johnson, *The Paintings of Eugène Delacroix: A Critical Catalogue. 1816–1831* (Oxford: Clarendon Press, 1981) 1:71.

18. Lee Johnson, *Delacroix* (New York: Norton, 1963), 86.

19. Lord Byron, *Sardanapalus: A Tragedy* (London, 1821), act 5 sc. 1.

20. Walter Friedlaendler, *David to Delacroix* (Cambridge, Mass.: Harvard University Press, 1952).

21. See Johnson, *Delacroix,* for a complete compilation of the critical reviews, 118–21.

22. *Delacroix: Selected Letters,* letter of 12 October 1830, p. 102.

23. Ibid., letter from Tangiers dated 23 and 29 February 1832, and 2 April 1832.

24. Delacroix, *Journal,* entry for 13 March 1832.

25. *Delacroix, Selected Letters,* letter from Tangiers, 8 February 1832.

26. Delacroix, *Journal,* entry for 21 February 1825, pp. 107–108.

27. Ernest Legouve, *Soixante Ans de Souvenirs* (Paris, 1888) 1:290.

28. *Memoirs of Hector Berlioz* (New York: Tudor Publishing Co., 1932), 58, 60.

29. Ibid., 97.

30. Ibid., 97–98. He is referring to his early *Huit Scènes de Faust* of 1827, not the later oratorio *Damnation of Faust.*

31. The letter is quoted in full in the *Memoirs of Berlioz,* 465–66.

32. Ibid., 66.

33. Ibid., 68.

34. Ibid., 471–72.

35. Victor Hugo, *Odes and Ballades* (1826). The "Ronde du Sabbat" is no. 14 of the *Ballades.*

36. See Goethe's *Faust,* pt. 1, the Walpurgis Night scene.

Notes

37. J. H. Elliot, *Berlioz* in *The Master Musicians Series,* ed. Eric Blom (London: J. M. Dent and Sons, 1938), 140.

38. Hector Berlioz, *Evenings in the Orchestra,* trans. by Charles E. Roche with Introduction by Ernest Newman (New York: Alfred Knopf, 1929), Introduction, xvii.

39. For a more complete discussion of the components of romanticism, see William Fleming, *Arts and Ideas,* 8th ed. (New York: Holt, Rinehart and Winston, 1991), chap. 19.

Chapter 9

1. William James, *A Pluralistic Universe* (New York: Longmans, Green, 1909; Cambridge, Mass.: Harvard University Press, 1977).

2. See William Fleming, "The Newer Concepts of Time and their Relation to the Temporal Arts," *Journal of Aesthetics and Art Criticism* 4 (Spring 1945): 101–106.

3. See Charles Jencks, *Post-Modernism: The New Classicism in Art and Architecture* (New York: Rizzoli, 1987). *See also* Robert Stern, *Modern Classicism* (New York: Rizzoli, 1988).

4. Marcel Proust, *Remembrance of Things Past,* trans. C. K. Scott Moncrieff (New York: Random House, 1934) 1:5.

5. See Patrick A. McCarthy, "The Structures and Meanings of *Finnegans Wake,*" and Barbara DiBernard, "Technique in *Finnegans Wake,*" in *A Companion to Joyce Studies,* ed. Zack Bowen and James F. Carens (Westport, Ct.: Greenwood Press, 1984), 559–687.

6. See Stuart Gilbert, *James Joyce's "Ulysses"* (New York: Random House, Vintage Books, 1931). This publication was authorized by Joyce himself. Subsequent scholarship, however, has corrected many points. For a summary of the new research on *Ulysses,* see *Joyce Studies,* ed. Bowen and Carens, 421–557.

7. James Joyce, *Ulysses* (New York: Random House, Vintage Books, 1961), 292.

8. Ibid., 738–83.

9. The text for *Akhnaten* is composed of passages from the *Book of the Dead;* the clay cuneiform tablets of the Amarna period; various Egyptian poetic fragments, letters and decrees; and the *Old Testament.* All are sung in the original languages. The text is also influenced by Sigmund Freud's *Moses and Monotheism* (1939), and allusions are made to Immanuel Velikovsky's *Oedipus and Akhnaten.*

10. Akhnaten, "Hymn to Aten," translated by D. Winton in *Documents from Old Testament Times* (London: Thomas Nelson and Sons, Ltd., 1958).

11. See Philip Glass, *Opera on the Beach* (London: Faber, 1988).

12. For a cogent and more detailed analysis of Mondrian's art, see Meyer Shapiro, *Modern Art, Nineteenth and Twentieth Centuries* (New York: George Braziller, 1978).

13. The literature on Botticelli's *Primavera* is vast, repetitious, and forbidding. The main arguments are summarized in Erwin Panofsky's *Renaissance and Renascences in Western Art* (New York: Harper and Row, 1969), 191–200. See also the copious footnotes.

14. Martin H. Bush, *Duane Hanson* (Wichita, Ks.: McKnight Art Center Book, Wichita State University, 1976) 38.

15. See Jencks, *Post-Modernism,* 48–49.

16. Gianmarco Vergani, "The Question of Unification and Musicalization of Art," *The Culture of Fragments,* precis 6, *The Journal of the Columbia University Graduate School of Architecture, Planning, and Preservation* (New York, 1987).

17. Wassily Kandinsky, *Concerning the Spiritual in Art* (New York: Dover, 1977), 19.

18. Walter Gropius, ed., *Theater at the Bauhaus* (Middletown, Ct.: Wesleyan University Press, 1960), 10.

MOTTOES IN TONARIES BY
REGINO OF PRÜM AND
ODO OF CLUNY
Early 10th Century

MOTTOES ON THE
CLUNY CAPITALS
Late 11th Century

1. *Primum quaerite regnum Dei.*
Seek ye first the kingdom of
God (and his righteousness;
and all things shall be added
unto you.) Matthew 6:33

1. *Hic tonus orditur modulamina primus.*
This tone is first in the order of
musical modulations.

2. *Secundum autem est simile huic.*
The second is like, namely this
(Thou shalt love thy neighbor
as thyself.) Mark 12:31

2. *Subsequitur ptongus numero vel lege secundus.*
There follows the tone which
by number and law is second.

3. *Tertia dies est quod hec facta sunt.*
Today is the third day since
these things were done. (A reference to the Resurrection on
the third day after the Crucifixion.) Luke 24:21

3. *Tertius impingit Christumque resurgere pingit.*
The third strikes and tells that
Christ is risen.

4. *Quarta vigilia venit ad eos.*
About the fourth watch of the
night he cometh unto them
(walking upon the sea . . .)
Mark 6:48

4. *Succedit quartus simulans in carmine planctus.*
The fourth follows representing a lament in song.

5. *Quinque prudentes intraverunt.*
Five of them were wise (and
five were foolish.) (A reference
to the wise and foolish virgins.)
Matthew 25:2–13

5. *Ostendit quintus quam sit quisquis tumet imus.*
How low is fallen he who
would exalt himself.

6. *Sexta hora sedit super puteum.*
It was about the sixth hour.
(The time when the woman of
Samaria came to Jesus at Jacob's well.) John 4:6

6. *Si cupis affectum pietatis respice sextum.*
If you desire the feeling of
piety, harken to the sixth.

7. *Septum sunt spiritus ante thronum.*
 There were seven lamps of fire
 burning before the throne
 (which are the Seven Spirits of
 God.) Revelation 4:5
 And I saw the seven angels
 which stood before God; and
 to them were given seven trum-
 pets. Revelation 8:2

8. *Octo sunt beatitudines.*
 (A reference to the eight beati-
 tudes from Christ's Sermon on
 the Mount.) Matthew 5:3–10

7. *Insinuat flatum cum donis septi-
 mum almum.*
 The seventh is the spirit bring-
 ing gifts to comfort the heart.

8. *Octavus sanctos omnes docet esse
 beatos.*
 The eighth teaches that all
 saints are blessed.

Index

Arcadelt, Jacques, 125
Arch of Triumph, 169
architecture, 1–3, 12, 29, 34, 48, 50, 149, 174, 180, 196
Ariel, 242
Aristotle, 48–52, 70, 278; *Nichomachean Ethics*, 48; *Poetics*, 264
Art of Fugue. See Bach, J. S.
Artemis-Diana, 253
Arts and Ideas. See Fleming
Aten, 268–69
Athanasias, St., 155
Athena, 35
Athena Lemnia. See Phidias
Athens, 1–4, 35–36, 55–56; Acropolis, 2 (fig. 1), 35, 252; Greek craftsmen, 4; Parthenon, 35, 55, 56; Temple of the Olympian Zeus, 55–56; Theater of Herodes Atticus, 3 (fig. 2); Theseum, 55
Attila the Hun, 232
Aubry, Etienne, *Fatherly Love (L'amour paternel)*, 193 (fig. 89), 194
Aufklärung, 184
Augustine, St., 60, 111, 156; *De musica*, 60
Austen, Jane, 212; *Sense and Sensibility*, 195
autobiographical mode, 212. *See* Chapter 8
autobiography, 213–14
avant-garde, 255–56, 270
Avénue de Paris, 168–69

Babylonian ziggurats, 281
Bacchae, The. See Euripides
Bacchus. See Michelangelo
Bach, Carl Philipp Emanuel, 200, 205; *Farewell to My Silbermann Clavier*, 194
Bach, Johann Christian, 205, 250
Bach, Johann Sebastian, 34, 143, 179; *Art of Fugue*, 199; Brandenburg Concerto, 179, fugues, 34, 289; *Unified Dueling of Shifting Strings*, 179; *Vereinigte Zweitracht der wechselnden Saiten*, 179; *Well-Tempered Clavier*, 34, 203; *Well-Tempered Clavier II*, 203 (ex. 6)
Baldachino, St. Peter's Basilica. *See* Bernini
Baldinucci, Filippo, 159
Balzac, Honoré de, 255
Banqueting House at Whitehall. *See* Jones
Barberini, Maffeo. *See* Urban VIII
baroque, 200. *See* Chapter 6; Age of Reason, 149; art, 13, 146–47, 167; art, England, 167, 171–73; art, France, 167–71; art, Germany, 174–78; astronomy, 146–47; imaginative phase, 164; liturgies, 149; music, 156–59, 178–81; opera, 180; palaces, 2, 174, 177; physical concept of universe, 147–48; political thought, 170; theme-and-variation idea, 179–80
Bassano, Jacopo, 39–40
Bastien und Bastienne. See Mozart
Bastille, 244
Battle of Lapiths and Centaurs. See Michelangelo
Baudelaire, Charles, 217, 255; "Correspondences," 32; *Les Phares*, 218
Baugin, 85; *Still Life: Allegory of the Five Senses*, 27, 28 (fig. 8), 29
Baumgarten, Alexander Gottlieb; *Aesthetica*, 6
Bavaria, 171
Bayeux tapestry, 103
Beatrice, 119, 237
Beaubourg complex, 2
Beauvais Cathedral, 9 (fig. 3)
Beckford, William, 85; Fonthill Abbey, 85
Beethoven, Ludwig van, 20, 22, 82, 206–207, 212, 236, 246, 250; *Egmont*, 242; *Piano Concerto in C Minor Opus 37*, 201, 202 (ex. 3); sonatas, 213
Beijing, China, 146
Bembo, Pietro, 125

Dante (*continued*)
118, 128, 131, 198, 220, 262; *Paradiso,* 118
Dante and Vergil in Hell. See Delacroix
Daphne, 29–31
Darwin, Charles, 198, 257
Darwin, Erasmus, 198
Daumier, Honoré, 235
David, King, 94, 95, 99, 104, 105, 118
David. See Michelangelo
Day (Giorno). See Michelangelo
De musica. See Boethius
De musica. See St. Augustine
De re aedificatoria. See Alberti
Death of Sardanapalus. See Delacroix
Debussy, Claude Achille, 255; *Sounds and Perfumes on the Evening Air,* 32
Decline of the West. See Spengler
Dedalus, Stephen, 261–63
Delacroix, Charles, General, 226
Delacroix, Eugène, 85, 215–34, 245–47, 255; African landscapes, 228; *Algerian Women in Their Harem,* Plate XI, 231; *Apollo Vanquishing the Python,* 232, 233 (fig. 97); *Arab Horses Fighting in a Stable,* 228, 229 (fig. 95); as seen by contemporaries, 217; ceiling and walls, Chapel of the Holy Angels, St. Sulpice, 234; chiaroscuro effect, 220; commissions, 218, 221; *Dante and Vergil in Hell,* Plate IX, 85, 215, 218, 220, 246; *Death of Sardanapalus,* Plate X, 85, 215, 224–26; galaxy of the gods, 232–33; *Greece on the Ruins of Missolonghi,* 222; *Jewish Musicians from Mogador,* 228; *Jewish Wedding in Morocco,* 229, 230 (fig. 96), 231; *Journal,* 214–15, 218, 220, 227, 234; journeys, 216, 221, 227–31; *Liberty Leading the People to the Barricades,* 226 (fig. 94), 227, 255; library of the Chamber of Deputies, 232; library, Luxembourg Palace, 233; lithographs of Faust, 215; *Massacre at Chios,* 215, 222, 223 (fig. 93); Peace, Orpheus, 232; personality, 217; political involvement, 216, 222, 226–27; Salon de la Paix, Hôtel de Ville, 232; *Self-Portrait,* Plate VIII, 217 (fig. 91); sketchbook, 227, 229; War, Attila the Hun, 232
Demeter, 253
Deposition. See Michelangelo
Der Freischütz. See Weber
Descartes, René, 5–6, 147, 189; *Traité des passions de l'âme,* 189
determinism, 249
Diana, 71
diatonic scale, 53, 55, 90, 91
Dichtung und Wahrheit. See Goethe
Diderot, Denis, 193; *Encyclopédie,* 184
Die Glückliche Hand. See Schoenberg
Die Kultur der Renaissance in Italien. See Burckhardt
Dilthey, Wilhelm, 11–13; *Geisteswissenschaft,* 12; humanistic studies, 11; *Naturwissenschaft,* 12
Dionysian chorus, 2
Dionysus, 1
Dis, city of Satan, 220
Disney, Walt, *Fantasia,* 289
dissonance, emancipation of, 256, 264, 287
divertimento-type symphony, 200, 206
Divine Comedy. See Dante
Don Giovanni. See Mozart
Don Ottavio, 209
Donatello, 116
Donna Elvira, 209
Donne, John, *An Anatomie of the World: The First Anniversary,* 147
Doré, Paul Gustave, 235
Dorian mode, 70–71, 92

Fountain Court. *See* Wren
Four Books on Architecture. See Palladio
Four Minutes and Thirty-Three Seconds. See Cage
Four Saints in Three Acts. See Stein, Thomson
France, 89, 106, 145, 149, 167, 170, 205, 199
Francis I, King of France, 135
Frankfurt, Germany, 197
French Revolution, 89, 240
Freudian psychology, 256
Friedlaender, Walter, 225
Friedlander, Max, 15
functionalism, 256
Fuseli, Henry, 279; *The Nightmare*, 198, 199 (fig. 90)

Gaea, 251, 264
Gaffurio, Franchino, tiburo of the Milan Cathedral, 71
galant, 190
Galilee, sea of, 103
Galileo, 54, 145–48; *The Starry Messenger,* 146
gallant style, 189–91, 195, 199–200, 209–10; *homme galant,* 189–90; rise of, 189
Gandhi, Mohandas, 265, 268–69
Ganymede, 196, 279
Garden of Love. See Rubens
Gauguin, Paul, 255
Gaulli, Giovanni Battista, 163
Gautier, Théophile, 224
Geisteswissenschaft, 12
Genesis, Book of, 85, 112
Genesis—The Break. See Newman
Géricault, Théodore, 216–18, 255; *Raft of the "Medusa,"* 218, 219 (fig. 92), 255
German repertory theater, 194
Germany, 6, 145, 158, 171, 174, 184, 194, 199, 205
Gesamtkunstwerk, 3, 174, 288–89

Gianotto, Donato, 117
Gibbon, Edward, 5
Gide, André, 261
Giorgi, Francesco, 61
Giorgione, 69; *Concert,* 41, 42 (fig. 13); *The Three Philosophers,* 41–42
Giovanni, Bertoldo di, 116
Giuliano, Duke of Nemours, 126, 128, 131–32, 137–38
Glaber, Radulphus, 91
Glass, Philip, 251, 265–70, 289; *Akhnaten,* 265, 268–69; *Einstein on the Beach,* 265–69; *Satyagraha,* 265, 268–69
Gluck, Christoph Willibald, 194, 236, 239, 246
God, 23, 52–55, 103–4, 107, 109–10, 119–20, 131, 140, 163, 249; creative force, 23, 25, 55
God Creating the Sun and Moon. See Michelangelo
Goethe, 85, 196, 278–79; *Dichtung und Wahrheit,* 213; *Egmont,* 242; *Faust,* 197, 213, 215, 221, 237, 240; *Fisherman,* 242; *Sorrows of Young Werther,* 197; *Urfaust,* 197; *Von deutscher Baukunst,* 197; Walpurgis Night Scene, 197, 240, 262; *Wilhelm Meister,* 213
Goliath, 12, 255
Gombrich, E. H., 15, 17
Goya, *Caprichos,* 198
Graces, 273–75
Great Fire of London, 169, 172
Great Rebellion, England, 150
Greco-Roman writings, 86
Greece on the Ruins of Missolonghi. See Delacroix
Greece, ancient, 188
Greek creativity, 2
Greek cross plan. *See* St. Peter's Basilica
Greek culture, 188, 273, 278
Greek drama, 34
Greek independence, 215–16, 222–24

Greek temple, 55
Greuze, Jean Battiste, 194; *Family Reading the Bible*, 193; *The Father's Curse*, 193; *The Paralytic Cared for by His Children*, 193; *The Prodigal Son*, 193
Gropius, Walter, 289
Gros, Baron, 224, 228
Guerin, Baron, 217
Guernica. See Picasso
Guggenheim Museum, New York, 256
Guicciardini, Francesco, *History of Florence*, 11
Guido of Arezzo, 92

Hades, 127
Hadrian, emperor, 56
Hall of Mirrors, Versailles. *See* Mansart, Lebrun
Hamburg, University of, 15
Hamlet, 237, 238, 242, 262
Hampton Court Palace, 173
Handel, George Frideric, 143, 180, *Harmonious Blacksmith*, 180; *Messiah*, 109, 203 (ex. 7)
Hanson, Duane, *Rock Singer*, 276 (fig. 107), 278
harmonic mode, 18
Harmonious Blacksmith. See Handel
Harmony in Blue and Silver. See Whistler
Harold in Italy. See Berlioz
Hartt, Frederick, 130
Hauser, Arnold, *Social History of Art*, 8
Haussmann George, 169
Haydn, Joseph, 82, 212; "La Passione" Symphony, 202; "Lamentation" in D minor, 200; "Farewell" Symphony in F-sharp minor, 200; Quartet Opus 1, No. 1, 199; Salomon Concerts, 82; String Quartet in F Minor Op. 20, No. 5, 203 (ex. 5); String Quartets, Opus 20 (Nos. 2, 5, and 6), 202; Symphony No.

44 in E Minor, 201 (ex. 1), 202 (ex. 4); Symphony No. 98 in B-flat Major, 210, 211 (ex. 13), (ex. 14)
Trauer Symphony in E Minor, 200–201
Haywain. See Constable
Hazlitt, William, 221
Hebrew, 87, 265, 267, 269
Hegel, Georg Wilhelm, 7–8, 14; *Zeitgeist*, 14
Hegelian philosophy, 16
Heine, Heinrich, 245
Heliodorus, Roman emperor, 234
Henrietta Maria, consort of Charles I, 78
Hercules, 233, 280
Herder, Johann Gottfried von, 7, 14; *Sturm und Drang*, 196; *Von deutscher Art und Kunst*, 197
Herrera, Juan de, Escorial Palace, 73, 74 (fig. 31)
hieroglyph, 1, 265, 269
High Renaissance, 48, 68–78, 118
Hiller, Ferdinand, 238
Hindemith, Paul, 82
Histoire du Soldat. See Stravinsky
historical process, 5
historicism, new, 16, 18
historiography, 13
History of English Literature. See Taine
History of Florence. See Guicciardini
Hoffmann, E. T. A., 243
Holy Family. See Poussin
Holy Spirit, 108–10, 155–56, 166
Homer, 233; *Odyssey*, 261–64
Hôtel de Soubise, Salon de la Princesse, 188 (fig. 86)
Hôtel de Ville, 232
Hugh of Semur, Abbot, 89
Hugo, Victor, 85, 216; *Cromwell*, 225; *Witches' Sabbath (Ronde du Sabbat)*, 240, 263
Huit scenes de Faust. See Berlioz
human imagination, 6; source of creativity, 23

humanistic context, 4, 12–13, 16, 249
Hutchison, Francis, *Essay on the Nature and Conduct of the Passions,* 192
Huxley, Aldous, 177–78
Hypnertomachia Poliphili. See Colonna

Iago, 222
Ibsen, Henrik, 255
iconographical mode, 18, 84–111. *See* Chapter 4
iconographical sources, 85
iconography, 33–46, 84, 109, 118, 134, 164
Ictinus, 8
idée fixe, 237, 242
Il Divo. *See* Michelangelo
Il Magnifico. *See* Medici, Lorenzo de'
illusionism, 166–67
imagination, 6–7, 33, 34, 45, 195, 212, 227
Imperial Room at Würzburg, 177 (fig. 84), 181
impressionism, 222, 255
Industrial Revolution, 246
Inferno. See Dante
Ingres, J. A. D., 222, 278
Innocent X, Pope, 162
Inquisition. *See* Spanish Inquisition
Interior of the Pantheon. See Pannini
Introduction to Universal History. See Michelet
Introit, 105
Ionic, 70–71, 154, 159
Isaac, Heinrich, 116
Isaiah, 109
isorhythmic motet, 65
isorhythmic symmetries, 64
Istitutione armoniche. See Zarlino
Italy, 6, 11, 74, 113, 122, 135, 167, 177, 205
Ivo of Chartres, 106

Jacob, 234
James I, King of England, 78
James, William, 23, 248

Jansenites, 149
Jefferson, Thomas, 78
Jehovah. *See* God
Jerusalem, 234
Jesuit order, 149, 160–61
Jesus, 23, 37, 42–44, 64, 70, 85, 88, 103–11, 122, 134, 138, 273; Sermon on the Mount, 91
Jewish Musicians from Mogador. See Delacroix
Jewish Wedding in Morocco. See Delacroix
John of the Cross, 149
John, Gospel of, 32, 41–43, 85
Johnson, Philip, AT&T Building, 281, 282 (fig. 111), 283; Citicorp, 281
Jones, Inigo, 76–78; Banqueting House, 76 (fig. 33), 77 (fig. 34), 78; Queen's House, 78
Joseph, 110
Journal. See Delacroix
Joyce, James, 256, 259–61; *Finnegans Wake,* 260–61; stream of consciousness, 260; *Ulysses,* 260–64
Judaism, 8, 48
Juliet, 239
Julius II, Pope, 48, 122, 125, 150, 214
Julliard School of Music and Performing Arts, 2
July Revolution of 1830, 215–16, 222, 226
Juno, 71
Jupiter. *See* Zeus

Kafka, Franz, *The Trial,* 259
Kandinsky, Wassily, 270, 289; *Concerning the Spiritual in Art,* 288
Kant, Emmanuel, 7, 196
Kantian purism, 16
Kauffmann, Angelica, 279
Kean, Edmund, 221
Kemp, Martin, 70
Kepler, Johann, 54, 146
Kierkegaard, Søren, 248

Maiano, Benedetto da, 116
Mâle, Emil, 90
Malton, Thomas, aquatint of ro-
tunda, St. Paul's Cathedral, 173
(fig. 81)
Manetti, Gianozzo, 64
Mansart, Jules Hardouin; garden fa-
çade, Versailles Palace, 170 (fig.
79); Hall of Mirrors, 169 (fig. 78)
Marchioness of Pescara, 138
Marian symbol, 62
Mariani, Carlo Maria, *Constellation of
Leo, School of Rome,* Plate XVI,
278–79, 280 (fig. 109)
Mark, Gospel of, 99–103
Marriage at Cana, The. See Veronese
Marriage of Figaro. See Mozart
Mars, 54, 70
Marx, Karl, 8
Marxian economics, 16
Mary Annunciate, 138, 273
Mary Tudor of England, 39
mass liturgy, 104–11; Communion,
108–9; Credo, 106; Introit, 105,
107; Kyrie, 105–106; Offertory,
107–108, 111
Massacre at Chios, The. See Delacroix
Matisse, Henri, *Dance,* Plate XIV,
272–73, 274 (fig. 105)
Mattheson, Johann, 189; *The Newly
Inaugurated Orchestra,* 190
Maugars, André, 158
Mausoleum of Halicarnassus, 281
Mazeppa. See Liszt
Mazzochi, Virgilio, 156
Medes, 224
Medici Chapel and Tombs, 125–38
Medici, Cosimo de', 116–17, 126,
135
Medici, Giovanni de'. *See* Leo X
Medici, Giulio de'. *See* Clement VII
Medici, Lorenzo de', Il Magnifico,
116, 117, 118, 126, 214
Medici, Piero de', 116, 121, 126
medieval cathedrals, 8, 34–36, 186
medieval mysticism, 90

medieval thought, 61, 63, 65, 91,
218
medieval times, 86, 87
medievalism, 14, 48, 53, 60–61,
113, 147–48
Medusa, French frigate, 218
Meknes, 228
Melamid, *Scenes from the Future,* 256,
257 (fig. 103)
melodrama, 242
melolgue, 242, 244
Melologue upon National Music. See
Moore
memento mori, 85
Memoirs. See Berlioz
Memphis, Egypt, 268
*Menacing Muses, The (Le muse inquie-
tante). See* Chirico
Mengs, Raphael, *Parnassus,* 279, 281
(fig. 110)
Menzel, Adolf, *Flute Concert of Fred-
erick the Great,* 191 (fig. 88)
Mephistopheles, 221, 240
Mercury, 53
Mesopotamian cultures, 250
Messiah. See Handel
metaphysical poets, 147
Metropolitan Opera House, New
York, 269
Meyer, Kathi, 93
Michael, Archangel, 234
Michelangelo Buonarroti, 11, 20,
22, 40, 44–45, 69, 74, 112–42,
143, 145, 150–51, 172, 181; altar,
Medici Chapel, 139 (fig. 64); *Bac-
chus,* 118; *Battle of the Lapiths and
Centaurs,* 118, 119 (fig. 54); Capi-
toline Hill, 138; *David,* 123, 124
(fig. 55); *Dawn (Aurora),* 128, 131;
Day (Giorno), 128, 131, 132 (fig.
59); *Deposition,* 131; *Dusk (Crepus-
colo),* 128, 131; Farnese Palace,
138; frescoes, 138, 218; *God Creat-
ing the Sun and Moon,* 27 (fig. 7); Il
Divo, 40, 112, 138; *Last Judgment,*
114, 115 (fig. 53), 118, 131, 138,

198; Laurentian Library, 73 (fig. 30); life of, 213–14; Medici Chapel, 125–38; new sacristy, San Lorenzo, 126, 127 (fig. 56); *Night (Notte)*, 128, 132, 133 (fig. 60), 135 (fig. 61); Pauline Chapel, 138; *Pietà*, 114, 131; *Prisoner*, 21 (fig. 4); River God, model of, 128 (fig. 57); Roman period, 138–42; self-portraits, 114; Sistine Chapel, 25, 112, 114, 138; sonnets, 20, 123; St. Peter's Basilica, 73, 74, 112, 138, 140, 141 (fig. 65), 142, 150–54; *Terribilità*, 132; Tomb of Duke Giuliano de' Medici, 125–38, 129 (fig. 58), 132 (fig. 59), 133 (fig. 60); Tomb of Julius II, 125; Vittoria Colonna, 119, 134, 138

Michelet, Jules, *Introduction to Universal History*, 8

Michelozzo, Palazzo Medici, 116

Middle Ages, 5, 54, 60

Milton, John, 147

Minerva, 71

Miranda, 242

Mirandola, Pico della, 117–18, 275

Miss Sara Sampson. See Lessing

Missolonghi, 222

Mnemosyne, 3, 279

Modern Age, 14

modernism, 251, 255–56, 259, 270, 280, 286, 288

Mondrian, Piet, 270–72; *Broadway Boogie-Woogie*, Plate XIII, 271, 272 (fig. 104), 273

Monet, Claude, 255

monochord, 108

monodrama, 242–44

monotheism, 265

Montault, Barbier de, 92

Monteverdi, 180

Moore, Henry, 78; *Vertebrae*, 79

Moore, Thomas, *Melologue upon National Music*, 242

Mornay, Count, 227

Morocco, 216, 227–31

Moses, 86–87

Moulin de la Galette, cabaret, 372

Mozart, Wolfgang Amadeus, 85, 86, 190, 200, 203, 206, 216, 250; "Jupiter" Symphony No. 41, 82; *Bastien und Bastienne*, 193; *Don Giovanni*, 85, 208–9; Flute Concerto in G Major, 210, 211 (ex. 11); fugal finales (*K 168* and *K 173*), 203; *Magic Flute*, 209, 242; *Marriage of Figaro*, 85; Piano Concerto in C Minor, 201, 202 (ex. 2); Piano Quartet in G Minor, 210, 211 (ex. 12); Prague Symphony (No. 38), 82; *Requiem*, 205 (ex. 10); String Quartet in F Major, 204 (ex. 8); Symphony No. 40 in G Minor, 203, 204 (ex. 9)

multiverse, 248–49, 289

Mumford, Lewis, *Technics and Civilization*, 148

Musak, 82

Muses, 2, 35, 279, 288

Museum of Modern Art, New York, 256

Music Party, The. See Watteau

musical terms, 192

Musset, Alfred de, 239

Myron, 4

Myrrha, 224

mystery play, 9

Mystic Mill: Moses and St. Paul Grinding Corn, The, 88 (fig. 36)

Nagy, Moholy, 289

Name of the Rose. See Eco

Napoléon II, 178, 224

Napoléon III, empire of, 215

Napoleonic wars, 215

Narcissus, 196

natural sciences, 12

Naturwissenschaft, 12

Nefertiti, 268

Neff, Emery, 14

neoclassical style, 5, 18, 255

neoclassicism, 183, 215, 225, 246, 278
neoplatonism, 41–44, 125, 275
Neptune, 232
Nerval, Gérard de, 237
Neumann, Balthasar, 176; Bishop's Palace, Würzburg, 29, 176, 177 (fig. 84); staircase, Bishop's Palace, 30 (fig. 9)
New State's Gallery (Neue Staatsgalerie). See Stirling
New Testament, 48, 85, 89
New York Music Library, 2
New York, New York, 2, 281
Newly Inaugurated Orchestra, The. See Mattheson
Newman, Barnett, *Genesis—The Break,* 25, 26 (fig. 6)
Newton, Isaac, 5, 20, 22, 146–47, 181, 249
Nichomachean Ethics. See Aristotle
Nietzsche, Friedrich, 3, 249; *Also Sprach Zarathustra,* 23; *Übermensch,* 196; *Night (Notte),* 136 (figs. 62, 63). *See* Michelangelo
Nightmare, The. See Fuseli
Nile, 268
Nineveh, 224
Nocturne in Blue and Gold: "Old Battersea Bridge." See Whistler
Nuper roseum flores. See Dufay

O'Neill, Eugene, 261
Odyssey. See Homer
Odo, Abbott of Cluny, 99, 105, 109
Old Testament, 48, 85
Olympian gods, 1, 29, 196
Olympus, Mt., 279
opera, 192, 194, 208, 210
Ophelia, 238
Orate fratres, 108
Ordo, Roman, 105
Orff, Carl, *Carmina Burana,* 266
Orpheus, 105, 232, 239
Ossian. See Macpherson

Othello, 221–22
Ovid, 275

Pachelbel, Johann, 203
Pacioli, Luca, *Divina Proportione,* 69–70
Paganini, Nicolo, 244, 255
Palazzo Medici. *See* Michelozzo
Palladio, Andrea, 71–78; *Caesar's Commentaries,* 74; *Four Books on Architecture,* 74; Villa Rotunda, 74, 75 (fig. 32)
Pamela. See Richardson
Pamina, 209
Pangloss, Dr., 184
Pannini, Giovanni Paolo, *Interior of the Pantheon,* 59 (fig. 21)
Panofsky, Erwin, 15, 125, 129, 132
Pantheon, Rome, 56, 57 (fig. 19), 58 (fig. 20), 59 (fig. 21), 78, 126, 145, 150, 284–85
Papageno, 209
Paradiso. See Dante
Paralytic Cared for by his Children, The. See Greuze
Paris Bibliothèque Nationale, 94
Paris salon, 221–22, 225, 229, 231, 235
Paris, France, 168
Parliament, English, 159
Parnassus. See Mengs
Parthenon, 35, 55–56, 145, 150
Pascal, Blaise, 181
Pater noster, 108
patronage, 35–36, 214
Paul III, Pope, 138, 214
Paul, St., 87, 89, 110
Pauline Chapel, 138
Pazzi Chapel. *See* Brunelleschi
Pei, I. M., east building National Gallery, Washington, D.C., 78
Pergolesi, G. B., 205
Pericles, 4, 35, 36
Perotin the Great, 81

Raft of the "Medusa." See Géricault
Rameau, Jean Philippe, *Traité de l'harmonie*, 189, 205
Ranke, Leopold von, 14
Raphael, 11, 13, 48, 69. 150; *Parnassus fresco*, 123, 279; *School of Athens*, Plate II, 48, 49 (fig. 15), 50 (fig. 16), 51 (fig. 17)
rationalism, 6–7
realism, 12–13, 278
Reformation, 146, 149
Regino of Prum, 99, 103, 104, 109; *tonarius*, 93
Reichardt, J. F., *Lullabies for Good German Mothers*, 194
relativism, 248–49, 251, 265, 285, 289–90
Rembrandt, 144, 220, 250; self-portraits, 212; Renaissance, 13, 15, 42, 48, 53–54, 61–68, 81, 112–13, 122, 138, 144–50, 164, 181, 271
Renan, Ernest, 10
Renoir, Pierre Auguste, 231
Republic. See Plato
Requiem. *See* Berlioz, Mozart
Requiem mass, 241
Revelations, Book of, 99, 109
Rhine, 171
Richard III, 221
Richardson, Samuel, *Pamela*, 194
Richelieu, Cardinal, 158
River God, model for. *See* Michelangelo
Rob Roy. See Scott
Robespierre, Maximilien de, 240
Rock Singer. See Hanson
rococo, 18, 118, 167, 174, 189, 195, 210
Rodin, Auguste, *The Thinker*, 137
Roman campagna, 279, 283
Roman Catholic Church, 122, 146, 149, 150, 155
Roman forums, 2
Roman missals, 106
Roman Pantheon. *See* Pantheon

Romanesque capitals, 89
Romanesque monasteries, 2, 86, 111
romantic aesthetic, 218, 246
romantic historiography, 10–14
romantic movement, 82, 201, 214–15, 243, 255
Romantic revolution, 226
romanticism, 6, 15, 198, 215, 225–26, 232, 246–47, 283
Rome, Italy, 89
Rome, University of, 163
Romeo and Juliet, 237–38, 244
ronde-du-printemps, 273
Rossini, Gioachino Antonio, 216
Rotunda, The, University of Virginia, 78
Rousseau, Jean-Jacques, 5, 184, 193, 196, 209; *Le Devin du Village*, 193; *Lettre sur la musique française*, 192; *Social Contract*, 186
Royce, Josiah, 290
Rubens, Peter Paul, 13, 220, 228, 232, 246; ceiling painting in the Banqueting House, 77; *Garden of Love*, Plate V, 171

Sacre du printemps. *See* Stravinsky
St. Denis, abbey church of, 87
St. Etienne, abbey of, 94; *First Mode*, 96 (fig. 40); *Fourth Mode*, 100 (fig. 46)
St. Ignatius in Glory. See Pozzo
St. Mark's Basilica, 81
St. Martial, abbey of, 94; *Fifth Tone*, 108 (fig. 52); *Final Mode*, 97 (fig. 42); *First Mode*, 96 (fig. 39); *Second Mode*, 102 (fig. 50); *Sixth Mode*, 98 (fig. 44)
St. Paul's Cathedral, 172
St. Peter's Basilica, 71, 126, 140–42, 145, 150–51, 152 (fig. 67), 153–56, 159, 172; apse and dome, 140, 150, 151 (fig. 66), 152 (fig. 67), 153; Cathedra, 153–56; Ecclesia, 154; Glory, 153, 156; Greek-cross plan, 140, 151; ground plan, 151;

Smithson, Harriet, 215, 237, 239
Smyrna, 223
Social Contract. See Rousseau
Social History of Art. See Hauser
Society of Jesus, 149
sociocultural-psychological methods, 16
Socrates, 4, 46
sonata, 192, 205–207, 209; development of social music, 206; key, 207; synthesis, 206
Sophocles, 4
Sorrows of Young Werther. See Goethe
Sounds and Perfumes on the Evening Air. See Debussy
South Africa, 265, 268
space-time continuum, 248–49, 252, 260, 265, 267, 272, 290
Spain, 36, 145, 167
Spanish Civil War, 36
Spanish Inquisition, 37
spatial motif, 251
Spengler, Oswald, *Decline of the West,* 14
Stanza della Segnatura, 123
Starry Messenger, The. See Galileo
Stein, Gertrude, 256; *Four Saints in Three Acts,* 266
Steiner, Ruth, 93
Stilgeist, 14
Still Life: Allegory of the Five Senses. See Baugin
Stirling, James, *New State's Gallery (Neue Staatsgallerie),* 283, 284 (fig. 112), 285 (fig. 113), 286 (fig. 114), 287 (fig. 115)
Stockhausen, Karlheinz, 251
Storm and Stress. *See* Sturm und Drang
Stradivarius viola, 244
Straits of Messina, 263
Stravinsky, Igor, 256, 289; *Histoire du Soldat,* 242; *Sacre du printemps,* 273
Strawberry Hill. See Walpole

stream-of-consciousness, 258, 260, 286
String Quartet in F Major. *See* Mozart
String Quartet in F Minor. *See* Haydn
Strozzi, Giovanni, 134
Sturm und Drang (storm and stress), 195–98, 200, 203, 208, 213
Study of Human Proportions according to Vitruvius. See Leonardo
Styx, 127–28
sublime, 185
Suger of St. Denis, Abbot, 87
Suleiman the Great, Sultan of Turkey, 39
Sun King. *See* Louis XIV
surrealist, 250–51, 256
symbolist poets, 27–28
Symonds, John Addington, 125
Symphonie fantastic (Berlioz), "March to the Scaffold," 240; "Reveries and Passions," 239
Symphony No. 98 in B-flat Major. *See* Haydn
Symphony No. 40 in G Minor. *See* Mozart
Symphony No. 44 in E Minor. *See* Haydn
Symposium. See Plato
synesthesia, 27–29, 32–33, 80

tableau vivant, 40–41
tactile imagery, 26–30, 32
Tafelmusik, 81
Taine, Hippolyte, *History of English Literature,* 10
Tangiers, 228
Teatro delle Quattro Fontane. *See* Cortona
Technics and Civilization. See Mumford
Tel-el Amarna, 268–69
Tempest, The, 16, 78

Index

Vergil, 116, 128, 233, 239, 244, 246, 274; *Aeneid,* 116, 215, 237
Veronese, Benedetto, 39
Veronese, Paolo, *Marriage at Cana, The,* 37, 38 (fig. 11), 39, 40 (fig. 12), 41–42, 44, 85
Versailles, 168–71, 173, 176, 181–82; Avénue de Paris, 168; Hall of Mirrors, 169
Vertebrae. See Moore
Vexations. See Satie
Vèzelay, Abbey of, 87, 94
Vico, Giovanni, *Scienza Nuova,* 6
Viennese School, 206
Villa Rotunda, Palladio, 75 (fig. 32), 78
Vingt-quatre Violons du Roi, 181
Virgin Mary, 61–62, 110
Virgin of the Sacred Heart, 218
Vitruvius, 57–58, 64, 69, 71
Voltaire, 7, 184, 186; *Age of Louis XIV,* 7; *Candide,* 184–85
Voluptas, 275
Von deutscher Art und Kunst. See Herder
Von deutscher Baukunst. See Goethe
Vulgate, 106

Wagner, Richard, 288
Walpole, Horace, 85; *Castle of Otranto,* 85; *Strawberry Hill,* 85
Walpurgis Night Scene. *See* Goethe
Walton, William, *Façade,* 243
Warburg Institute, University of London, 15
Warburg, Aby, 15
Warren, Charles, 65
Watteau, Jean-Antoine, *Music Party, The,* Plate VII, 189, 190 (fig. 87)
Waverley. See Scott
Weber, Carl Maria von, 218, 239; *Der Freischutz,* 221, 236, 242
Webern, Anton von, 256

Well-Tempered Clavier, The. See Bach, J. S.
Well-Tempered Clavier II, The. See Bach, J. S.
Whistler, James Abbott McNeill, *Harmony in Blue and Silver,* 32; *Nocturne in Blue and Gold: "Old Battersea Bridge,"* Plate I, 32
Wieskirche (Church in the Meadow). *See* Zimmermann
Wilhelm Meister. See Goethe
William of Baskerville, 264
Wilson, Robert, 266–67, 289
Winckelmann, Johann Joachim, 5, 278
Wind, Edgar, 15
Witches' Sabbath (Ronde du Sabbat). See Hugo
Wittgenstein, Princess, 243
Wölfflin, Heinrich, 5; *Principles of Art History,* 13; *Stilgeist,* 14
Woolworth Building, 281
Wren, Christopher, 147, 169, 172–73, 182; city plan, London, 169; Fountain Court, 173; St. Paul's Cathedral, 172, 173 (fig. 81); wing, Hampton Court Palace, 173
Wright, Frank Lloyd, 170

Yves, St., 163

Zarlino, Gioseffe, *Istitutione Armoniche,* 75–76
Zeitgeist, 14–15
Zephyr, 274–75
Zerlina, 209
Zeus, 3, 23, 35, 54–55, 71, 196, 279; Temple of Olympian Zeus, 56 (fig. 18)
Zimmermann, Dominikus, *Wieskirche,* 174, 175 (fig. 82), 182
Zola, Émile, 255
Zusammenhang, 12